ROMAN GLASS

REFLECTIONS
ON CULTURAL CHANGE

ROMAN GLASS

REFLECTIONS
ON CULTURAL CHANGE

STUART J. FLEMING

UNIVERSITY OF PENNSYLVANIA MUSEUM
of Archaeology and Anthropology

Design, production
　　Bagnell & Socha, Bala Cynwyd, Pa.

Printing
　　Piccari Press, Inc. Warminster, Pa.

CONTENTS

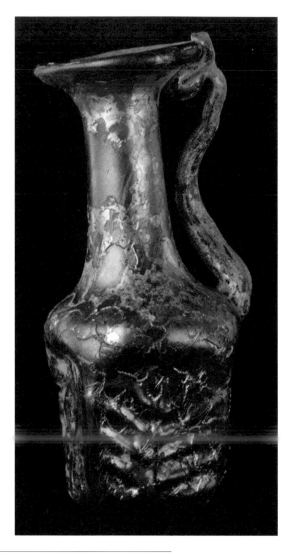

PLATE F.0

Jug, decorated on its side-walls with
simple floral motifs
Colorless, but heavily weathered
Ht., 12.6 cm
6th century A.D.
Provenance unknown
Gift of Lydia T. Morris (1916)

The body of this vessel was created by blowing a bulb of hot glass into a square mold,
the inside surfaces of which had previously been stamp impressed with floral motifs on
the sides and a spoked motif on the base. A rough spur on the base is where a smear of
glass was added so that the body could be attached to a long metal rod (a pontil). This
the glassworker held in one hand while he reheated the body's upper part and used tongs
to stretch out the shape of the neck. The handle was added later.
The attractive "peacock's tail"-like shimmer of color on the vessel's surface arises from
the natural weathering of the glass during its centuries-long burial in damp conditions.
The processes involved in this weathering are discussed and illustrated in Appendix A.
MS 5653

FOREWORD

"We have done things that will be deemed mythical by
those who come after us . . ."

(Pliny the Elder, *Natural History* XXXIII.53)

I WAS BORN AND RAISED IN SOUTH WALES. MY brother and I spent many a weekend afternoon clambering over the walls of Roman camps while my father, an amateur artist, committed to canvas the charm of nearby villages in and around the Wye valley. I would read tales of how the woad-painted native people, the Silures, fiercely defended their homeland against advancing Roman legions, despite the latter's superior weaponry. I would spend hours copying drawings of Roman soldiers in their fighting gear, standing stoically beneath their eagle-headed standard. At school I even quite enjoyed Julius Caesar's *On The Gallic War*, though my battles with the Latin subjunctive were rarely as easily won as his with the Helvetii and the like. So, it has been fascinating for me to come full circle, after a thirty-five-year career that has mixed radiation physics and archaeology, to create the exhibition *Roman Glass: Reflections on Cultural Change*, there to take a fresh look at the Romans through an aspect of their material culture—its glassware—rather than revive my youthful imaginations about their militancy.

Over the past seven years, I have come to realize that the path of development followed by the Roman glassworking industry was a complex one. Its period of innovative productivity spans the late 1st century B.C. through to the early 7th century A.D., during which time there was a constantly changing tide of foreign cultural influences upon Roman beliefs both from within the Empire and from beyond its frontiers. It involved a people who were self-assured about their destiny to control and direct the lives of others, yet quick to build a value system that was rife with foreign philosophies and attitudes. It revolved about a material that could be as colorful or as colorless as glass technology allowed; as plain or as sculpted as Roman fashion dictated. So the storyline of *Roman Glass: Reflections on Cultural Change* is a dynamic one that illustrates the aesthetic and technical response of a industry to changes in personal taste. This was particularly true wherever glass could be used to mimic another material, whether it was mundane pottery or luxurious rock crystal. Meanwhile the cultural backdrop for that storyline is rich and varied, defining forces for change as diverse as imperial assassinations and episodes of the bubonic plague, Empire-wide religious bigotry and local racial hatred, "global" economic crisis and blatant individual over-indulgence.

Are there modern overtones in such ideas? Certainly, and in the main text of the book I will draw what I believe are some reasonable analogies between the Roman society and our own. So it should it be, since the products of modern industries often reflect changes in *our* cultural values and shifts in *our* taste. But to peer into the ancient Roman World through an eye-glass tinged too strongly with modern notions, particularly about materialism, is to risk some dangerous misconceptions.

Roman wealth was usually based upon ownership of land, rarely on a business that produced consumer goods, so craft-based industries such as glassworking were never a key element of the Roman economy. Slavery was an undisputed integral part of Roman life in both its pagan and Christian eras. Since early on at least, most of the craftsmen in those industries were slaves, their practical skill was just exploited rather than respected or admired.

In Roman society there was a veritable chasm between the haves and have-nots, so there was no really definable Roman middle class. When I and other writers use such a term, it is to convey the sense of a numerous rank-and-file of craftsmen and tradesfolk who, unlike the Empire's welfare poor and the chattel of slaves, could in the best of times support themselves and their families. In the Roman World wealth defined social status, and for much of the Roman citizenry the acquisition of wealth was a compelling reason for getting up in the morning. To paraphrase an observation made by Horace (*Satires* I.I), the prevailing attitude was: "You cannot have enough; you are what you own."

The Romans also were a people that managed to marry together hard-nosed business acumen with an impressive load of life-governing superstitions in a way that we surely would struggle with today. Omens, dire or encouraging—howling apparitions, comets in the sky, and the like—controlled the big events such as the impending defeat or death of an emperor, of course. But a fear of other, more common troubles—crop failure, stillbirth, unexplained sickness, etc.,—kept most Romans close to their traditional gods in their everyday affairs to such an extent that, as St. Augustine observed: "In their obsession with legalistic exactness, the Romans had apparently attributed a spirit to almost every action of man or the natural world." (*City of God* IV.8) They lived in dread of the ghosts such as the *Lemures*, kinless and hungry creatures who brought confusion and sickness to a household. They always were afraid that ritual carelessness would threaten a person's immortality, so they expended a great deal of energy and money in preparations for the moment when a deceased relative would meet the gods. The reader's appreciation of these and other characteristically Roman attitudes that I will point up in the main text is essential for placing not just glassware but all Roman materialism in its proper framework.

When we want to get close to an ancient society, it always helps to know how it felt about itself, so I have laced both the main text and the Endnotes with quotations from a wide range of Roman writers (see also Appendix B). Unfortunately, none of these writers were glassworkers, nor were they intimately involved in glassmaking, so their words rarely touch upon the technical matters of the industry. Nonetheless, each had a unique view on what was going on around them, and each links their times to the past as they interpreted it and to the future as they anticipated it might be. In a cultural synthesis of the kind that I have attempted here, such views provide crucial touches of human color in what otherwise would be a clinical appraisal of the history of a technology (see Appendix A).

Conventional early historians such as Tacitus (*The Annals*), Suetonius (*Lives of the Caesars*), and the various librarians who put together the later *Augustan Histories*; they are the ones who provide the backbone to the timeline of my story, so they get occasional but essential mention. But my literary favorites are the late 1st century A.D. satirists, Martial (*Epigrams*) and Juvenal (*The Satires*). Both of them poked fun at the rich and famous, commented frequently on the lot of the disadvantaged, and kept up a relentless stream of entertaining, albeit sometimes risqué, commentary on the world about them. Their social experience spanned most everything from the banquet halls of the Esquiline Hill to the slums of the Subura; their material experience encompassed everything from gold to glass. Their words tracked the pulse of life in the city of Rome more precisely than any of their contemporaries.

Then there is Pliny the Elder, a man whose ceaselessly inquiring mind led him in A.D. 79 to sail *towards* the eruption of Vesuvius, there to be overwhelmed by its sulfurous fumes. He usually is identified as a pure encyclopaedist; reasonably so, in the sense that his *Natural History* ran to thirty-seven volumes and ranged over everything from werewolves—he didn't believe in them (see Book VIII.80)—to "Marks of vitality and character derived from the conformation of limbs in man, . . . " discussion of which put him uncomfortably at odds with the universally revered Aristotle (see Book XI.273). For

my part, I think of him as a far broader personality than that; someone would could not resist the occasional social commentary of his own, complaining bitterly about medical charlatans or about the influx of Greek beliefs (including the myths about werewolves) at a time when obviously he was part of the movement for the revival of erstwhile Republican Roman values.

Where the written word is lacking, I have used images that are evocative in their own way—manuscripts and mosaics, relief decoration on silverware and coffins, and so on. Few of these images express moments from real life with quite the clarity of the Dutch tavern scenes captured by Jan Steen or Adriaen van Ostade some three hundred years ago. Taken together, however, they do create a backdrop against which I have been able to place each item of glassware in something like its proper context.

In the end, when I talk of glass reflecting the Roman culture, I really mean that it reflects the way the people behaved towards one another; people of all walks-of-life—tradesmen with clients, mistresses with maids, and businessmen with slaves. Somehow, glass more than any other material allows us to relate to such people: the other staples of most Romans—pottery and iron—now seem mundane and remote, and the materials coveted by the Roman wealthy, with the possible exception of gold, have shed their ancient symbolism. Maybe it's just that there is something special about being able to look through a glass window pane and view the world beyond, or stare into a glass mirror and recognize ourself exactly as we are.

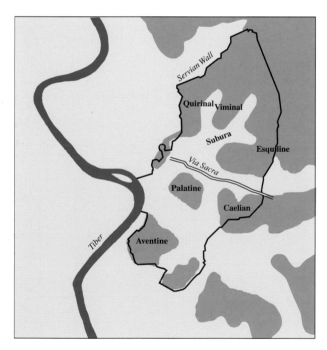

MAP I.I
THE ORIGINS OF ROME

In 390 B.C., the city of Rome lay in ruins, burnt and plundered by invading Celtic tribes. Just twelve years later, however, the Romans had encircled their city with the massive Servian Wall, the wall itself following the topography of the various hills that overlook the Tiber. The tops of these hills became prime locations for patrician homes, because they caught the light breezes of the evening; the slums of Rome, such as the Subura, developed in valleys between the hills.
The Via Sacra was the first road built in Rome. Initially it was flanked by religious buildings—hence its name—but by the early 1st century A.D. it had become the elite shopping area for the city.
Graphic by Andrea Jacobs, MASCA

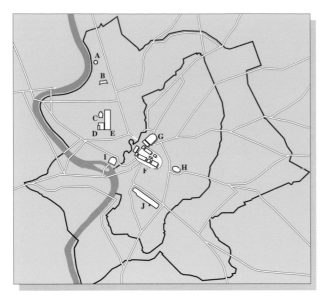 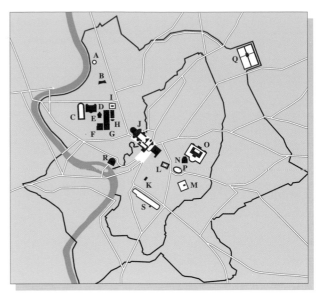

A Tomb of Augustus		**F** Forum Romanum	
B Solar Clock of Augustus		**G** Forum of Augustus	
C Pantheon		**H** Colosseum	
D Thermae of Agrippa		**I** Theater of Marcellus	
E Saepta Julia (for voting)		**J** Circus Maximus	

A Tomb of Augustus		**K** Temple of Apollo	
B Solar Clock of Augustus		**L** Temple of Venus	
C Stadium of Domitian		**M** Temple of Divine Claudius	
D Thermae of Nero		**N** Thermae of Titus	
E Pantheon		**O** Thermae of Trajan	
F Thermae of Agrippa		**P** Colosseum	
G Saepta Julia		**Q** Praetorian Camp	
H Temple of Isis		**R** Theater of Marcellus	
I Temple of Divine Hadrian		**S** Circus Maximus	
J Forum			

MAP I.2

ROME IN THE AUGUSTAN ERA, CIRCA A.D. 14

The driving force behind Augustus' public works programs seemed to be twofold: {i} ". . . the city was not adorned as the dignity of the Empire demanded. . . ." (Suetonius, Lives of the Caesars: The Deified Augustus.XXVIII*)—which can be translated to mean that Rome's architectural splendor lagged behind that of Athens, the spiritual center of the Greek World in the East; and {ii} Rome was highly susceptible to ruin by fire and flood. Building in stone helped lower the fire risk, but Augustus went one step further, by dividing the area of the city into regions—fourteen in all—and instituting a system of stations with night watchmen who could sound the alarm in times of trouble. As for flooding, he had the channel of the Tiber widened and cleaned free of accumulated rubbish.*

Crafts that were fire hazards, such as glassmaking, were required to set up shop in Regio XIV*, at the western edge of the city and beyond the Tiber.*

Graphic by Annette Aloe, Bagnell & Socha

MAP. I.3

ROME'S MAJOR LANDMARKS IN THE MID-2ND CENTURY A.D.

Rome was a dynamic city, one with a constantly changing aspect. The famed Golden House of Nero had burned down in A.D. *104, and now was buried beneath the Colosseum and the* thermae *of Trajan. The building of the massive* thermae *of Caracalla lay some fifty years ahead.*

Graphic by Annette Aloe, Bagnell & Socha

ACKNOWLEDGMENTS

I wish to acknowledge the National Endowment for the Arts, the Samuel H. Kress Foundation, and the personal generosity of Dr. and Mrs. Gregory Maslow that together provided the funds which made possible many of the graphics in this publication. I extend my personal thanks to the many scholars who so helpfully responded to my innumerable queries: including Margaret Alexander, Marijke Brouwer, Hilary Cool, Hugh Elton, Gillian Evans, Yael Gorin-Rosen, Karin Goethert, Kevin Greene, David Grose, Anne Hochuli-Gysal, Fraser Hunter, In-sook Lee, Flemming Kaul, Lawrence Keppie, Analies Koster, Paolo Liverani, Jacob Neusner, Jennifer Price, John Scarborough, George Scott, Genevieve Sennequier, Cecil Smith, Marianne Stern, Andreas Schmidt-Colinet, Eugene Vance, Michael Vickers, David Whitehouse, and Stephen Zwirn. I would also wish to express my appreciation of all my hardworking colleagues in the University of Pennsylvania Museum—particularly those in the Photographic Department, H. Fred Schoch and Francine Sarin—and of the staff of various photographic services departments of sister institutions worldwide, who were so patient with my seemingly endless requests for more illustrative material: particularly Tricia Buckingham of the Bodleian Library, Janet Larkin of the British Museum, Michelle Brown of the British Library, Jill Thomas-Clark of the Corning Museum of Glass, Edwin Hofbauer of the Österreichische Nationalbibliothek, and Guido Cornini of the Vatican Museum.

I would also hope that all readers will admire as much as I do the superb maps, line art and computer graphics which are used here to complement the conventional photographs in this book. The quality of these images are a credit to the skill and patience of six individuals most of all—Annette Aloe, William Fitts, Jennifer Hook, Mary Ann Pouls, Veronica Socha, and Paul Zimmerman—who were most ably assisted, however, by Gina Davies and Andrea Jacobs. I am also much indebted to Joseph Farrell, Mary Ann Pouls, and Ralph Rosen for the care and attention that they paid to the translation of the numerous ancient texts that I have used to help tell my story.

THE EXHIBITION, *ROMAN GLASS: REFLECTIONS ON CULTURAL CHANGE,* TO WHICH THIS BOOK OWES ITS TITLE, HAS BEEN MADE POSSIBLE, IN PART, BY GENEROUS SUPPORT FROM THE FOLLOWING DONORS:

THE SUSAN HELEN HORSEY FUND OF THE PHILADELPHIA FOUNDATION

RESOURCE AMERICA, INC., IN MEMORY OF FRANCIS "REDS" BAGNELL

THE NATIONAL ENDOWMENT FOR THE ARTS, A FEDERAL GRANTING AGENCY

DR. AND MRS. GREGORY MASLOW

PECO ENERGY COMPANY

MR. AND MRS. A BRUCE MAINWARING

THE PEW CHARITABLE TRUSTS

MR. AND MRS. ROBERT GROFF, JR.

THE ESTATE OF CLIVE HULICK

THE SAMUEL H. KRESS FOUNDATION

THE JOHN MEDVECKIS FOUNDATION

GEORGE VAUX (DECEASED)

THE ESTATE OF CONWELL SAVAGE

AND "IN-KIND" CONTRIBUTIONS FROM:

THE BRITISH MUSEUM, LONDON

THE BRITISH LIBRARY, LONDON

CORNING MUSEUM OF GLASS, CORNING, NY

DUMBARTON OAKS, WASHINGTON, DC

THE A-Z BOTANICAL COLLECTION, LONDON

GRAPHICS COORDINATION

KAREN VELLUCCI

DESIGN

BAGNELL & SOCHA

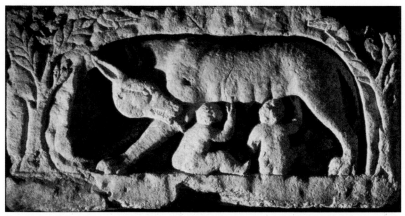

FRONTISPIECE F.I see page 159

Reflect continually how things came to
pass in days gone by as they do today,
and reflect that so they will hereafter. . . .

(Marcus Aurelius, *Meditations* X.27)

E. I

A CRAFT IN TENSION

IMAGINE FOR A MOMENT THAT IT IS A DAY IN THE
MID-4TH CENTURY A.D.—you are a traveler from Rome exploring the ways
of the people who live in the provinces that flank the course of the Rhine
at the Empire's northern frontiers. In Colonia Agrippina (modern Cologne
in Germany) you stop to watch an engraver patiently cutting into the sur-
face of a glass dish (Plate E.I). As you arrive, he is working around the outlines
of a horse's eye which he had wheel-cut onto the dish earlier in the day.
Gradually, a circus scene takes shape, all its parts crisply laid out on a transpar-
ent background, with each charioteer urging his horse-team forward, hard on
the heels of the competition. This image begins to look more and more like the
one on a silver platter that you saw in Rome only days before. It is quite possi-
ble that, at that same moment, far away in a narrow street of Scythopolis (mod-
ern Beth Shean in Israel), there is a glassblower carefully winding a pale green
thread around the neck of a small jug (Plate E.2). His workshop is stifling with
the heat of the fire where he softens the glass, so he is looking forward to the

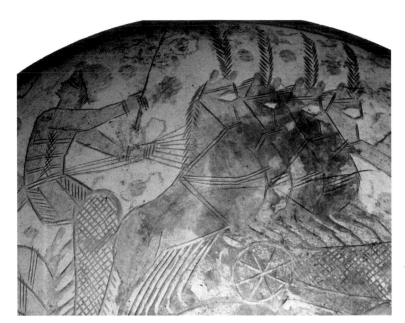

PLATE E.I

This dish, which dates to around A.D. 330, was found in one of the sarcophagi of a family cemetery at Braunsfeld near Cologne. The Roman use of engraving to decorate glass dates back to the latter half of the 2nd century A.D. (see Section E.8). Earlier decorative themes invariably were based upon early Greek mythology. During the 4th century A.D. however, secular topics such as boar-hunting and the Circus gained in popularity, as did imagery for subjects from both the Old and the New Testament (see Harden 1987). Courtesy of the Römisch-Germanisches Museum, Cologne

cool of the evening. Nearby lay the simple tools he used to shape the bottle; all around the work area there are clusters of his wares that are ready for the marketplace. He has little doubt that tomorrow will be very like this one—busy, since everything from skin lotion to insect repellent seemed to need a bottle or flask of some sort.

Both men would have worked instinctively with methods that had been common in glassworking for many generations past. Both accepted that they, like their neighbors—potters, woodworkers, tanners, and the like—were but a tiny part of the rhythm of everyday life in the sprawling Roman Empire that extended far beyond their personal horizons. Most glassworkers made their living from a rapid turnover of domestic vessels—jugs and bottles, cups and platters—so the routine of the Scythopolis craftsman was echoed daily and many times over in hundreds of Roman towns and vil-

lages. The same cannot be said for the routine of the Cologne engraver. But the mimicry of precious metal items in glass was certainly popular in his day, so that he always had some contemporaries with similar skills both in his own neighborhood and in other large cities, including Rome itself.

Probably, neither of these men had much grasp of the political events surrounding them, understanding only how they would suffer if those events led to the disruptions of war. Yet they were caught up in a crucial period in Roman history, one marked by Constantine's wholesale shift of the Empire's administrative core from Rome to Constantinople. Glassworking in the Eastern provinces—particularly in Cilicia and Syria—was on the verge of a revival, and all material crafts in those regions were about to be influenced more strongly by ideas from other cultures beyond the Eastern frontiers.

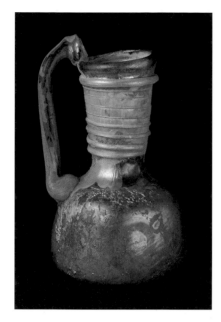

PLATE E.2

Juglet with decorative threads on the neck and rim Colorless body, with a light green handle and decorative threads Ht., 7.1 cm 4th–5th century A.D. From Beth Shean in Israel: Northern Cemetery, tomb 226 Excavated by Gerald M. Fitzgerald (1926) 29-105-706

FIGURE E.I

The three-way "tension" effect that wrought change in Roman glassworking over the centuries will be a recurring theme throughout this essay. Graphic by Annette Aloe, Bagnell & Socha

HISTORICAL EVENTS

ROMAN GLASSMAKING

TECHNICAL INNOVATION

FASHION AND TASTE

From our modern vantage point, we can see that the lives of these, and indeed all glassworkers, in the Roman world then were being manipulated by an elastic "tension" from at least three factors that can be labeled simply as *historical events, technical innovation,* and *fashion and taste* (Figure E.I). And we can see that this same three-way tension directed the course of glassworking just as surely during the previous five centuries while Rome was the Empire's center, as it did over the subsequent three centuries, during both the drama of the collapse of the Western Empire and the rise of Christianity to a prime position in Roman affairs.

For the most part, when we talk of change in the glassworking craft in Roman times, we mean the introduction of a new function for glass or the development of a new vessel shape. (The general chemistry of glass coloration was worked out well before the Romans took an interest in it, so color change figures here as a technical innovation only

every once in a while.) As we might expect, the changes with most far-reaching impact occur when all three components of the tension process are very active. The diversity of the glassware that became available during the early decades of the 1st century A.D. demonstrates that point most clearly (see Section E.4). A lesser change was certainly quite likely, and often took place, however, whenever just one tension component gained some ascendency. There was always some important event on the horizon—usually a war, but sometimes a change in Imperial policy—that would influence where and how glass was made soon thereafter. And, if it were ever true that most glassworkers were falling into a set way of doing things, there were always a few of them who were exploring outside the conventions of their craft. It is not so much a question of whether such a three-way tension existed for Roman glassworking, but rather of recognizing the form which it took.

3

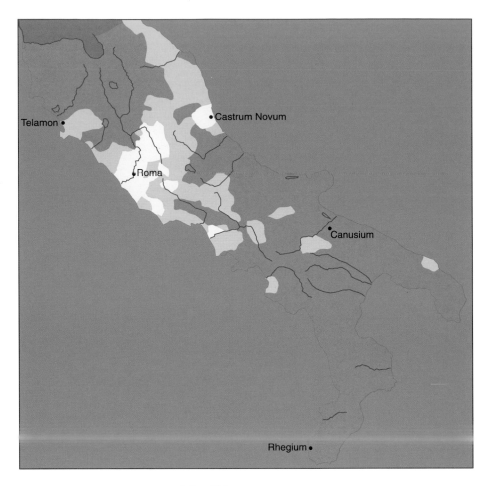

MAP E.I

With the absorption of the area around Castrum Novum (north of modern Pescara) in 241 B.C., Rome's authority extended the length of the Italian mainland. Defeated enemies either were forced to become allies or were offered some level of citizenship.

KEY

Full citizenship (civitas optimo iure) *Obligations included payment of taxes and military service; the primary benefit was full civil rights under Roman law.*

Half citizenship (civitas sine suffragio) *Obligations included payment of taxes and military service; civil rights were quite limited (thus, no vote in the Roman assemblies).*

Alliance *Obligations included contribution of troops to the Roman army; no civil rights under Roman law.*
Graphic by Paul Zimmerman, MASCA: after Cornell and Matthews (1982)

FRONTISPIECE F.2 see page 159

It would be best of all if the Greeks never made war upon each other. . . . For it is evident that, whether the Carthaginians defeat the Romans or the Romans defeat the Carthaginians in this war . . . they are sure to come here and extend their ambitions beyond the bounds of justice. . . .

(Polybius, *The Histories* V.104)

E.2

ROME AND THE HELLENISTIC WORLD

HOW FAR BACK SHOULD WE GO, TO TELL THIS STORY? IN PURELY HISTORICAL TERMS, the growth of Rome began in earnest around 378 B.C. when it gave some forewarning of its militant intent by enclosing itself in a massive, ten-kilometer long wall. At that point, Rome's territories measured just 1570 square kilometers: less than the span of a modern city with a 25 kilometer radius of suburban sprawl. By 241 B.C., when its fleet defeated the Carthaginians off the western tip of Sicily, Rome controlled, either by alliance or dependency, all the land on the Italian peninsula from the course of the Arno river to its southernmost port of Rhegium (modern Reggio) (Map E.I). Sicilia became its first province; Sardinia and Corsica soon followed. In 225 B.C., a crushing victory at Telamon turned back an intense Gallic invasion and thereafter extended the Roman territories northward into the Po River Valley and the foothills of the Alps.

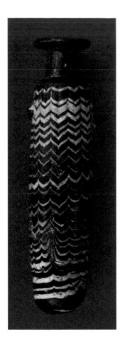

PLATE E.3

Perfume flask (alabastron)
Core-formed, yellow threads
marvered into a dark blue ground
Ht., 11.5 cm
Mid—4th—late 3rd century B.C.
Provenance unknown

A Hellenistic alabastron was produced by
a series of manipulations:
a. *The shape of the vessel was defined by*
 wrapping a mass of clay, sand, and
 straw over the end of a support rod.
 Heavy threads of glass of the primary
 color—usually blue—were coiled
 closely around this core-mass, then
 repeatedly heated and rolled on a smooth
 surface to produce the vessel's body.
b. *Finer threads of glass of the secondary colors—usually*
 yellow and/or white—were wound in loose spirals over the
 body. Subsequent heating and rolling bonded these spirals
 into a decoration pattern that was then given a "feathered"
 look by drawing a metal pin across them.
c. *The support rod now was removed and the vessel heated to*
 harden its surface. The core-mass was then scraped out,
 leaving the alabastron with a rough, often pitted interior.
29-6-388

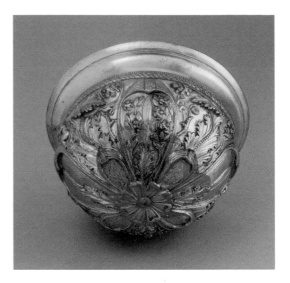

PLATE E.4

Silver Megarian bowl
Ht., 7.6 cm
Weight, 225 grams: Capacity, 0.46 liters
Second half of the 2nd century B.C.

The gold examples of these kind of bowls that are
mentioned in ancient literary sources have long since been
melted down as part of the booty of war (Rotroff 1982;
Vickers et al. 1986).
Courtesy of the Toledo Museum of Art

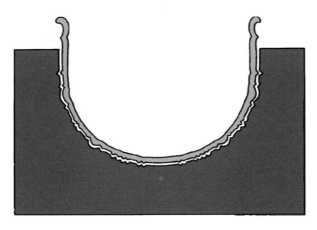

FIGURE E.2

MOLD CASTING OF POTTERY
First, clay is pressed into a mold which
has the desired decoration cut into its
inner surface. The clay is smoothed flat,
then both it and the mold are left out in
the sun, so that the clay dries out and
becomes leatherhard. Because the clay
shrinks quite a lot during this
preparatory step, the bowl-to-be can be
lifted free of the mold with no difficulty and stacked in a kiln with
hundreds of other vessels like it (see also Bédoyère [1988: fig. 10]).
Artwork by Veronica Socha, MASCA

But these are not events to dwell upon here. Glass did not figure significantly in the Roman way of life during this territorial growth spurt, nor would it do so for almost another two centuries. In hindsight, however, we can see that certain matters were coming together in the late 3rd century B.C. in a way that would later be quite crucial to the growth of several Roman crafts, glassworking included.

In the lands of the Eastern Mediterranean that shared the heritage of having been part of Alexander the Great's massive empire a century earlier—in what we now call the Hellenistic world—glassworking was undergoing vital change. The craft's repertoire already included a range of small, multi-colored vessels made by a core-forming technique that can be traced back to a Mesopotamian innovation in the mid-8th century B.C. (Plate E.3).[1] Around 220 B.C., however, Athenian potters began to produce a mold-made bowl that they cast with a shape and relief decoration that clearly mimicked the popular Hellenistic silver and gold vessels of the day (Plate E.4 and Figure E.2). These so-called *Megarian* bowls were traded far and wide, and inspired several forms of imitation in Asia Minor and on the Italian mainland over the next half century or so.[2]

Glassworkers did not adopt this ceramic technology directly. Instead, they turned the potter's approach upside-down and inside-out, using a plain clay mold to define the shape of the glass vessel from its interior (Plate E.5). No decoration was applied this way.[3] Subsequent decoration with

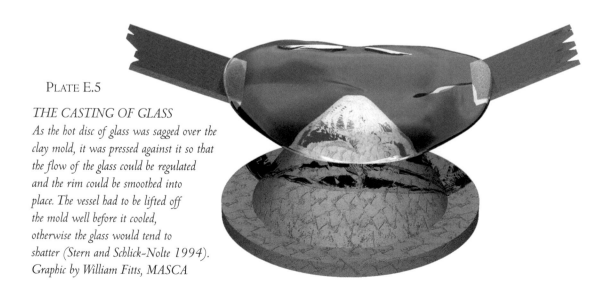

PLATE E.5

THE CASTING OF GLASS
As the hot disc of glass was sagged over the clay mold, it was pressed against it so that the flow of the glass could be regulated and the rim could be smoothed into place. The vessel had to be lifted off the mold well before it cooled, otherwise the glass would tend to shatter (Stern and Schlick-Nolte 1994). Graphic by William Fitts, MASCA

FIGURE E.3

In Hellenistic times, this kind of conical bowl (Ht., 9.9 cm) was known as a mastos *because of the resemblance of its shape to a female breast. The discovery of fragments of thousands of these bowls at the site of Tel Anafa (near the headwaters of the river Jordan) indicates the popularity of the shape during the late 2nd–early 1st centuries B.C. (Grose 1970; Weinberg 1973). Silver and pottery versions of this vessel type are known from Spain to Asia Minor (see Strong [1966; 108]; Oliver [1977: entry 47]).*
The use of groups of wheel-cut grooves as a means of decoration of these glass bowls, both inside and out, probably is intended to imitate molded ridges that were created in low relief on silver and pottery prototypes.
Artwork by Veronica Socha, MASCA: after Stern and Schlick-Nolte (1994: item 79)

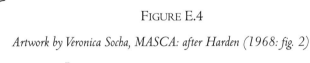

FIGURE E.4

Artwork by Veronica Socha, MASCA: after Harden (1968: fig. 2)

INSET

A close-up view of a bowl recovered in 1869 from a burial at Canusium (modern Canosa di Puglia) depicts in gold leaf the kind of floral designs that were often cast in relief on Hellenistic silverware. Here the gold leaf is sandwiched between two layers of glass that were fused together to create the vessel's body wall (Goldstein 1989). In other instances, gold leaf was applied directly to a vessel's exterior to highlight a painted motif (see Stern and Schlick-Nolte (1994: item 69).
The 12th century writer Eraclius describes his reconstruction of this technology in his De Coloribus et de Artibus Romanorum I. *part 4 (see Merrifield 1967).*
Courtesy of the Trustees of the British Museum

lathe-cut bands of grooves and ridges, and with cut reliefs on this base—invariably a star or rosette motif—indicate that these glass vessels also drew inspiration from gold and silver prototypes (Figure E.3). In some instances, the mimicry of gold vessels was taken to the extreme of layering a gold leaf pattern of foliage between two transparent glass shells (Figure E.4); in others, a floral design was painted onto the glass and then highlighted with gold leaf pressed on top of it. Whatever the means of decoration might have been, what we can say is that the use of a casting mold of this kind was a small but significant step towards the ideas of mass-production that later would be central to the Roman glassworking industry.

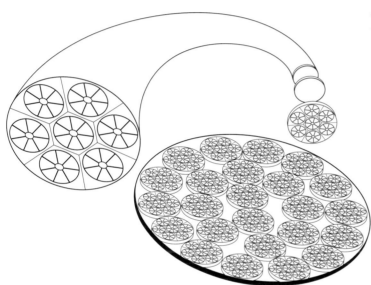

PLATE E.6

*The patterning of this shallow mosaic
dish includes one of the most
common composite canes used by
Hellenistic glassworkers in the
late 2nd century B.C.—a simple
spiral—along with a less common
striped motif and several
monochrome rectangles. The last of these
may have served as some kind of workshop
"signature."*

*Other dishes and bowls of this kind were
made up of such spirals mixed in with an
attractive "star-burst" motif; others were patterned
solely with these spirals and others again solely
with "star-bursts" (see Inset).*
*Courtesy of the Corning Museum of Glass,
Corning, N.Y.*

INSET

*The small pellets that were fused together to create
a mosaic pattern were cut from a fine thread
that had been stretched out of a thicker ingot
(see also Figure E.10).*
Artwork by Veronica Socha, MASCA

At the same time, mold-casting opened up several new avenues that were quite separate from that defined by Megarian pottery. A brand new style of riotously colored glassware emerged, with bowls and dishes fashioned from a fused mosaic of composite glass canes (Plate E.6).[4] The patterns within the canes were mostly limited to spirals and "star-bursts" (Plate E.6, Inset). But the flow of the glass during casting often produced surreal effects among these otherwise simple geometric motifs.

Also new was a delicate lace-work pattern which gave bowls the look of a coil-woven basket; an analogy that, as like as not, describes quite well how the vessels were made. Archaeological finds from various Greek and native Italic communities in southern Italy and Sicily (*Magna Graecia*)—most notably, five hoards of glass found at Canusium (modern Canosa di Puglia: see Map E.I)—illustrate that all this cast glassware was being traded extensively by the beginning of the 2nd century B.C.

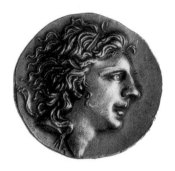

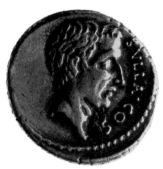

PLATE E.7

The Roman military movement eastward in the early 2nd century B.C. entailed the humbling of the Macedonians of Philip V and the Seleucids of Antiochos III. But peace was confirmed in the Eastern Mediterranean only in 63 B.C. after Mithridates VI of Pontus was defeated in turn by Sulla, Lucullus, and Pompey, and took his own life.

a. Mithridates VI fascinated the Romans for centuries after his death, because of a "prescription"—two dried walnuts, two figs and twenty leaves of rue, plus a pinch of salt—that reputedly was able to protect a fasting person against poisoning (see Pliny, Natural History *XXIII.149).*
silver tetradrachm (D., 3.4 cm)
Courtesy of the Trustees of the British Museum

b. Cornelius Sulla, a consul who took Rome by force in 88 B.C., was Mithridates' first adversary. He died early in 78 B.C., leaving behind a legacy of political bitterness that cast a deep shadow over the closing years of the Roman Republic.
silver denarius (D., 1.7 cm)
Courtesy of the Trustees of the British Museum

War after war, alliance upon alliance, gradually toppled each of Rome's competitors for power and carried its influence into almost every land surrounding the Mediterranean (Plate E.7) and over the Alps into Gaul. With the soldiers went the merchants and the traders. By the late 2nd century B.C. as much as a tenth of the land of southwestern Greece was owned by Romans and Italians, and Roman bankers on the Aegean island of Delos were handling over 10,000 transactions every day in the lucrative trading of slaves. It was these growing cultural contacts with the Hellenistic world that set the stage for what was to follow—a transformation of Roman involvement in the glassworking craft which moved from being minimal before the mid-1st century B.C. to dominating just a few decades later.

So we move forward to the middle decades of the 1st century B.C. when the newly emerging Roman World seemed bent on its own destruction. Sulla's retirement from public life in 79 B.C. had triggered a fresh round of political strife among Rome's leading families, while the countryside around was turned topsy-turvy by the slave revolt led by the Thracian gladiator, Spartacus. Piracy had become so rife that, at one point, raids on the Italian coastline reached all the way to the port of Ostia, so threatening Rome with starvation. It was now that the consul Pompey rose to power. It took him just eighty days in 67 B.C. to regain control of the high seas, and just another four years to overwhelm all of Anatolia and Syria, and capture Jerusalem.

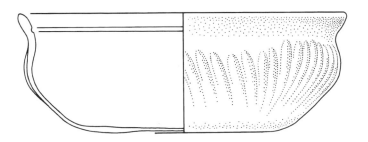

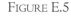

Ribbed bowl
Yellowish green
D. 14.8 cm (at rim)
Mid–1st century B.C.
From Kourion (modern St.
Hermogenes) in Cyprus: tomb 1
Excavated by George H. McFaddden
(1940)
63-1-117
Artwork by Jennifer Hook, MASCA

INSET

Close-up of part of the sidewall
(at magnification, 1.5x)

The irregularity of ribbing's spacing and
the soft definition of the ribs themselves
are features that are characteristic of the
earlier Hellenistic experimentation with
this vessel type (cf. Plate E.18, Inset).

PLATE E.8

This close-up of the famous Farnese
tazza illustrates well the natural banding
of color in sardonyx.
Courtesy of the National Museum, Naples

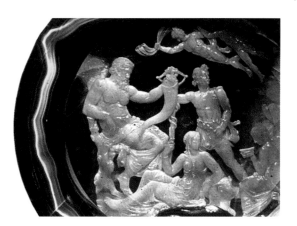

The Romans took control of this area of the Hellenistic world just at the time when its glass-working craft was passing through another phase of technical innovation. Among monochrome bowls, the shallow fluting that had been quite popular a century earlier had given way to a raised ribbing (Figure E.5); among mosaic vessels, the earlier composite cane and lacework patterns were augmented by new ones, among them one comprising lengths of monochrome and lacework canes laid side-by-side, so that they fused into a vividly striped design. Mosaic bowls now were stabilized by the addition of a base ring that was simply a coiled-up length of one of the vessel's body canes.

This was also the time when glassworkers experimented with blends of dark amber and white glass, to simulate the natural appearance of sardonyx (Plate E.8), a hardstone that would become fashionable among wealthy Romans during the first decades of the 1st century A.D. for elaborately carved bowls and drinking vessels at elite banquets (see Section E.4).

As for the core-form bottles produced during this period, we can detect that some changes in Hellenistic taste were taking place, as several of the traditional shapes of the previous couple of centuries now vanish from the repertoire. But we cannot infer that the new methods of glassworking

were eclipsing the old ones, since the public demand for two traditional kinds of core-formed vessel—the *alabastron* (Plate E.9) and the *amphoriskos* (Plate E.10)—was as strong as ever. They were always in demand by the Hellenistic cosmetics industry, whereas the mold-cast vessels satisfied the domestic market for tablewares. The only obvious intrusion of the new technology is expressed by the introduction of an elegant gold-banded alabastron (Plate E.11). Its multi-cane construction clearly places it in the sphere of the workshops already producing mosaic wares, but its color scheme and design puts it in the same market as core-formed bottles. All the signs we have indicate that, despite all the political upheaval surrounding it, glassworking in the Hellenistic lands of the Eastern Mediterranean during much of the first half of the 1st century B.C. was as healthy as it had ever been.

PLATE E.9

Tubular bottle (alabastron)
Core-formed, yellow threads
marvered into a blue ground
Ht., 12.6 cm
Early 1st century B.C.
Provenance unknown
Gift of Phoebe A. Hearst
(1897)
MS 2541

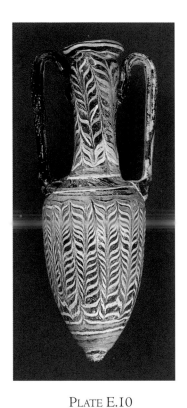

PLATE E.10

Two-handled bottle (amphoriskos)
Core-formed, white threads marvered into
a brown ground; amber handles
Ht., 15.8 cm
Early 1st century B.C.
Possibly from Aleppo in Syria
Purchased from Vestor and Co. (1913)

This bottle imitates in miniature the amphorae that were the
standard vessels for grain, wine, and oil transport from Rhodes
and the Aegean islands to every port in the Hellenistic World.
MS 5100

PLATE E.11

Tubular bottle (alabastron)
Core-formed: blue-green
ground, with gold-band
decoration layered into it
Ht., 19.0 cm
Early 1st century B.C.
Provenance unknown

This vessel's stopper is missing,
but other examples indicate that it also
would have been made of glass and
been designed to double as an
applicator for the cosmetic stored inside
(see Grose [1989: fig. 113]).
Courtesy of the Rijksmuseum van
Oudheden, Leiden

We often hear a conversation behind closed doors, of course because the voice can pass unhindered through tortuous passages in a substance, while images refuse: for they are split up, unless they have straight passages to swim through, such as those of glass through which every appearance will fly.

(Lucretius, *On the Nature of Things* IV.597)

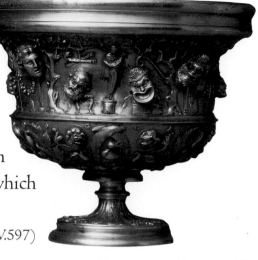

FRONTISPIECE F.3 see page 159

E.3

WATERSHED I:
THE EASTWARD ADVANCE

THUS FAR, EVERY ITEM OF GLASSWARE THAT I HAVE ILLUSTRATED HAS been of Hellenistic manufacture, not Roman. Yet these illustrations are essential to my story. It is only by having a good sense of Hellenistic shapes and decorations that we can recognize how influential they were as prototypes for all the important sectors of the Roman glass industry, and how much technical change that industry underwent during the Imperial era. So let us pause for a moment and anticipate to some extent the coming few decades, ones in which there would be a revolution in the glassworking craft, both in terms of its technologies and in terms of where it would find important niches in Roman daily life.

Though glass (*hyalos*) had long been part of the Hellenistic vocabulary, and its production in the Eastern Mediterranean was on the rise early in the 1st century B.C., there was as yet no Latin word for it in the Roman World, and it was playing only a minor role in Roman material culture.[5] In contrast, scarcely a century later, we have a snobbish dinner host comparing glass (*vitrum*) favorably to bronze: "You will forgive me if I say that I prefer glass; at least it doesn't smell. If it were not so breakable I should prefer it [even] to gold; as it is, it is so cheap." (Petronius, *Satyricon* 50).

We have reached a point where, even in the Hellenistic world, glass had lost much of its luxury status; it was becoming a common medium for tablewares, with a value moving towards that of pottery. The Roman involvement in glassworking would soon accelerate that trend.

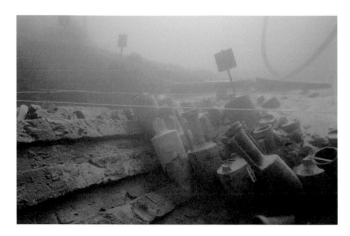

PLATE E.12

The ship that around 60 B.C. came to grief at La Madrague de Giens (near Toulon in southern France) was carrying fine wine from the Caecubum region of Campania (near modern Terracina). The cargo of some 7000 amphorae (equivalent to about 350 tons) was a large one for its time; a third of that was more typical (Liou and Pomey 1985; Parker 1992).

Courtesy of CNRS-Centre Camille Jullian, Aix-en-Provence: image 54/6

FIGURE E.6

Two of the cast glass vessels recovered from the early 1st century B.C. shipwreck at Antikythera:

a. Wing-handled cup (skyphos) (Ht., 17.5 cm: reconstructed)

b. Shallow bowl (D., 23.6 cm, at rim), decorated in relief alternately with a long petals and short bosses. On the underside, there is an eight-pointed star engraved within three concentric circles.

a.

The glassware from this shipwreck also included several mosaic bowls of each type—spiral cane, striped, and lacework—that Roman glassworkers were to adopt so avidly a few decades later (see Plates E.19, E.22, and E.23, respectively). Artwork by Veronica Socha, MASCA; after Weinberg (1992: entries 58 and 61)

b.

Now the Roman and Hellenistic trade networks gradually were blending together. As indeed it would be for centuries to come, that trade was dominated by shipments of grain, olive oil, wine, marble and other building materials (Plate E.12).[6] Glass was not, and never would be, a primary trade item in the ancient Mediterranean. Finds from a shipwreck near Antikythera in southwestern Greece, do show, however, that a load of glassware could easily move appreciable distances, by "piggybacking" on the main cargo of pottery amphorae and marble statuary (Figure E.6).[7]

Had Pompey maintained his grasp on the Republic, glassworking might have entered the Roman World rather sooner than it did.[8] As it was, just five years later in 58 B.C., his fortunes were in full reverse. There was a new force in Rome, one with towering political ambitions—Gaius Julius Caesar (Plate E.13), whose six-year campaign in Gaul brought all its tribes to heel so effectively and so ruthlessly that his rise in power at home was meteoric.[9]

I will return to these times at a later stage, to assess the impact of Caesar's conquest of Gaul on

PLATE E.13

Julius Caesar (100–44 B.C.) depicted on a the reverse of a gold aureus of Marcus Antonius minted in Gaul.

Though he was instrumental in the elevation of both Crassus and Pompey to consulship in 55 B.C., Caesar dominated the decision-making processes among the three leaders.[9]

When in 53 B.C. Crassus died at the battle of Carrhae in the Syrian desert, personal differences between Caesar and Pompey came to a head. Rome's political machinery, now with Pompey's complicity, was busy plotting Caesar's downfall in early 49 B.C. as he turned away from Gaul and led his army across the river Rubicon and back into Italy. Courtesy of the British Museum

MAP E.2

As with every part of the Empire, it was the network of roads on land and their inter-connection to major port cities that underpinned the commercial activities of Roman business in the Eastern Mediterranean. Artwork by Mary Ann Pouls, MASCA; after Cornell and Matthews (1982: 157)

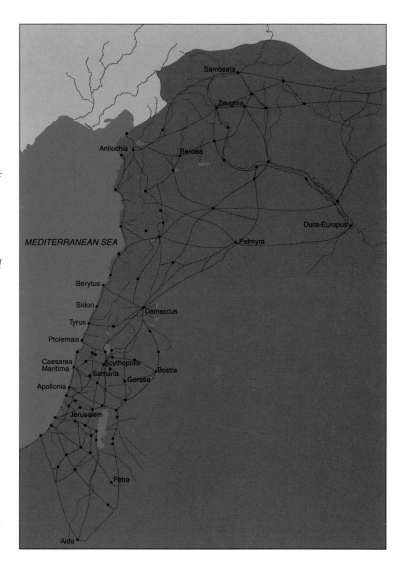

the overall growth of glassmaking and glassworking in western Europe (see Section E.9). It suffices to say here that, thirteen years and three civil wars later, Octavian—Caesar's adopted son and heir—was Rome's sole and undisputed ruler. His naval victory at Actium in 31 B.C., which had spurred the suicide of Anthony and Cleopatra, gave him Egypt. Thus Rome had complete control of the grain trade throughout the Mediterranean and, as importantly, unrestricted access to the traffic of oriental materials flowing into Alexandria via the Red Sea and the nearby Arabian peninsula. Rome's Eastern frontiers now stretched as far as the river Euphrates. In 27 B.C. Octavian accepted the title of Augustus, and though he was restrained in his response to other honors that might have implied he held dictatorial power, in effect he was now Rome's first emperor.

The new political stability afforded by the firm Roman presence in the Eastern Mediterranean had huge trade ramifications. Major roads such as the *Via Mare* that linked Antiochia in the north to Alexandria in the Nile Delta, could be improved and maintained (Map E.2). Merchants now could

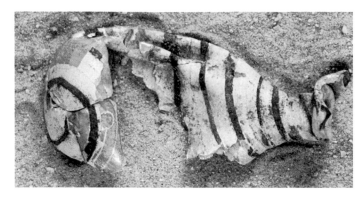

FIGURE E.7

THE STEPS OF INVENTION

The pinch-sealed glass tube

The hot, inflated bulb of glass

PLATE E.14

This blown bottle (Ht., approx. 8.3 cm) was discovered in 1971, just as we see it here, during excavations in the Jewish Quarter of the Jerusalem's Old City. It and the pieces of several similar bottles were mixed up with fragments of glass rods, tubes, partially blown bulbs, pottery, and coins that had become a refuse heap in an ancient disused bathing pool. The coins in the context date this accumulation of glassworking debris to the early decades of the 1st century B.C.
The body of this bottle was originally honey-colored and the parallel trails of glass wound round it were opaque white. Presumably it was discarded because of the way its sidewall sagged immediately after the decorative step was completed.
Courtesy of the Expedition for Archaeological Excavation in the Jewish Quarter of the Old City, Jerusalem: photograph by Mariana Salzberger.

work out of the well-established ports and inland cities of the area—among them Tarsus and Tyrus, Antiochia (modern Antakya) and Palmyra—with some feeling of security about their future. In turn, that stability fostered the growth of several crafts that was traditionally practiced within the region, providing them with easy access to more distant markets. In the case of glassworking, however, these events did more than just encourage a greater production level. They also set the stage for something which would revolutionize the craft—the invention of *glassblowing*.

Just how that invention came about is uncertain. Finds of glassworking debris from Jerusalem suggest that, sometime during the decades before Pompey's conquest of the region, there had been some crude experimentation with the sealing and inflation of one end of the kind of tubing that was normally used in bead-making (Plate E.14 and Figure E.7). There is no evidence that this way of manipulating glass gained any significant popularity among glassworkers as a means of producing small vessels. But the use of the tube as an air inlet device in such a direct manner has obvious parallels with the way that metalworkers of the day would force air into a furnace through a bellows tipped with a ceramic nozzle. If a glassworker added a long clay tube to such a nozzle, he had the kind of blowpipe that was to become the essential tool for glassblowing proper (see Plate A.1 in Appendix A). It was a tool that allowed the craftsman to gather a sizable chunk of hot glass from a small furnace and expand it into larger, sometimes more complex forms. With the invention of the blowpipe, glassblowing would soon sit alongside the then well-established methods of mold-casting, as the main Hellenistic contributions to the future of glassworking in the Roman World.

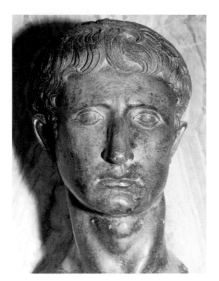

Considering it also of great importance to keep the people pure and unsullied by any taint of foreign or servile blood, he was more chary of conferring Roman citizenship.

(Suetonius, *Lives of the Caesars:* Augustus.3)

FRONTISPIECE F.4 see page 159

<center>E.4</center>

THE INFLUENCE OF AUGUSTUS

WOULD THE DISCOVERIES OF THE INFLATABILITY OF GLASS AND OF THE ceramic blowpipe have made it inevitable that glassblowing would attain its modern industrial potential? Almost certainly, since the elegant simplicity of the process would not have escaped the attention of the many technology-minded cultures that have followed the Romans over the past two millennia. Based on that argument, within the concept of a three-way tension underlying this essay, we would have the factor of *technical innovation* overwhelming those of *historical events* and *fashion and taste* in this part of glassworking's development. There is a timing of matters here, however, that requires us to think somewhat more broadly, if only because an "on-the-streets" availability of blown glass via its mass-production was delayed several decades after its invention.[10] We must recognize that, for the Roman people, Augustus' reign was a period of much-needed legal reforms and the restoration of traditional values. One consequence of this harking back to the past was an intensification of several craft activities throughout Italy. In essence, there was a concerted effort to make Italy (and thus Rome) much more self-sufficient.

PLATE E.15

This kind of cast glass dish with its angular rim and one-strand foot-ring, was available in several monochrome colors and a wide range of multi-colored mosaic patterns (among others, A–F illustrated here, at magnifications of about 4x):

Typical variations in rim form for these wares are illustrated in Grose (1982: 422). They were invariably cast with rim diameters of about 16 or 23 cm.

A 3rd century A.D. floor mosaic excavated at Antiochia in southeastern Turkey from what is now called the "House of the Buffet Supper" suggests that these dishes were all-purpose platters for a Roman antipasto course (gustum) (see Levi [1947: pl. XXIV]). Cups like those illustrated here in Plate E.16 were sometimes placed at the center of the platter, presumably containing an appropriate sauce or dressing. Artwork by Veronica Socha, MASCA

A. TMA 80.382 B. TMA 80.980 C. MS 5383A

D. TMA 80.375 E. TMA 80.372 F. MS 5399AA

So it was that glassworking took root in Rome itself, around the port of Puteoli (just south of modern Naples), and thereafter in a few cities in the north, including Aquileia on the Adriatic coast.[11] Several factors ensured the craft's rapid growth, not least that it was run by Roman entrepreneurs who had an understanding of the marketplace. They also ensured the skill of their labor force, by including in it many Syrian craftsmen who had been enslaved as part of the plunder during the wars in the East. Some of these craftsmen brought to Italy an experience in Hellenistic casting techniques; others, a knowledge of the less-sophisticated but more versatile technique of glassblowing.

What emerged in the first decades of the 1st century A.D. was a glassworking industry with a significant amount of product homogeneity. The most popular kinds of cast plates and cups tended to come in just two or three different sizes, and the choice of body and rim shapes was sufficiently limited as to suggest that some degree of standardization was being imposed (Plates E.15 and 16). The complex, angular rim on some of these vessels was a strong departure from the narrow-ledged rim or rimless finish of Hellenistic tablewares, and thus the start of a uniquely Roman tradition. The same distinct rim shapes are also to be found in the pottery cups of this time, both they and the glass ones illustrated here following a prevalent new taste in metal tableware (Plate E.17).

The colors of these tablewares were also novel, with emerald green and peacock blue being most common, followed distantly by dark blue and aquamarine. These color choices, like vessel form, seem to have been following some fashion trend that was not in effect for contemporary cast *ribbed* bowls, the latter tending to stay with the traditional

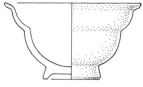

a.

A. MS 5383z

B. MS 5383w

C. TMA 80.315

PLATE E.16

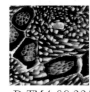
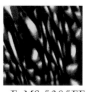

D. TMA 80.225

E. MS 5385EE

These three kinds of cast glass cup were available in several monochrome colors and in a wide range of multi-colored mosaic patterns (among them, A–J illustrated here, at magnifications of about 4x).

Typical variations in rim shape for these cups also are illustrated in Grose (1982: 423–426).

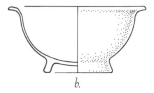

F. MS 5383c

G. MS 5383e

H. TMA 80.534

I. TMA 80.532

J. MS 5385DD

b.

These cups invariably were cast with rim diameters of about 9, 12, or 15 cm.
a. Cup with an angular rim
b. Cup with a simple, outsplayed rim (see also Plate A.14 in Appendix A)
c. Cup with a plain rim
Artwork by Jennifer Hook and Veronica Socha, MASCA

c.

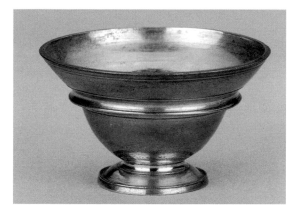

PLATE E.17

This silver cup (Ht., 4.5 cm) dates to about 20 B.C.–A.D. 10. Its angular rim form was very popular at that time, and much imitated by potterymakers and glassworkers (see Hayes [1970: fig. 17.5]; Grose [1988, pp. 421–426]: also Plate E.16 here).
Courtesy of the Trustees of the British Museum

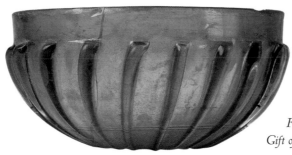

PLATE E.18

*Ribbed bowl decorated inside with
a pair of fine lathe-cut lines
Amber
D. 13.3 cm (at rim)
Early-to-mid-1st century* A.D.
*From Toscanella in Italy
Gift of Phoebe A. Hearst (1897)*

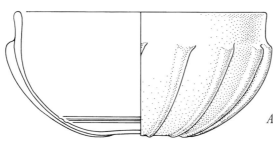

FIGURE E.8

*A modern reconstruction of how a
ribbed bowl of this kind might have
been made can be found in Stern and
Schlick-Nolte (1994).
MS 1506
Artwork by Jennifer Hook, MASCA*

palette of purple, dark blue, pale blue, golden brown, or olive green (Plate E.18).

The Italian glassworkers repeated these new forms of plates and cups in a casting of wares with distinctive opaque colors (e.g., powder blue, apple green, blood red, and opaque white: see Appendix A) and a whole new repertoire of mosaic patterns, many of which made their Hellenistic forerunners look quite coarse (Plate E.19). Sometimes just one cane pattern was used to make the entire vessel; other times, a couple of cane patterns were mixed together, along with simple bundles of single- or two-colored strands. Yet more pattern parts were created, as they had been for a couple of centuries past, simply by cutting such bundles along their axes instead of across them (Plate E.20: see also Plate E.6).

Ribbed bowls and cups also were produced in myriad of the mosaic patterns of composite canes (Plate E.21), though many others are patterned with just clusters of relatively heavy spiral motifs which seem to hark back to simpler Hellenistic designs (see Plate E.6). On occasion, it is clear that some of these items of tableware were created by the fusion of fragments from monochrome and mosaic-patterned vessels that presumably had been broken in household use and recycled back to the local glass workshops. This was truly the most colorful era of Roman glassworking's history and one to which even the many patterns and color combinations shown here do only partial justice.

The frequent use of lathe-cutting to produce a supplementary decoration of narrow bands of lines and grooves echoes the Hellenistic roots of this Roman glassware clearly enough (cf. Figure E.3 and Plate E.18, Inset), but the strongest line of continuity is to be found among the striped and lacework patterns that Roman glassworkers also included in their new repertoire of vessels. Overall, the arrangement of these patterns displays an almost seamless Hellenistic-to-Roman transfer, with only minor modifications in production methods and a predictable shift to Roman tastes in colors and shapes.

The most common new striped wares have a parallel-row pattern (Plate E.22). At first sight, this pattern creates the illusion of being a fusion of dozens of monochrome and lace-work canes. In

PLATE E.19

This is a fine example of the complex mosaic patterning by this cluster of canes in a cast flat dish of Augustan times (see also Plate E.15)

For an interesting discussion of the mosaic pattern variations that were possible through the admixture of different cane types, see Fünfschilling (1986: abbs. 2 and 3).
(magnification, 3x)
MS 5383B

PLATE E.20

Mixture of radially- and transverse-cut cane clusters (at a magnification of about 4x).
MS 3371B

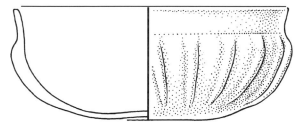

A. MS 5859 *B. MS 3869H*

PLATE E.21

Mosaic patterns for ribbed bowls and ribbed cups (A–D illustrated here, at magnifications of about 3x):
Artwork by Veronica Socha, MASCA; after Grose (1987: 417)

C. MS 3370Q *D. MS 5387u*

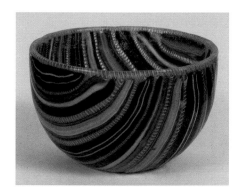

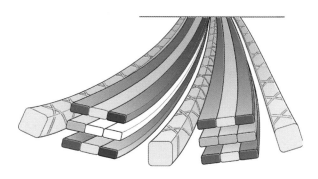

PLATE E.22

Hemispherical bowl
Striped mosaic (see Figure E.9)
Ht., 5.6 cm
Late 1st century B.C.–early 1st century A.D.
Provenance unknown

A modern reconstruction of how one of these vessels might have been cast and finished can be found in Stern and Schlick-Nolte (1994: fig. 118).
Toledo 68.87
Courtesy of the Toledo Museum of Art, Toledo

FIGURE E.9

CANE CONSTRUCTION FOR STRIPED MOSAIC WARES

The color scheme used here matches that of the bowl illustrated in Plate E.22, but this kind of layered construction of the canes was used for almost all Roman striped mosaic wares.
Artwork by Veronica Socha, MASCA: after Grose (1983: 42)

PLATE E.23

This close-up (at a magnification of about 3x) shows how lacework canes were used in the patterning of a cast hemispherical bowl. Note how the canes themselves contain a pair of white spirals that alternate along the length of the cane.

To create a lacework pattern, the glassworker would first wrap one or more monochrome canes (invariably white or yellow) onto a cone of colorless glass and roll them flush to the cone's surface. By rotating the cone while the thread was being drawn, the colored canes would form a single or double spiral (see Stern and Schlick-Nolte [1994: figs. 72 and 73]; and Grose [1983: 42]).

These lacework canes also were used to finish the rim of all kinds of Roman mosaic bowls (see Plate E.22).

MS 5389A

reality, however, each cane is composed of two or three color strips—some translucent, some opaque—each themselves comprising three thin laminated layers (Figure E.9). Although it does seem to enhance the brightness of the colors in these vessels, the reason for this rather fussy technology is now obscure. Some of the patterns used to create entire vessels—rod bundles and lacework canes, among them (Plate E.23)—also occur as components of striped mosaic patterns. This suggests that all these wares were made in the same place or at least came under the same administrative umbrella.

While two of our influential tension factors—*historical events* (in the Augustan policies for the concentration of crafts in Italy) and *technical innovation* (as better control of casting processes and a sophistication in cane construction)—clearly were influential in the development of all mosaic wares, the factor *fashion and taste* was central to the surge in the popularity of those known as *onyx-wares*. The goal was as simple as it had been in Hellenistic times—to simulate the swirling, natural banding in the various kinds of sardonyx then being so skillfully carved into luxurious vessels for the Roman elite (Plate E.24).[12] Dependent upon the production technique, the result in glass was either a "marbling" effect which was achieved by

layering thin ribbons of white glass onto a dark brown or amber base, or a "swirling" effect which came from the fusing together of large slices from a thick rod that had the onyx pattern already defined within it (Figure E.10 and Plate E.25). In either case, the pattern distortion created by the addition of ribs on the outside of these bowls often simulated the natural variations of this hardstone's texture very well (Plate E.26). The uniformity of shape and size of onyx-ware bowls suggests that they were all the product of a single Italian workshop (or a closely knit group of them), while archaeological evidence indicates that the fashion for them was short-lived, lying within just the reigns of Augustus and Tiberius, i.e., lasting only until about A.D. 35.

During the span of these same two reigns, the production of glass, both cast and free-blown, grew so swiftly in and around Rome that one ancient scholar observed: ". . . a [glass] drinking cup could be bought for a copper coin." (Strabo, *Geography* XVI.2). As a consequence, there was a sharp decline in production of the equivalent thin-walled cup in pottery that had been in vogue for a previous century and a half (Figure E.11). At the same time, the usual suite of pottery vessels that stored the offerings to a deceased relative in his or her burial now had mixed among them various kinds of

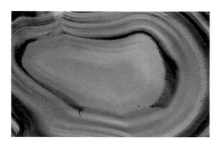

PLATE E.24

SARDONYX

A slice of the hardstone, backlit to show its natural banding. Pliny (Natural History XXXVII.86) describes true sardonyx as a stone with a layer of carnelian (clear red chalcedony) resting on a layer of white ". . . like flesh superimposed on a human finger nail (sarda), both parts of the stone being translucent." But there were other, less expensive forms of onyx around then, including one banded with red jasper and one banded with a reddish-brown chalcedony which we call "sard" today.
From Carolina Biological Supply Co., Burlington, NC: GEO 4643A

PLATE E.25

Deep ribbed bowl
Cast; swirling, sardonyx-like patterning
D. 9.7 cm (at rim)
Late 1st century B.C.–early 1st century A.D.

This vessel seems to have been constructed from just three slices of a large "jelly-roll"-like rod comprising about half a dozen thin layers of white glass interleaved with as many, but thicker dark brown ones (see Figure E.10; also Grose [1987: fig. 125]).
Courtesy of the Kunsthistorisches Museum, Vienna

FIGURE E.10

CREATING AN "ONYX-WARE" BOWL

Step 1: *Sheets of brown and white glass are fused together into a large cylinder. This is then sliced up, to produce a number of discs of similar thickness and onyx-like patterning.*

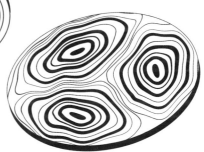

Step 2:
Some of the discs are melted together to form a single pancake-like sheet. This sheet is then re-heated and slumped over a mold of the bowl's shape (cf. Plate E.5).
Artwork by Veronica Socha, MASCA

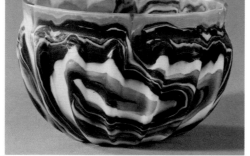

PLATE E.26

Close-ups of three back-lit sherds of "onyx-ware" (A–C, at magnifications of about 3x) give us some sense of how well the glassworkers mimicked the brilliant optical effects of expensive sardonyx vessels. The purple streaking in sherd C is interesting in that it matches the appearance of certain kinds of banded hardstones that Pliny (Natural History XXXVII.87) described as having "usurped" true sardonyx by his time.

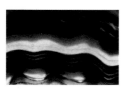

A. MS 5386vv

B. MS 3370R

C. MS 5386yy

INSET

A typical example of a Roman ribbed and footed "onyx-ware" bowl of the early 1st century A.D.
Artwork by Veronica Socha, MASCA: after Grose (1987: fig. 122)

glass *unguentaria*—free-blown globular or tubular flasks (Plates E.27 and E.28) that contained the perfumed oils and lotions which were so socially important in the Roman World of the living. Larger flasks of this kind were used more and more around Roman homes as storage vessels alongside their pottery counterparts.

The quality of finish of cast tablewares was far higher than that of the vast majority of this first wave of free-blown items. In fact, asymmetry in the shape of so many small unguentaria indicates how they were produced in short order, the bulb of the body beginning to droop down just as the neck was being sheared away from the blow-pipe. The rhythm of blow/shear, blow/shear, . . . must have

made this work remarkably monotonous. Such rapidity of production was the key, however, to why the Roman glassworking industry now embraced free-blowing as its core technology. As the range and quality of free-blown products increased, the demise of glass-casting was swift: its only significant usage after the middle of the 1st century A.D. was in the production of fine, colorless tablewares. Within the space of just the four decades or so that enfolded the reign of Augustus, glass-working had undergone what can only be described as an industrial revolution, and glass had truly "arrived" as a practical alternative to pottery in many parts of Rome's huge domestic marketplace.

Figure E.11

This thin-walled pottery beaker (Ht., 13.9 cm) dates to the third quarter if the 1st century B.C. and comes from Cosa (near modern Orbetello), about 110 km northwest of Rome. This is one of the first kinds of vessels that glassworkers copied from the domestic repertoire of their potterymaking counterparts during the early part of the Augustan era. Artwork by Veronica Socha: after Moevs (1973: entry 24)

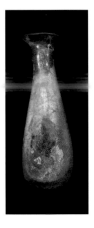

Plate E.27

Unguentarium
Pale green, heavily weathered
Ht., 7.7 cm
Late 1st century B.C.—mid—1st century A.D.
Probably from Carthage in Tunisia
Gift of Margaret Wasserman Levy (1991)
91-26-12

Plate E.28

Unguentarium
Pale green
Ht., 9.0 cm
Early to mid—1st century A.D.
Provenance unknown
Gift of Charles A. Jayne (1932)
32-35-14

Lest the orchard from Cilicia
lose color in dread of winter
and the brisker air bite the
tender grove, transparent panes
facing the wintry south winds
admit clear suns and
unadulterated daylight.

(Martial, *Epigrams* VIII.14)

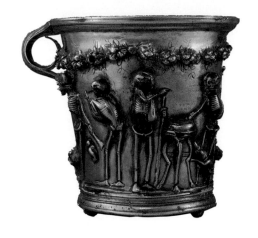

FRONTISPIECE F.5 see page 159

E.5

THE AGE OF EXTRAVAGANCE

I T IS SAID THAT AUGUSTUS LIVED A SIMPLE, AUSTERE LIFE. AT HIS DEATH IN A.D. 14, he left behind him an Empire that was economically sound and a political system that was no longer dominated by the military. But he was followed by three emperors of quite different character, each driven emotionally either by bitterness or greed, sometimes both. Tiberius and Gaius (self-styled as Caligula) in turn instituted reigns of terror, that of the latter leading to his assassination in A.D. 41. And, after a brief respite under Claudius, came the excesses of Nero who in A.D. 59 set the tone for his reign by murdering his own mother (Plate E.29).

In hindsight, it is difficult to grasp the sheer scale of the extravagance of these times. Nero mounted several remarkable public spectacles that found favor with the people of Rome, but they also brought the Imperial treasury close to bankruptcy. Nor did his private excesses help much in that regard:

> Good authorities declare that Arabia does not produce so large a quantity of perfumes in a year's output as was burned by the emperor Nero in a day at the obsequies of his consort Poppaea.
>
> (Pliny, *Natural History* XII.83)[13]

PLATE E.29

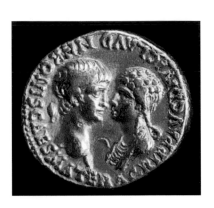

Young Nero and his mother Agrippina
gold aureus (D., 1.8 cm)
Agrippina's poisoning of her husband Claudius in A.D. 54 enabled her son to
become emperor at the tender age of 16 years. The depiction of them together hints at
her expectation that she would wield ultimate power in the Roman State. Nero did
not share that view of matters and contrived several complex plans to have her
murdered (see Suetonius, Lives of The Caesars: *Nero.34). When those all*
failed, he resorted to laying false evidence that she was plotting to murder him!
Courtesy of the Trustees of the British Museum

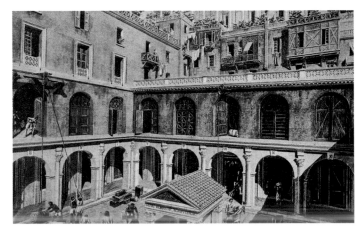

PLATE E.30

*Apartment blocks (*insulae*) were the standard unit of housing for Roman urban dwelling.*
In Rome itself, they crowded in upon, and usually towered over all the city's fine administrative
buildings, temples, and fora (Reynolds 1997). This reconstruction illustrates how they were
sometimes blended in with a warehouse—in this instance, the Horrea Aggripiana—probably as
homes for some of the vendors who had a shop at the ground level (from Gatteschi [1924: pl. 19]).
The upper sections of these buildings were invariably built of wood and mud brick, and so were
notoriously unstable and prone to destruction by fire.[14]

What the emperor did, the court circle around him was sure to imitate, as long as it was in keeping with traditional Roman funerary practice. Thus:

> Then reckon up the vast number of funerals celebrated yearly throughout the entire world, and the perfumes such as are given to the gods a grain at a time, that are piled up in heaps to the honor of dead bodies! . . .
>
> (Pliny, *Natural History* XII.83)

Similarly it is said that Nero's early tutor, Seneca, had a set of 500 identical tables made from Mauretanian citrus wood placed on legs of Ethiopian ivory, both materials being luxuries that ranked alongside gold (see Endnote 25). Gluttony in banquetry, the lavish use of perfumed oils in everyday social activities, the heavy burning of incense in the daily rituals and at funerals, and the constant search for new pleasures—all these things were a norm for Roman high society.

It is scarcely surprising then that the extraordinary wealth of Rome was an irresistible attraction for so many of the Empire's peoples. They

FIGURE E.12

Wide-mouthed, square-sided jars like this one from Herculaneum (Ht., 12.8 cm: capacity about 0.7 liters) were used in the Campanian countryside to store pickled olives and various culinary herbs—black lovage, capers, rue, fennel, etc.,—in preparation for their shipment northward to the marketplaces of Rome (see Columella, On Agriculture *XII.6). See also Follmann-Shulz (1988: item 94), for one of these jars with a "signed" base similar to those often found on large bottles at this time.*
Artwork by Veronica Socha, MASCA: after Scatozza-Höricht (1995: plate XXXVIII)

PLATE E.31

*Fennel (*Foeniculum vulgare*)*
*This herb's unopened flower and stalk would be preserved in brine and vinegar, then taken out just a few sprigs at a time and dried to become a flavorsome garnish for a fish dish. Freshly pickled fennel spiced with pepper is a popular side-dish (*cartucci*) in Italy today (Grieve 1971).*
Courtesy of Anthony Cooper

crowded into the squalid apartment blocks that lined the city's inner streets (Plate E.30); they filled its straggling suburbs to overflowing, swelling the city's population to well over half a million. Dozens of other Italian cities suffered the same fate. This explosion of the Italian population meant that, by the mid-1st century A.D. the domestic demand for glassware was huge. The cost of glass fell so sharply that broken glass (*vitrea fracta*) was used proverbially to mean "rubbish."

Besides the obvious things like wines and oils, so much of what flowed into Rome from near or afar needed some kind of container. Squat, square-sided jars of both pottery and glass were used to store and ship all kinds of produce from the farms of Campania to Rome's warehouses and marketplaces (Figure E.12 and Plate E.31).[15] Culinary spices were stored dry in smaller jars, as were the herbs, local or oriental, that would become ingredients for the perfumed oils and lotions, and then be stored in an increasingly diverse range of unguentaria.

Similar vessels were used to store everyday medicines—sting balms, cough mixtures, and so on—and, I imagine, some of the more exotic oriental ones which became fashionable after one of Nero's army surgeons, Pedacius Dioscorides, pub-

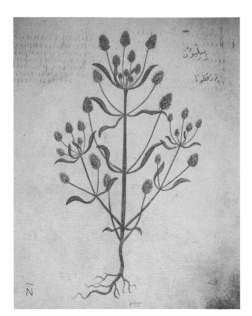

PLATE E.32

The manuscript leaf from a 5th century A.D. *version of Dioscorides'* De Materia Medica *depicts Psyllium* (Plantago psyllium). *It takes its name from* psylla, *the Greek for a flea, as an allusion to the appearance of its seed. The oil extract from the seed now is used medically to treat severe diarrhoea and cosmetically as an eye lotion and for skin-cleansing as an ingredient for a face mask. In Dioscorides' times it was used as a lotion (mixed with vinegar and rose oil) to treat a headache, and as a liniment that would combat inflammation (see Pliny,* Natural History *XXV.90).*
Courtesy of the Österreichische Nationalbibliothek

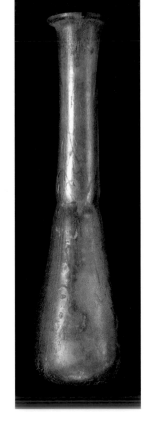

PLATE E.33

Unguentarium
Pale green
Ht., 11.2 cm
Early–mid–1st century A.D.
Provenance unknown
Gift of Mrs. James Mapes
Dodge (1949)

PLATE E.34

Ointment pot
Light green
Ht., 3.6 cm
1st century A.D. *or later*
From Beth Shean in Israel:
Northern Cemetery, tomb 91
Excavated by Gerald M.
Fitzgerald (1926)
29-105-722

This vessel has a direct parallel in a physician's grave at Cologne (Künzl [1983: Germ. Inf. 4]).
49-6-4

lished his illustrated treatise, *De Materia Medica*, on the folklore of herbs in foreign lands (Plates E.32 and E.33). Many of these cosmetics and medicinal lotions were applied by finger-tip out of a certain kind of ointment pot (Plate E.34) which, perhaps because it was so easily made, was to remain in the Roman glassworkers' repertoire for at least another three centuries.

Glassworkers continued to adapt their skills and to find new outlets for their products. For example, the traditional materials used for the construction of wall and vault mosaics in artificial grottoes (*nymphaea*) and fountain houses—shells, stone chips, and pieces of the opaque pigment Egyptian blue—in Augustan times were supplemented by sherds of broken colored glass and twisted glass rods. A couple of decades later, small glass tiles (*tesserae*), mostly yellow or green, were being used extensively alongside the Egyptian blue to produce mosaics of mythical scenes and a whole range of floral or geometric panels and borders (Plate E.35). Huge amounts of glass tesserae—mostly various shades of blue and green, but also opaque white—were included in the dome over the dining-room of Nero's opulent Golden House that, according to one mid-2nd century A.D. historian, "... revolved slowly day and night, in time with the sky." (Suetonius, *Lives of the Caesars:* Nero.31)[16]

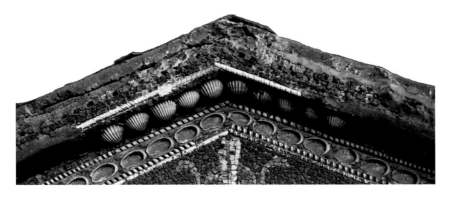

PLATE E.35

This panel forms part of the cornice of an elaborate fountain in the courtyard of the Casa del Granduca at Pompeii. The central motif of an acanthus plant is made up of green and yellow glass tessarae laid into a ground of Egyptian blue pellets. Variously colored twisted glass rods and rows of shells are used to frame out this decoration (see Sear 1977: also Plate A.16 in Appendix A).
Courtesy of Frank Sear, University of Melbourne

PLATE E.36

Cameo plaque depicting the head of a man
Dark blue ground, with white overlay
Ht., 2.5 cm
Early-mid-1st century A.D.
Provenance unknown
From the Maxwell Sommerville gem collection
29-128-1138

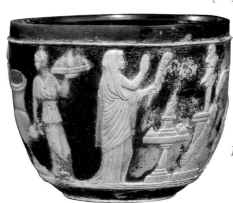

PLATE E.37

The kind of classical imagery depicted on this cup (Ht., 6.2 cm)—in this instance, a ceremony associated with the Bacchic cult—is common among cameo designs and is thought to imitate contemporary reliefs carved in the expensive hardstone, onyx (see Harden [1987: 53-91]).
Courtesy of the Corning Museum of Glass, Corning, N.Y.

The concept of a *cameo*, which traditionally was made by carving a relief decoration out of agate or sardonyx in a way that exploited the natural layering of these stones, now became part of the glassworker's repertoire as well. The kind of flat, Wedgewood-like cameo that became popular wall plaques and gemstones was quite easily made (Plate E.36). A blank was prepared by the fusion of two separately cast sheets of glass, usually white-on-blue. Then, all the surplus glass in the overlying layer was carved out from around the out-line of the decorative scene, so exposing the underlying layer as a background.

The production process for cups and bottles in cameo glass was somewhat different. A mass of the background color was gathered up at the end of a blow-pipe and dipped into a crucible of the molten glass for the overlay. This two-layered mass, again usually white-on-blue, was then blown to the required shape and size, and the decorative scene carved out on the expanded vessel's surface (Plate E.37). The scenes on these vessels often feature ear-

lier Greek myths, and assuredly drew their inspiration from contemporary silverware and hardstone carvings with equally elaborate relief designs.[17]

Among the more mundane developments in glassworking of these times was the production of the first window panes. Which is not to say that soon thereafter every Roman house was a well-sheltered environment, insulated from the cold of winter and the street odors of summer. Most of these panes, being cast slabs that were thick and so not overly transparent, were made for Roman bathhouses—a careful balance between a good sealing against heat loss and a source of at least some natural light.[18] The household use of window glass was quite sparing; perhaps for a screen in a bedroom alcove, while the windows everywhere else were shielded by hanging cloths or skins. The use of pane glass may well have extended beyond the usual household purpose of excluding the elements, to a greenhouse-like protection of certain special crops. Thus, early spring buds of the saffron crocus were shielded in this way, since they were a key ingredient in several of Rome's most fashionable scents (Plate E.38)—see the quotation at the head of this Section—and the early flowering of vines at prestigious wineries may also have rated such care.[19]

PLATE E.38

The manuscript leaf from a 5th century A.D. version of Dioscorides' De Materia Medica depicts Saffron (Crocus sativus).

According to Martial (Epigrams IX.38 and XI.8), the petals of the saffron crocus were used to scent a fine mist of water which was sprayed over both the stage and the audience during theater performances in Rome on some hot summer evenings. His poetic allusion to this luxurious spray as "the Corycian shower" matches a more down-to-earth observation by Pliny (Natural History XXI.31) that the most essence-rich petals of this flower came from Mount Corycus in the province of Cilicia.

Courtesy of the Österreichische Nationalbibliothek, Vienna

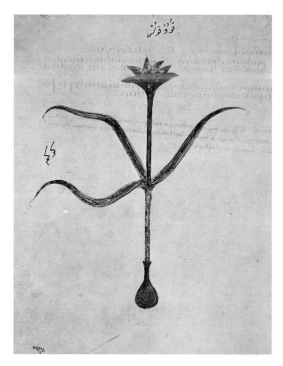

The workman cut the glass and brought it. He put the lump, hard as iron, into the fire, and the glass, set ablaze by the all-devouring flames, ran out, melted like wax.

(Mesomedes, *The Palatine Anthology* XVI.323)

FRONTISPIECE F.6 see page 159

E.6

THE INDUSTRY TAKES SHAPE

DURING THE DECADES OF POLITICAL UNCERTAINTY THAT FOLLOWED THE death of Augustus, glassworking changed its complexion in many important ways. For one thing, we can be fairly sure that by the middle of the 1st century A.D. the clay blow-pipe was a thing of the past, replaced by a more robust and probably much longer one made of iron. Now the Roman glassworker could gather up a quite sizable amount of hot glass, blow it into almost any basic shape, and then extend that shape in many different ways, simply by rotating and swinging the blow-pipe as the glass began to cool. Nature's centrifugal force did the crucial work here, ensuring elongation of a vessel's body as the verve of the glassblower's swing encouraged it. The simplest of tools—various pairs of tongs with different nose-shapes, a flat wooden paddle, trimming shears, etc.—allowed for extra shaping such as the crimping of a bottle's neck and the shaping of its base, or

FIGURE E.13

Wine beaker (Ht., 8.1 cm)
From Adana in ancient Cilicia
(modern southern Turkey)
Bölge Museum 849

The set of ribs is pinched out of the bulb before it is
fully inflated. It is easiest to pinch the glass around the far
end of the bubble because that is where the glass is thickest.
The same technique can be used to create raised ribbing
anywhere on the body (see Plate E.44).
Artwork by Veronica Socha, MASCA: after Stern
(1989: fig. 10)

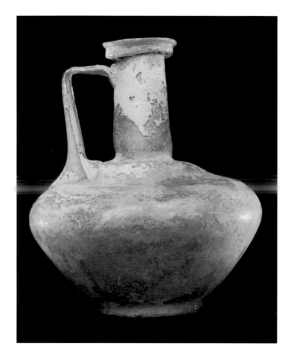

PLATE E.40

Bulbous flagon, with a strap handle
Pale green
Ht., 19.5 cm
Mid-1st century A.D.
Provenance unknown
Gift of Mrs. Earl Ford (1963)

This vessel is an imitation of early pottery flagons
from mainland Italy which in turn imitated Hellenistic
pottery and metal prototypes (see Weinberg 1965).
63-26-3

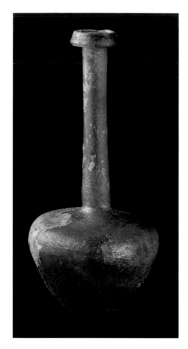

PLATE E.39

Bulbous-bodied bottle decorated
with four sets of lathe-cut lines
Yellowish green
Ht., 17.5 cm
Second half of the 1st century A.D.
Provenance unknown
Gift of George and Henry J. Vaux
(1986)

The long neck of this vessel suggests
that it was used to store perfumed oil
in the same way as the smaller
unguentaria of the day.
86-35-100

PLATE E.41

Small bottle
Amber with an overlying white
spiral decoration
Ht., 6.2 cm
Second half of the 1st century A.D.
Possibly from Nazareth in Israel
Purchased from Vestor and Co.
(1913)
MS 4929

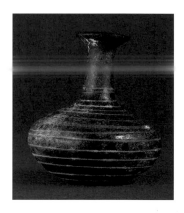

PLATE E.42

This kind of globular pottery bottle
(Ht., 13.6 cm) was the model for
similar ones in glass that were
produced in great numbers during the
mid-1st century A.D. By the end of
that century, however, the glass version's
popularity was far outstripping that of
its pottery prototype.
From Beth Shean in Israel: Northern
Cemetery, tomb 222
Excavated by Gerald M. Fitzgerald
(1926)
29-102-631

FIGURE E.14

The decorative thread usually was applied to a partially inflated glass bulb before the latter was re-heated and inflated to its full extent as the vessel's body. This means of decoration was used on a wide range of cosmetics-related vessels at this time (see Plate E.41 here; also Fleming [1996: figs. 15 and 19]).
Artwork by Veronica Socha, MASCA

FIGURE E.15

a. This free-blown dish (D., 14.7 cm at rim), which dates to around A.D. 45, was found during excavations of the Atrium Publicum at Cosa (near modern Orbetello) on the west coast of Italy. It is somewhat unusual in that its base was created from a second bulb of blown glass; a true ring base (as a thick glass thread) or a solid base were more common. The tubular rim on this dish should be contrasted with the angular one on the cast mosaic platter illustrated earlier in Plate E.15.

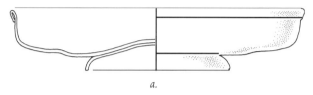

a.

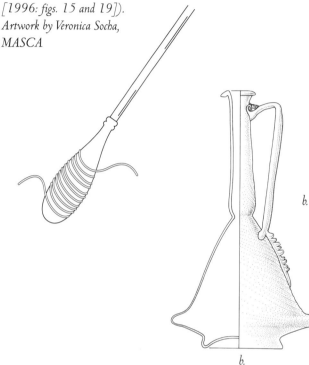

b.

b. This bell-shaped jug (Ht., 26.1 cm) was produced by what now is called optic-blowing. *A glass bulb was first partially inflated inside a cylindrical mold which had a series of grooves cut into it. The now-ribbed bulb was reheated and twirled as it was blown to the full size of the vessel's body, so that the ribbing was stretched to a softer outline (see also Sections E.17 and E.21 for 4th and 6th century A.D. examples of this kind of glassworking.)*
Artwork by Veronica Socha, MASCA: after Grose (1977: fig. 3c) and Harden (1987: entry 69)

the indentation or ribbing of a beaker's sidewall (Figure E.13). If the glassware included as grave goods in the middle decades of the 1st century A.D. burials are a reasonable indication of popularity of vessel types in the real world, then small unguentaria and wine beakers were still very much the glassworker's stock-in-trade. It is clear, however, that the industry was producing a new range of vessels that became larger and/or more diverse in shape and decoration as the century wore on (Plates E.39–E.41; also Figures E.14 and E.15).

The key for many of the changes in the glassworkers' repertoire at this point was a simple fact—that casting could be used only for vessels with an open form—platters, bowls and cups—whereas free-blowing could be used both for those

and for vessels with a closed form—for the kind of narrow-necked jugs and bottles and food storage jars, square-sided and globular, that previously had been the marketplace prerogative of potterymakers (Plate E.42). The cast, angular-rimmed cups which had been so popular during the Augustan era all but vanished just a few decades later, supplanted by free-blown equivalents with tubular, folded or solid rims just like those being used everywhere else among free-blown bottles and unguentaria (Plate E.43 and Figure E.16). Free-blowing would not have been compatible with the composite cane technology that was required for making mosaic wares, at least not for the production of any sizable vessel, so the new tablewares lack that colorful aspect of their cast predecessors. Some of the

a. MS 4995

b. MS 5002

c. 86-35-77

d. 86-35-78

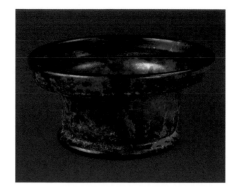

PLATE E.43

Free-blown cup, with a folded-back, ledged rim
Dark blue
Ht., 3.8 cm
Mid-1st century A.D.
Probably from Aleppo in Syria
Purchased from Vestor and Co.
(1913)
MS 4995

FIGURE E.16A

Four common kinds of mid-1st century A.D. cups, all free-blown but with different tubular rim finishes (with colors as shown in the color strip Inset):

On the base all of these cups have the feature that is diagnostic of them having been free-blown—remnants of the globule of glass that was used to join the vessel to a pontil rod while the glassworker heated and shaped the rim. The "pontil scar" is particularly pronounced on the base of cup b here.
Artwork by Veronica Socha, MASCA

FIGURE E.16B

The rims of the glass cups of Figure E.16a obviously were folded and crimped in ways that were intended to imitate the profile created by mold-casting on contemporary pottery cups of the kind shown here (see also Barnett and Mendelson [1975]):

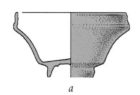

a

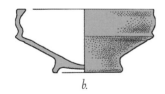

b.

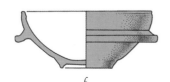

c

a. From Beth Shean in Israel (called Eastern sigillata A ware)
29-102-546
b. From Beth Shean in Israel (called Eastern sigillata A ware)
29-102-549
c. From the Fayoum region of Egypt
Hayes 22.12
Artwork by Veronica Socha, MASCA: after Hayes (1997)

stronger monochrome colors of cast wares—particularly dark blue and dark green—were retained, however, among their free-blown counterparts.

The glassworkers of northern Italy used the robustness of the iron blow-pipe to particularly good effect during the second quarter of the 1st century A.D. to produce a range of small, colorful bowls with a distinctive pinched-rib finish (Plate E.44). These were made by gathering up some of the ground color—usually amber or purple—and winding about it several threads of white glass (see Figure E.14). A reheating of this mass softened it so that, as it was rolled on a flat wooden slab, the white glass was pressed flush (*marvered*) into the surface. This now two-color gather was then blown into a globular shape, its lower sidewall modified with square-nosed pliers and its upper body cut to form the bowl's rim.

A similar technique was used to create polychrome two-handled jars, except that the initial gather was partially blown before it was rolled in a heap of colored glass chips. Subsequent marvering then smeared out the decorative colors and completion of the blowing process stretched those colors into a host of flowing patterns.[20] The pinched-rib bowls were exported the length and breadth of the Empire, while polychrome jars seem to have found strong favor only in the Western provinces. The production of both of these vessel types declined rapidly before the end of the century, however, as the balance of trade shifted in northern Italy and it became a net importer of finished goods.

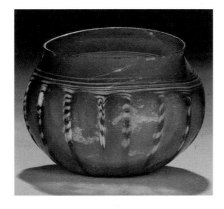

PLATE E.44

Pinch-ribbed bowl
Amber, with white threads
marvered into the surface
Ht., 6.5 cm
Mid-to-late 1st century A.D.
From Vaison in France

The geographic distribution of find-spots for this vessel form in the Empire is from Spain to the Black Sea, a high concentration of them occurring in northern Italy (Haevernick 1967).
Courtesy of the Trustees of the British Museum

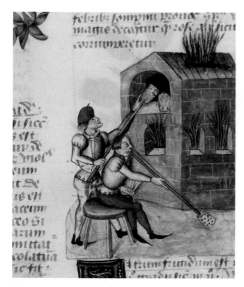

FRONTISPIECE F.7 see page 159

Suppose, for example, that a wise man is exceedingly fleet of foot; he will outstrip all the runners in the race by virtue of being fleet, not by virtue of his wisdom. I should like to show Posidonius some glassblower who, by his breath, molds the glass into many shapes which scarcely could be fashioned by the most skillful hand. No, these discoveries have been made since we men have ceased to discover wisdom.

(Seneca, *Moral Letters to Lucilium* XC.31)

E.7

DECORATIVE MOLD-BLOWING

I HAVE COMMENTED REPEATEDLY THAT THE MARKET PRESSURES FOR innovation in glassworking came from changes that were going on in the sister industry of potterymaking. Already, I have spelt out that idea in connection with the introduction of mold-casting in the Hellenistic world around the mid-3rd century B.C., and thereafter focused on how the mold-casting and the free-blowing of glass took the various directions they did in Augustan times (see Plates E.15, E.16, and E.21; and Figure E.16). By then, however, long-established Roman potterymaking centers in northern Italy had increased their scale of operations dramatically and were mass-producing a quite new range of mold-cast plates, bowls and cups with a distinctive red gloss finish and bands of floral motifs and fluting that mimicked well the current tastes for relief design on silverware. The carved surface of a cameo glass also could simulate these designs (see Plate E.37), but each item would be a unique product. The broader response from the Roman glassworking industry was the development of mold-blowing, i.e., the inflation of a hot bulb of glass within the confines of a pre-prepared container, the inside of which had carved into it the patterns that would eventually appear as a raised decoration on the finished vessel.

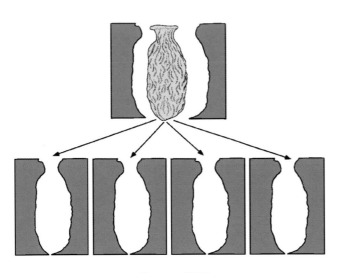

Small date-shaped flask
Dark brown
Ht., 7.6 cm
Mid 1st–early 2nd century A.D.
Probably from Aleppo in Syria
Purchased from Vestor and Co.
(1913)
MS 5112

INSET

Profile and base showing
the mold-seams
Artwork by Jennifer Hook,
MASCA

FIGURE E.17

Replication of clay molds by repeated casting from a
plaster model which has the shape of the final glass vessel
(in this instance, a date-shaped flask: see Plate E.45).
Graphic by William Fitts, MASCA

Simple though this innovation might sound, it was fraught with some interesting technical limitations that may explain why it was introduced only several decades after free-blowing first made its industrial mark. As I have already discussed, a potterymaker could use a one-piece mold for any open form of vessel, because the decoration was taken up on an unfired clay surface that, as it gradually dried out, would shrink quite a lot and so would free itself from the mold of its own accord (see Figure E.2). A glassworker could not copy that technology, except for the simplest of forms and decorations. As he blew the hot glass into the mold cavity, it would be forced against the the outline of the mold's pattern: the glass would tend to pool and thicken in some recesses of the mold. Thereafter, the glass vessel, when cold and rigid, would be locked in place at various points around the mold's surface. Of course, if the vessel was to have a *closed* form, the dilemma of how to remove the vessel from the mold changed from problematic to impossible.

Too much time and effort would have to be invested in preparing any kind of mold for it to be cracked open and discarded after just one use. The glassworker's solution was to use a mold with two or more parts, each of which could be drawn *away* from the glass after each use, then bound together again for the next one. Some of these multi-part molds may have been made of hard-wearing stone or sheet bronze, in which case they were produced individually. Most of them, however, were of clay and created in quantity, as secondary castings from a pre-sculpted model of fired plaster, pottery, wax, or wood, in much the same way as molds were prepared for mass production of pottery lamps (Figure E.17).[21] However the mold was created, the fact that it was used, and how, is usually quite obvious to us today. Blowing the glass will have driven some of it into the joins between those mold's parts, so creating raised vertical seams on the vessel's body wall and ridges across its base (Plate E.45).

PLATE E.46

The decoration of this two-handled cup (Ht., 6.0 cm) from the workshop of Ennion, with ivy and vine sprays on the body and fluting on the base, would appear to have drawn its inspiration from contemporary tastes in Roman silverware (Oliver [1977: entry 82]). The range of vessels associated with Ennion, not all of which bear his name in their decoration, are discussed in detail by Israeli (1983) and Price (1991).
Courtesy of the Corning Museum of Glass, Corning, N.Y.

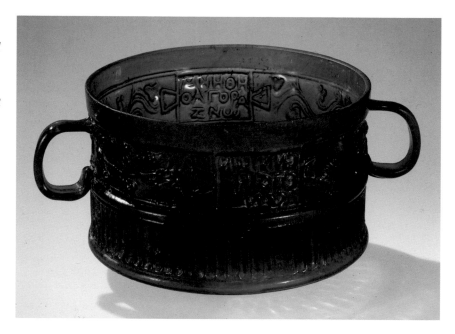

We also have a reasonably good idea *when* this new technology was introduced. A beaker from Cosa on the western coast of Italy, that has a mold seam hidden amid its band of palm branches and a fragment of the motto ΜΝΗΘΗ Ο ΑΤΟΡΑΖΝΩ ("Let the buyer be remembered") on it has been dated close to A.D. 40–45. Contexts of similar date at various places in northern Italy have yielded two-handled cups inscribed with the same motto and the phrase ΕΝΝΙΟΝ ΕΠΟΙΗΣΕ ("Ennion made me") (Plate E.46). Mold-blown beakers and cups of later date—but perhaps only by a decade or so—again include that motto or an upbeat one, such as "rejoice and enjoy yourself" and "seize the victory." Ennion's name crops up regularly for a couple more decades, but others occur as well, such a Jason, Meges and Neikaios, and someone self-titled "Aristeas the Cypriote," who seems to have been a follower (perhaps even a co-worker) of Ennion, or a mimic of his style.

Despite the inclusion of ΕΠΟΙΗΣΕΝ ("made me") in some instances, or ΕΠΟΙΗΣΕ ("made it") in others, it is still not clear as to which part of the glassworking process this "made it" refers. The name beside it could be a "signature" for either the sculptor of the initial model, or the person who fashioned a mold from that model, or the glass-blower who produced the finished product. If, however, we could draw a direct parallel with how things were managed in the potterymaking industry at that time, it is most likely that the name refers to the owner of the workshop; a mark to signify the superiority of his wares, perhaps also a deterrent to plagiarism of design.[22] If a craftsman in his employ was to be identified, we expect it to be in a much more discrete spot on the vessel, and probably by no more than some initials scratched onto one of its surfaces.

The common feature among these mottoes and names is, of course, that they are all Greek. If we add to this the facts that both Meges and Jason were common Jewish names at the time, and that the motto ΜΝΗΘΗ Ο ΑΤΟΡΑΖΝΩ which they and Ennion used so frequently is thought to have been a popular Semitic blessing, we would place the innovation of mold-blowing firmly in the provinces of Judaea and/or Syria. To explain the finding of so many Greek-inscribed vessels on the Italian mainland only requires that I invoke a reasonably high mobility of people and goods around

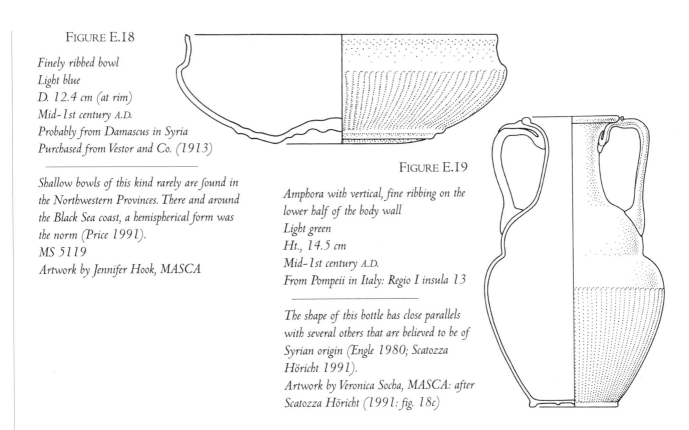

Finely ribbed bowl
Light blue
D. 12.4 cm (at rim)
Mid-1st century A.D.
Probably from Damascus in Syria
Purchased from Vestor and Co. (1913)

Shallow bowls of this kind rarely are found in
the Northwestern Provinces. There and around
the Black Sea coast, a hemispherical form was
the norm (Price 1991).
MS 5119
Artwork by Jennifer Hook, MASCA

FIGURE E.19

Amphora with vertical, fine ribbing on the
lower half of the body wall
Light green
Ht., 14.5 cm
Mid-1st century A.D.
From Pompeii in Italy: Regio I insula 13

The shape of this bottle has close parallels
with several others that are believed to be of
Syrian origin (Engle 1980; Scatozza
Höricht 1991).
Artwork by Veronica Socha, MASCA: after
Scatozza Höricht (1991: fig. 18c)

the Roman trade network, a notion that will crop up time and again throughout this story of Roman glassworking, as I track its development in subsequent centuries (in particular, see Section E.11).

It is clear, however, that mold-blowing also became part of the technical repertoire of glassworkers in Italy and various parts of the Western Empire at this time. Fragments of mold-blown ribbed bowls have been recovered from contexts that date close to A.D. 45 at the legionary fort of Vindonissa (modern Windisch on the upper reaches of the Rhine) and at the colony of Forum Julii (modern Fréjus, on the southern coast of France), and several sites in Romano-Britain just a decade or so later. Only slightly later again are the first examples of the cylindrical and ovoid cups that depict gladiatorial combat and chariot-racing that were popular at military settlements in the Northwestern provinces until about A.D. 80.[23] The inscriptions on these cups are always in Latin, and they have no parallel in the Eastern provinces at all.

However different some of the products of mold-blowing in the Eastern and Western parts of the Empire may have been, one point of common ground does link the glassworkers of the two regions. The foliage, spiral and scroll motifs on some tall conical beakers found at Pompeii are close enough to decorative elements on Eastern mold-blown wares to suggest a strong Syrian influence upon (and even the presence of enslaved Syrian craftsmen at) some of the glass workshops which flourished in the Campanian region south of Rome in the mid-1st century A.D. Underlying the decorative scheme of much of this mold-blown glassware was the glassworkers' concerted attempt to copy contemporary mold-cast pottery, which in turn meant that they were mimicking the ornamentation of bronze and silver vessels. This is most obvious in the frequent use of narrow ribbing on many bowls and bottles of these times (Figures E.18 and E.19).

PLATE E.47

Small hexagonal bottle, its body decorated with fruits
Dark blue
Ht., 8.4 cm
Mid-to-late 1st century A.D.
Possibly from Aleppo in Syria
Purchased from Vestor and Co. (1913)

The equivalent mold-blown bottle in the Western Empire was
four-sided and usually was decorated with masks of Medusa
and characters from the Bacchus cult (Lightfoot 1987).
MS 5011

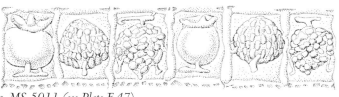

a. MS 5011 (see Plate E.47)

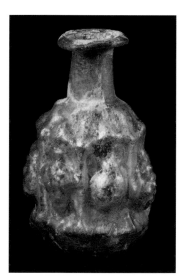

PLATE E.48

Small hexagonal bottle, its body decorated with fruits
Light green
Ht., 7.3 cm
Mid-to-late 1st century A.D.
Possibly from Aleppo in Syria
Purchased from Vestor and Co. (1913)
MS 5010

b. MS 5010 (see Plate E.48)

FIGURE E.20

Each of these mold-blown vessels are decorated with three pairs of images related to the cult of
Bacchus: a pomegranate, as an Eastern cult symbol for fertility; a pine cone which represents Sabazios,
Bacchus' equivalent deity in Phrygia; and a bunch of grapes, as a direct allusion to the place of wine
in Bacchanalian mysteries and revelry (Lehmann-Hartleben and Olsen 1942: Fleming 1996).
Note the mold-seams on the base.

The slumped form, relatively flattened decoration, and poorly defined basal pattern on vessel b suggests
that it was made with a later generation of the mold used for vessel a (see Stern [1995: fig. 50]).
Artwork by Jennifer Hook, MASCA

While mold-blowing did add a new aesthetic dimension to the Roman glassworker's repertoire, it never played more than a minor role in the industry overall. Repeated use of a mold resulted in damage of every awkward edge in the decoration and thus a gradual loss of its crispness (Plate E.47 and E.48; also Figure E.20). Any roughness in the motifs carved into the mold's surface would translate into a bubbling or pitting in the glass surface that marred the decorative image that little bit more. A craftsman could extend the life of a mold by minor tinkering with an existing outline or prominence in its decoration. In truth, however, small, fussily decorated molds of this kind simply were not the stuff of mass-production in this industry in the way that they were in others. When, in the latter part of the 1st century A.D. the fashion pendulum swung towards the faceting and wheel-cutting of decorative elements, the kinds of mold-decorated, cups, bottles, and juglets illustrated here all but disappeared. They only re-emerged as the fashion for some unusual form or decoration demanded (see Plates E.83 and E.128).

If you are wise, let your hair ever glisten with Assyrian unguent and garlands of flowers circle your head. Let the clear crystal grow dark with old Falernian and the soft couch be warm with a beguiling loved one.

(Martial, *Epigrams* VIII.77)

FRONTISPIECE F.8 see page 159

E.8

FASCINATION WITH FACETING

THOUGH THE LOW COST OF FREE-BLOWN GLASS WILL HAVE ADVERSELY effected the market potential for cast tablewares, it cannot have been the sole reason that the latter all but vanished from the Roman glassworking repertoire around the middle of the 1st century A.D. In the Augustan era, we have seen that onyx-ware bowls and cups cast in various ways from mixtures of amber and white glass were the middle-class alternative to expensive vessels carved from sardonyx (see Plates E.25 and E.26). But sardonyx was still very much in fashion during and beyond Nero's time, whereas its counterpart in glassware was definitely not. There were other hardstones that also were popular with wealthy Romans throughout the 1st century A.D.—agate, the blue equivalent of sardonyx; and fluorspar, with a banded structure similar to sardonyx except for some distinctive streaks of deep purple and white. 24 These too were mimicked in cast glassware, but again only

PLATE E.49

This, the Crawford Cup (Ht., 9.7 cm), is one of only three vessels that survive today which were sculpted from murrhine—a form of the mineral fluorspar that the Romans imported from Iran (Vickers 1997). This fluorspar was regarded as one of the most costly products from the Earth's interior, alongside diamonds and emeralds, and ranked well above gold in Roman material values (Pliny, Natural History XXXVII.204) (see also Endnotes 24 and 25). Courtesy of the Trustees of the British Museum

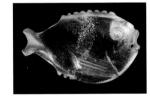

INSET

Close-up of a sherd of a glass ribbed bowl, backlit to reveal the patterning that may well have been intended to simulate the natural banding in fluorspar. magnification, 4x MS 5387ii

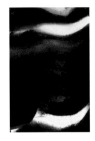

PLATE E.50

So few ancient items of carved rock crystal have survived, we have only a vague sense of the nature and quality, and of Roman craftsmanship in working this material (Vickers 1996). This model of a sun-fish (L., 3.0 cm) is intact, however. It was probably used as a game counter. Courtesy of the Trustees of the British Museum

for the first three decades or so of the century (Plate E.49).

Just as these polychromes went out of vogue, so did most of the richly colored monochromes; no more emerald green or opaque red, gradually less and less opaque white, opaque turquoise and dark blue. Free-blown vessels with a bichrome mix amber-, blue- and purple-and-white did retain some popularity for a few more decades (see Plates E.41 and E.44). In terms of color, however, the pendulum of Roman taste was fast swinging in completely the opposite direction, with everyone now hankering for decolorized wares—completely transparent vessels which glassworkers could produce by the controlled addition of a manganese-rich mineral to their stock recipe (see Plate A.5 in Appendix A). No pun intended, but here was a clear technological step forward towards the glassware that we take so much for granted today, at every meal, picnic, and cocktail party.

In part, the stimulus for this new fashion was the mimicry of similar vessels carved from rock crystal, vessels so highly prized that they also rated being mimicked in silver and bronze.[25] I would hazard a guess that very few ordinary Romans ever saw, let alone handled, a rock crystal bowl or cup. But there are a number of indications in the literature of the later 1st century A.D. to suggest that nouveau riche Romans were willing to spend a fortune on such items, by way of imitating the lifestyle of the emperor and his immediate circle (Plate E.50). We get some feeling of just how influential the tension factor of *fashion and taste* was in glassworking at this point from the comments:

> Apples seem more beautiful if they are floating in a glass.
> (Seneca, *Investigations in Natural Science* I.6)
> (Plate E.51)

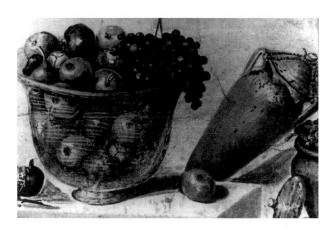

PLATE E.51

This wall painting from the "House of Julia Felix" in Pompeii, is a perfect echo to the historian Seneca's view that a glass bowl is the most dramatic way to show off a mixture of fruits in a table setting. We assume that the sealed pottery amphora to the right contains wine but we cannot judge its color or clarity, as we could if the vessel were made of glass. For a review of similar illustrations of glassware in wall paintings, see Naumann-Steckner (1991). Courtesy of the Deutsches Archäologisches Institut, Rome

FIGURE E.21

This cup (Ht., 9.0 cm) was found in 1868 at Barnwell in England, along with the ribbed jug illustrated in Figure E.15b. Its network of closely knit, hexagonal facets is typical of wheel-cut decoration in vogue during the latter part of the 1st century A.D. (cf. Figure E.22). Artwork by Veronica Socha: after Harden (1987: entry 104)

FIGURE E.22

This beaker (Ht., 17.0 cm) is unusual in that its large and oval faceting creates a pattern of curving lines rather than the usual network effect (cf. Figure E.21) It was found at Pompeii and so predates the devastation of that city in A.D. 79. Artwork by Veronica Socha: after Harden (1987: entry 102)

While a shipment from the Nile is bringing you crystal, accept some [glass] cups from the Flaminian Circus [in District IX in Rome]. Are they the bolder, or those who send these presents? . . . They don't interest a thief, Flaccus, and are not damaged by overly hot water.

(Martial, *Epigrams* XII.74)

If people as influential in elite circles as Nero's tutor, Lucius Seneca, and as in touch with all levels of Roman society as the satirist Martial, were promoting the virtue of glass, the pressures on glassworkers to explore this "higher end" market for their products were considerable.

The surface of a rock crystal vessel could be sculpted in low relief, so its close imitation in glass called for a quite robust body that could withstand the pressures of extensive drilling, wheel-cutting and polishing. It is no mere chance then after its eclipse elsewhere in the industry that the earlier tra-

dition of glass casting *did* continue for a full five decades through the production of colorless and weighty, relief-decorated tablewares. Rock crystal also lent itself well to delicate faceting, so the free-blowing side of the industry developed the skill of producing thick-walled blanks, whose rim, foot and inside could be cut away and smoothed on a lathe, before the outside was cut and ground with patterns of interlocking or overlapping diamonds and ovals (Figures E.21 and E.22).

Early on, the translucency of glass, even though there might be heavy tinge of green or aquablue, was something that set it apart from opaque materials such as pottery and any metals. Such naturally colored glass was then, and would continue to be, the stock material of the industry for the bulk of domestic needs. But the *transparency* of colorless glass gave it a much stronger appeal just where one might expect, among the vessels used to serve wine. A thin-walled beaker could be

FIGURE E.23

Beaker decorated with lathe-cut grooves and lines on the body
Colorless
Ht., 12.5 cm
Last quarter of the 1st century A.D.
Provenance unknown
Gift of George and Henry J. Vaux (1986)
86-35-80
Artwork by Veronica Socha, MASCA

PLATE E.52

This bronze group of two hounds attacking a boar (Ht., 50.0 cm) originally stood between other bronze figures of a snake, a deer, and a lion at the center of a fountain basin in the "House of the Citharist" at Pompeii. Water gushed into the pool from the boar's mouth and from the mouth of the hound on the right (Ward-Perkins and Claridge [1976: entry 83]).
Courtesy of the National Archaeological Museum, Naples

mounted on a lathe and its surface scored with the edge of a wheel or a scribing point, to create delicate patterns of lines spaced in any rhythm the glass-cutter chose (Figure E.23): a thick-walled one could be decorated with grooves with all sorts of depth of cut, width and spacing.

This documentation of the various glass-working innovations of the Neronian era does much to help us appreciate how far the skill level within this Roman industry had advanced in the mere seven or eight decades of its history. We should not imagine, however, that the position of glass had changed significantly in the Roman material hierarchy over that time period. The reasonably effective mimicry of elitist silver, rock crystal and fluorspar did not elevate the status of glass in some "by-the-bootstraps" way, or give the glassworkers themselves some new social standing. The views held by the inherently wealthy sector of Roman society as to what were inappropriate ways to earn a living had been perfectly expressed by the lawyer Cicero a century or so earlier:

> All craftsmen, too [like retail merchants], are engaged in vulgar occupations, for a workshop or factory can have nothing genteel about it.
>
> (*An Essay about Duties* I.150).[26]

We also should recognize that the industry which glassworking most rivaled in the marketplace—potterymaking—itself had benefitted greatly from the industrialization mindset of the Augustan era. With the exception perhaps of the vessels attributed to the Ennion workshop that I discussed in the last Section, the relief decoration on mold-blown glassware fell well short of what was now being produced on mold-impressed pot-

PLATE E.53

This medallion (D., 4.1 cm) depicts a Medusa mask and has the phrase AMARANTVS F[ECIT] ("Amarantus made it") scratched upon its lower edge. Amarant[h]us is thought to have been a glassmaker with a workshop in southeastern Gaul whose products were exported as far as Normandy and the Rhineland (Sennequier 1986). This medallion was probably the lower terminal of a jar handle (see Inset). Parallels in bronze for this and other kinds of handle decorations are illustrated in Franchi dell'Orto and Varone (1993: entries 60, 68, and 105–107).

Few glass representations of this kind have their surface features as sharply defined as this one. They were produced simply by dribbling and coiling a trail of glass into a small cup-like mold (Cool and Price [1995: fig. 8.1]).
Courtesy of the Musée des Antiquités de Rouen
Artwork by Veronica Socha, MASCA

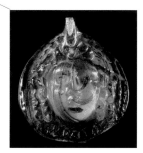

tery, in terms of image crispness (see Plate E.60). Meanwhile the industry that was on next rung of the material ladder—bronzemaking—was not only thriving at the domestic level but also advancing just as rapidly in its technical abilities, as applied both to the sheer size of castings and to their aesthetic power (Plate E.52).[27] When glassworkers attempted to imitate the complex masks that were often added at the lower end of the handle on even quite small pottery or bronze jugs and bowls at this time, they could not capture anything like as well the detail in hair styles and facial features (cf. Plate E.53 and Figure E.24).

The size of items that each could produce also set glassworking and potterymaking industry apart from one another. The famous cameo amphora from the "House of the Mosaic Columns" at Pompeii that stands close to 32 cm high is massive in glassworking terms, ar least for something

with so complicated a decoration. But it is dwarfed by many contemporary pottery items, such as the figures of an actor and an actress (each about 113 cm high) that were found near the theater in the same ancient city. Nor do we have any glassmaking project recorded in ancient literature that rivals the following:

> Vitellius, when emperor, had a [pottery] dish made that cost a million *sestercii*, for which a special furnace was constructed in the open country, since luxury now has reached a point when even earthenware costs more than vessels of fluorspar.
> (Pliny, *Natural History* XXXV.46)

The mention of such a lavish expenditure again brings to mind the opulence of Rome under its first succession of emperors. While Rome

played, however, an economic crisis had been gathering momentum in the surrounding countryside: a crisis that eventually would have a profound impact on the history of glassworking. The heartland soils of Italy were becoming exhausted; an earlier agricultural surplus, as mirrored by the huge numbers of Italian trade amphorae that found their way into Gallic contexts, was slipping away. Many of the famed vineyards of Augustan times had fallen into disrepair and even those of the Falernum region (near Capua) were losing their revered status because of an ill-considered emphasis on quantity rather than quality.[28] Meanwhile, the fuel demands of the much expanded pottery- and iron-making industries, along with the domestic heating and building needs of a growing population, were gnawing away at many of the mainland's forests.

The relentless forces of urbanization was stretching to the limit the Roman skill for resource management, and the Romans knew it:

A short time and our princely piles will leave but a few acres to plough; on all sides will be seen our fish-ponds spreading wider than the Lucrine Lake, and the lonely plane-tree will drive out the elm. . . .
(Horace, *Odes* II.15).

Many Italian entrepreneurs now built new workshops in and around the Empire's fast-growing provincial cities, so that they could both exploit a new pool of cheap labor among the local peoples and have access to the fuel and lumber supplies of northwestern Europe's vast forests. Many others forsook Italy altogether and moved to Gaul.

FIGURE E.24

The figurative elements applied to the body of this jug (Ht., 16.9 cm at the rim) are mold-made: they depict the classical myth of Iphigeneia. A similar molded mask of a satyr covers the point where the handle joins to the vessel's body in direct mimicry of the decorative terminii that were made part of the handles on bronze vessels of the day.

DETAIL

Close-up of the Satyr mask
Artwork by Veronica Socha, MASCA: after
Franchi dell'Orto and Varone (1993: entry 131)

... and about the rest of the wines grown in the province of Narbonensis, no positive statement can be made, inasmuch as the dealers have set up a regular factory for the purpose and color them by means of smoke. . . .

(Pliny, *Natural History* XIV.68)

FRONTISPIECE F.9 see page 159

E.9

THE WESTWARD EXPANSION

TO UNDERSTAND THE APPEAL OF GAUL TO THE ROMANS IN THE MID-1ST century A.D. we have to slip back almost a century and look at the processes by which Julius Caesar incorporated the various regions that he had conquered into Rome's territories. To begin with, he resettled some 80,000 citizens and their families—a mixture of Rome's landless poor and the veterans discharged after his campaigns—into more than thirty urban colonies (*colonia*) at strategic places, such as Arelate (modern Arles) on the coastal road to Spain, and Lampsacus (modern Lapseki) at the link between the Aegean and Black Seas. In Gaul, he created just three *colonia* of Lugdunum, Noviodunum and Augusta Rauricurum, respectively (Lyon and Nyons on the Rhone, and Augst on the Rhine: see Map E.3. From these, the Romans were able to organize an efficient exploitation of the agricultural resources of the new provinces, while their very presence served to deter Germanic tribes from probing the newly defined frontiers. (Wine was about to become one of Gaul's major exports to Rome, despite Pliny's low opinion of some of it, as cited above.) He then converted many of the native Gallic settlements into regional capitals. Each capital (*civitas*) was redesigned to have a military-style rectangular pattern of outer ramparts, uniform blocks of buildings, and a grid of straight streets. In that sense, they had a very Roman look to them. But their function differed from *colonia* in that they were administered by local leaders who accepted a role as Rome's tax collectors and were willing to arrange for the Roman army to receive a constant supply of fresh Gallic recruits.[29] Augusta Treverorum (modern Trier) developed in this way, its location on the Mosel giving it a valuable waterway-link to the military camps that were then scattered along the Rhine further to the East (Plate E.54).

MAP E.3

The Romans conquered the southern part of Gaul (Gallia Narbonensis) to ensure security of communications with Spain. They conquered the northern part (Gallia Comata [= "long haired"]) for its rich agricultural land, for slaves—some say as many as a million of them were taken during Julius Caesar's campaign alone—and to block off potentially disruptive barbarian invasions across the Rhine. (An adjoining area—Germania Inferior—was a military zone that for the most part fostered a population of soldiers and their families.) Close contact with the Celtic peoples of Gaul provided crucial technological advances for the Roman World, not least the skills of the wheelwright and the design of vehicles for road transport, a whole range of iron farm tools and machines, and the use of waterpower for higher crop yield (White 1984).

Graphics by Andrea Jacobs and Mary Ann Pouls, MASCA: after Cornell and Matthews (1982: 129)

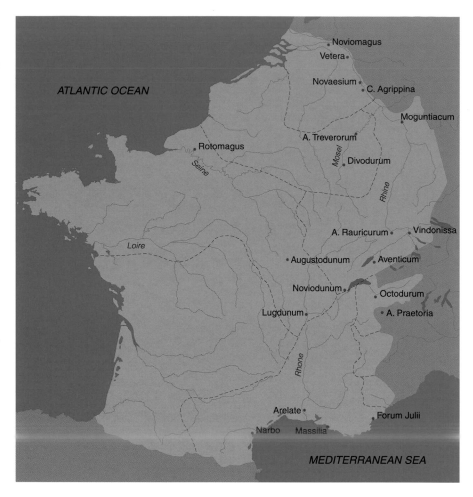

PLATE E.55

Unguentarium
Light green
Ht., 18.3 cm
1st–late 2nd century A.D.
Provenance unknown
Gift of John Thomas Morris
(1916)

The shape of the Roman unguentarium evolved rapidly from its earlier simplicity. The shear-cut rim (see Plate E.27) gave way to one that, as here, invariably was finished by folding or crimping. Also, as the century progressed, the neck became more and more extended.
MS 5519

PLATE E.54

Trier was the capital of a mixed Celtic peoples, the Treveri. Now overgrown and surrounded by the modern urban sprawl, the amphitheater shown here was one of the first major building raised after Augustus visited the city in 14 B.C. Though always an important Roman administrative center, Trier's significance grew appreciably in the late 3rd century A.D. when it became the main imperial residence in the West.
Courtesy of Hilary Cool

FIGURE E.25

Squat cylindrical bottle
Light green
Ht., 11.2 cm
Mid-to-late 1st century A.D.
Probably from Carthage in
Tunisia
Gift of Margaret Wasserman
Levy (1991)

This vessel has a close parallel in a
somewhat larger bottle from Sphakia in Crete.
(Weinberg [1992: entry 88]).
91-26-15
Artwork by Veronica Socha, MASCA

FIGURE E.26

As one might expect, the Spanish wine industry
stimulated the local production of many kinds of glass
beakers. The two shown here, with their bands of finely
abraded lines, are typical. Find spots for these beakers
are concentrated in the valleys of the Guadiana and
Guadalquivir rivers, and then extend little further
than the nearby coastline of northern Africa and the
northeastern coastline of Spain.
Artwork by Veronica Socha: after Price (1987: fig. 1)

Augustus continued Caesar's earlier policies for colonization, particularly along the coastline of north Africa and in the province of Lycia in Asia Minor. Meanwhile, new legionary camps at the frontiers were established at strategic places such as Aosta which could guard the nearby Alpine passes of the Great and Little St. Bernard. A similar need for protection of the frontier at the course of the Danube subsequently led to the creation of Carnuntum (east of modern Vienna) and Aquincum (now overlain by modern Budapest). It was not long before each of these camps found itself surrounded by a loosely knit community (*vicus*) of traders, craftsmen, prostitutes, and others, all seeking a share of the prosperity of Rome's professional soldiers. By the 2nd century A.D. many of these camp/vicus clusters were smeared-out suburbs of the traditional civilian city (*municipium*), complete with its own suite of temples, public baths, and amphitheater.

The new provincial Romans brought with them as much of their domestic property as they and their slaves could manage. Initially that property may have contained only small amounts of glassware. Their presence and their wealth was a strong stimulus, however, for many craftsmen, including glassworkers, to settle nearby. At the same time, the redeployment of a legion to a frontier flash-point would likely be the occasion for a wholesale movement of soldiers' chattels, some glassware included. (For example, we have records of the legion *X Gemina* being in Carnuntum for six years before being transferred to Noviomagus (modern Nijmegen), on the Rhine in A.D. 71; then serving in the province of Dacia just three decades later.) This also will have been true in times of crisis, such as the civil wars which broke out after Nero's suicide in A.D. 68, and during the Jewish Revolt which resulted in the destruction of Jerusalem in A.D. 70.[30] As these various movements of people and troops took place, so glass of every shape, size and quality became commonplace throughout the entire Empire (Plate E.55 and Figure E.25).

The growth of provincial urbanism and the accompanying greater clout that provincial leaders had in the economic affairs of the Empire had the political fallout that we might anticipate. After Nero's death, there emerged one emperor, Servius

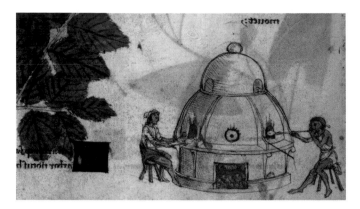

Though this glassblowing scene dates to the 15th century A.D. the depiction of glass being worked after it has been heated in a relatively small, compact oven is probably quite close to technology used in the Roman World. For a comprehensive discussion of early illustrations of glassblowing installations including this one, see Charleston (1978), and Foy and Sennequier (1989).
Courtesy of the Vatican Library

PLATE E.57

This glassmaking furnace, which most likely dates to late 1st or 2nd century A.D. was found in the eastern corner of an apartment complex during recent excavations at Octodurus (modern Martigny) in Switzerland (Wiblé 1986) (see Map E.3). Its modest dimensions—about 85 cm x 75 cm—and the fact that it was a rough pit cut directly into the ground, underscores how temporary such structures are likely to have been. For a similar example from Aventicum (modern Avenches) in Switzerland, see Morel et al. (1992: fig.3).
Courtesy of Francois Wiblé, Recherches Archéologiques de Martigny

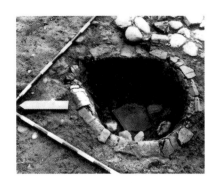

Sulpicius Galba, who previously was a governor in the province of Tarraconensis in eastern Spain. He was able to manipulate the Senate in Rome to support his ascendency, even though he remained distant from the city itself. Though Galba was murdered scarcely three months after he *did* come to the capital, Spain was destined to provide two of the most successful and popular Roman emperors—Trajan (reigned A.D. 97–117) and Hadrian (reigned A.D. 117–138), both of whom were natives of Italica (now modern Seville)—so that the Spanish provinces became the agricultural powerhouse of the Empire for a century or so thereafter. In similar vein, north Africa's economy received a major boost in the early 3rd century A.D. under the patronage of the Emperor Septimius Severus (reigned, A.D. 193–211)—a native of Leptis Magna (120 km east of modern Tripoli in Libya)—while his marriage to the Syrian-born Julia Domna set the stage for her grandnephew Elagabalus in A.D. 218 to become the first emperor from the Eastern provinces.

Again, however, I leap ahead of myself. Returning to the events of the late 1st century A.D.,

I would argue that the process of provincial urbanism had an appreciable impact not only upon where new workshops were placed (Figure E.26) but also upon the ways in which each of them maintained their glass stock on a day-to-day basis. To explain how, I should make it clear that glassmakers and glassworkers usually were not one and the same people.[31] Probably many an Eastern glassmaker in the pre-Augustan era could turn his hand at glassworking as well. But the enslaved glassworkers in Roman workshops on the Italian mainland and in the Western provinces during the 1st century A.D. had little or no contact with the glassmaking process.

Many early glass*making* sites, for good reasons, were located on a wooded hillside close to a seashore. First, common beach sand, as a natural mixture of quartz, feldspar, and calcium-rich shell debris, was an ideal source for two of glass's primary ingredients, silica and lime. Second, the efficiency of the sea routes in the Roman trade network assured a steady and direct supply from Egypt of the soda-rich carbonate (*natron*) that was the other primary

ingredient for glass that was preferred in those times (see Appendix A). Third and fourth, a combination of an ample supply of wood fuel and a coastal breeze at the right time of day ensured there was a strong enough air draft to raise a furnace's temperature to around the 1100°C needed for the full fusion of these ingredients. The end-product of such a glassmaking enterprise would be ingots of glass that covered the entire spectrum of colors, both translucent and opaque.

In the lands of the Western Empire, however, things seem to have been organized rather differently. Sizable furnaces at various places in Britain, for example, suggest that bulk stocks of glass were being produced, but most likely not from raw ingredients. Instead, loads of broken glassware (*cullet*) would be carted in periodically from the local towns and military camps and be re-melted.[32] (It is surely not just chance that these glassmaking facilities often grew up alongside the two other Roman industries that depended for their success on a sound understanding of furnace technology—iron- and pottery-making.[33]) Presumably the end-product again was some kind of ingot, but the color range was probably limited to some hue of green—ranging from light and blue-tinged to blackened and murky—and very much an arbitrary blend of whatever went into the melting pot on any particular day.

In contrast, glass*working* could be done almost anywhere. Re-melting of a small chunk of glass required only about 750°C to make it fluid enough to be worked by either casting or blowing. That temperature could be attained in something as small as a well-shielded hearth (Plate E.56), and only relatively small amounts of wood fuel were needed to maintain it. As a matter of convenience, some glassworkers may well have established themselves close to glassmaking facilities, if there happened to be a city nearby that could be a reliable marketplace for their wares. Otherwise what would determine the location for a glass workshop would be proximity to a road or a river in the Roman trade network, so that it could receive bulk glass stock of some kind.

There are no Roman technical handbooks on these matters, but I am inclined to believe that workshops not too distant—perhaps a river valley's length or so—from glassmaking facilities would get their stock as ingots of the kind described above. For example, this might be the case for some of the newly flourishing inland towns in the Iberian peninsula, such as Emerita Augusta (modern Mérida) and Aeminium (modern Coimbra), where significant amounts of glassworking debris have been found. This might also be the case for Octodurus (modern Martigny) where glass workshops were established around the middle of the 1st century A.D. (Plate E.57), perhaps because ingot glass easily could be included among the huge amount of goods that were traded out of Italy and along the length of the Rhine every day. By the same token, any settlement on any other major European river that was plied by Roman traders could be a home for glass*working* without there being any local glass*making* activities.

At the same time, a glassworker willing to tramp the roads between towns and the dirt tracks between more remote villages had two choices. He could buy some glass ingots and carry them with him along with his blow-pipe and tool kit of pincers, shears, and so on. Or he could have set up a rhythm in his travels, rather like that of a Medieval tinker who would patch up iron pots and pans, and remind everyone to hold on to their broken vessels until he came around again. In this latter instance, it would be the glass*worker* who could re-cycle a piece of cullet (perhaps more than once, over the years) straight back to the household who brought it to him. Thus, a heavy bottle fragment could be converted into a number of thinner walled jugs and cups for the kitchen or the supper table, or into several unguentaria for perfumed oils or medicinal balms. If this recycling resulted in a few extra vessels, all well and good; they could be sold to the folk in the neighborhood or hawked in the next village on the glassblower's itinerary.

The way in which glassworking developed in the Western Empire therefore varied appreciably

FIGURE E.27

Beaker, with lathe-cut lines
Light amber
Ht., 10.4 cm
Mid-to-late 1st century A.D.
Provenance unknown
Gift of George and Henry J. Vaux (1986)

There is also a somewhat squatter form of this vessel
that is now called a Hofheim cup, after the site in
Germany at which they were first found in
appreciable numbers (see Price 1978).
86-35-93
Artwork by Jennifer Hook, MASCA

FIGURE E.29

Globular jar with a collared rim
Bluish green
Ht., 15.7 cm
Mid 1st–early 2nd century A.D.
From Hermeskeil (near Trier) in
Germany, grave 8

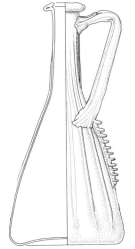

FIGURE E.28

Conical jug
Amber
Ht., 28.3 cm
Mid-to-late 1st century A.D.
From Radnage in England

The findspots of this kind of vessel
are discussed in Price (1978). The
vertical ribbing on the body was created
by applying trails along a partially
inflated glass bulb. The bulb, was taken to
full size during a subsequent re-heating, thereby
stretching the ribs into a softer outline (cf. the
optic-blowing technique that will produce a similar
ribbing effect: see Figure E.15b and Figure E.51)
Artwork by Veronica Socha: after Harden (1987: entry 68)

The findspots of this kind of vessel are discussed in Price (1978).
Artwork by Veronica Socha: after Goethert-Polanschek (1977: pl.
14.146)

from region to region. Industrial-style workshops were set up quite rapidly in and around the main cities and expanding military settlements, as Roman entrepreneurs relocated some skilled craftsmen from their Italian workshops and then drew upon the native population for inexperienced labor as and when they needed it.[34] Elsewhere, however, the developmental process was surely slower and probably had at least two stages. In Britain, for example, in the two decades or so following Claudius' invasion of A.D. 43, much of the glass used was of necessity imported from quite distant parts. Initially, these imports were the common tablewares that characterized the fading Italian and the growing Gallic industries of the day—cast mosaic and monochrome ribbed bowls, free-blown beakers decorated with wheel-cut grooves (Figure E.27), and all manner of domestic jars and bottles, large and small.[35] Then, just a few years later, the imported wares shed their Italian features and instead began to mirror the novel vessel types then emerging from primary workshops in the Rhineland and in central and northern Gaul. Two of these provincial products—a long-necked conical jug with an angular handle, and a globular jar with a collared rim (Figures E.28 and E.29)—seem to have found no favor at all south of the Alps.

A decade or so later again, more and more everyday needs were being satisfied by local production. Each additional degree of regionalism in the production of domestic glassware made its long-range movement less and less necessary. So it was that the glassworking industry overall began to shed much of its earlier organizational coherence—not its scale, however, since the Empire's population was growing steadily by the decade and many of its new citizens were developing a thoroughly Roman taste for urban comfort and materialism.

Mockery of every sort was added
to their deaths. Covered with the
skin of beasts, they were torn by dogs
and perished, or were nailed to
crosses. . . .

(Tacitus, *Annals* XV.44)

FRONTISPIECE F.10 see page 159

E.10

CULTIC CONNECTIONS

I HAVE ALREADY DEVOTED MUCH OF THIS ESSAY TO EVENTS OF THE FIRST seven decades or so of the 1st century A.D., surely with justification since so many of the innovative aspects of Roman glassworking emerged during that period. I cannot move on, however, beyond the times of the Emperor Nero (Plate E.58) without commenting briefly on some of the new directions taken by Roman religious practices from the end of his reign onward. This digression in part will explain the taste for certain motifs used for glassware in the late 1st century A.D. It also will serve to set the stage for the major religious upheavals that came with the rise of Constantine two and a half centuries later, and subsequently carried the Roman glassworking industry into the novel areas of ecclesiastical imagery and church lighting.

In A.D. 64, a terrible fire sprang up in the older quarter of Rome and raged throughout the city for an entire week.[36] Though, to its credit, this fire destroyed many of the worst slums of the city, it also ruined several of Rome's finest ancestral homes and many of its most ancient temples. Popular anger soon demanded scapegoats for the associated loss of life and property, so Nero turned upon the city's Christian community and savaged it.[37]

It would be wrong, however, to read into Nero's actions a unique loathing for Christians. He is known to have hated almost all foreign religious cults, finding them offensive to traditional Roman piety and, in their rituals, disruptive to the customary patterns of Roman worship. Such attitudes were by no means unusual for his time, excepting for the ferocity with which they were expressed. Previously Tiberius had targeted Egyptian cults and Jews for his displeasure, requiring the destruction of all their vestments and holy items. In A.D. 19, the Roman senate forced 4000 ex-slaves "tainted" with such beliefs to accept the miserable task of suppressing an outbreak of banditry in Sardinia. In each instance, the cult was described as a *superstitio*, the idea of superstition here translating simply into strange or irresponsible, at least to the Roman way of thinking. Punishment for excesses in cult rituals—for example, drunkenness and debauchery among the followers of Bacchus—were often meted out purely on hearsay or rumor. In the case of Judaism, however, the Roman reaction was more one of bewilderment over, and distrust of, their refusal to eat pork, the practice of circumcision, and an adherence to the Sabbath. (According to a cynical Juvenal [*The Satires* XIV.105], this last activity could be nothing more than a day of ". . . taboo for all life's business, dedicated to idleness . . .") All non-traditional beliefs, not just Christianity, experienced frequent swings of the imperial pendulum from cautious tolerance to violent rejection.[38]

The Eastern cults differed from traditional paganism in that they offered the chance of per-

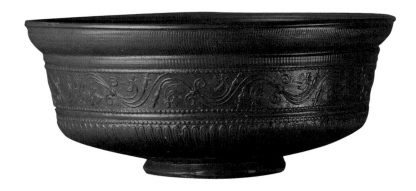

PLATE E.60

This pottery bowl (D., 21.2 cm) was made at La Grauferenque in southern France, around A.D. 30. The frieze of vine tendrils with buds and lozenge-shaped leaves on its sidewall closely imitates the Greek-inspired decoration that was in vogue for Roman silverware at that time (see Oliver 1977: entry 82).
Courtesy of the Trustees of the British Museum

sonal redemption through mystery-laden communion with the divine powers, whether it was the Egyptian goddess Isis, the Phrygian goddess Cybele (Plate E.59), or some other foreign deity. The secrecy that surrounded most initiation rites and celebrations did trouble the Roman authorities, of course, but they were slow to interfere with ideas that clearly appealed to their own citizens at every level of society. From the latter part of the 1st century A.D. onwards, the State religion was infused more and more by these cultic ideas, while comforting attributes of one cult were often adopted by another. In nearly every major city of the Western Empire, buildings dedicated to foreign deities soon crowded up against those dedicated to Italic ones. (In Rome itself, there was a temple of Isis close to the Colosseum on the Via Sacra, and another one just northeast of the Baths of Agrippa.) Perhaps because of the uncertainties about the future inherent in soldiering, the Roman legions were a solid breeding ground for oriental notions

of salvation (particularly those of the male-only cult of Mithras), so that those values were carried to the Empire's furthest Western frontiers.[39] The later association of some of these cults with healing and sanctuary for the disabled did much to provide them with a non-threatening aspect in the eyes of Roman authority.

In the storyline about glassworking, however, the crucial feature about the rapid progress of these various cults through the Roman World is how it measures the prevalent Roman susceptibility to fresh ideas coming from the East; a philosophical susceptibility in the case of religious attitudes, of course, but something that can be documented in material matters as well. It is clear in the way that Hellenistic mythic scenes and plant motifs became so common among the design elements of Roman metalwork and mold-cast pottery (Plate E.60). It is also evident in the frequent use of mold-blowing to create hexagonal-bodied juglets and bottles decorated with all kinds of imagery

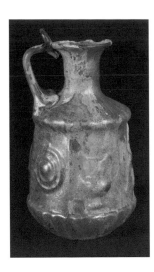

PLATE E.61

Juglet, with a hexagonal body decorated
with Bacchic symbols
Colorless, but green-tinged
Ht., 9.9 cm
Mid-to-late 1st century A.D.
Possibly from Aleppo in Syria
Purchased from Vestor and Co. (1913)

The three main characters of Bacchic revelry—
Bacchus himself, the drunken Silenus, and pipe-playing
Pan—are represented symbolically here by the various
items that would be carried in public processions
during the cult's festivals.
MS 5016

INSET

| wine amphora | pan-pipes | cymbals | wine basin | crossed shepherd's staffs | wine jug |

Artwork by Jennifer Hook, MASCA

related to the Bacchus cult—imagery aimed at capturing either his lofty place as the deity who would be invoked each Spring to protect crops or as the roguish character with his constant companions in revelry, the drunken Silenus and the pipe-playing Pan (Plate E.61: see also Figure E.20).

It is not hard to imagine how, as foreign traders and anyone in search of steady work flowed into the large cities of Italy, those cities became social melting-pots.[40] These peoples brought with them new ideas about the decoration of all kinds of materials, from gold to glass, and so always were a driving force in the prevalent definition of Roman taste. As we shall see, other cultural fusions that occurred in other parts of the Empire during subsequent centuries would play an equally strong part in directing the course of the Roman glass-working industry.

FRONTISPIECE F.11 see page 159

I got another cargo of wine, bacon, beans, perfumes and slaves. Fortunata did a noble thing at that time; she sold all her jewelry and clothes, and put a hundred gold pieces in my hand. They were the leaven of my fortune.

(Petronius, *Satyricon* 76)

E.11

THE HEYDAY OF ROMAN TRADE

T RAJAN CAME TO POWER IN A.D. 98 AND OPENED THE DOORS ON A CENTURY or so of dramatic change in the cultural attitudes of the Roman World. The new emperor's approach to life echoed the traditional values of earlier times—power through military strength, compassion through public welfare, and wealth through efficiency in trade (Plate E.62). Thus, his annexing of Arabia in A.D. 106 squashed any doubts about who controlled the southern caravan routes for Eastern exotics, while his campaigns beyond the Danube secured the gold of eastern Europe. By the end of his reign, the Empire would reach its greatest extent and be politically stable for many decades to come: it was easier and safer than ever before to move troops and goods, by land or by sea.

How would I characterize the glassworking industry at this time?—successful certainly, but at a turning point between a novel past and a traditional future (Plate E.63). Glass was used to make everything from fruit bowls to inkwells, from hors d'ouevre platters to fancy wine fountains.[42] Meanwhile, the scale of production was soaring. Around A.D. 116, at the maximum extent of Roman military power, it is estimated that there were *54 million* people in the Empire. In the large cities many people lived in crowded apartments where

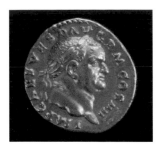

PLATE E.62

Emperor Trajan (reigned A.D. 97–117)
gold aureus (D., 1.8 cm)

Trajan's personal pleasures were rustic—wild-game hunting and rock climbing—and his piety was expressed well by the special funds (alimenta) that he set aside for the upkeep of the poor. As for trade, he rejuvenated the road system of Italy with fresh stretches of paving and a host of new river bridges.[35] Courtesy of the Trustees of the British Museum

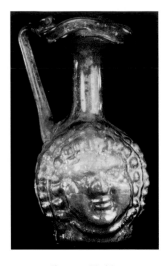

PLATE E.63

Twin-headed bottle
Amber body, light blue handle
Ht., 13.3 cm
Late 1st–early 2nd century A.D.
Provenance unknown
Purchased from Vestor and Co. (1913)

Scholars now dismiss the notion that the two heads on this kind of vessel represent the Janus—the god of comings and goings, and of beginnings (so that January is the first month of the year). But the imagery is still a good metaphor for the changes the Roman world was going through at the end of the 1st century A.D., as it turned its back of the volatile times of Nero and entered the calmer times of Trajan. MS 4993

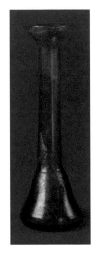

PLATE E.64

Unguentarium with a body shaped like a flared-mouth bell
Medium green
Ht., 10.9 cm
Early 2nd century A.D.
Provenance unknown
Gift of Mrs. R. Hare David (1950)

Though this shape of unguentarium crops up occasionally at sites throughout the Empire, it is very common in northern Gaul and the Rhineland (Sennequier [1985: entries 121–140]; Goethert-Polaschek [1988: form 73]).
50-1-114

domestic possessions were kept to a practical minimum (see Plate E.30). Nonetheless, we can make an educated guess that, on average, as many as 8 million homes were using sixty or more items of glassware every day; everything from unguentaria that were involved in each lady's morning toiletries to the plates, bowls, and wine cups that were brought to the supper table each evening. (The tableware and storage vessels in the slaves' quarters most likely were of glass as well.) Allowing for breakage of just a dozen or so of those items per household every year, we can say that glassworkers had to turn out close to *100 million* items annually just to keep pace with current demand—production on an industrial level indeed.

The primary methods of glassworking—casting, free- and mold-blowing—were now in place and highly developed, so that what lay ahead was innovation in vessel form and decoration that was, for the most part, only a response to prevalent taste. The only common technique of glassworking in later Imperial times that had as yet been little explored was engraving. That was a development awaiting a cultural stimulus that lay a few decades ahead (see Section E.12).

The sign of a tradition having been established in any craft is the way that the common wares changes their shape and/or decoration only bit-by-bit, each change being only an adaptation of something already at hand rather than a break with the past. The evolution of free-blown unguentaria is typical of how such matters worked in Roman glassworking, a much extended narrow neck and a conical body (often with a recessed base) becoming standard features for these vessels from the early 2nd century A.D. and for two centuries thereafter

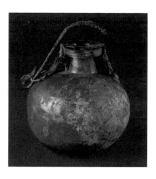

PLATE E.65

Oil flask, with remnants of
its bronze carrying-handle
Light green
Ht., 10.1 cm
Late 1st–2nd century A.D.
Probably from northern
Turkey
Gift of George and Henry J.
Vaux (1986)
86-35-89

FIGURE E.30

The forms of the rims and handles of oil
flasks show significant regional variations
(Sorokina 1987; Bailey 1992;
Fleming 1996).
A collar-like rim invariably is
found in the eastern provinces
from Asia Minor to Syria
(flasks a and b here). A rim
with an inwardly flattened
profile is found Empire-wide
(flasks c, d, and e here).

 A handle with a curved pivot
that stretches from one point on
the flask's shoulder to another
one either onto or just below the
neck is most common in the
Eastern provinces (flasks a and
b here). A handle that comprises a drape
of glass that runs upwards or downwards
along the flasks body and neck and then curls
back on itself is found in Italy, Gaul, and the
Rhineland (flasks d and e here).

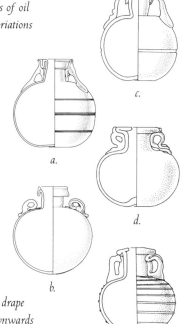

a. Probably from Asia
Minor (see Plate E.65)
86-35-89
b. Ras el-Ain in Syria
91-8-4
c. Cyzicus in northwestern
Turkey
Bailey 12
d. Cologne in Germany
Friedhoff 2.17
e. Trier in Germany
Trier 63,360
Artwork by Jennifer Hook
and Veronica Socha: after
Bailey (1992: fig.12);
Friedhoff (1989: abb. 2);
and Goethert-Polaschek
(1977: Tafel 11).

(Plate E.64: see also Figure E.36). There were similar trends among bottles, jars, and bowls—nothing overly dramatic; just gradual changes in the body, rim, sometimes handle shape, and in basic decoration, that picked up on some current fashion.

The power structure of the Roman World was becoming quite diffuse. Provincial cities had become bureaucratic clones of Rome, and their civic leaders adopted the social trappings of the mother city, albeit at a less ambitious scale of extravagance.[43] Juvenal (*The Satires* III.34) noted how provincial magistrates who previously had been expected only to fund a musical accompaniment to gladiatorial contests in country towns now would pay for the entire spectacle. They also would take it upon themselves the right to authorize the kill, presumably by an emperor-mimicking "thumbs-down" signal. By much the same mechanisms of

provincial expansion that I discussed earlier (see Section E.9), throughout the first half of the 2nd century A.D. glassworkers continued to gravitate to regional centers of power, so that the shape and decoration of their products displayed an increasing degree of regionalism as well (Plate E.65 and Figure 30).[44]

The distribution patterns for various kinds of glassware in their provincial context make it clear that it was bottles, jars, and jugs, sometimes also unguentaria—sealable vessels, rather than open bowls, cups and plates—that moved furthest afield in the greatest quantities.[45] Glass vessels were not significant Roman trade items per se, not within the confines of the Empire, at least;[46] their travels were a by-product of the trading of what they could contain. It would be a mistake, however, to think of glass ever substituting for pottery as the

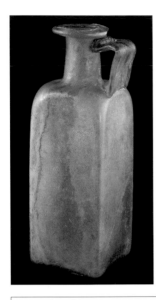

PLATE E.66

Square-sided bottle
Light bluish green
Ht., 22.4 cm
Late 1st–early 2nd century A.D.
Provenance unknown
Gift from George and Henry J. Vaux
(1986)

The capacity of this vessel is close to 750 ml, and thus equivalent to about 1.5 Roman sexterii.
86-35-27

FIGURE E.31

Squat cylindrical bottle
Light green
Ht., 10.4 cm
Late 1st–early 2nd century A.D.
Provenance unknown
Purchased from Vestor and Co.
(1913)

A bottle of the kind was found at Pompeii, together with a slightly taller one, in a pottery carrying basket (see Ward-Perkins and Claridge [1976: entry 244]). Many of these bottles bear vertical scratches from time-and-again being lifted out of such a holder.
MS 5128
Artwork by Jennifer Hook, MASCA

Roman liquid measures:
1 amphora = 3 modii = 8 congii = 48 sexterii = 576 cyanthii
1 sexterius = 0.54 liters
(after Duncan-Jones [1982: Appendix 18])

PLATE E.67

Just this handle from the neck of a Spanish pottery wine amphora is as big as the glass square-sided bottle illustrated in Plate E.66.
Close-up of amphora handle
ST.PR is thought to have been one of the trade marks used by a vintner who particularly was active around A.D. *80–120 in the Roman town of Arva near the modern village of Pena de la Sal in southern Spain (see Callendar [1965: entries 130 and 1673]).*

PLATE E.68

Square-sided bottle
Light bluish green
Ht., 16.4 cm
Late 1st–early 2nd century A.D.
Provenance unknown
Gift of Lydia T. Morris
(1916)

This vessel's capacity is close to 265 ml and thus equivalent to about half a Roman sexterius (see Box in Plate E.67).
MS 5621

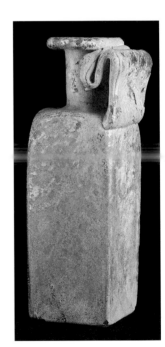

material for containers that could move *bulk* quantities of things such as wine or olive oil. For that purpose, robustness alone would give pottery some commercial edge, and we know of very few glass vessels that had anything like the capacity of the kinds of pottery amphorae that the Romans used for long-range transport of such perishables (Plates E.66 and E.67).

Rather, the place of glassware in Roman trade most likely lay with local needs for something to hold smaller quantities of liquids. Bottles and jars could could be carried on hand-carts—perhaps even just by hand—from one of the shops that were crowded around the city's main warehouses and; from there across the city's breadth through its narrow streets (Figure E.31). Some would even reach an outlying town or villa, along roads that were never built to bear heavy vehicles. (We really have no idea what the usual content of these jugs and bottles might have been, but if it was not wine

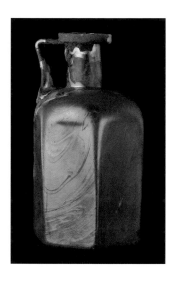

PLATE E.69

Six-sided bottle
Colorless
Ht., 16.5 cm
Early 2nd century A.D.
Probably from Aleppo in Syria
Purchased from Vestor and Co.
(1913)

———————————

This vessel's capacity of close to 530
ml and thus equivalent to 1 Roman
sexterius (see Box in Plate E.67).
MS 5254

FIGURE E.32

Variations on the form of the reeded
handle for Roman glass bottles:

a. 86-35-27
 (see Plate E.66)

b. 91-26-15
 (see Figure E.25)

c. MS 5128
 (see Plate E.68)

d. MS 5254
 (see Plate E.69)

Artwork by Jennifer Hook, MASCA

or oil, then we would expect it to have been the fish sauce [*garum*] or the crushed grape mush [*caroenum*], each of which were popular ingredients in Roman cuisine.) After that, many of them became storage containers in someone's kitchen or cellar, while others were re-filled and packed off to another market in a neighboring region.[47] An ongoing cycle of sale, storage, emptying, and refilling—perhaps with a different liquid each time—could well have resulted in some bottles and jars having a useful life of many decades, and a range of travel many times greater than the original one.

Judging by the huge numbers of fragments recovered from Roman settlements, civilian or military, glass bottles must have been produced in the tens of thousands every year—squat ones, tall ones, large and small. During the late 1st and 2nd centuries A.D. these bottles mostly came in two shapes—free-blown cylindrical or mold-blown square—though mold-blown hexagonal ones also were reasonably popular (Plates E.68 and E.69). Many of them seem to have been made to match units in the Roman scale of liquid measure. The barrel-shaped bottle that would be so common in

the Northwestern provinces a century or so later (see Figure E.35) also was gaining some favor at that time. Whatever their body shape, these bottles were invariably finished with a broad, angular handle with a reed-like appearance, though a wide-ribbed or plain handle was equally preferred for smaller bottles (Figure E.32). The less common rectangular-sectioned and octagonal bottles of this time always had two handles, these again being either reeded, wide-ribbed or plain.

For these bottles, mold-blowing had the practical advantage of assuring uniformity of size along the vessel's length, so that replicated sets of them could be packed neatly and safely together, in storage or during transport. The bases of these bottles often have raised markings at each corner, such as L-shapes or indented dimples (Figure E.33a), that may have helped steady the vessel when it was placed on a storage shelf or uneven floor. In other instances, however, these markings are combined with or replaced by geometric patterns that range from simple squares and sets of concentric circles to more complex floral or rosette motifs (Figure E.33b and c). Other bottle bases are stamped with

a. b. c.

FIGURE E.33

Some typical examples of the molded markings on square-sided bottles (see also Charlesworth 1966; and Fleming [1996: fig. 34]):

a. Corner dimples
 Mid-to-late 2nd century A.D.
 From the base of the bottle illustrated in Plate E.68
b. Wreath of leaves
 Late 1st–early 2nd century A.D.
 From Conimbriga in western Spain
c. Six-petalled rosette
 Late 1st–early 2nd century A.D.

The symmetry of this pattern indicates the use of a compass and a straight edge to pre-define the design on the clay (or wooden) mold's surface before it was gouged out in fuller relief (Cool and Price 1995). For this and a whole range of other geometric patterns of this kind that have been found at sites in Portugal, see Alarcao (1975).
Artwork by Veronica Socha: after Alarcao (1975: entry 34)

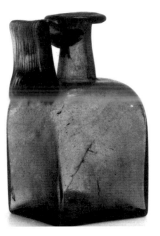

PLATE E.70

a. Square-sided bottle
 Ht., 14.5 cm:
 capacity, 0.44 liters
 Kam XXa.304

b. Marking: QAF
 Kam XX.a.300

This marking is found on square-sided bottles from various sites throughout northwestern Europe, with a variant that places the AF within two concentric circles (Charlesworth 1966).
Courtesy of the Provinciaal Museum G.M. Kam, Nijmegen

INSET
Base of bottle
Marking: CCPC
Kam XXa.304

c. Marking: FROTI
 Ashmolean 1948.36

A number of markings of this kind—
FRO, FRONI, FRONT, *etc.,—*
which are found only on mold-blown ribbed bottles, all seem to be an abbreviation of the name FRONTINUS. *The generally held view is that this identifies a major workshop that operated for more than two centuries; its products reached as far afield as northern Britain and the coast of the Black Sea (Cool and Price 1995; Sennequier 1975). The absence of the phrase "made me" (*FECIT, *or abbreviated to* F.) *does, however, put a question mark about that notion.*
Courtesy of the Ashmolean Museum, Oxford

Judging by the way such lettering is used as an abbreviation in Roman inscriptions, the first C may well stand for Colonia (thus, city: see Section E.9); otherwise the meaning of the group is obscure.
Courtesy of the Provinciaal Museum G.M. Kam, Nijmegen

FIGURE E.34

This marking •PATRI:: [M]ONIVM was cast into the base of the ointment pot shown in Figure E.36d The addition of the letters V and M may represent the words Vectigal and Monopolium, which stands for the product of a plant stuff—presumably a perfume or a medicine—the quality of which was State-guaranteed in some way (Frova 1971).
Artwork by Veronica Socha: after Goethert-Polaschek (1977: abb. 35)

FIGURE E.35

This barrel-shaped, ribbed bottle (Ht., 17.4 cm; Capacity, about 0.7 liters) was found in 1849 at Cany in western France, and probably dates to the first half of the 2nd century A.D. The mark on its base comprises two concentric circles and the letters F.R.O curved around them.
Artwork by Veronica Socha: after Sennequier (1985: entry 275)

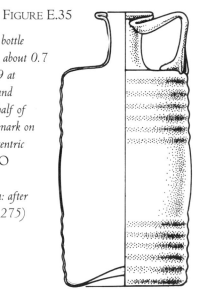

groups of letters and/or symbols that we assume are abbreviations for personal names and places, sometimes official titles (Plate E.70).

Once in a while, these markings clearly identify the owner of the glass workshop. Thus SENTIA SECUNDA FACIT AQ VITRA links two rectangular bottles from Lentia (modern Linz) in Germany, to a businesswoman who owned a glasshouse in Aquileia on the northern coast of the Adriatic. Similarly, P. GESSI AMPLIATI links a number of vessels from Herculaneum (south of Naples) to an entrepreneurial member of the Gessius family which had strong links to the East through the port of Puteoli.

There is also an intriguing series of markings on various kinds of unguentaria that key into a full or an abbreviated form of the word PATRIMONI (Figure E.34). The use of this word would seem to indicate that a monopoly of some kind was being exerted over the marketing of these vessel's contents: when coupled with the letters AVG as an abbreviation for Augustus, it is clear that the monopoly was vested with the Imperial treasury. The introduction of such a monopoly seems in some instances to have been punitive, in response

to anti-State activities in the provinces. Thus, during the first Jewish Revolt of A.D. 66, it is said that the Jews sought to deny the Romans access to their valuable crops of balsam, venting their wrath on this plant

> . . . as they also did upon their own lives, but the Romans protected it against them, and there have been pitched battles in defense of this shrub. It is now cultivated by the treasury authorities, and was never before so plentiful.
> (Pliny, *Natural History* XII.54)[48]

A similar kind of State intervention occurred during the latter part of the 2nd century A.D. when several politically motivated confiscations of land and property resulted in the governmental takeover of some parts of the Spanish perfumes industry (see Section E.14).

Most other markings on the bases of bottles, jars, and unguentaria are completely ambiguous, however, as to whether they refer to the maker of the vessel or the supplier of its contents for the initial commercial use. This is true whether an entire name is spelt out or whether the name is reduced

to a fragment or to a set of enigmatic initials—even more so, when the markings are just geometric patterns without even a letter mixed in with them. If we can draw a parallel from the firm ties between Roman vintners and the makers of pottery amphorae at this time, it may well be that the producer of the bottle's contents sometimes owned a glass workshop as well, so that markings on a bottle's base were a "trademark" for both enterprises.

Many of these patterns, both geometric and lettered, show a great deal of secondary variation, such as an extra concentric circle or two or a range of abbreviations of what was almost certainly the same Roman name—e.g., FRO or F.R.O, FRONTSCF, FRONT SEXTIN, and so on (see Plate E.50c and Figure E.35). These variations may have served to subdivide a bottle's contents according to its quality or date of the production. Alternatively, they may have been a means of more closely defining the region of production or of attributing ownership among family members. We simply don't know.

Some bottles of this kind also were produced in the Eastern Mediterranean; they give themselves away by the Greek (rather than Latin) lettering included in the markings on their base. Otherwise, whether they were square, hexagonal, or barrel-shaped, they were very much a prerogative of the glassworking industry in the Western Empire. Thick-walled and heavily collared, these bottles stand out as the most substantial and enduring products of that industry.

Such is the mark set on these herds of slaves for sale . . . [they are now] all but sent back with the rods of office wreathed in laurels to the places from which they came to Rome with their feet colored with the white earth!

(Pliny, *Natural History* XXXV.58)[49]

FRONTISPIECE F.12 see page 159

E.12

OF SLAVES AND GREEKS

WHO THEN WERE THESE ALL-BUT-ANONYMOUS PRODUCERS AND/OR bottlers who were such an integral part of Roman trade mechanisms? The answer may be a surprising one to a modern reader: more than likely they were the descendents, three or four generations removed, of the slaves who in Republican and Augustan times had been treated simply as household chattels. Just a few of those who had been forced to do every menial and/or unpleasant task in Roman private or public life (Plate E.71), had, by grim survival and the rise in status to freedman, become vital threads in the Empire's human fabric.[50] The great wars were over, so it was becoming rare for hordes of defeated peoples to be herded through the streets of Rome and sold one-by-one to the highest bidders. As the Stoic doctrine—that all men were equal before the gods—gained greater credence in Roman philosophy, slaves generally were treated with greater dignity.[51]

Not all of the slaves who had been brought to Italy by force in earlier times, however, were the rough soldiers or the farming peasantry of illiterate neighboring regions who then worked the land or ended life as gladiatorial fodder in an amphitheater. Besides the skilled craftsmen of the Augustan pottery- and glassmaking industries that I have already discussed, there also would have been innovative textile weavers, experienced builders, cultured men who could teach Greek to Rome's children, and actors and poets who carried with them a knowledge of Classical verse and drama. As freedmen, each of these could

PLATE E.71

Slaves were employed in and around the city in many different ways, such as the everyday cleaning of public buildings and the construction of roads and aquaducts. This relief from a 1st century A.D. tomb shows several of them engaged in the miserable task of powering the treadmill for a crane used to build the funerary monument for the Haterii family. Courtesy of the Vatican Museum

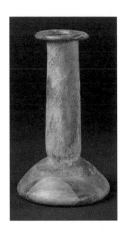

PLATE E.72

Unguentarium
Light green
Ht., 14.7 cm
Mid-2nd century A.D.
Probably from Carthage in Tunisia
Gift of Margaret Wasserman Levy (1991)
91-26-6

FIGURE E.36

During the 2nd century A.D. the shape of free-blown unguentaria evolved gradually in two directions that modified the body's shape from a flare-mouthed bell to either a wide-mouthed cone or a squat discoid. The base was now often concave, becoming more exaggerated in that sense as time went on. The neck became far more extended, presumably to prevent evaporation of the contents. (For broader reviews of unguentarium time-lines of this kind, see also Fleming 1997a, Fleming 1997b): Artwork by Jennifer Hook and Veronica Socha, MASCA

a. Bell-shaped
Early 2nd century A.D.
50-1-114
b. Cone-shaped
Mid 2nd century A.D.
MS 5518

c. Cone-shaped (see Plate E.72)
Mid 2nd century A.D.
91-26-6
d. Discoid, squat
Mid 2nd century A.D.
Trier inv. 13,839e

e. Discoid, long-necked
Mid-to-late 2nd century A.D.
Sennequier 161

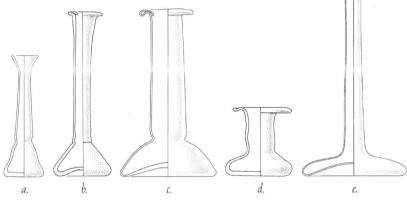

a. b. c. d. e.

aspire to middle-class Roman life and hope for their offspring to prosper.[52] This was most true of the educated slaves who emerged as estate bursars and private secretaries and so became the skilled handlers of their owner's money or affairs.[53] If, in freedom, they enjoyed their master's patronage, their sheer business know-how did much to offset any initial shortfall in their own capital wealth. The increasingly common economic, and thus political success of ex-slaves and/or their heirs did not sit

well with many Republican-minded Romans, such as Pliny the Elder—see the quotation at the head of the Section—but it was a tide of change they simply could not hold back.[54]

The changes in shape and decoration of Roman glassware however generally were quite conservative at this time. Invariably, they were only minor modifications of mid-to-late 1st century A.D. aspects, rather than sharp departures from them (Plate E.72 and Figures E.36 and E.37).

FIGURE E.37

This kind of simple, cylindrical cup (Ht., .6.1 cm) appears to have replaced the hemispherical type that had been so fashionable during the second half of the 1st century A.D. (see Figure E.27). Like the latter, this cup probably originated in the Rhineland. Like the long-necked jug and the ribbed jar shown in Figures E.28, and E.29, it was traded widely throughout the northwestern provinces but hardly at all southward beyond the Alps (Sennequier 1987). Most of these cups were naturally colored—aquablue, amber, or medium green (Inset a)—and quite utilitarian. But there are a few 1st and 3rd century A.D. versions of this vessel that have a painted decoration of either plants and birds or scenes of circus combat and wild animal hunting (Insets b and c). Similar scenes on some 4th century A.D. cups were created by engraving (Inset d). (For complete vessels of this kind, see Harden [1987: entry 147]; Hansen [1995: 149]; and Goethert-Polaschek [1977: entry 150].)

a. b. c.

d.

a. 1st century A.D.:
 monochrome green
 Copenhagen C 24137.H1/146
b. 1st century A.D.: painted
 BM GR 1905.11-17.2
c. 3rd century A.D.: painted
 Copenhagen C 4613
d. 4th century A.D.: engraved
 Trier 06,16
Artwork by Veronica Socha, MASCA

FIGURE E.38

These are examples of the massive jars and bottles that glassworkers produced during the late 1st to mid-2nd century A.D. (see also Harden [1987: entry 38], and Sennequier [1985: entries 215-224]). Each was given sturdier handles than were common in the previous century, presumably to help with the moving of both the greater bulk of the vessel itself and of the increased weight of its contents.

1 Roman sexterius is equivalent to about 0.54 liters

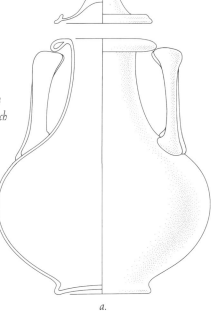

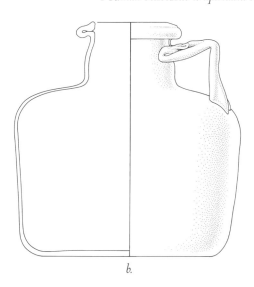

b.

a. Storage jar with stout,
 M-shaped handles
 Ht., 29.0 cm: capacity, about
 10.2 sexterii
 From Trier in Germany
 Trier inv. 14,86b
Artwork by Veronica Socha, MASCA: after
Goethert-Polaschek (1977: Tafel 12.140b)

a.

b. Bottle with an angular, reeded handle
 Ht., 28.5 cm; capacity, about 20 sexterii
 From Flamersheim in Germany
 CMG 66.1.241
Artwork by Veronica Socha, MASCA: after Harden
(1987: entry 39)

PLATE E.73

Emperor Hadrian (reigned A.D. 117–138)
gold aureus (D., 1.9 cm)

This emperor's wholehearted embrace of Greek customs
did not go uncriticized. For example, Hadrian's conservative
contemporaries sneeringly referred to him as "the little Greek,"
and the 4th-century historian, Aelius Spartianus (in
Augustan Histories: *Hadrian.26), claimed that he had*
adopted a full beard solely to cover up the blemishes on his face
(Walker 1995). Whatever the truth, the traditional Augustan
clean-shaven look did not return to fashion until the reign of
Constantine (A.D. 306–327) (see Plate E.88).
Courtesy of the Trustees of the British Museum

Whether this was the result of a reasonable caution on the part of new workshop owners (who, if I am right in identifying their slave origins, had improved their lot amid formidable social barriers), or because that glassworking was not being infused by much fresh blood at this time—rather it was based on father-to-son training and inheritance—I cannot say.

This conservatism of the early 2nd century A.D. could be characterized by recognizing that two of the factors with the potential to cause change in the glassworking industry—*technical innovation* and the pressures of *fashion and taste*—now were quite passive. Glassblowers were, however, continuing to make further inroads in the domestic marketplace, most obviously with the routine production of much larger bottles and storage jars that presumably were modeled after pottery equivalents of the time (Figure E.38). Meanwhile, the third factor—the course of *historical events*—was active only inasmuch as Roman citizenship now was something that many a freedman could use to advantage as he moved into the business sector of the Roman economy.

With the rise to power of the Emperor Hadrian (reigned A.D. 117–138), however, the factor of *fashion and taste* came back into play with significant intensity. The emperor himself frequently dressed in the flowing robes appropriate to a Greek philosopher and he adopted the Greek custom of a wearing a beard (Plate E.73). He traveled throughout the Empire, encouraging massive new building programs that sought to recapture the centuries-old Greek ideals of architecture in a number of major provincial cities, among them his home town of Italica in Spain, Ephesus and Aphrodisias in Asia Minor, Cyrene and Carthage on the north African coastline (Plate E.74). One suspects that Hadrian would have preferred to live in Athens, amid its poets and philosophers, rather than play his imperial part in the political theater of Rome.

There had always been a sector of Roman society that objected to the strong cultural and economic role that the citizenry of the Eastern Mediterranean played in Rome's everyday affairs. Thus, we have an early 2nd century B.C. playwright railing:

PLATE E.74
The public baths (thermae) at Carthage are one of the finest examples of Hadrian's generosity in the provinces during his travels. When eventually inaugurated by Antoninus Pius in A.D. 162, these baths covered about eight acres, making them second in size only to the thermae of Nero and Titus in Rome itself (Fleming [1997a: plate 30]). The surviving ruins represent just the massive substructure of the building, along with some service rooms and portions of the first floor.
Courtesy of Margaret Alexander, Corpus of the Mosaics of Tunisia

And as for those bloody Greeks, walking along with their muffled heads, their cloaks bulging with books and shopping baskets. . . . They stand around gabbling at each other, the swine, blocking your way, bumping into you, and prancing along with their high-flown talk.

(Plautus, *Curculio*, 288)

And we have the satirist Juvenal expressing the same kind of distrust and dislike that was prevalent during the late 1st century A.D.:

For a long time the Syrian [river] Orontes has poured its sewage into our Tiber—its language, its customs, its foreign tambourines. . . . They are heading for the Esquiline and the Viminal, aiming to become our owners.

(*The Satires* III.58)[56]

But the public enthusiasm for Hadrian's new and restorative activities in and around Rome itself—notably, the Pantheon and the Temple of Venus and Rome in the city, and his personal villa near Tivoli—now overwhelmed such critics.

If these critics had hoped that the death of Hadrian might allow them to repeal the impact of his Eastward-looking philosophies, they were to be disappointed. Antoninus Pius (reigned A.D. 138–161) owed his ascent to power directly to the fact that Hadrian had adopted him just six months before his death and so would hear no ill word of his benefactor. (Antoninus also cultivated a fine, Graecian-style beard. In death, he went one step further eastward than his predecessor, by turning away from the Roman tradition of being cremated, thus to be inhumed in the manner that for millennia past had been the norm in the lands of the Eastern Mediterranean.) Then came Marcus Aurelius (reigned A.D. 161–180), Hadrian's nephew and Antoninus' adopted son, who pursued his passion for philosophy dressed in an appropriate rough Greek cloak and sporting a longer, more "serious-looking" beard.[57] Neither Antoninus Pius nor Marcus Aurelius displayed the overt fever that

Hadrian had for things Greek, but it would never have crossed their minds to reject his ideology.

In a modest way, Roman glassworkers now responded to these Eastern Mediterranean influences—architectural, philosophical, and social—by adding to their repertoire a variety of bowls and platters decorated with scenes from Greek mythology. Hunting scenes and the Bacchic revelries that Roman metalwork had co-opted so fully from the Hellenistic world now became popular glass motifs as well. Most metal dishes and bowls of the early-to-mid-2nd century A.D. were decorated in low relief by casting into pre-sculpted molds of plaster or fired clay. As the century advanced, however, it became more common for decoration to be created by *cold tooling*—a mixture of gouging and hammering (*flat chasing*) relief designs into the metal's surface. The same kind of relief could be produced on a glass vessel using a lathe-powered wheel.[58] Finer detail, whether it was on metal or glass, was then engraved into the surface with various kinds of sharp-pointed tools (Plate E.75).

Many of the early attempts to engrave glassware seem a little crude to the modern eye. Perhaps the Romans felt the same way, which might explain why the evolution of this glassworking technique was quite slow. It was, however, one of the favorite means of glass decoration in Gaul during the 3rd century A.D. and some of the engraved dishes and bowls produced in the Rhineland a century later were extremely refined (see Plate E.I).[59]

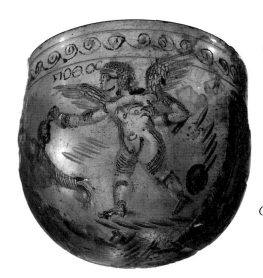

PLATE E.75

The scene on this beaker (Ht., 7.1 cm) captures the Greek legend of Hypermnestra who, like all fifty daughters of Danaus, was ordered by him to kill her bridegroom on her wedding night. She alone spared her husband Lynceus because of the intervention of Pothos (= love or desire).
The bodies of each figure—Pothos is shown here—were given depth by cutting facets deep into the glass. Then the texture of the limbs and faces, and other details (including the characters' Greek names) were added by engraving.
Courtesy of the Römisch-Germanisches Museum, Cologne

Our history now descends from a kingdom of gold to one of iron and rust.

(Cassius Dio, *Roman History* LXXII.36)

FRONTISPIECE F.13 see page 159

E.13

RIPPLES IN THE GOLDEN POND

THE PERIOD OF A.D. 98–180, WITH ITS SUCCESSION OF FOUR POLITICALLY skillful emperors—Trajan, Hadrian, Antoninus Pius, and Marcus Aurelius—generally is regarded as a golden age for the Roman World. In truth, however, not everyone fared equally in those times. Hadrian spent close to sixty percent of his twenty-one year reign away from Italy, yet scarcely a year of it in the Northwestern provinces. While there in A.D. 21, he concerned himself with little more than the formally stated purpose of his travels—a tightening of military discipline, a strengthening of the frontiers, and an inspection of the efficiency of the Imperial administration abroad (Map E.4). In effect, he underscored a long-standing Roman view that the Empire's new citizenry in the Western and Northwestern provinces were culturally barbaric, when set alongside the Greeks. So the Northwestern cities did not receive the same level of Imperial benefaction as their Eastern counterparts.[60]

Hadrian also did not extend his Eastward-oriented generosity to include Judaea. He knew all about the devastation caused in A.D. 116 by a Jewish uprising in the north African province of Cyrenaica. That emotional firestorm had spread to Egypt and Cyprus, leaving some 220,000 non-Jews—many of them Greeks—dead in its wake. He knew too that the Jews harbored a desire for a national identity outside the global coherence of Roman society—naming their children after Hebrew patriarchs, and openly expressing their dream that a Messiah would soon rise to set his people free from Rome's dominance and restore Jerusalem. As other emperors before him had observed with annoyance, such dogma ran counter to Roman traditional values, as did many Jewish rituals.

MAP E.4

Behind firmly secured frontiers in the West and the East during much of his reign, the Emperor Hadrian was able to visit almost every part of his Empire. His first journey, as summarized here, spanned the years A.D. 121–125 and was his longest. A second journey, in A.D. 138, took him to Sicily and the Eastern provinces of North Africa; a third, during A.D. 128–132, took him to his beloved Athens, then through Asia Minor and the provinces of the eastern Mediterranean shoreline and southward along the Nile as far as Thebae (modern Luxor) in Egypt; then back by sea to Athens. Artwork by Annette Aloe, Bagnell & Socha: after Scarre (1995: 99)

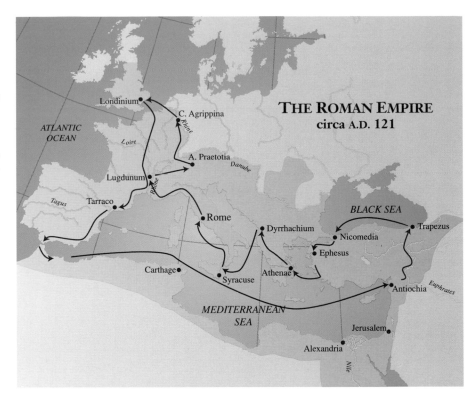

So Hadrian turned against this religion, making plans to level Jerusalem and build a Graeco-Roman city in its stead.[61] In the circumstances, what followed was inevitable—beginning in A.D. 132, another Jewish revolt sprang up, followed by another vicious Roman suppression that once again left Jerusalem in ruins.

How these events in Judaea played out in the history of glassworking is difficult to assess. Though fragmentary, archaeological and literary evidence seems to indicate that glassworkers were active in Jerusalem throughout the seven centuries of Roman administration of its Eastern provinces (see Sections E.7 and E.21: also Endnotes 99 and 110). The scale of their contribution to the industry's overall production, however, is completely unknown. The aftermath of each revolt must have hurt the domestic crafts centered in such a major city, both in terms of physical damage to property and through the reduction of the local marketplaces. It is also likely, however, that many craftsfolk, glassworkers among them, will have fled to the then flourishing Eastern cities *outside* Judaea—some of them even further afield to the Western provinces and to Rome itself—there to be assimilated into local Jewish communities that could help them rebuild their trade. As with all business activities, ancient and modern, we can be sure that one city's loss was another city's gain.

If there was an historical event that I would put forward as being most influential in defining the course of glassworking in the 2nd century A.D. it would not be what happened in Judaea. Rather I would point at something which occurred almost three decades later—to be specific, in A.D. 167, when the plague arrived in Rome.[62] It was brought to the city, along with the spoils of war that had been gathered up by Marcus Aurelius a year earlier

PLATE E.76

The wave of social unrest among the ravaged peasantry and the obsession with death in all ranks of European society that arose after the plague episode of A.D. 1346–1351—the Black Death—were reflected in several popular Medieval moral tales, including "The Three Living and the Three Dead" shown here (Cowie 1972: McEvedy 1988). Some of the reactions to the disease—homespun cures, anti-Semitism, etc.,—no doubt were echoes of how plague and other epidemics has been dealt with in the Roman World centuries before.

Courtesy of the Bodleian Library, Oxford

during his successful campaign against the Parthians at the Mesopotamian frontiers. It moved westward, ravaging the provinces in Gaul and the Rhineland; it lingered year-after-year, raging forth again in Rome in A.D. 180, almost symbolically heralding in the depraved reign of Marcus Aurelius' son, Commodus (reigned A.D. 180–192).

If the well-documented impact of various plague episodes in medieval Europe is anything to go by (Plate E.76), this outbreak in the Roman World disrupted the social fabric of every city, town, and village, and every military camp as well. The contagion rife in the crowded and unsanitary back streets of each city was silently hawked through the marketplace as effectively as any new stock of domestic necessities. As the death toll mounted, the survivors mostly will have been those who, in fear, abandoned their workshops and fled to the countryside. A society stalked by the plague would not be one that would appreciate technical innovation in any craft other than that of healing the sick. In the short-term then, I have to believe that the Roman glassworking industry, like much of the very fabric of Roman society, was in disarray.

Widespread epidemics do, however, seem to have a revitalizing effect upon society. Whether it is because it psychologically refocuses the survivors and makes them more self-sufficient, or because the brief removal of the pressure of population growth opens up some chance of a general rise in the standard of living—I don't know. There would have been some areas of the Empire that were touched only lightly by the plague, so that industries there would have thrived in its aftermath, fulfilling by trade the domestic needs of the less fortunate. So, as we move into the last decade or so of the 2nd century A.D. Roman industry was poised for a fresh forward movement, with the agriculturally rich provinces of Gaul and Egypt preparing to lead the way.[63]

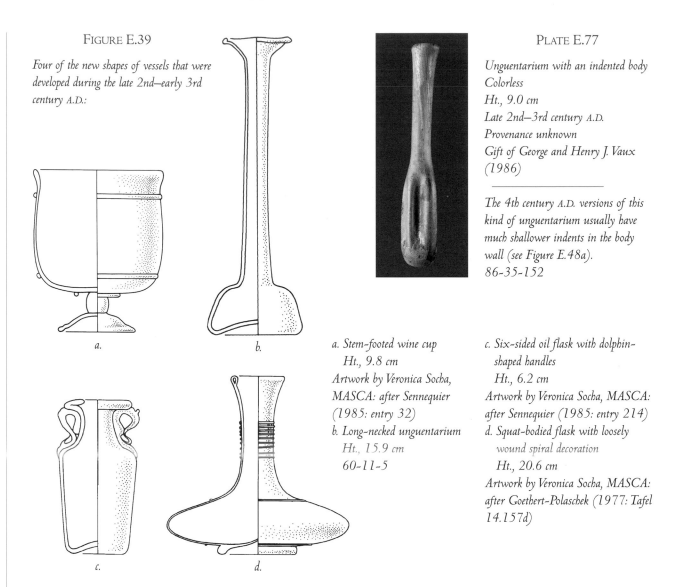

Four of the new shapes of vessels that were developed during the late 2nd–early 3rd century A.D.:

Unguentarium with an indented body
Colorless
Ht., 9.0 cm
Late 2nd–3rd century A.D.
Provenance unknown
Gift of George and Henry J. Vaux
(1986)

The 4th century A.D. versions of this kind of unguentarium usually have much shallower indents in the body wall (see Figure E.48a).
86-35-152

a.

b.

c.

d.

a. Stem-footed wine cup
 Ht., 9.8 cm
Artwork by Veronica Socha,
MASCA: after Sennequier
(1985: entry 32)
b. Long-necked unguentarium
 Ht., 15.9 cm
 60-11-5

c. Six-sided oil flask with dolphin-
 shaped handles
 Ht., 6.2 cm
Artwork by Veronica Socha, MASCA:
after Sennequier (1985: entry 214)
d. Squat-bodied flask with loosely
 wound spiral decoration
 Ht., 20.6 cm
Artwork by Veronica Socha, MASCA:
after Goethert-Polaschek (1977: Tafel
14.157d)

For glassware, this was a period when several new shapes emerged, among them a bead-stemmed wine beaker (Figure E.39a) which stands out as very different from all previous vessels of this kind, most of which were raised on a simple ring-base. To the seemingly endless choices among unguentaria was now added one type with a gong-shaped body and one with an indented body wall (see Figure E.39b and Plate E.77). Some of the new shapes had only a relatively brief period of appeal (Figure E.38c and d). Others, such as a square-bodied, thick-walled vessel that is now often referred to as a "Mercury flask" (Figure E.40),

were to remain in fashion right through into the 4th century A.D.

If we want to cross-link this period to the "tension" concept for the glassworking industry's development, we can now document one of the most obvious instances of *fashion* being the dominant factor for change. For it was in these times that a motif we now call "snake-thread" was first created in the Eastern Mediterranean, from there to be transmitted somehow or other to the Rhineland within the space of just a decade or so (Plate E.78). Once there, this was a motif that underwent several refinements over the next half

FIGURE E.40

The popular modern name for this kind of square-sided "Mercury" flask (Ht., 25.0 cm) comes from the fact that many of the surviving examples of it have a cast-in figure of the Roman fleet-footed deity on its base (see Inset). The flask's shape persisted well into the 4th century A.D., but with different markings (see Isings 1971; Boeselager 1989; and Follmann-Schulz 1989). Artwork by Veronica Socha; MASCA: after Goethert-Polaschek (1977: entry 1142)

INSET

Flask base
L., .5.6 cm
Trier 39,1 111
Courtesy of the
Rheinischen
Landesmuseums Trier

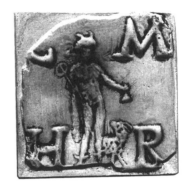

PLATE E.78

The "snake-thread" decoration on this flask (Ht., 21.3 cm) draws its inspiration from contemporary vessels in the Eastern Mediterranean (see Harden [1987: entry 59]). Each motif is flattened, naturally-colored like the body of the vessels, and single-hatched, sometimes only just surface-nicked. Find spots for western "snake-thread" vessels suggest that the route of transmission of this stylistic innovation was via Massalia (modern Marseille) and along the Rhone valley, rather than via the Adriatic coast and the Danubian provinces through which so much east-west technological transfer had occurred in earlier centuries (Taniichi Takashi 1982).

In the Eastern provinces, by the mid-3rd century A.D., the "snake-thread" often was cross-hatched instead (see Plate E.82), but this motif does not seem to have been penetrated westward beyond the lower Danube. Courtesy of the Rheinisches Germanisches Museum

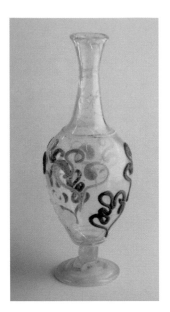

century or so, in part under the influence of a taste for stronger colors among the Germanic peoples who were crowding into the cities close to the Rhine frontier (Plate E.79). That Germanic influence became far more widespread, of course, after the Frankish invasion of Gaul in A.D. 263.

Whether the westward movement of the "snake-thread" motif was the result of Eastern glassworkers themselves migrating to the Rhineland, or whether it came about by the trading of their products to an Adriatic port and then northward along the river routes of the Danube and the Rhine, it is impossible to say. It is, however, in keeping with a prevailing mood in the Roman world, that this movement of an idea bypassed the Italian mainland. The falling stock of Rome in provincial eyes at this time is most clear in the so-called "Pagan Martyr" texts which present fictional encounters between Alexandrian dissidents and Roman emperors at various points from Tiberius' reign forward. Thus a certain Appianus, when on trial for accusing the Emperor Commodus of illegal activities in the Egyptian grain trade, has the nerve to state:

> The divine Antoninus [Marcus Aurelius] your father was fit to be emperor for he was first of all a philosopher, secondly had no love of money and thirdly was a lover of goodness. But you are the opposite— tyrannical, boorish, and uncultured.
> (*Papyrus Oxyrhynchus* 33. col. ii: after Musurillo [1979])

In this instance, Commodus' claim to be the god Hercules, and his well-curled beard and hair that echoed the look of Antoninus Pius, had failed to impress the aristocratic Greeks among his subjects!

Meanwhile, in the Gallic provinces, discontent with the Empire's central authority was expressed rather more violently. Lugdunum emerged as a hotbed of dissent, in part because its trade had suffered such a sharp downturn during the years after A.D. 170, when the forces of the Macromanni crossed the the frontiers on middle Danube and invaded northern Italy. Lingering

social tensions—in essence, a distrust of foreigners—is often cited as the reason for that city's persecution of local Christians in A.D. 177. Then there were the peasant revolts of the 190s—the first of their kind in the West—that embroiled the whole of Gaul and Spain and foreshadowed similar revolts a century later. In part these events also mirrored a growing irritation with Rome's political authority, matters that came to a head in A.D. 260 with an attempt by Postumus—then the governor of Lower Germania—to take the Gallic provinces out of the Empire altogether.

In the last years of the century the character of Roman politics was gathering a modern American overtone. A provincial governorship was now a potential stepping stone to imperial power, however humble a man's birthright, for those who had the courage to try and grasp it. Thus, in A.D. 193, Pescennius Niger made his bid to be emperor backed by the legions of Syria, while in A.D. 196 Clodius Albinus laid his claim by crossing into Gaul back by the legions of Britain. The ultimate victor was yet another provincial—Septimius Severus from the north African province of Tripolitania.

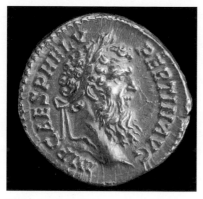

A comparative survey . . . would reveal no similar succession of reigns, variety of fortunes in both civil and foreign wars, disturbances among the provincial populations. . . . There have never been such earthquakes and plagues, or tyrants and emperors with such unexpected careers.

FRONTISPIECE F.14 see page 159

(Herodian, *History of the Empire* I.1)

E.14

SHIFTS OF POWER— LOTS OF THEM

THOUGH THE TEMPO OF HISTORY CANNOT BE MARKED OFF LOGICALLY IN neat, century-long packages from any calendar, religious or pagan, it is the transition years from the 2nd to the 3rd century A.D. that correspond to yet another important change in organization of Roman World. In A.D. 197, Septimius Severus could look back on a remarkable three years of military endeavor. He had crushed a revolt by his governor of Syria, Gaius Niger; overcome a challenge to his authority by the governor of Britain, Clodius Albinus; and humiliated the Parthians so badly that northern Mesopotamia once more was a Roman province. It was the middle of these three ventures that influences our story the most since Severus did not stop at just purging Rome of his immediate political enemies. He also vented his wrath on the Spanish provinces that had supported Albinus' cause against him by confiscating all manner of private estates and businesses. A product of Leptis Magna himself, Severus redirected Imperial patronage to that

PLATE E.80

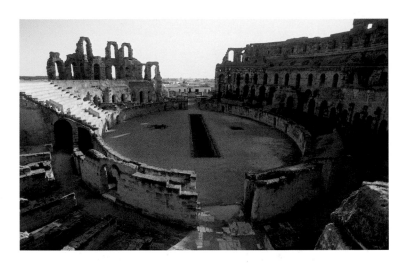

The amphitheater at Thysdrus (modern El Djem) in Tunisia was built early in the 3rd century A.D. from the profits of local olive growing. In size, it was then second only to Rome's own Colosseum. As in every prosperous north African city of the day, it offered the usual fare of popular Roman entertainment—gladiator combats and the savaging of criminals by wild beasts (Raven 1993).
Courtesy of Margaret Alexander, Corpus of the Mosaics of Tunisia

and many other north African cities and their agricultural hinterland (Plate E.80). As a consequence, the Spanish export trade, already weakened by the over-exploitation and contraction of its mining areas, suffered a sharp decline in its markets for wine and olive oil.[64] Most likely, the secondary industry of perfume-making, also was sharply curtailed at this time, taking with it the allied production of glass unguentaria.[65]

When Septimius Severus died at Eubracum (modern York) in A.D. 211, he left his sons Geta and Caracalla a greater inheritance than any emperor before him. But in that wealth lay the seeds of the near-collapse of the Empire's fiscal structure some fifty years later. Scarcely a year had passed before Caracalla murdered his brother and, to support his new position as sole emperor, bribed the Praetorian Guard with a promise to increase the pay of every soldier by a half. This stripping of Rome's treasury by some 70 million *sestertii* squandered in one day all that Septimius Severus had accumulated over eighteen years. Here was a political statement that often would be echoed thereafter—to control the Empire, you had to control the army; to control the army you had to pay well and willingly, in cash or in kind. Thus, in A.D. 235,

Maximinus was able to plunder the funds set aside for the support of Rome's poor and their grain dole in order to double his soldiers' pay. He knew well enough that his predecessor, Alexander Severus, had managed to impose additional taxes on all artisans—glassworkers included—but had been murdered the moment he tried to extend his tough fiscal policies towards the army.[66]

The next fifty years witnessed the arrival and departure of *twenty* emperors, most of them in bloody circumstances (Plate E.81).[67] With them went the intrinsic value of Roman currency. It makes for a stunning contrast to look back at the same section of the previous century when, under the firm rule of the long-standing emperors Hadrian and Antoninus Pius, the precious metal content of silver coinage had remained steady at about 2.9 grams.[68] By Caracalla's time, that content had dropped to about 1.9 grams; by the reign of Aurelian—the only emperor to exert any reasonable fiscal control over this period—it was less than 0.1 grams.

Despite their dramatic nature, however, I am inclined to believe that these manipulations of coin purity had little direct impact upon the glassworking industry. The debasement process did not carry with it the inflationary spiral that is the *bete noir* of

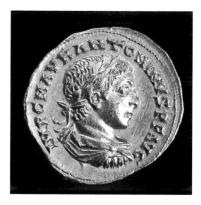

PLATE E.81

Emperor Elagabalus (reigned A.D. 218–222)
gold aureus (D., 2.2 cm)

It is some measure of the chaotic state of Roman world during the first half of the 3rd century A.D. that it would be ruled by a 14 year old Syrian who was a hereditary priest of the Oriental sun god, Elagabal. In the space of just a four year reign, the bisexual antics and bizarre cult rituals of this youthful emperor shocked Roman sensibilities even more intensely than the earlier political savagry of Caracalla and Commodus (see Scaffe 1995). It is fitting perhaps that this latterday Caligula-cum-Nero should be murdered in a latrine at the Praetorian Camp, then beheaded and dragged naked through the streets of Rome before being hurled in the Tiber, the traditional treatment of a convicted criminal.
Courtesy of The Trustees of the British Museum

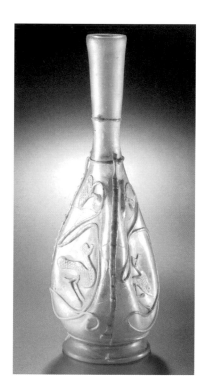

PLATE E.82

This ring-based flask (Ht., 21.7 cm), from Syria, shows how the naturally-colored light green decoration of the last 2nd century A.D. has given way to much brighter monochromes—in this instance, an opaque yellow. The flattened parts of the motifs are cross-hatched, an innovative feature of "snake-thread" wares that never seems to have been transmitted westward to the workshops now so active in Gaul and the Lower Rhine (Taniichi Takashi 1982: see also Plate E.78).
Courtesy of the Glassmuseum Hentrich, Düsseldorf

FIGURE E.41

This kind of cylindrical jar (Ht., 12.5 cm) seems to have been introduced in western Gaul late in the 3rd century A.D. first to supplement then replace the kind of small ointment pot shown in Plate E.34 (see Sennequier 1985: entries 195–200, and Table 2). Its occurrence in several 4th-century A.D. tombs in the Eastern Mediterranean (see Plate E.96) may represent a rare instance of West-to-East technological transfer. Artwork by Veronica Socha, MASCA: after Sennequier (1985: entry 195)

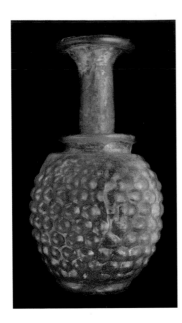

PLATE E.83

Grape-shaped flask
Colorless
Ht., 12.5 cm
Early 3rd century A.D.
Probably from Yebna in Syria
Purchased from Vestor and Co. (1913)

The evolution of this kind of vessel is discussed
in Stern (1995: entries 119–128).
MS 5114

INSET

A slight surplus of glass on each side
of this vessel reveals the location of
the joins of the two part-mold
used to create this vessel.
Artwork by Jennifer Hook,
MASCA

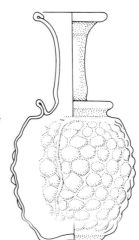

FIGURE E.42

THE MOLD-BLOWING PROCESS

The mold segments—in this instance two of them, though three
segments were used for some kinds of vessels (see Figure E.20)—
already have the final shape and decoration of a bottle's body carved
out of their inner surface. The glassblower first would warm the
mold, then inflate a hot bulb of glass into its cavity. Once
everything had cooled down, he would separate the mold
segments and so release the glass. The surplus
bulb above the body would later be reheated
and stretched to create the bottle's neck. That
neck might then be pushed back down so that
the bottle finished up with an annular flange
just above the body (see Inset). Crude though
that flange looks now, if as we suspect the
bottle was used to store a perfumed lotion, it
may have served the purpose of entrapping
fragments of crushed herbs each time the liquid
was decanted.
Artwork by Veronica Socha, MASCA

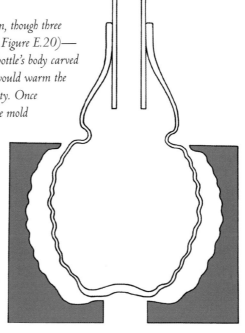

economic thinking for modern global markets. Each rival claimant to imperial power tended to have a regional power base with at least one major city. There he would mint vast amounts of coinage so that he could pay local men to be part of an army that was vital to his cause. At best, such enticement to serve was only effective in the short-term, since the local tradesfolk's reaction to the soldiers' wealth of coinage was to reject its face value. As one later historian put it, herein lay the first steps towards ". . . currency being driven out of the market." (Themistius, *Orations* XXXIII.367b). Emerging now was the notion of taxation and debt settlement with a component of "payment-in-kind" which would become an integral part of Roman governmental policy by the mid-4th century A.D.[69]

No, what must have undermined all Roman industries in the middle decades of the 3rd century A.D. was the disruption to trade, both short- and long-range, that is inherent in extended periods of military conflict. This certainly will have been true whenever one combatant or another sought to harness popular feeling against his rivals by deliberately cutting off the flow of staples such as grain and olive oil.[70] There were other disruptive forces at work as well, not least a loss of skilled civilian manpower, in part through regional conscription, in part through the ravages of the plague which re-emerged with frightening vigor over the period of A.D. 251–266.

As civil wars raged across the Empire, those outside it sought their own advantage. The Emperor Decius was killed by the Goths in A.D. 251 at the battle of Abrittus (on the eastern coast of the Black Sea); the Emperor Valerian was captured, at Edessa in A.D. 260, during his Eastern campaign against the Sasanians; and, in A.D. 260, the Franks swept across the Rhine, through Gaul, and into northeastern Spain. Understandably, the stream of calamities that overtook the Roman people during these middle decades of the century must have made them feel that they were being singled out for punishment from on high.[71]

The impact of this slew of crises varied enormously from province to province, and even within each one of them.[72] As economic conditions fluctuated in any particular region, so would the scale and originality of the glassworking activities there. Busy though this period of Roman history was, however, it is not one that has handed down much information about the organization of industrial activities. It is now much easier to invoke a shift in *taste* than a specific historical event to explain the popularity of certain vessel shapes and decorative motifs at this time, even though the social inspiration underlying that shift remains obscure (Plates E.82 and E.83; Figures E.41 and E.42). What we *can* say with confidence is that glassworkers continued to draw a great deal of their inspiration from contemporary metalware in a variety of ways (Plates E.84 and E.85).

Throughout this story of the Roman glassworking industry, my own instincts are to link the production of poorer quality glassware to times of economic stress and that of finer items to times of economic vitality. In the 3rd century A.D. that would seem to be a particularly easy thing to do, almost in an arbitrary manner, since every province experienced at least one period of hardship and one period of affluence.[74] In reality, however, such differences of quality just as easily could represent a substructure within the organization of the industry.

Egyptian glassware, for example, certainly displays a quality spectrum, at one end of which would lie some decidedly "clunky" unguentaria which were produced to satisfy simpler, rural needs (Plate E.86). At the other end, there were some attractive engraved and lathe-cut vessels which were marketed to a more sophisticated urban clientele (Plate E.87). The gentry of Rome and other cities around the Empire may have followed the imperial lead thus:

> Gallianus always drank out of gold cups; he despised a glass, because nothing was more common, he said.
> (Trebellius Pollio, *Augustan Histories:* The Two Gallieni XVII.5)

PLATE E.84

This bowl (Ht., 7.8 cm) is part of a silver hoard was buried at Chaourse in northern Gaul by a wealthy Roman as he fled the advancing Germanic forces during the middle years of the 3rd century A.D. Its decoration in relief with a dimple-and-boss already had been a popular one for Roman silverware for about half a century by then (Oliver 1977), and one that rather well mimicked in glass (see Plate E.85).[73]
Courtesy of the Trustees of the British Museum

PLATE E.85

Bowl with various bands of faceted decoration
Colorless
Ht., 8.7 cm
Mid-3rd century A.D.
From Leuna in Germany
Courtesy of The Trustees of the British Museum

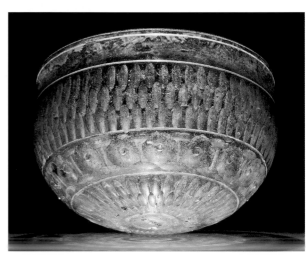

PLATE E.86

Thick-walled, squat unguentarium
Green
Ht., 9.7 cm
3rd century A.D.
Provenance unknown
Gift of George and Henry J. Vaux (1986)
86-35-159

PLATE E.87

This cup (Ht., 8.6 cm) depicts a nude male chiseling a new mark into one of the many measuring posts that were placed in the water of the Nile river, to keep track of its level after its annual inundation of the nearby land. The vessel itself was free-blown as a thick-walled blank of colorless glass, then ground to its outline shape. The Nilotic scene was facet- and linear-cut, and final detail was added by engraving (Harden 1987). Though this cup displays a great deal of craftsmanship, it probably still is a relatively inexpensive copy of a contemporary vessel of bronze or silver.
Courtesy of the Trustees of the British Museum

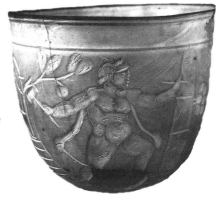

But some provincial families of means must have welcomed the availability of glassware that was more delicate than anything they could obtain locally.[76]

At the close of the 3rd century A.D. there was certainly some fine glassware in the marketplace; items that no one, now or then, would describe as "run-of-the-mill" (Figure E.43). Yet I do not believe that such wares raised glass significantly higher in the traditional ranks of Roman materialism. The societal attitudes towards glass that I have previously cited from earlier literary sources such as Petronius and Martial re-emerge in legal texts such as this one, which describes the proper steps to be taken when applying for public assistance:

If a man formerly used gold vessels, he must sell them and use silver ones; if he used silver vessels, he must sell them and use bronze ones; if he formerly used bronze vessels, he must sell them and use glass ones.

(Tosephta, *Peah* IV. 11)

The cultural reflection that glass offers at this point is of a Roman middle class within which there was a modest spectrum of wealth of the kind to be found in any American city today, and of a parallel spectrum of glassworking skills that had been developed to cater to everyone's domestic needs.

FIGURE E.43

This colorless glass wine flute (Ht., 34.7 cm) was found in a tomb at Sedeinga, a Meroitic town just south of the Third Cataract on the Nile, but it most likely is a product of an Alexandrian workshop (Leclant 1973). Its wheel-cut decoration comprises 73 lines, with the first and last bands cut more deeply for added emphasis. Given the woeful state of Alexandrian industry around A.D. 270, I suspect that this vessel must date to a decade or so later than that.[75]

What appears to be a smaller version of this flute is depicted in a mummy portrait panel illustrated in Parlasca (1966: Tafel 52). Artwork by Veronica Socha, MASCA: after LeClant (1973: fig. 3).

Thus goldsmiths use only fire made from straw when they shape the gold, because other kinds of fire are regarded as unfit. . . . Doctors again, demand a fire of vine twigs . . . when they distill their medicines. Those whose business it is to melt and fashion glass feed their fire with pieces of tree called the tamarisk.

FRONTISPIECE F.15 see page 159

(Macrobius, *The Saturnalia Conversations* VII.16)

E.15
WATERSHED II:
THE CONSTANTINE ERA

IN THE ROMAN WORLD, IT WAS ONE THING TO TOLERATE THE CHRISTIAN religion, it was quite another to embrace it. But the Emperor Constantine did precisely that in A.D. 312, immediately after his victory over Maxentius at the Milvian bridge just west of Rome (Plate E.88). He claimed to have had a vision of the Cross in the noonday sky just before the battle began, and on that Cross to have seen the divine command to "Conquer all this." All that day, the emperor pondered on the meaning of this vision. But then, that night, as he slept, ". . . the Christ of God appeared to him with the same sign that he had seen in the heavens, and commanded him to make a likeness of it and use it in all engagements with his enemies." (Eusebius of Caesarea, *The Life of Constantine* I.28).[77]

These events were a fitting epilogue to the lengthy story of Roman persecution of Christians which, less than a decade earlier, had been given such an ugly final chapter by Diocletian's savage assault on the faithful throughout the Eastern provinces.[78] Here too ended the history of Christians (along with Jews) being blamed for everything from outbreaks of the plague to earthquakes and crop-destroying storms; a history that had inspired one theologian to write a century earlier: "If the Tiber floods or the Nile fails to do so, the cry goes up: the Christians to the lion!" (Tertullian, *Apology* XL.I)

PLATE E.88

Emperor Constantine (reigned, A.D. 307–337)
Gold medallion (D., 3.6 cm)

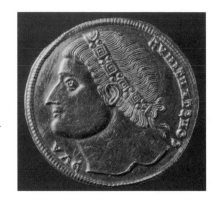

In a way that echoes the experience of several modern American presidents,
here was an emperor you either adored or loathed. Christian writers such as
Eusebius of Caesaria (circa A.D. 330) acclaimed him as a heaven-sent relief
from the pagan terrors of his predecessors; pagan writers such as Ammianus
Marcellinus (circa A.D. 390) attributed his stripping the precious materials
from pagan temples as a wish to line his own pockets rather than to carry
through an act of religious conviction. Whatever the truth of these views, we
can say with certainty that Constantine's conversion to Christianity had a
profound impact upon the course of the Roman glassworking industry.
Courtesy of Dumbarton Oaks, Washington D.C.

Only two decades later, Constantine founded Constantinople on the Bosphorus of northeastern Asia Minor as the new administrative heart for the Roman World, and declared it to be a city that, in its new architecture, would be exclusively Christian.

Constantine proceeded to shower privileges and money on the church. His specific exemption of the clergy from certain taxes attracted many a wealthy urban administrator to holy orders: senior officials in Rome itself were converted to Christianity, driven either by an honest hope of salvation or by a cynical wish to protect their political status (Plate E.89). The special property tax (*follis*) that Constantine exacted from major land owners was used exclusively to fund many church activities throughout the Empire.

That is not to say, however, that either the followers of the State's traditional pagan religion or the influential adherents to other cults calmly accepted Christianity's new-found primacy. First the Emperor Julian (reigned A.D. 360–365) attempted to turn back the clock, when he removed the tax exemption that Constantine had given the Christian clergy. Then, in A.D. 391 matters came to head, when the Emperor Theodosius issued edicts that prohibited pagan sacrifices and confiscated old temples and the estates surrounding them. It took a civil war that pitted Theodosius against a usurper Eugenius, who was backed by ardent followers of

the cults of Ceres and Cybele, before the pagan cause was finally crushed in A.D. 394 at the battle of the Frigidus river, southwest of modern Ljubliana, in Slovenia.

Between the zealous poles of the philosophical debate which brought Christian and pagan moral values into such violent conflict, there was a middle ground full of religious confusion. In the landscape of Rome itself, where the Church thrived on the strength of Nero's murder of Peter and Paul, new churches and martyr shrines took their place alongside the symbols of the past—the Forum of Trajan, the Colosseum, and the massive *thermae* of Caracalla, to mention but a few. This was the city where you could stand in one street and see the arches of Christian Constantine and pagan Titus (reigned A.D. 79–81) at either end of it. Not far away would be a temple dedicated to one of the mystery cults—Cybele, Mithras, and Serapis were the most popular at this time—with a priesthood that drew its members from the highest levels of Roman society.

Rome's material culture now reflected this mixture of beliefs at all social levels just as clearly as it did in its architecture. An already established taste for gold and silver vessels decorated in relief with pagan myths and Greek heroics was now extended to include Christian symbolism as well. In turn, these patterns were mimicked in glass by fine

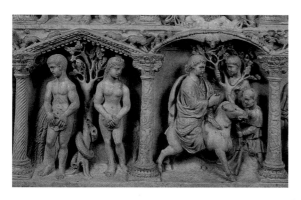

The senator Junius Bassus was baptized only a short while before he "went to God" in A.D. 359 (Keppie 1991). The elaborately carved niches of his sarcophagus capture ten Biblical scenes—the detail here here depicts those of "Adam and Eve" and "Jesus Entering Jerusalem". The layout of the images echoes contemporary pagan sarcaphagi that might instead recount a sequence of Bacchic revelries or the mythical labors of Hercules (Toynbee [1971: pl. 85]).
Courtesy of the Fabbrica di S. Pietro in Vaticano

PLATE E.90

The inscription on this mid-4th century A.D. fragment (D., 5.6) from the center of a gold-glass bowl reads "Sweetheart, may you live [long]." Christ holds two small wreaths over the married couple, thereby giving their union his blessing. For other Christian representations in gold-glass, and equivalent pagan ones, see Harden (1982) and Whitehouse (1996).
Courtesy of the Trustees of the British Museum

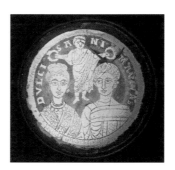

wheel-cut engraving that, in its skill of execution, set it above anything then being produced in the Western provinces. At the same time, picking up on an earlier use for glass as a matrix for portrait miniatures executed in gold leaf, Rome's glassworkers began to incorporate similar figurative images into the bottom of certain types of mold-blown bowls. These images also mirrored the diversity of religious views then prevalent in that city, from portrayal of the Evangelists or a youthful Jesus to commemoration of a pagan couple's wedding vows in a ceremony presided over by Eros or Hercules (Plate E.90: see also Figure E.50).

Meanwhile, beneath Rome's streets lay the catacombs, mile upon mile of galleries and chambers, each with burial niches cut into their walls. In the Via Latina catacomb, we find evidence of how even within one family there could be a division in beliefs: most of the burial chambers contained paintings of biblical episodes, yet one of them was decorated with the Greek myth of Herakles slaying the multi-headed Hydra. Meanwhile, in the Rondanini catacomb, we find a Jew laid to rest in a

sarcophagus which was decorated with a menorah surrounded by motifs usually associated with the cult of Bacchus.[79]

Rome's catacombs holds an important place in the history of glassworking at this point. Their origins go back at least to the years following the end of the Jewish revolt started by Shimeon bar-Kosba in A.D. 132. The long-standing Jewish custom in the Eastern provinces of burying the dead in rock-cut tombs (see Section E.16 below) was carried over into the subsoil of Rome, where layers of soft tufa were solid, yet easily cut. When a gallery's extent came close to the foundations of a building or a property line, the digging proceeded downward. So, with time, the catacombs became multi-leveled, resembling a pile of evergreen branches pressed down upon one another. The city's Christian community adopted this idea around A.D. 200, when Pope Zephyrinus commissioned the public cemetery that we know today as the catacomb of his deacon (later, the saint) Callixtus.

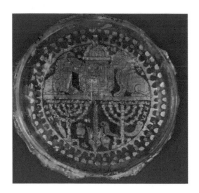

PLATE E.91

This fragment (D., approx. 7.0 cm), with its image of a menorah image, indicates clearly enough that was used to mark a Jewish burial in the catacombs (Schüler 1966). Gold-glass representations of stories from the Old Testament may also reflect a Jewish influence, but those scenes often appear in early Christian catacomb art as well (see Harden [1982: entry 154]).
Courtesy of the Vatican Museum

PLATE E.92

In the classical myth, the ill-tempered Thracian King Lycurgus took an ax and drove Dionysus into the sea, then headed into the forest to chase the Maenads. When attacked, one of them—Ambrosia—was transformed into a vineshoot by Mother Earth. Lycurgus is shown here in his vain struggle to prevent himself being strangled by Ambrosia's fast-spreading tendrils.

The presentation of this scene in glass, as a cage of decoration, follows an already-established taste for openwork design in Roman sculpture and metalwork, where again the imagery was often based on Bacchic themes (Kondoleon 1979). The use of a dichroic glass—jade-colored in reflected light, magenta-colored in transmission (as shown in the Inset)—suggests that the stimulus for creation of this, the Lycurgus Cup (Ht,. 16.5 cm) was the mimicry of a hardstone; possibly rock crystal, but more likely a similarly-colored amethyst (Vickers 1996).

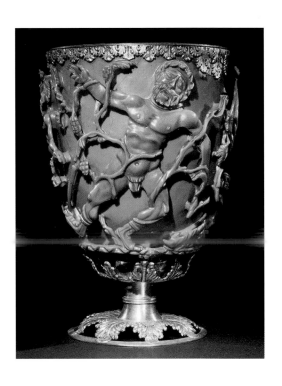

jade green
reflected light

magenta
transmitted light

Aspects of the cup's means of coloration and method of construction are described by Brill (1965) and Scott (1995), respectively. For a discussion of earlier forms of this kind of decoration—particularly a 1st century A.D. example from Ulpa Noviomagus (modern Nijmegen)—see Koster and Whitehouse (1989).
Courtesy of The Trustees of the British Museum

MAP E.5

The extent of the Christian church around the mid-3rd century A.D. The cities specifically named here held the status of patriarchate. Graphic by Mary Ann Pouls, MASCA: after Chadwick and Evans (1989:25)

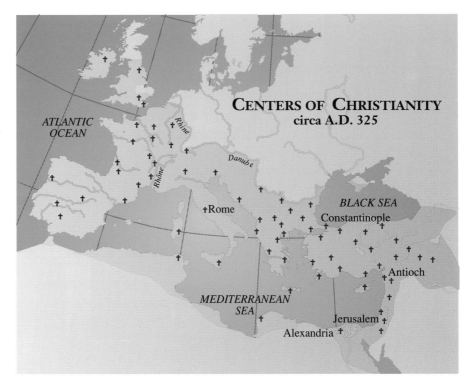

The burial niches for the dead were usually arranged two by two into the depth of the wall, then in tiers over the height of it, rather like bunkbeds. Each niche was sealed by stucco tiles in the case of Jewish catacombs, by stone or marble slabs in the case of Christian ones. Occasionally, this seal was inscribed with the deceased's name; more often they were marked by a coin or a pottery lamp, sometimes with the central disc of one of the gold-glass bowls described above (Plate E.91).

It had taken more than a half century for the swing of the State's pendulum towards Christianity to complete its course. Provincial Romans were more conservative than their Italian cousins, so their adoption of the new faith, for the most part, was much more gradual. In Athens, one marble carver's depiction of Christ has him playing a lyre just as Apollo would have done in a Classical sculpture of days long gone by. In Alexandria, young Christian ladies wore at their necks miniature texts of the Gospels that in outward appearance were the same as the papyrus rolls of love poems carried (and often hidden) by their pagan counterparts. In Cologne, the furnishings of a 4th century A.D. grave were as likely to contain a glass bowl engraved with the story of Apollo and Artemis as with that of Adam and Eve.[80]

The cult of Bacchus was particularly slow to yield to the ascendancy of Christianity, perhaps because it shared with the latter the notion that the savior god would offer his followers forgiveness in life and salvation in the Hereafter. This cult's persistence and strength is well-mirrored in silverware of this time—e.g., the massive dish from the Mildenhall treasure now in the British Museum, and the Dionysiac Ewer from the Sevso Treasure [81]—and, in glass, by the famous Lycurgus cage-cup (Plate E.92). Bacchus and his acolytes also crop up frequently enough, however, amid the decoration of less refined glassware in various parts of the Western Empire. If any previous emperor had endorsed this cult as fervently as Constantine did Christianity, Bacchus could well have emerged as the Empire's primary deity, with long-term consequences now too complex to contemplate.[82]

PLATE E.93

In earlier times, the rectangular sides of a sarcophagus that had been ideal sculptural surfaces for illustration of the unfolding events of a Greek myth or for the festive characters of a Bacchic procession. Now they provided just as good a format for the imagery of Christ among his apostles, as he handed down to them the "new law" of Christianity.
Courtesy of the Louvre, Paris

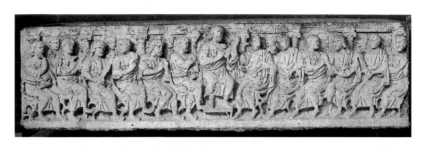

PLATE E.94

A close-up from the Thomas Panel *shows how the head was built up from shaped, skintone glass fragments, a variety of reddish-brown glass tiles and sliced canes, and dark brown strips that outline the eye (Brill and Whitehouse 1988; Auth 1990).*
Courtesy of the Corning Museum of Glass

It was perhaps the speed at which Christianity spread through the Empire that alarmed its opponents most. A commitment to the care of the poor and a readiness to share material wealth struck a chord in a Roman society that the Emperor Diocletian, in the preamble to his famous price-fixing Edict, had criticized as driven too often by "furious avarice." At the same time, many of the Church's leaders were quite tolerant of the way that many converts adapted certain decidedly traditional pagan notions into the rituals of their new belief (Plate E.93), even when on occasion those notions ran counter to the Gospels. Thus: "Their naivety is unconscious of the extent of their guilt, and their sins arise from devotion, for they wrongly believe that saints are delighted to have their tombs doused with reeking wine . . . But how can the saints approve after death what they condemned in their teaching? Does Peter admit to his table what his doctrine rejects?" (Paulinus of Nola, *Poems* XVIII.566) This same bishop Paulinus dedicated the cuttings of his first beard at a shrine for Saint

Felix in a way that recalled the important old Italian custom of *depositio barbae* that marked a youth's passage into manhood.[83]

By the second quarter of the 4th century A.D. there were thriving Christian communities throughout the Empire (Map E.5). Bishoprics as far afield as Armagh and Petra, Seville and Mosul, gave the Church a coherence of purpose, while an endless string of heated philosophical debates among its leaders ensured its dynamism. Rumors of past miracles gave many small towns a vital Christian significance, and the places of early martyrdom attracted large building endowments from the Roman aristocracy.[84]

Society's mood was persuasive to holy pilgrimage, so the devout increasingly ventured forth along the centuries-old, but still well-maintained network of roads and sea routes that criss-crossed the Roman World. Rome, Constantinople, and Jerusalem were the primary goals for such travelers, but there were numerous well-tended shrines, such as that of St. John in Ephesus, which could be visited along the

FIGURE E.44

a. High-based bowl
 Colorless
 Ht., 10.2 cm
 Second half of the 4th century A.D.
 Probably from Toobas, in Syria
 Purchased from Vestor and Co. (1913)

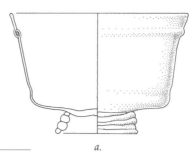
a.

The trail-wound base of this vessel has several parallels among the glass dumped near the furnaces at Jalame, in Israel, that operated for just three decades or so after A.D. 350, as does the double-folded ridge on its sidewall (see Weinberg 1988: Figs. 4–16 and 4–21).
MS 5055

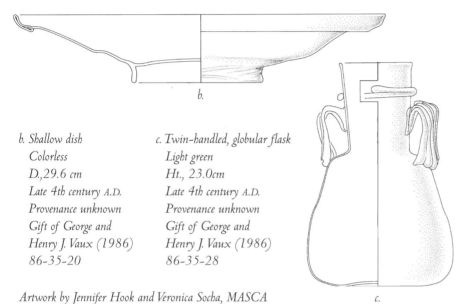
b.

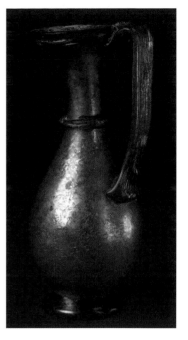

PLATE E.95

Jug with a reeded strap handle
Light green body, handle and single-coil decoration on the neck and at the rim
Ht., 19.3 cm
Late 4th century A.D.
Provenance unknown
Bequest if Mrs. Harry Markoe (1943)
43-12-18

b. Shallow dish
 Colorless
 D.,29.6 cm
 Late 4th century A.D.
 Provenance unknown
 Gift of George and Henry J. Vaux (1986)
 86-35-20

c. Twin-handled, globular flask
 Light green
 Ht., 23.0cm
 Late 4th century A.D.
 Provenance unknown
 Gift of George and Henry J. Vaux (1986)
 86-35-28

c.

Artwork by Jennifer Hook and Veronica Socha, MASCA

way. Early pilgrims ventured into lonely desert areas in search of scriptural history in the Palestinian landscape, and so pioneered the paths to holy places.[85] They brought back word of rare experiences that surely stimulated others to follow.

One find of glass, an unusual wall decoration now called the *Thomas Panel* (Plate E.94), puts in perspective the prevalent state of Roman religious attitudes at the everyday level. The panel itself is thought to come from the Fayoum region of Egypt, and to have been part of the architectural space of a monastic chapel. Its use in this way will have further defined the new order of things, in a region where the Gospel of Thomas (which was

later declared heretical) had been circulating as a manuscript on papyrus for about a century or so. Yet the workshop that produced this saintly image also created a similar set of panels that ended their days in packing crates close to the harbor of Kenchreai, the eastern part of Corinth in Greece that was abandoned in A.D. 375 in the aftermath on an earthquake. The imagery of those panels— scenes of life from the Nile marshes mixed up with images of legendary Classical characters such as Homer—indicate that they were intended to be part of a renovation of the local temple of Isis. Here was an attempt to restore the *old* order of things with a display of the comfortable icons of paganism.

Monks aside, Christian communities were mostly urban, moving out into the countryside only slowly. I am inclined to believe that for at least a century or so after Constantine rose to power, rural folk retained a faith in the power of the traditional pagan deities who stood watch over the practical matters of life, such as crop abundance and childbirth. Just as many converts clung to some of the more comfortable aspects of pagan last rites (see Endnote 83), so they also felt obliged to provide the deceased with all manner of daily necessities—toiletries and jewelry, tablewares and lamps to see by, and so on, just as pagan Romans had for centuries past. This, even though a Christian, in life, would have been taught that he/she had no use for such items in the blessed Hereafter. In those settings, worship had no need of a formal church: the notion of a Christian congregation was meaningful even if it were only a household gathering of family and friends.

A "homeliness" of this kind may well have given glass a significant place in the fabric of Roman religious life. Back at the turn of the 3rd century A.D. when Pope Zephyrinus required that glass vessels be accepted for use among the ritual vessels for the Mass, he was probably formalizing the status quo for that ceremony, wherein glass bowls, jugs, and flasks were part of the equipment for makeshift household altars throughout the Empire (Figure E.44 and Plate E.95). It is true that, around A.D. 225, Pope Urban I insisted on the use of silver for sacred vessels, but that minor edict is unlikely to have had much influence in rural areas where few had the where-with-all for such precious items.[86]

At the same time, it would be wrong to forge a particular link between certain types of glassware and the blossoming of Christianity. For example, in the farming village of Karanis in the Fayoum region of Egypt, where the pagan temples were closed in the 3rd century A.D., there were a number of homes that, a century or so later, had pottery figurines of Isis and stone carvings of crocodiles and hippopotamii (symbolic of the local deities, Sobek and Opet) mixed in with the normal range of domestic items. Glass vessels most likely had a place in the pagan rituals of those households. Jugs and cups would be taken from a kitchen shelf as needed, gaining a cultic significance only from whatever was poured or drunk from them during worship.

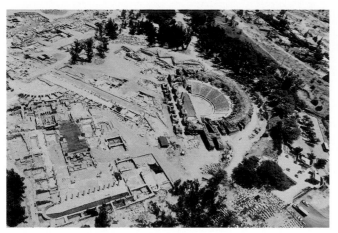

That is why we see in the skulls of the dead certain sutures which serve, so to speak, to tie together the two halves of the head. When these passages are somewhat large, dryness takes the place of moisture; and so such men are rather slow to go grey, but they do go bald.

(Macrobius, *The Saturnalia Conversations* VII.10.3)

E.16
BURIAL CUSTOMS IN THE EASTERN PROVINCES

THE DOMESTIC IMAGES PRESENTED TO US BY ANCIENT SITES SUCH AS Karanis are, of course, crucial to the kinds of reconstructions of cultural and craft interactions that I am attempting here. Truth to tell, however, by far the bulk of what we know about Roman glassware comes from the interpretation of its use as a grave good (Plate E.96 and Figure E.45); inevitably so, perhaps, since urban areas usually evolve by the destruction or modification of earlier structures, committing all kinds of domestic material to landfill and trash. Cemeteries, areas that out of respect for the deceased, already were set apart from the buildings and streets of the living, were intruded upon only rarely.

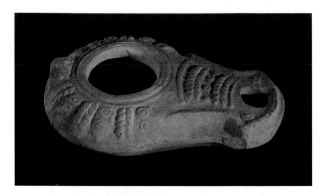

PLATE E.97

The arc of rope-like garlands, along with the cluster of pine cones and the so-called "Solomon's knot," are among the most common motifs found on pottery lamps in tombs throughout the Northern Cemetery at Scythopolis (modern Beth Shean) in Israel. Lamps like this one (L., 8.4 cm) have parallels at several well-dated sites in the region (see Seligman et al. 1996) and, along with some coin evidence, provide us with a reasonably reliable chronology for the individual graves within any one tomb complex.
32-15-14

PLATE E.96

This ointment pot (Ht., 12.3 cm), along with the jug shown in Figure E.45, was recovered from the middle grave in the rear chamber of tomb 1 of the Northern Cemetery at Scythopolis (modern Beth Shean) in Israel. Though the walls of the entrance eventually collapsed and the main chamber was in a ruinous state, several of the seven graves laid out in niches in this tomb's sidewalls were well enough prepared to shelter from any damage the glass items within them (Fitzgerald 1931).
29-105-684

FIGURE E.45

Jug with a thick, single thread handle
Colorless, yellow-tinged
Ht., 16.0 cm
Late 4th century A.D.
From Beth Shean in Israel: Northern Cemetery, tomb 1
Excavated by Gerald M. FitzGerald (1926)

Two of the five pottery lamps in this grave bear decorative motifs—one, a cluster of three pine cones; the other, an arc of rope-like garlands—that match those found in the tomb 295 discussed in detail later in this Section (see also Plate E.97).
29-105-703
Artwork by Jennifer Hook, MASCA

In the Western provinces, because burial grounds tended to cluster alongside the roads leading out of every town or city, cemeteries often developed an urban quality of their own, with a real houses-and-streets character.[87] In the Eastern provinces, however, they grew in a relatively haphazard manner—at least, that's how they look today in a bird's-eye view of the landscape. Often the burial chamber was hewn from the rock on the rise of a local hillside; otherwise, it was carved out underground, complete with approach steps, a linteled doorway and stone piers that supported the roof of its one or more rooms. Individual graves were cut at right angles into the wall of each room, the rooms in turn being linked by a doorways or a set of steps, depending upon how local geology controlled the expansion of the tomb complex, generation after generation (Plate E.97).

Perhaps the most impressive example of a tomb of this kind was the one built in A.D. 108 at Palmyra in the Syrian Desert for someone called Yarhai.[88] Running southward some 22 meters from a doorway covered with classical moldings, it had a sturdy 5-meter high barrel-vaulted gallery; its walls were lined with fine sculptures, including portrait busts that sealed individual graves, and various representions of funerary banquets. Its more than two hundred burial niches were almost all filled over the century and a half of this tomb's usage.

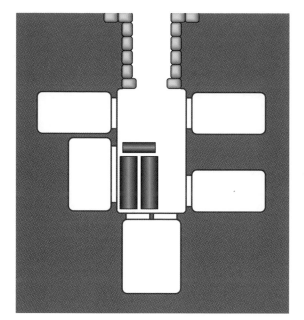

FIGURE E.46

Simplified ground plan for tomb 295 in the Northern Cemetery at Beth Shean in Israel. Other well-documented tombs of this kind included those in the cemetery close to the western wall of the frontier settlement of Dura-Europos, on the Euphrates (Toynbee [1971: figs.23–25]), and the burial caves on the hillsides overlooking Bet Shemesh, about 23 kilometers west of Jerusalem (Seligman et al. 1966).

The vessels shown in the Plates and Figure on page 100 are all from the second burial chamber on the left of this tomb. With the exception of one pottery oil lamp, a bronze bracelet and a bronze bell, all the grave goods in this chamber were of glass.
Graphic by Paul Zimmerman, MASCA

Much simpler tombs, such as those in the northern cemetery at Beth Shean in Israel, were far closer to the norm, comprising just a half dozen burial niches. In the example illustrated here (Figure E.46), the entrance porch was roofed over simply by two old sarcophagus lids; the central chamber was rough-hewn, and at some point a pit had been dug in its floor to make space for three unlidded sarcophagi. The glassware included among the grave goods of one of the burial niches is typical of what was available in the domestic marketplace during the mid-4th century A.D. when the interment occurred (Plates E.98–E.101 and Figure E.47)—various flasks, pots and juglets that were used to prepare or apply cosmetics in some way or other, and a jug and a bowl for water or wine.

It is difficult to detect the post-Constantine upsurge of Christianity in such burial contexts.[89] Almost every 4th century A.D. grave at Beth Shean contained a few pottery oil lamps; invariably these are decorated with just geometric and floral designs, but on occasion we do find one with a True Cross motif on it. The glassware associated with these Christian burials is, however, invariably secular, tangibly domestic, and similar to that found in all the other burials in the cemetery—jugs, bottles, small dishes, unguentaria, ointment pots, and other vessels that were probably used to store cosmetics of some sort or other. A wish to decorate glass vessels with the usual Christian symbols, such as the Xi-Rho style of the True Cross, should have encouraged a resurgence of mold-blowing, but that simply did not occur.[90]

In the land of the living, however, the Roman glassworking industry of the 4th century A.D. did receive one significant boost from the religious changes going on around it. Constantine's initial building program in Constantinople was followed through aggressively by later emperors so that, a century or so later, the city itself was twice as large as the original and boasted at least fourteen churches and eleven imperial palaces within its walls. At the same time, the pilgrimage to Jerusalem that Constantine's mother, Helena, undertook in A.D. 326 stimulated a rash of new church building there and throughout the Holy Land. Supportive private donations flooded in for the decoration of these churches, to cover their inner domes with fine mosaics and make them ablaze with light from massive gold and silver chandeliers. Glass oil lamps were being used more and more throughout the Roman World, to light homes

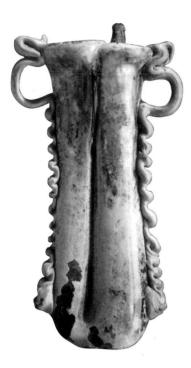

PLATE E.98

*Twin-chambered flask,
including a bronze spatula
for dispensing eye make-up
(see Plates E.106–E.109)
Light green, weathered
Ht., 11.2 cm
32-15-68*

FIGURE E.47

*a. Bottle with four looped handles
Colorless body, turquoise handles
Ht., 10.0 cm
32-15-59*

*b. Cylindrical flask, possibly
an ointment pot
Colorless (but purple tinged),
heavily weathered
Ht., 10.2 cm
32-15-85*

a.

b.

PLATE E.99

*Juglet decorated with single-thread
decoration at the neck and rim
Colorless body, green threads
Ht., 10.2 cm
32-15-66*

PLATE E.100

*Droplet unguentarium
Colorless
Ht., 18.4 cm
32-15-83*

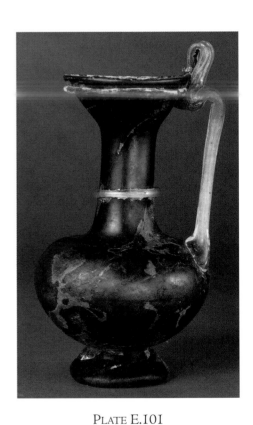

PLATE E.101

*Ovoid-bodied jug
Purple body, light green handle
Ht., 15.0 cm (to rim)
32-15-56*

and warehouses (Plate E.102). Now these could be mounted as sets in high-hung chandeliers, so that in some of the renowned churches of the day ". . . you would believe that the heavens were adorned with the twin constellations of the Wain." (Prudentius, *Hymns for the Day* V.144)

There was appreciable political pressure upon all government officials and wealthy landowners in the rural parts of the Eastern Empire to follow the lead of their urban counterparts. So, by the mid-5th century A.D., many a remote town could boast of a small, but ornate church that was replete with a few high-hung bronze chandeliers that could hold about a dozen or so glass lamps at a time.

I will discuss this ecclesiastical usage of glass in some detail later (see Section E.20). It suffices to say here that, of my three tension factors, *fashion and taste*, was exerting little pressure here: the near-universal usage of a cone lamp is a sign of practical expediency, not of any social favoring of this particular vessel shape. Of the other two factors, *technical innovation* also was of little importance—the idea of the cone—shaped lamps originated in the latter half of the previous century—while *historical events* were crucial, as the needs of church-builders now encouraged the production of lamps on an industrial scale.

PLATE E.102

Cone-shaped lamp, decorated
with a band of blue-blob clusters
Yellowish-green
H., 15.7 cm
Late 4th century A.D.
Provenance unknown
Purchased from Vestor and Co. (1913)

Fragments of this kind of lamp were
recovered in appreciable quantities from
the factory dump associated with the
glassmaking furnaces at Jalame in Israel
(Weinberg 1988) (see also Figure E.50).
MS 4943

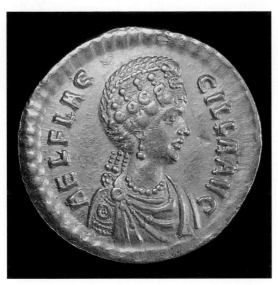

All this wasted pain on arranging your hair; what contribution can this make to your salvation? . . . One minute you are building it up, the next you are letting it down.

(Tertullian, *On the Worship of Women* II.7)

FRONTISPIECE F.17 see page 159

E.17

THE FORCES OF FASHION

ECCLESIASTICAL STIMULI ASIDE, ROMAN GLASS-WORKING UNDERWENT several other changes during the 4th century A.D. The imperial status of Constantinople brought Rome's military protection much closer to home and breathed fresh life into the economy of the Eastern provinces. Constantine himself influenced our story quite specifically at this time by granting to glassworkers an exemption from compulsory public services, ". . . to become more proficient themselves and instruct their children." (*The Theodosian Code* XIII.4.)[91]

One thing that had stayed constant through the centuries was the Roman love of cosmetics and perfumery. The morning ritual for the lady of the house—bathing, hairdressing, and the application of make-up (Plate E.103)—was as elaborate now as it had been in the 1st century A.D. when it had attracted so much mockery from the satirists Martial and Juvenal. Maids still lived in fear of a beating from their mistress, should they cause too much pain as they plucked out offending gray hairs or bound together the ringlets according to

PLATE E.103

In this scene on the famous Proiecta Casket (L., 55.9 cm) from the Esquiline Treasure (Shelton 1981), maids wait patiently as their mistress checks her appearance after they have prepared her complexion and her hair for the day. These were tense moments, since a maid could get a beating, if things were amiss (see Ovid, Love Letters I.14).
Courtesy of the Trustees of the British Museum

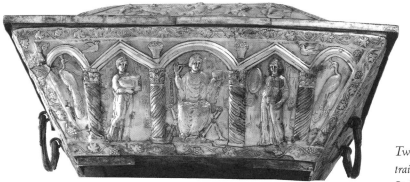

PLATE E.104

Twin-handled flask decorated with both pinched-tooth trails and a loosely bound coil at the neck
Light amber body, pale green trails and threads
Ht., 19.5 cm
Late 4th century A.D.
Provenance unknown
Gift of Lydia T. Morris (1916)
MS 5581

some current fashion.[92] The various kinds of flasks that were used to store scented oils and lotions were still part of a stock-in-trade for glassworkers, and there were the usual additional bottles and juglets that were used to prepare and decant fresh ingredients whenever necessary (Plates E.104 and E.105; Figure E.48).

It was now, however, that a very different kind of flask was added to this cosmetics kit; a heavy-walled vessel with two chambers in its body and a handle that in one way or another was attached alongside or above the body's rim (Plate E.106 and E.107). It was invariably used to store powdered galena, something that had always been popular in the ancient world as an eye make-up, but for some reason more in vogue than ever at this time (Plate E.108).[93] Galena is a toxic lead-based mineral so it

is not the ideal substance to have spread on one's face or for a maid to crush and handle as part of her servile duties. It seems, however, that health concerns were outweighed by a love of the subtle, silvery luster that characterizes galena, either solid or finely powdered (Plate E.109).

Some of these flasks still contain a bronze spatula that was used to portion out some galena powder as needed; others contain a roll-tipped applicator, suggesting perhaps that one chamber was used to store the cosmetic after it had been turned into a paste. That much we can guess about how these flasks were used; beyond that, however, this vessel's form is an enigma. The sometimes exaggerated looping of the handle suggests the flask was hung up or carried, not shelved or boxed like the traditional kinds of unguentaria. Yet many

PLATE E.105

Ointment pot with an extended
neck and splayed out rim
Green body
Ht., 5.3 cm
Second half of the 4th century A.D.
From Beth Shean in Israel:
Northern Cemetery, tomb 295
Excavated by Gerald M.
Fitzgerald (1929)

This vessel's form seems to be a direct adaptation of the
squater ointment pot that was so popular from the mid-1st
century A.D. onwards (see Plate E.34; also Sennequier 1985:
entries 64–69). As with so much glassware from Beth Shean,
this vessel has close parallels at a cluster of caves recently unearthed
in the Kidron Valley southeast of Jerusalem (Avni and Greenhut
[1996: fig. 5.5]).
32-15-80

a.

FIGURE E.48

a. Tear-drop unguentarium with four shallow
indents in the sidewall
Colorless
Ht., 22.9 cm
4th century A.D.
Provenance unknown
Gift of Lydia T. Morris (1916)
MS 5583

b. Juglet with amphora-shaped body and knob base
Colorless body, turquoise blue decoration
Ht., 9.1 cm
Late 4th–early 5th century A.D.
Provenance unknown
Purchased from Vestor and Co.
(1913)
MS 4949

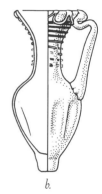

b.

of these handles were constructed in such a way that would have made it quite difficult to extract the cosmetic, dry or moist, from the chambers beneath (Figure E.49).

However impractical some of these flasks may have been, during the 4th century A.D. they were one of the most common items among tomb goods in Syria and Judaea and continued to be so over the next century or so. Typically, during the mid-5th and early 6th century A.D. a burial would contain two or three of these kinds of twin-chambered flasks, with the decorative motifs and handle types illustrated here mixed together in what seems to have been a quite arbitrary manner. Yet their popularity never spread even briefly beyond the Eastern Mediterranean; unlike so many glasswork-

ing innovations of previous centuries, this one found no favor at all in the Western Empire.

That does not mean, however, that the channels of communication across the Roman World were now so weakened that such a transfer of technology was not viable, if some broader dictates of fashion called for it to occur. A decorative motif that we now call "blue-blobbed" emerged in simple form during the latter half of the 3rd century A.D. almost simultaneously in various parts of the Empire, so we have no way of judging where the taste for it first took hold. The high point of this motif's popularity came in the early part of the 4th century A.D., but it stayed in the glassworker's repertoire for another century or more.

PLATE E.106

*Twin-chambered flask with a bronze
rolled-tip applicator
Light green body and decoration
Ht., 11.7 cm
Late 4th–early 5th century A.D.
Possibly from Beth Jibrin in Israel
Purchased from Vestor and Co.
(1913)*

*For the glassmaker, this new vessel
type was a relatively simple
innovation. A body with two chambers was created by
warming a tube of glass at its center and folding it upon
itself; one with four chambers was simply two of these
folded tubes fused together along their length.*
MS 5237

PLATE E.107

*Twin-chambered flask, with a
U-shaped carrying handle
Light green body, heavily
weathered
Ht., 18.9 cm
Late 4th–early 5th century A.D.
Probably from Tell Nimrin in
Israel
Purchased from Vestor and Co.
(1913)*
MS 5108

PLATE E.108

*In this gold-glass wall mosaic of the Santa Maria Maggiore in Rome
both the Empress Theodora (died A.D. 548) and her well-dressed
servants are depicted with black lines of thickly applied eye make-up.
Courtesy of the Christlich-archäologisches Seminar, Universität Bonn*

FIGURE E.49

*Twin-chambered flask with a
double-looped handle applied
over the rim
Light green body, blue handle
Ht., 18.2 cm
5th century A.D.
From Lydda in Israel
Purchased from Vestor and Co.
(1913)*

*For more elaborately developed handles
of this kind, see Fleming (1997b: fig. 25)
and Harden (1987: entry 77).*
MS 5103

PLATE E.109

*The lead sulfide mineral, galena, was always popular
as an eye-liner in the ancient Mediterranean world
(Paszthory 1990). Residues of it have been found in
several twin-chambered flasks of the kind illustrated
in Plates E.106 including one found in tomb 200
at Giv'at Sharet that had a number metal cosmetic
spatulae and spoons lying beside it (Blanchard et al.
1992; Seligman et al. [1996: fig. 17.2-4]).
Courtesy of Carolina Biological Inc., Burlington N.C.*

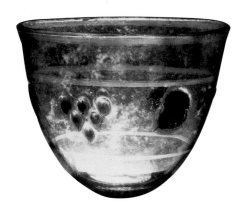

PLATE E.110

Deep bowl with a band of blue-blob motifs and
three sets of wheel-scratched lines
Colorless (greenish tinge) body, dark blue decoration
Ht., 9.5 cm
4th century A.D.
From Cyprus, formerly in the L.P. di Cesnola Collection
Courtesy of the Trustees of the British Museum

In the Eastern Mediterranean and around the Black Sea coastline, this motif became common on conical oil lamps and on handleless cups and bowls (Plate E.110 and Figure E.50, a and b): invariably, the blobs were set up within a single register and spaced out along it in a roughly symmetrical way. In the Rhineland the blob motif was used for all manner of vessel types (Figure E.50, c–f), but the color scheme eventually moved beyond dark blue to include various combinations of green, brown, and colorless. To be sure, this was a change of taste, but not a Roman one. Rather, it came with the Germanic peoples who were now streaming across the northwestern frontiers and settling around the larger Roman cities of that region. The tide of historical events now was carrying the western part of the Roman glassworking industry in quite new directions that soon would have very few parallels in the East.

Alongside this foreign-influenced development of the "blue blob" motif, however, I believe there was a real expansion of the glassworker's technical repertoire in the Western Empire that was a response to quite traditional aspects of Roman taste. At first sight, the backdrop of current historical events might not seem overly conducive to such an expansion. It is true that the political state of the Empire was much troubled by the personal conflicts among Constantine's heirs after he died in A.D. 337, but the associated civil wars tended to have limited flashpoints and were quite quickly resolved. Vast regions of the Western Empire were touched only marginally by these matters. Meanwhile the foreign threat was thoroughly well-contained over the first seven decades or so of the century, first by Constantine himself, then in the third quarter of the century by Julian and Valentinian I.[94]

With the Roman military presence beefed up in and around the main cities of the Rhineland, I suspect that there was an easy flow around that region of technical ideas about glassworking and possibly of the industry's craftsmen as well. So, alongside the "blue blob," at least two other decorative motifs were in vogue at this time. One of these motifs was a fine spiral of ribbing along the length of the vessel's body (Figure E.51). This was achieved by a molding technique that today is called *optic-blowing* (Figure E.52) that had been around in the Roman World at least since the third quarter of the 1st century A.D. (see Figure E.15b) though not used in the interim as extensively as we see here. The other was the application of a web of thick threads, usually directly onto the vessel's body, but sometimes slightly apart from it, like a cage (Figure E.53). Again, this motif was not new—less intricate web motifs of this kind were applied to wine beakers in Gaul during the early 2nd century A.D.—but it was now being applied to a much broader range of vessel types.

FIGURE E.50

A montage of vessel forms to which the "blobbed" decorative motif was applied (with blob colors as quoted):

a. *Deep bowl (see Plate E.110)*
 Dark blue only
 BM inv. GR
 1871.10-4.3
b. *Cone lamp*
 Dark blue only
 Karanis inv. 457
c. *Globular flask*
 Dark blue only
 RGM inv. N 133

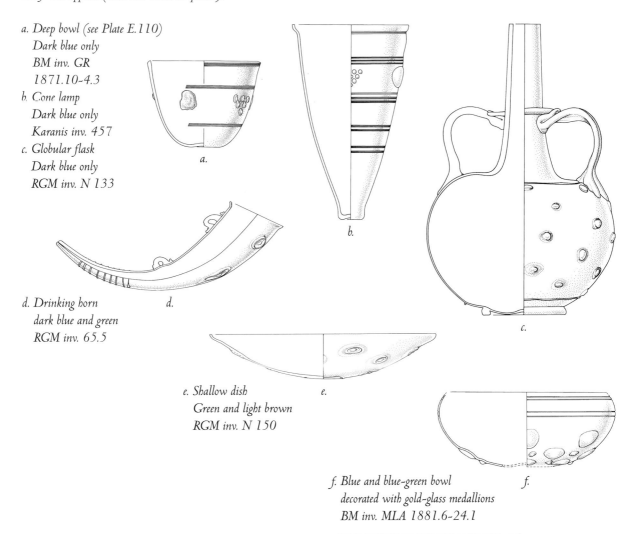

a.

b.

c.

d. *Drinking horn*
 dark blue and green
 RGM inv. 65.5

d.

e. *Shallow dish*
 Green and light brown
 RGM inv. N 150

e.

f. *Blue and blue-green bowl*
 decorated with gold-glass medallions
 BM inv. MLA 1881.6-24.1

f.

INSET

Old Testament scenes of this kind do not reflect a particular Jewish influence; they often are included in early Christian art in the catacombs. Artwork by Veronica Socha, MASCA: after Harden (1987: entries 46–49 and 154)

The decoration of this bowl (D., at rim, 18.8 cm) comprises three concentric rings of gold-glass medallions that were pressed into the vessel's outside surface and then individually sealed over by blue blobs. The gold-glass images include various scenes related to the story of "Jonah and the Whale," "Adam and Eve," "Abraham sacrificing Isaac," and each of the three "Children of Babylon" being cast into the fiery furnace (see Inset).

a.

FIGURE E.51

Two examples of optic-blown vessels from the first half of the 4th century A.D.:
a. Wine beaker
 Ht., 18.0 cm
 Trier ST.9 611a
b. Jug with fluted handle
 Ht., 25.2 cm
 RGM N 5947
Artwork by Veronica Socha: after Goethert-Polascheck (1977: Tafel 23.249a), and Harden (1987: entry 70)

step a.

FIGURE E.52

OPTIC-BLOWING

The glass bulb is first partially inflated while inside a grooved mold (step a), then free-blown to full size so that the ribbing on its surface are stretched and thinned (step b). The otherwise vertical patterning of the ribs then could be turned into a spiral either by a sharp spin of the blow-pipe while the glass was still hot, or by twisting the end of the vessel as its base was being shaped by pincers.
Artwork by Veronica Socha, MASCA

step b.

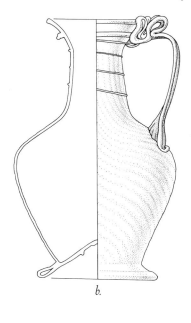

b.

a.

b.

FIGURE E.53

Two examples of web-threaded vessels from the first half of the 4th century A.D.:
a. Wine beaker
 Ht., 24.7 cm
 Trier 18 298b
b. Drinking horn
 Ht., 24.5 cm
 Trier 56,8m
Artwork by Veronica Socha: after Goethert-Polaschek (1977: Tafel 17.180m and Tafel 16.17)

This application of a web-like decoration to glassware gives me the opportunity to discuss a matter which, in principle, I could have raised at various points earlier in this story. Repeatedly, I have claimed that the decoration of glass vessels mimicked that of similar vessels cast in metal. The imitation most likely would be of bronze, because within his circle of market contacts the glassworker would have greater accessibility to it than to gold or silver. But these bronze vessels, in turn, invariably were imitations of ones fashioned from those precious metals.

What sets bronzecasting and glassworking apart from one another, in terms of process, is that the former is passive, while the latter is dynamic. By that I mean that a metalworker, when sculpting motifs into the surface of the casting mold, would pre-define their exact organization well in advance

PLATE E.III

Very little Roman silverware has survived from the early Byzantine era, so we are fortunate to have even this fragment from the cage-like decoration of a bowl that was part of the silver hoard from Scotland known as the Traprain Treasure (Curle 1923). Each of the identical oval-like parts measure about two centimeters across. Courtesy of the Royal museum of Scotland, Edinburgh

FIGURE E.54

The body of this cage-cup (Ht., 12.1 cm) is colorless, but the cage is carved from a green overlay, while the lettering around the rim—the Greek for "Drink, and may you always live well"—is carved from a red overlay. It was found in an early 4th century A.D. grave in a family cemetery at Köln-Braunfeld in Germany (see Harden [1987: entry 135]). The workmanship of this cup stands out because all the other goods associated with the grave were relatively simple items—a bone-handled knife, a few pottery jugs, and various kinds of domestic glass vessels, including a large plate with poultry bones on it. For a discussion of the development of this kind of decoration, see Koster and Whitehouse (1989): for a modern reconstruction of the processes and materials used to create such a vessel, see Scott (1993). Artwork by Veronica Socha: after Harden 1(987: entry 135)

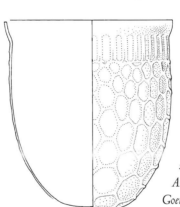

FIGURE E.55

As with other optic-blown glassware, the production process of this kind of cup (Ht., 12.4 cm) presumably had two steps to it. First, a bulb of glass was inflated within a relatively small mold, in this instance one with a neat network pattern carved on its inner surface (cf. Figure E.52). Then that bulb was reheated and free-blown to full size, so stretching, thinning, and somewhat distorting the decoration. Artwork by Veronica Socha, MASCA: after Goethert-Polaschek (1977: Tafel 25.309a)

of the bronze (or any other metal) being poured in. That organization could be precisely repetitive and formal—the molten bronze had no choice but to faithfully reproduce that formality. In the context of a web-like decoration, by intent the bronze version would be a rhythmic lattice of equally thick, similarly shaped metal units (Plate E.III).

In contrast, a glassworker who wanted to create a web-like pattern with thick glass threads had to handle a fluid material, one that was becoming less so by the moment, as it cooled. His actions will have been rapid and instinctive. The precision of the final patterning was controlled only by the craftsman's manipulative skills—inevitably the end-

product would be imperfect but unique. Whether one perceives such imperfection as a sloppiness and a technical limitation of glass as a medium, or as a vibrant means of artistic expression is very much a matter of personal taste.

As we pass through this period in the history of Roman glassworking, however, we cannot fail to take note of the one instance where glass was worked in a way that truly did come close to replicating metalwork. I refer to the production of the "cage cup"—a vessel with a web-like shell of decoration that entirely surrounds but stands proud from the solid body of the cup proper (Figure E.54). Few kinds of glass vessel have attracted more

modern attention or scholarly debate than these, not least over the question of whether or not they were luxury items and so were a breach of the usual ordering of Roman material hierarchy—maybe so, maybe not. Overall, however, they would seem to be represent a short side-street—given their quality, perhaps the metaphor rather should be "an elegant city mews"—off the main avenue of Roman glass-working development in the industrial sense.

There is a parallel to be drawn here with the range of quality that was evident among Egyptian glassware during the late 3rd century A.D. (see Section E.14). The technical skill inherent in creating the complex and fragile decoration on a cage cup places it at the top level of glassworking craftsmanship. At the next level down would be the freely woven web-caged vessels (cf. Figure E.53); below that again probably was a mass-produced, mold-blown variant of the web-like decoration that resembled a wide-meshed netting (Figure E.55). And, of course, beyond these three variations on a decorative theme lay a fourth one—no decoration at all.

That last observation raises another important issue. In tracking so many of the changes of decorative motifs as I have over the last few pages, amid the history of the 3rd and 4th centuries A.D., it would be easy to overlook the more mundane sectors of the Roman glassworking industry. Cooks always needed storage jars for spices and pickled food, and platters upon which to serve the meal. Maids always needed plenty of unguentaria in which to keep their mistress' favorite perfumed lotions. Physicians of the day, just like their early Imperial predecessors, stored their remedies in glass bottles and jars (Plate E.112). I think we can safely assume that, for every dish or flask with a "snake thread" or "blue blob" decoration applied it, there will have been hundreds more that were plain, or at most had a simple thread wrapped around it or a couple of abraded lines cut into its surface. It was through the production of tablewares and everyday necessities that most glassworkers, either itinerant or workshop-employed, made their living and fed their families.

PLATE E.112

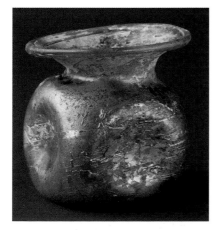

Squat jar with an indented sidewall
Light blue-green
Ht., 7.2 cm
4th century A.D.
Provenance unknown
Gift of John Frederick Lewis (1928)

This jar could have been used for all manner of purposes—to store a spice, to preserve a herbal perfume, or to carry a medicinal paste. This vessel is quite similar to one found in a physician's grave at Cologne (Künzl [1983:Germ. Inf. 7]).
38-28-64

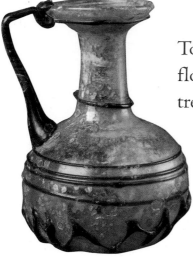

To the men it was a marvel to see the trail flowing from the fire, and the workman trembling lest it should fall and break.
Then he put the lump upon the double points of the pincers.

(Mesomedes, *The Palatine Anthology* XVI.328)

FRONTISPIECE F.18 see page 159

E.18
MOTIFS AND MOTIVATIONS

THE GOLD-GLASS ROUNDELS WITH THEIR STRONG ECCLESIASTIC FEATURES, the twin-chambered cosmetic flasks, the blue-blobbed and web-caged vessels, all of these stand out because of their aesthetic freshness. By the mid-to-late 4th century A.D., however, something intriguing was happening to the decoration of glassware in the Eastern provinces. Just four design motifs—all of them, an instinctive use of hot glass thread, as far as the glassworker was concerned—were beginning to dominate the decoration of the majority of domestic vessels. I have labeled these motifs as follows:

(i) Pinch-ridged trails, two thick threads of glass being draped down either side of the vessel, then pinched repeatedly along their length (Plate E.113);

(ii) The meander, a single thread of glass of medium thickness being applied in a zig-zag manner around the entire body of the vessel (Figure E.56);

(iii) The single-wrapped coil, two thick threads of glass being wound around just once at different points on the vessel's body, with one of them invariably placed at just below the rim (Figure E.57);

and (iv) The tightly wound spiral, a thin thread of glass being wrapped along a short length of the vessel's neck, invariably at just below the rim (Figure E.58).[95]

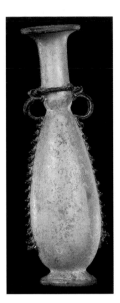

PLATE E.113

Twin-handled flask with pinched-tooth
trails applied down each side
of the body
Colorless body, turquoise blue handles,
collar and decorative trails
Ht., 21.1 cm
Mid-late 4th century A.D.
Provenance unknown
Gift of George and Henry J. Vaux
(1986)
86-35-62

FIGURE E.57

Juglet with an indented sidewall, and thick,
single-wound coils applied to the neck and rim
Light green body and decoration
Ht., 13.5 cm
Mid-to-late 4th century A.D.
Provenance unknown
Gift of John Harrison (1895)
MS 221

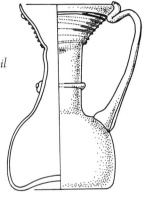

FIGURE E.58

Juglet with a thin, tightly wound coil
Light green body and decoration
Ht., 15.4 cm
Mid-to-late 4th century A.D.
Beth Shean in Israel: Northern
Cemetery, tomb 226
Excavated by Gerald M.
Fitzgerald (1926)

FIGURE E.56

Loop-handled oil lamp with a
zig-zag meander thread applied
to the body
Light green body and decoration
Ht., 11.0 cm
Mid-to-late 4th century A.D.
Provenance unknown
Purchased from Vestor and Co. (1913)
MS 4939

See also Plates E.2 and A.18 for other examples
of this decorative motif.
29-105-705
Artwork by Veronica Socha, MASCA

The nature of the workforce that was producing this tight repertoire of decorative motifs on glassware was rather different from what it had been two centuries earlier. The pool of slaves had shrunk considerably over the intervening years: far fewer craftsmen could be selected from the human cargo that came with spoils of war.

Anyone who would read into the dwindling of the Roman slave population some sign of a kinder world view among the Romans whom they served would be way off the mark. The coming of Christianity had not improved the lot of slaves one iota—indeed, some would argue that it was now far worse.[96] One of the foremost Christian moralists of the day did state: "He did not intend that His rational creature, who was made in His image, should have dominion over anything but the irrational cre-

ation—not man over man, but man over the beasts." (St. Augustine, *The City of God* XIX.15). Yet, within the space of a paragraph, that same writer was to observe: "The prime cause of slavery is sin, which brings man under the dominion of his fellow."

Slaves mostly were to be found in urban households handling the usual run of domestic duties. Lack of at least two or three slaves would have been viewed as a middle-class Roman's slide towards poverty—as symptomatic in this regard as renting (as opposed to owning) his lodgings. In rural areas, the land now was worked directly by freeborn men who were caught up in a seasonal cycle of payment-in-kind and only a small amount of cash income upon which to build the dream of owning a significant farm of their own. This rhythm of life would seem to be an echo of the Republican

PLATE E.114

Nowadays, we look back in wonder at the magnificence of the churches and palaces that were built in Constantinople by the Emperor Constantine and his imperial successors, and in other major cities of the Empire by the new adherents to the Christian faith. But this papyrus document, now called the Meletian Schism *and dating to about A.D. 330, captures all too poignantly the hardship imposed upon the craftsfolk and farming peasantry by the various kinds of government taxation that were introduced during the early Byzantine era. The text documents the sufferings of a certain wine-dealer, Pamonthius, who has fallen into so much debt that he was forced to not only sell all his property and his wardrobe but also to hand over his children to his creditors. Though the pledging of one's children as a security—and so, in the eventuality of default, committing them to a life of slavery—was illegal, it was widespread (Bell 1924).*[97]
Courtesy of the Trustees of the British Museum

view of workmen who were paid for their labor, ". . . for with these men, their pay is itself a recompense for slavery." (Cicero, *An Essay on Duties* I.42)

It may have been that slaves did carry out the most menial tasks in the craft workshops of the Eastern provinces. But the way that the social needs of artisans are respected in legal documents such as *The Theodosian Code* that I have cited earlier (see Section E.17), suggests that these skilled folk most likely were citizens, struggling like everyone around them to balance life against the relentless burden of taxes (Plate E.114). Despite such economic stress, however, freeborn status did give such folk an opportunity assuredly denied the slave of those or any other times—an option to move further afield, to another province or another land, if hard times struck the region they were in. As had been true in early Imperial times (see Section E.10), early Byzantine cities and towns of the Roman World were always in cultural flux, and always were a social melting pot and a place where technical ideas could be shared and brought to fruition.

Bureaucracy ran riot as Constantine and his successors sought to extend the revenues of the treasury by taxation, while wealthy landowners and merchants tried either to temper or to evade any imperial interference. Consequently, a great deal of the Empire's administrative routine was committed to leaf upon leaf of papyrus.[98] Hundreds of individuals were named in these documents. Yet I am not aware of a single glassworker being mentioned in this period or during the two subsequent centuries.[99] Either they were unusually honest folk, stalwarts of a town's industrial community; or else they were a part of society that still ranked low in the scheme of things. The uniformity of their products might suggest the latter, a low degree of patronage of their skills discouraging any significant amount of innovation.

With mold-blowing being a technique now used only quite sporadically, gone were the days when, for example, the Semitic character of a Greek goodwill message on a glass cup could point to Judaea as the vessel's most likely source (see Section E.7). For the most part, we are forced back to guesswork when trying to work out where each of the primary decorative motifs that I have described above first gained favor. We do know, however, that during its brief three decades of heavy productivity after about A.D. 355, a glassworking center at Jalame, about 15 kilometers southeast of the modern port of Haifa, was producing large numbers of vessels with either the thick, single-wrapped coil or tightly wound spiral on them.

PLATE E.115

Juglet with a zig-zag meander thread applied to the lower part of the body and thick, single-wrapped coils applied at the neck and under the rim
Amber body, light green decoration
Ht., 11.0 cm (to rim)
Early-to-mid–5th century A.D.
Provenance unknown
Gift of George and Henry J. Vaux (1986)
86-35-70

PLATE E.116

Jug with a pointed base and single-coil decoration applied around the neck and under the rim
Amber body, turquoise coils
Ht., 13.9 cm
4th century A.D.
Probably from Aleppo in Syria
Purchased from Vestor and Co. (1913)
MS 5133

This was a popular color combination for jugs and bottles of this period (see Fleming [1997b: fig. 6]).

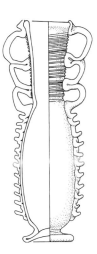

FIGURE E.59

Twin-handled flask decorated with both pinched-tooth trails and a tightly bound coil at the neck
Light green body and neck coil, dark green trails
Ht., 16.5 cm
Early-to-mid–5th century A.D.
Provenance unknown
Gift of George and Henry J. Vaux (1986)
86-35-64

FIGURE E.60

Amphora-shaped juglet with a zig-zag meander thread applied at the neck
Colorless body, dark blue decoration
Ht., 9.2 cm (to rim)
Early-to-mid–5th century A.D.
Provenance unknown
Gift of Mrs. Lydia T. Morris (1916)
MS 5538
Artwork by Veronica Socha, MASCA

If there was any regionality in the original use of any of these motifs, it was soon to be blurred out by the movement of craftsmen which occurred almost as easily as that of glassware itself along the major roads and caravan routes of the East. By the early 5th century A.D. the pairing up of motifs was becoming increasingly common and, along the way, a rather bland color palette of green-on-green gave way to a more imaginative use of blues—usually a dark one, but sometimes a turquoise—in the decorative meanders and threads. The bodies of these vessels now ranged in color from colorless to amber (Plates E.115 and E.116; Figures E.59 and E.60).

These various changes of patterning and color were quite effective, in aesthetic terms. Viewed in hindsight, however, I think it is fair to say that for once this was a time when it was the glassworkers of the Western Empire, particularly those in the Rhineland, who were carrying the torch for technical innovation. Their counterparts in the East were squarely in the grips of a tradition.

The wealthiest city of Gaul [Trier] was taken by storm no less than four times . . . the stench of the dead brought pestilence on the living; death breathed out death . . . What followed these calamities? The few men of rank who had survived the destruction demanded circuses from the emperor, as the sovereign remedy for a ruined city.

(Salvianus, *On the Governance of God* VI.13)

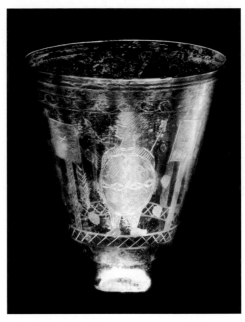

FRONTISPIECE F.19 see page 159

E.19

COLLAPSE IN THE WEST

THE DECORATIVE MOTIFS OF EASTERN GLASSWARE WERE DEFINITELY a consequence of prevalent fashion, regional or other-wise; each was applied to vessels of many different shapes and sizes. Their longevity of use was remarkable—the tightly wound spiral was still popular in the mid-6th century A.D. (see Plate E.125)—and was surely a product of the political stability of the Eastern provinces in those times—arid deserts and massive fortifications protected the Eastern frontiers, and Constantinople's walls easily withstood the assaults of northern barbarians.[100] When we look at the Western Empire over this same period, the cultural reflection we get from glassware is very different indeed.

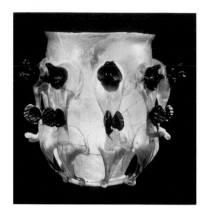

PLATE E.117

The group of dolphins that form the raised decoration of this mid-to-late 4th century A.D. cup (Ht., 14.7 cm) are a subtle combination of a then century-old technique of glassworking in the Rhineland—the application of modeled blobs of blue glass (cf. Figure E.50)—and a new one, where hollow tugs were pulled out from the glass of the body wall to form each creature (see Inset). Found in Cologne in Germany
Courtesy of the Römanisch-Germanisches Museum, Cologne

INSET

CROSS-SECTION OF A DOLPHIN'S BODY
To create bulbous protrusions of this kind, the as-yet unshaped mouth of the vessel will have been sealed in such a way as to leave access only through a narrow pipe (Follmann-Schulz 1995: fig. 1). As air was blown down that pipe, a part of the sidewall will have been reheated and a pontil rod attached so that a tug of glass could first be pulled outward, then downward, until it pressed against and fused into the vessel's body.
Artwork by Veronica Socha, MASCA: after Harden (1987: entry 145)

Diocletian's tax reforms early in the 4th century A.D. had done much to ensure that the army was paid regularly and supplied properly, and a strategy that separated civil and military authority in the western provinces reduced sharply the likelihood of rebellion by upstart governors. Authority returned to the central government in Italy and life in the Roman World calmed down for a while. In the Rhineland, frontier towns such as Noviomagus, Moguntiacum and Vetera (modern Nijmegen, Mainz and Xanten, respectively) shrank in size as the military withdrew from the crisis regions. The civilian city of Cologne flourished, however, as did its agricultural hinterland. This city's suburbs became even more crowded with all manner of industrial activities, among them several new state-run factories making weapons and clothing for the army. Glassworkers were thriving somewhere out there as well, producing both familiar wares, for domestic and trading purposes, and many others that were novel, in both technical and visual terms (Plate E.117).

It was not long, however, before the storm clouds of strife began to gather once more. From A.D. 328 onwards, the Rhine frontier was threatened time and again, until, during the last days of A.D. 406, a new wave of Germanic intruders—Vandals, Alans and Suebi—crossed the frozen Rhine and ravaged Gaul. The Vandals pushed forward through Spain and settled in North Africa in A.D. 439. Further east, the picture was much the same. Goths of the lands north of the Black Sea thrust into Greece, and in A.D. 410 Alaric's Visigoths forced open the gates of Rome itself. The Western Empire was fast vanishing in the face of a ceaseless tide of Germanic invasions, and trade in raw

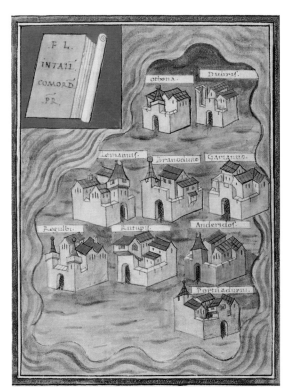

materials that underpinned the everyday rhythm of Roman industries such as glassworking was in disarray. Most glassworkers fled the cities and moved deep into the forests where they could be assured fuel for their furnaces.[101] Hereafter, the style and decoration of their products would be better described as Germanic rather than Roman.

Nowhere is this cultural transition more obvious than in Britain. It had been spared the first barbarian incursions that had so disturbed the Rhineland and Gaul during the third quarter of the 3rd century A.D. so that it was free to prosper and develop its own distinctive form of Roman culture.[102] By A.D. 343, however, Britain was in sufficient turmoil to justify the Emperor Constans risking a Channel crossing in the midwinter. He soon completed his first task—the hardening of the northern frontier against a threat of invasion by the Picts. Then he set about strengthening the fortifications against the raiding parties of various Saxon tribes from northern Germany, as they sought to settle along Britain's eastern shores (Plate E.118). A few years later, Emperor Julian staved off another threat from the Picts, but in A.D. 367 a "confederacy" of Picts, Attacotti and Scots (who were Irish tribes in those days) in the north, and Saxons and Franks along the eastern coast, invaded and devastated the British landscape. Soldiers deserted in great numbers, slaves escaped, and disorder reigned in the towns and villages. We do know that this was a time when many a smaller pottery workshop was destroyed or fell into ruin, never to be restored. We can assume that glass workshops suffered a similar fate, while itinerant glassworkers appreciably limited their orbit of travel to well-soldiered cities.

By A.D. 410, Emperor Honorius had to all intents and purposes washed his hands of the British provinces. During the intervening decades leading up to this dramatic political decision, there was an equally dramatic shift in emphasis in the range of glassware being used. All kinds of bottles, jugs, and flasks simply had been dropped from the glassworkers' repertoire of domestic wares, leaving it dominated by drinking vessels (Figure E.61).

This was something of an augury for the post-Roman World of the mid-5th century A.D. when the most distinctive glass vessel of northwestern Europe would be a slender cone-shaped beaker (Figures E.62 and E.63). This vessel was so distant from anything then being produced in the Eastern Mediterranean at that time, we can only wonder at the speed at which glassworking in the Western provinces shed its Roman mannerisms.[103]

FIGURE E.61

This shallow, dimpled wine cup (D., 15.7, at rim) makes its first appearance in the northwestern provinces sometime around A.D. 320 (Goethert-Polascheck [1977: type 15]. Over the next few decades it gained popularity alongside a number of cups with shapes—tall and conical, squat and cylindrical, etc.,—that clearly were ongoing adaptations of many earlier forms (see Cool and Price [1995: figs. 13.5 and 13.6]). Decoration with just a few bands of lathe-cut concentric lines was now the norm.
Artwork by Veronica Socha, MASCA: after Cool (1995: fig. 5)

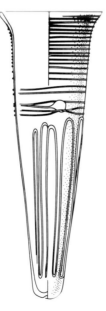

FIGURE E.63

This conical beaker (Ht., 21.5 cm) was found at Sint Gillis, in Belgium, and dates to the early 6th century A.D. The distribution of this vessel type ranges as far east as the area around modern Prague. Clustering in such beaker's findspots does suggest, however, that there were at least two main production areas for them, one in northern Gaul and one in southeastern Britain (Evison 1972).
Artwork by Veronica Socha: after Evison (1972: fig. 21)

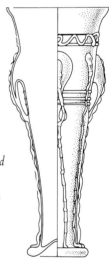

FIGURE E.62

This footed beaker (Ht., 17.5 cm) from Flavion, in Belgium, dates to the early 5th century A.D. (Follman-Schulz 1995). Its cone shape and its surface finish with tugs and trails, is a fascinating admixture of newly emerging fashions for glassware in northwestern Europe at that time (cf. Plates E.120 and also Figure E.62). Its decorative color scheme—opaque brown and opaque green over a light green body—is also decidedly Germanic in taste (see Section E.17).
Artwork by Veronica Socha, MASCA: after Follman-Schulz (1997: fig.13)

FRONTISPIECE F.20 see page 159

But while he [Emperor Julian] was putting into effect these methods of government, which should serve as a model to all good rulers, the fury of the barbarians burst out more violently than ever. They were like wild beasts which have acquired the habit of stealing their prey through the neglect of shepherds having consumed what they had plundered, they were driven by famine to renew their raids.

(Ammianus Marcellinus, *The Later Roman Empire* XVI.5)

E.20

WORLDS APART

WE ARE MOVING TOWARDS THE END OF OUR STORY. THE ROMAN World is fast-shrinking and taking on a complexion remote from the cultural style that would for ever characterize it in most people's eyes, ancient and modern. (One cannot help but wonder what pro-Republicans of the late 1st century A.D. such as the philosopher Pliny the Elder and the satirists Martial and Juvenal, would have made of the demise of traditional paganism and the fact that the Roman army was now dominated by foreign mercenaries.) In the West, the age-old pattern of power struggles and civil war, of murder and mayhem at the highest levels of government, continued to plague the Empire's stability. This was true even after A.D. 476, when the last Roman emperor, Romulus Augustus, took early retirement in Campanian countryside, so that Italy itself became part of the Ostrogothic kingdom.[104]

There can be no question that the original heartland of the Roman World finally had succumbed to the barbarian tide. Traditionalists who yearned for the revival of Rome's earlier glory were rueful about the state of their Empire: ". . . For what was once a world, you have left but one city." (Rutilius Namatianus, *On His Return* I.66). In A.D. 402, the imperial capital had been moved to the northern Adriatic port of Ravenna, just as barbarian hordes were sweeping into northern Italy. There, in A.D. 410, protected on the landward side by marshes and numerous tributaries of the Po river, Emperor Honorius was able to wait out and defy Alaric the Visigoth, even as he overwhelmed the rest of the Italian peninsula. (In turn, Ravenna also would prove to be a safe refuge for the barbarian kings of Italy, until it was captured in A.D. 540 by the forces of Emperor Justinian.)

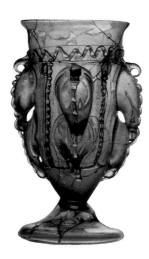

PLATE E.120

Despite the bloody means by which it usually was achieved, however, the translation of a Roman province into a Germanic one was rarely an abrupt break with the past (Plate E.119). The existing local aristocracy held on to much of its land and its political power because the new rulers needed their experience to survive. The conversion of the barbarian leaders to Christianity patched over many of the differences between the intruders and the entrenched; in fact, so effectively that many of the Empire's most active enemies bore Roman names just by virtue of their new faith.

However fuzzy some of the philosophical boundaries may have been at this time, contemporary glassware did mirror quite clearly the new Germanic/Byzantine division of the Mediterranean. The technical adeptness apparent in the construction of a Saxon stem-footed beaker with claw-like protrusions on the body (Plate E.120) can be traced back with little difficulty to late 4th century A.D. vessels from Cologne (see Plate E.117). The elegant simplicity and limited decoration of a long-necked unguentarium of the kind which would become so popular in the Eastern provinces in the 6th century A.D. (Figure E.64) can be traced back to various kinds of late 4th/early 5th century A.D. juglets and bottles from that region (see Figures E.58 and E.59). Set side-by-side, the amount of stylistic separation of these vessels is a fascinating counterpoint to the closeness of some earlier Eastern and Western decorative motifs—particularly, "snake-thread" and "blue blobbed" (see Plate E.78 and Figure E.50)—that had resulted from the efficient flow of glassworking technology across the old Roman trade network.

During the 6th century A.D., even though the political landscape of Europe could be delineated as Germanic or Byzantine, Christianity was still the dominant religion in Rome and there was a constant dialogue between that city's patriarchs and

FIGURE E.64

a. *Globular bottle with a tightly wound*
 thread applied along the neck
 Light green
 Ht., 9.6 cm
 Early 6th century A.D.
 Probably from the Galilee in Israel
 Purchased from Vestor and Co. (1913)
 MS 4942

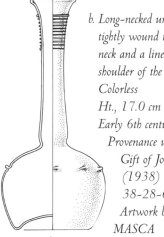

a.

b. *Long-necked unguentarium with a*
 tightly wound thread applied at the
 neck and a line of small tugs on the
 shoulder of the body
 Colorless
 Ht., 17.0 cm
 Early 6th century A.D.
 Provenance unknown
 Gift of John Frederick Lewis
 (1938)
 38-28-68
 Artwork by Veronica Socha,
 MASCA

b.

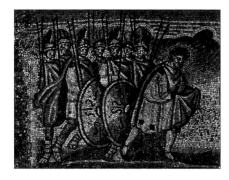

PLATE E.121

This mosaic from the Church of St. Maria Maggiore in Rome depicts
Joshua before the Angel of the Lord, and dates to the mid-5th century
A.D. (Elton 1997). Since they are laid out at slightly different angles,
the individual gold tesserae *create a scintillating effect in the*
background to this scene.
The most spectacular use of gold tesserae was in the Church of San
Vitale at Ravenna, where Emperor Justinian and his wife Theodora
are depicted among their numerous court attendants. There, the visual
power of a massive array of tesserae *led an unknown poet to*
conclude that about the mosaics of the Archibishop's Chapel: "Either
light was herein born, or else here imprisoned freely ruled."
(Bustacchini 1973).
Courtesy of the Christlich-archäologisches Seminar, Universität Bonn

Constantinople. This shared faith provided an area of common ground in the technology of glassworking as well, via the gilded glass tiles (*tesserae*) that were used to decorate the walls and high vaults of the churches in the East and the West (Plate E.121).[105]

The production of these tiles consisted of applying a fine gold leaf to a sheet of plain sheet of glass about a centimeter thick, then covering the gold with a layer of powdered glass that would be fired so that it sealed the surface. The uneven thickness of this final overlying glass layer created subtle variations in the gold tone of the mosaics in which the tesserae were placed.

There is little evidence for the use of gold tesserae before the time of Constantine, except the two remarkably early ones, in Nero's Golden House around A.D. 65 and in a complex piece of garden architecture of around A.D. 90 that is now known as the Stadium of Domitian. By the mid-5th century A.D., however, these gold mosaics were to be found all over the place, not only in ecclesiastical settings, but also in the decoration of private villas, public baths and various administrative buildings in the Northwestern provinces.

In the East, the one vessel type that did evolve strongly over the 5th and 6th centuries A.D. was the glass lamp. The cultural stimulus here undoubtedly was the practical demands of the Christian Church. An early 5th century A.D. bishop-poet wrote:

Then, in the middle of the basilica hang hollow lamps, attached to the high ceiling by brass chains. They look like trees throwing arms like vine shoots; at their tips the branches have glass goblets as their fruit, and the light kindled in them is, so to say, their spring blossoms. With the abundant foliage of their flames, they resemble close-packed stars, and stud the heavy darkness with countless flashes. . . .

(Paulinus of Nola, *Poems* XIX.416)

PLATE E.122

The original Church of Holy Wisdom in Constantinople was burned down in A.D. 532 during riots of factions of circus supporters against unpopular ministers of the Emperor Justinian's government. The church was rebuilt and consecrated just five years later. Its magnificence prompted Justinian to declare, "Solomon, I have surpassed you!"

Though this is a much more recent view of the interior of the Church, it does give us a sense of how many lamps would be needed to illuminate a building of this size. Courtesy of the British Library: from G. Fossati's Aya Sophia *(1852)*

FIGURE E.65

The two kinds of cone lamps shown here were found in 6th century A.D. contexts at Samaria in Jordan, some in the town itself, some in the ruins of the Church of St. John the Baptist. For some of the contemporary variants of these lamp shapes, in terms of bowl fullness and stem length, see Crowfoot et al. (1957: fig 99).

*a. Long-stemmed, deep
 bowl chamber
 Ht., 7.8 cm
 Samaria 96.1*

a.

*b. Long-stemmed,
 shallow bowl chamber
 Ht., 9.0 cm
 Samaria 96.2*

Artwork by Veronica Socha, MASCA: after Crowfoot et al. (1957: fig. 96)

b.

PLATE E.123

*Oil lamp with three looped handles on an extended neck
Light green
Ht., 13.4 cm (to rim)
Mid 5th–early 6th century A.D.
Provenance unknown
Gift of George and Henry J. Vaux (1986)*

This kind of vessel also may have been used as a storage cup for food offerings, when placed among grave goods (Seligman et al. 1996). 86-35-23

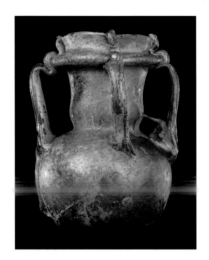

As for the Church of Holy Wisdom in Constantinople (Plate E.122), another poet described how the basilica's chandeliers were massive silver discs, pierced through so that: ". . . they may receive shafts of fire-wrought glass, and hold light on high for men at night." (Paul the Silentiary, *Description of San Sophia* II.823)

By then, the simple cone lamp that had been so popular in the previous century (see Plate E.102) had been re-shaped in a variety of ways (Figure E.65). These lamps in turn would be the prototypes for those used to light mosques in the Islamic world from the 9th century A.D. through to present day. Meanwhile, various vessels that could just as easily have been cups, jars, and bowls in a domestic setting seem to have had secondary use as lamps. Those with open-looped handles could have been suspended individually, rather than be part of a chandelier (Plate E.123); these too were prototypes for mosque lamps in later centuries. Other cup-shaped lamps without handles certainly were used in synagogues, either as a set mounted on a cross-bar on the top of the menorah or individually, on the tip of each of its seven branches.[106] In the 6th century A.D. the addition to bowl-shaped lamps of a central glass tube that would hold the wick steady and erect did assure a constancy of the flame. But this innovation was by no means universally adopted.

URBS CONSTANTINOPOLITANA NOVA ROMA.

FRONTISPIECE F.21 see page 159

Glass vessels for eating and drinking
are to be considered in the class of
household goods, just as earthenware
vessels are, not only the common ones,
but also those that are more costly.

(Paulus, *The Digest* XXXIII.10)

E.21
OF JUSTINIAN AND JERUSALEM

B Y CHOICE, I WOULD PAUSE HERE TO DISCUSS IN SOME DETAIL THE events of Emperor Justinian's reign (A.D. 527–565) (Plate E.124). His reconquest of Italy and North Africa and refortification of the frontier on the Danube, his rationalization of Roman Law in A.D. 529 (as *The Digest*), the severity of both the taxes he imposed and the way he collected them; all these aspects of his rule recall the dynamic times of earlier emperors such as Augustus, Trajan and Constantine, when glassworking underwent such significant change. His wooing of and marriage to Theodora (see Plate E.108)—by some accounts, an erstwhile exotic dance-hall performer and itinerant prostitute—and their subsequent joint efforts to increase the imperial fortune at the expense of every level of society rivaled the personal and political scandals of Nero's days that resulted in so many changes in taste and fashion in Roman material culture, including glassware. Again echoing past times, in A.D. 542, there was a devastating outbreak of the plague that raged through Constantinople itself for close to four months, and seemed to usher in an era of pestilences and epidemics in the Byzantine World for two centuries thereafter.[107] Tens of thousands died from this afflication, just as so many others had done before them in the mid-2nd and later 3rd centuries A.D.

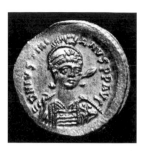

PLATE E.124

Emperor Justinian (reigned A.D. 527–548)
gold solidus *(D., 2.2 cm)*

Justinian was a fervent Christian who believed that the strength of the Empire depended on God's favor, which he resolved to win by the harsh suppression of both paganism and heresy. This religious intolerance, along with many aspects of his private life, attracted plenty of criticism—not least from Procopius of Caesarea, whose scandal-rife Secret History *was, for good reason, only published a few years after the Emperor's death (see Atwater 1966). Justinian is well-respected by modern scholars, however, because of his efficient reform of the legal appeals system and the way he rooted out corruption in the Roman administration of the provinces. Courtesy of the Byzantine Collection, Dumbarton Oaks, Washington, D.C.*

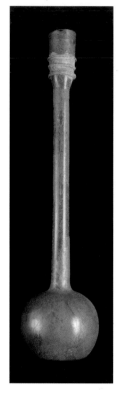

PLATE E.125

Long-necked unguentarium
colorless
Ht., 30.4 cm
Early 6th century A.D.
Probably from Beth Shean in Israel
Purchased from Vestor and Co.
(1913)

As the years slipped by, most of the standard decorative motifs of the 4th century A.D. either went out of fashion or underwent significant adaptation. The tightly wound spiral motif remained in vogue, however, for almost two centuries (Fleming 1997b).MS 5022

Justinian's times would seem to be an ideal setting, therefore, for another discussion of my "tension" concept for the course of glassworking's development. Sadly, however, the archaeological record for glassware from the Eastern provinces is nothing like as fine-structured as that of the Western provinces during the early Imperial era. There are few stratigraphic sequences to match those at 1st and 2nd century A.D. military settlements on the Rhine frontier and the *colonia* of Romano-Britain, sequences that are crucial to the accurate dating of changes in fashion among the decorative elements of tablewares and other domestic glassware. Though the traditionally sturdy tombs of the Eastern provinces have done so much to protect early Byzantine glassware for us, the multiple- and re-use of so many of the burials within those tombs certainly clouds matters a great deal.

The lack of written records of the war-racked and plague-ridden years of 3rd century A.D. (see Section E.14) limited me to conjecture as to what brought about changes in the Empire-wide organization of glassworking thereafter. Similarly now, in the 6th century A.D., I can only argue from logic that much the same kind of scenario applied; that Justinian's military campaigns will have interrupted the flow of glassmakers' raw materials and that the spread of the plague will have scattered or caused the death of significant portions of the industry's workforce.

In fact, in the aftermath of these difficult times, it may be inappropriate to describe glassworking as an industry any more. Presumably the scale of overall production was roughly proportional to the Empire's population and so stayed high, because of the everyday wear-and-tear on domestic vessels. But the shifts in material taste that assuredly occurred in Constantinople now seem to have minimal provincial impact: several of the popular decorative motifs for Syrian and

FIGURE E.66

Unguentarium, with a tightly wound thread applied at the neck and diagonal ribbed on the globular body and raised shoulder
Colorless, optic blown
Ht., 17.7 cm
Early 6th century A.D.
Provenance unknown
Purchased from Vestor and Co. (1913)

Some flasks of this kind have a deliberate constriction folded into the point of juncture of the body and the neck. This feature, along with a long neck, would prevent overly rapid evaporation of perfumed oils stored in the main body.
MS 5265

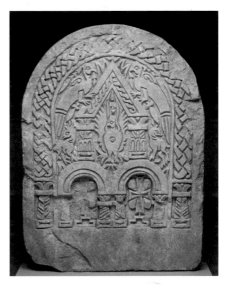

PLATE E.126

The relief decoration on this sandstone tombstone (Ht., 58.5 cm) from Esneh in Egypt, has as its centerpiece the phoenix, the mythical bird that was sacred to the Isis cult and symbolic of the periodic renewal of her son Osiris. Christians adopted the bird as a symbol of the risen Christ.
Courtesy of the Museum of Fine Arts, Boston, Sears Fund

Judaean glassware during the 5th century A.D.—most obviously the tightly-wound spiral, as applied to the necks of bottles and unguentaria (Plate E.125 and Figure E.66)—extend themselves seamlessly into the 7th century A.D. and beyond (see Figure E.67). If a workshop owner did turn his thoughts to that city most likely it was only to ponder whether or not the heavy taxes he paid ever reached there. If glassware is indeed a guide on such matters as this, his customers were the conservative provincial folk in his nearest town.

However cloudy our picture may be of craft activities during the 6th century A.D., what we do know is that the Christian Church then was having a great deal of success in reaching the hearts and minds of ordinary people. Over the years, it had broadened its appeal by a selective absorption of popular elements of other cults into the mainstream of its beliefs (Plate E.126). Meanwhile, it had encouraged the development of subsidiary

cults that honored specific saints and other holy persons. Their images, when formally presented as *icons*, became a tangible focus for a faithful follower's prayers. This was when the Virgin Mary gained cultic significance, as the special protector of Constantinople itself, so that exquisite icons of her holding the infant Christ were to be found throughout the city. Imperial patronage, like that of Justinian for the Monastery of St. Catherine at Mount Sinai, ensured the artistic quality and impact of such imagery, wherever it was displayed.

With so much to see and search out, the flow of pilgrims eastward to Jerusalem continued to rise. With stubborn determination and for months on end, they trudged the bandit-ridden roads and dirt tracks that linked Eastern towns to the myriad of monasteries and hallowed places where they had heard this or that relic could be found.[108] Once in the Holy City itself, however, they could walk in comfort to its two main shrines—the supposed site

of the Crucifixion (*Golgotha*) and the reputed burial place of Jesus, both of which were housed in the Church of the Holy Sepulcher (Plate E.127). At both these places a pilgrim could ask for a small bottle or juglet of sacred oil; something to be taken home and cherished as the most important momento of his or her travels.[109] An excerpt from the writings of someone who accompanied Antoninus of Piacenza during his travels through the Holy Land in about A.D. 570 captures the excitement of pilgrimage to Jerusalem in these times:

> At the moment the cross is brought for veneration. . . . they offer oil to be blessed in little flasks. When the mouth of one of the flasks touches the Wood of the Cross, the oil instantly bubbles over, and unless it is closed very quickly it all spills out.
> (*The Piacenza Pilgrim*, v. 173: from Wilkinson [1977: 83]).

We can only guess what kinds of vessels were used in this way—almost all the bottles and flasks which earlier I attributed to the paraphernalia for preparing or storing perfumed oils and lotions could have served such a purpose. If we were to

link any particular vessel to this outcome of pilgrimage, however, it would be a hexagonal juglet that has images of the True Cross impressed into its body wall; actually, three different representations of that Christian symbol that would place the period of manufacture firmly in the last couple of decades of the 6th century A.D. (Plate E.128).

Was the influx of pilgrims into the shrine-laden cities of the East directly responsible for the popularity of this vessel? For its iconography, obviously so; for its underlying shape, I think not. The latter probably entered the glassworkers' repertoire a few decades earlier, at which point the decoration may have been limited to floral and/or geometric patterns. The first use of this kind of vessel as a vehicle for religious imagery may well have been Judaic (Plate E.129); thereafter perhaps it was a case of Jewish glassworkers catering to the needs of Christian pilgrims as a matter of practicality; as a logical market extension that simply could not be ignored, whatever religious animosites still existed between these groups.[110] Alongside these vessels were others that were decorated with fishes and birds in ways that might or might not have religious meaning, Christian or Jewish.

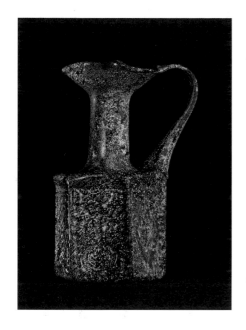

PLATE E.128

Jug with a hexagonal body and
trefoil mouth
Brown, weathered to a gold-speckled
appearance
Ht., 14.7 cm
Late 6th century A.D.
Possibly from Damascus in Syria
Gift of J. Morris (1936)
MS 5632

The find spots claimed for vessels of
this kind include Damascus, Tyre,
Gerasa, Beth She'arim and
Nazareth. The decoration of the
vessel's body includes the True Cross
in three different basal settings, each
with a particular symbolism and
historical significance.

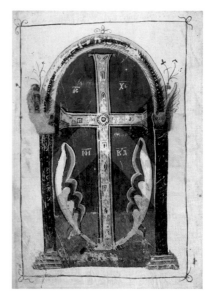

a. The Cross set in the Tree of Life, *as*
depicted in the 9th century A.D. *Leo Bible.*
Courtesy of the Vatican Library

DECORATION OF THE BODY WALL

The six motifs on the body panels.
Artwork by Jennifer Hook, MASCA

- *The crux gemmata, matching the one*
 erected by Theodosius II in A.D. *420 at*
 Golgotha, the navel of the Earth.
- *The crux gemmata amid a cluster of*
 branches or leaves, matching the notion of
 the Cross as life-giving and the early
 Oriental traditions of the Tree of Life.
- *The crux gemmata atop three steps, a*
 form known from the writings of the
 pilgrim Theodosius who wandered the Holy
 Land around A.D. *530. It is in this form*
 that it eventually appears on coins issued
 for Tiberius II in A.D. *578 (Hendy*
 1985: plate 13).

b. The Cross atop the steps to Golgotha, here
depicted on a silver nummus *issued around*
A.D. *528 at Constantinople for Tiberius II.*
Courtesy of Dumbarton Oaks, Washington D.C.

The visible feature that ties together the workshops that produced jugs and flasks of this kind is the lozenge-shaped motif that is so often interleaved between the more diagnostic patterns in their decoration, whether the latter are floral, Jewish, or Christian. But they also share a distinct technological feature which sets them apart from all the other kinds of mold-blown vessels. These six-sided vessels were created from a pair of three-faced molds, each with relief designs stamped onto their inner walls, so that the decoration is impressed *into* the glass's surface, rather than raised from it. Wherever this innovation in glassworking originated, it did not survive the turmoil caused by the foreign intrusions into Judaea and the neighboring provinces that occurred in the early part of the 7th century A.D.

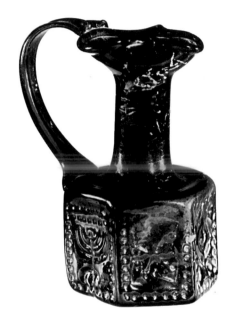

PLATE E.129

This hexagonal jug (Ht., 13.5 cm) has four panels with Jewish motifs, including the menorah shown here, and two with a lozenge motif that matches the one shown in Plate E.128. Courtesy of the Staatliche Museen zu Berlin

For now we see through a glass darkly, but then face to face. Now I know in part; then I shall understand fully, even as I have been fully understood.

(Paul, *I Corinthians* XIII.12)

FRONTISPIECE F.22 see page 159

E.22

EPILOGUE

IRST CAME THE PERSIAN FORCES OF CHOSROES II, THAT SACKED Jerusalem in A.D. 614; neither the sword or a prayer could stop them. Nonetheless, eight years later "In the Roman camp, the emperor [Heraclius] sought delight in psalms sung to mystical instruments, which awoke a divine echo in his soul. . . ." (George of Pisidia, *The Persian Expedition* III.1). Seemingly, this echo was sufficient to ensure the Persians were driven from the land. Then, in A.D. 638, came the westward sweep of Islam which overwhelmed the entire eastern Mediterranean shoreline. In the battle-strewn landscape that once had been Rome's Eastern provinces, glassworking reverted more and more to a local craft level. New centers of glassworking emerged throughout Iran and Iraq, seeking now to satisfy the needs and tastes of Baghdad, not Rome or Constantinople (see Endnote 110).

FIGURE E.67

Long-necked unguentarium with tightly spiralled decoration at the neck, tugs on the body wall, and threads drawn up inside
Light green body and decoration
Ht., 18.3 cm
5th–7th century A.D.
Probably from Beth Shean in Israel
Purchased from Vestor and Co. (1913)

This vessel has a reasonably close parallel in a fragmented flask with turquoise threads that was recovered from the basilica at Kourion, in Cyprus, in a context that dates to third quarter of the 7th century A.D. (Young 1993).
MS 5253

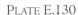

PLATE E.130

The "tear-drop" like protrusions on this 16th century A.D. beaker (Ht., 26.3 cm) from Krefeld, in Germany, echo the stylized dolphins and curled-over claws that were so popular in Rome's northwestern provinces during the 4th and 5th centuries A.D. (see Plates E.117 and E.120)
Courtesy of the Glassmuseum Hentrich, Dusseldorf

FIGURE E.68

This kind of wine cup (Ht., 9.1 cm) was extremely popular in Germany and the Netherlands from the mid–15th to the early 18th century A.D. (Liefkes 1997). Its decoration, with its applied large blobs (nüppen in German, prunts in English) echo the "blob" motif that was used throughout the Roman world during the late 3rd and early 4th centuries A.D. (see Figure E.50). After about A.D. 1630, the prunts usually were overstamped with a nobbly pattern that resembled the appearance of a ripe raspberry (see Theuerkauff-Liederwald 1968: plates 31–51). Artwork by Veronica Socha, MASCA: after Foy and Sennequier (1989: entry 356)

The fusion of Islam cultural attitudes with local ones, Muslim tastes in color and subject matter, and some new production techniques meant that the same three factors that so influenced Roman glassworking—*historical events, technical change* and *fashion and taste*—were effective during these later times as well. So the development of Islamic glassworking echoes the story of the Roman industry in many small ways. Relief-cut, rock crystal vessels were as revered in Baghdad as they had been in Rome, so the Islamic imitation of them in glass was quite common: and the early Byzantine decorative motif of a tightly wound spiral outlasted all the political crises of the 7th century A.D. (Figure E.67) and would have Islamic parallels that date as far forward as the 12th century A.D.[111] But the mimicry of turquoise in glass, and of enameling of glass with a silver luster stain, those innovations were purely Islamic. If there were outside influences on Islamic glassworking, they invariably came from the Far East, not from Byzantium.

In the West, the political upheavals that had accompanied the barbarian movements of the 5th century A.D. were eventually resolved with the emergence of Charlemagne as head of the Frankish Empire in A.D. 771. The glassworking industry that had become so fragmented in the Northwestern provinces of the later Roman world gradually regained its cohesion, and by the early 13th century A.D. had recaptured much of its earlier energy. Venice soon would dominate the world market for superior glassware, while newly-established

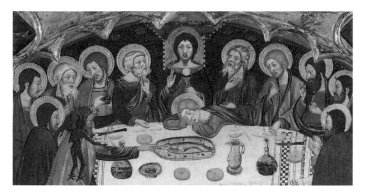

PLATE E.131

As with all medieval representations of the event, the tablewares depicted in this 14th century A.D. version of "The Last Supper" are anachronistic—they represent the kinds of vessels and dishes that were in fashion at the time the artwork was created, not those that would have been used in 1st century A.D. Judaea (see Foy and Sennequier [1989: entries 229-232]).
Courtesy of the Museu d'Art de Catalunya, Barcelona

PLATE E.132

In this scene from a 12th century A.D. manuscript, the cleric Hugh of St. Victor works by the light of a conical lamp, as he teaches monastic novices how to read and understand the Bible.
Courtesy of the Bodleian Library, Oxford

glasshouses in central Europe also were to make significant contributions to the industry's scale, when Bohemian towns such as Prague flourished as trade centers during the late 14th and 15th centuries A.D.[112]

Time and again, Medieval European glassware demonstrates its debt to the novel styles and technologies of the workshops of the later Roman and early Frankish Rhineland. Abstract "snake-thread" motifs, gold-glass medallions, claw-like bulbous protrusions (Plate E.130), applied blobs that resembled the spiraling top of an Italian ice-cream (Figure E.68)—all of these and many other methods of glass decoration that had seemed so revolutionary in the late 4th and early 5th centuries A.D. were elaborated over subsequent centuries and

established a niche in the traditional repertoire of glassworking throughout the Western world.[113]

In that same world, as monasticism became such a respected and well-patronized element of the Christian Church, so its vehicle for artistic expression of the Faith—illuminated manuscripts of the Gospels—increasingly included glassware in its illustration. *The Last Supper* was a natural setting for the depiction of bowls, pitchers and wine beakers that were then in fashion (Plate E.131), while scenes of saints putting their holy thoughts into words, or of monks at work, usually would include one of the various kinds of glass lamps that lit monastic chambers (Plate E.132).[114] Dozens of types of glass vessels also are to be found in the scenes that capture everyday life in

PLATE E.133

Anyone who looks closely at illustrated medieval manuscripts for a while, soon discovers all sorts of unexpected details tucked away in the artwork. This leaf of the mid–9th century A.D. Moutier Grandfual Bible has a cross-shaped candelabrum of glass lamps suspended beneath one limb of the letter F (see Higashi 1990).
Courtesy of the Trustees of the British Museum, London

PLATE E.134

Almost the whole life of a German glasshouse during the late 17th–early 18th century A.D. is captured in the decoration of this remarkable gold and enamel box (Ht., 4.0 cm), that was used to store two faceted scent bottles and their filling funnel (Charleston 1978,b) On the broad side of the box visible here, an assistant has just inflated a sizeable bulb of glass [see Inset]: opposite him sits the master craftsman, who is trundling his pontil rod on the arms of his chair as he shapes a drinking vessel. There are three fully finished vessels in the niche above these workers' heads.

* On the back surface of the box, one workman stands over a mortar as he pounds on one of the glassmaking ingredients—either calcined quartz or soda-rich wood ash (see Appendix A)—while another shapes the one of the clay pots in which these ingredients eventually will be melted together in the furnace. On one side surface of the box is shown a workman crouching down to feed wood into the stoke-hole beneath the furnace; on the other, a workman is shown reaching forward as he puts in or takes out a flask from a cooler part of the furnace.*
Courtesy of the Corning Museum of Glass, Corning, N.Y.

INSET

miniature in the margins of leaves of 15th and 16th century A.D. illuminated bibles and in the various versions of the *Book of Hours* then used for private devotion (Plate E.133).

In the parallel secular domain, the contrived "still-life" scenes of 17th century A.D. Dutch masters such as Pieter Claesz and Jan van de Velde provide us with dozens of depictions of wine glasses arranged among platters of food, loaves of bread and cutlery; and genre artists of the same era—particularly Pieter de Hooch, but also Gerard ter Borch, among others—capture wine drinking in a variety of convivial settings.[115] The glass mirror also becomes an important artistic device at this time, and more specialized glass items such as spectacles and telescope crop up here and there, where appropriate.

Lest I appear to be "vitrophobic," however, it has to be said that both Medieval ecclesiastical manuscripts and Dutch genre paintings provide an even broader visual record for the popular pottery products of their day—stoneware flagons, porcelain dishes, etc.,—while many a later 17th century A.D. tavern scene documents the growing use of pewter for jugs and drinking vessels. The paucity of Roman illustrations of any mass-produced domestic items—whether there were made of glass, pottery, or bronze—is to some extent a reflection of how artistic patronage worked in those times. Roman patricians were willing to pay well for the work of fresco painters and mosaicists. But they were wealthy by virtue of inheritance rather than by personal experience in commerce. So they expected the art in their homes to reflect their everyday life rather than capture the pleasures and plights of the urban middle classes or the rural poor. Humble medieval monks and newly prospering burghers viewed the world somewhat differently.

Many of our modern perceptions about glass have their roots in the late 17th century A.D., when the dictates of fashion and taste were being defined less by the whims of kings and courtiers and more by the lifestyles of northern Europe's God-fearing burghers and penny-wise merchants. Glass, along

with pottery (as bone china), now was a socially acceptable material from which to eat and drink. The depiction of the various steps of production in glassmaking and glassworking—something that was so lacking and perhaps inappropriate in the Roman world—became equally acceptable both on glassware itself and in other artistic media (Plates E.134).[116] Thereafter the Arts and Crafts Movement of the mid-19th century A.D. fuelled the popular regard for the aesthetic merits of glass amid a literary convention that chose to ignore the uglier human aspects of the Industrial Revolution in favor of a Utopian view of social conditions—thus the half-true, half-false observation". . . glassblowing is a rather sweltering job; but some folk like it very much indeed." (William Morris, *News from Nowhere*). At this point we are but a short step away from the industrial-scale production of lead-enriched glass which, by virtue of its clarity and the ease with which it could be faceted and/or engraved, was to gain its present misnomer of "crystal."

Just as there was an increasing artistic representation of glassware from the Byzantine era forward, so there was also an increasing amount of literature on the technical aspects of glassmaking and glassworking. As we have seen, the distaste for all kinds of manual labor that kept Roman writers socially distant from their craft-skilled contemporaries ensured that descriptions of production processes were largely superficial, and often no more than poetic and mystical (see Section E.18). A couple of anonymously authored manuscripts—*Compositiones variae* and *Mappae Clavicula*—show that the will was there to properly record the procedures and recipes of a number of crafts. The attention to detail in these documents reflect a general monastic curiosity about the nature of chemistry. But the intent seems to have been to draw together and uncritically transcribe all the scraps of already existing "technical" literature. Thus, in *Mappae Clavicula*, a sound recipe for green coloration of glass, such as "Grind glass well and add three ounces of clean copper fillings to each pound of it, then cook for three days . . ." is soon followed by a

fanciful one for purple coloration without any heating that reads "color thin glass pieces, mix and coat them with dragon's blood. . . ." The innovative practices of contemporary workshops are scantly represented.[117]

By the 12th century A.D., however, all that had changed. Enquiring scientific minds, such as those of Theophilus Presbyter and Eraclius—the authors of *Schedula Diversarum Artium* and *De Coloribus et Artibus Romanorum,* respectively—were providing accounts of the furnaces in glass workshops that were sufficiently detailed to allow their modern reconstruction with a quite reasonable accuracy. And, by the mid-16th century A.D., well-illustrated treatises such as Biringuccio's *De la Pirotechnia* and Agricola's *De Re Metallica* removed the mystery from the glassmaking industry altogether.[118]

So it is that our own era sits at the end of a long and winding path of change in the story of glass. Many of the ways that we now use glass and how it is often formulated for specifically 20th century purposes—the shatter-proof automotive windscreen is an obvious example—distance us a great deal from the Romans (Figure E.69). As people, too, we have freed ourselves from the social rigidity of Roman material hierarchy—today, at a Washington cocktail party, the gold of a Tiffany's bracelet may vie for light's attention with a Lennox champagne flute in a way that, beyond its obvious anachronism, would have been impossible in Nero's *Domus Aurea* or Trajan's Tivolian villa. Yet so much of Roman everyday practicality persists in our modern world. The Romans envisioned industrialization as a means-to-an-end that would improve everyone's standard of living: so, I think, do we. The Romans appreciated how an exploration of a material such as glass, with its fascinating range of intrinsic characteristics—natural translucency, fluidity when hot, and so on—were part-and-parcel of the human purpose: so, I think, do we. They enjoyed such exploration; so, I think, do we.

FIGURE E.69

The lands that once were the Western Empire of the Roman World are now largely encompassed by the countries that form the European Union (EU). At the height of recent EU glass production, in 1992, the output was 23.3 million tonnes (Anon. A.R. 1994). This output was dominate by container glass (15.3 million tonnes), of which close to 38% derived from recycling. The category "other" here includes several things unknown in Roman times—fiberglass, laboratory supplies, light bulb shells, cathode ray tubes for televisions and computer monitors, and so on.
Graphic by Annette Aloe, Bagnell & Socha

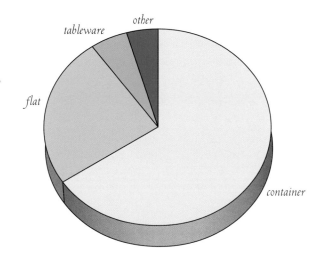

And so we must now proceed to explain the nature of glass. . . .

(Pliny, *Natural History* XXXVI.189)

FRONTISPIECE F.23 see page 159

APPENDIX A
TECHNICAL ASPECTS OF ANCIENT GLASSMAKING

BECAUSE OF THE HISTORICAL EMPHASIS OF THE EXHIBITION, *Roman Glass: Reflections on Cultural Change*, to which this book is so closely linked, I have tended to steer clear of describing the intrinsic complexities of glass as a material. But you don't achieve the industrial success that Roman glassmakers enjoyed just by throwing ingredients together in a haphazard way. They accepted and understood the tried-and-true Hellenistic recipes for both the production of bulk glass stock and the way to color it by the addition of various metal-rich minerals. So I have created this summary of such matters mainly for the interest of the technically-minded among this book's readership, while noting to others that these technical ideas often had some intriguing cultural cross-currents. Thus one Christian scholar found, in the fragility of glass, a yard-stick for the brevity of life:

> Are we not frailer than if we were glass? . . . For even if glass is fragile, you find grandsons and and great grandsons drinking out of the cups of the grandfathers and great grandfathers . . ."
> (St. Augustine, *Sermons* XVII.7)

and even the now-mundane process of glassblowing (Plate A.1) once inspired a poet to wrap a cloak of mysticism about its mechanics (see Appendix B).

As was true of the major modern sites of glass production established in the wake of the Industrial Revolution, so it was with ancient sites as well: where to locate them was invariably governed by two practical factors—ready access to the essential ingredients of glass, and the proximity to a reliable supply of fuel. It is no matter of chance that many coastal cities of Syria and Judaea with many forested hillsides behind them—for example, Tyrus, Sidon, and Ptolemais (see Map E.2)—were renowned for glassmaking long before the Romans moved eastward.[1] Local beach sand provided not only glass's primary constituent—silica—but also a substantial amount of lime which would enhance the durability of the product. Two parts of this sand mixed with one part of a sodium-rich material, such as Egyptian natron, comprised the recipe for soda-lime glass which was to be the norm well into the Islamic era. (Figure A.1)[2]

However, beach sands always contain small amounts of iron-bearing minerals which give glass a light aquamarine-to-green tinge. Roman glass usually contains about 0.3% iron, so that tinge tends to be slight, unless the glass is quite thick. A higher iron content will deepen the tinge to some extent, as will allowing air to circulate in the furnace so that the atmosphere around the glass melt is oxygen-rich (i.e., in an *oxidizing* state). The most effective darkening agent of most naturally colored Roman glass, however, is sulfur, which most likely got into the mix as a sodium sulfate contaminant of the natron ingredient.[3] Sulfur's presence at typical levels ranging 0.2% to 1.4% would change an aquablue into a light-to-medium green (Plate A.2).

The Romans seemed willing enough to tolerate these tinges among everyday domestic items (Plate A.3). Perhaps, given the complex ways in which the impurity of ingredients can affect the color chemistry of glass (see below), that was a realistic attitude to take. But there are some indications that the larger workshops which operated on the Italian mainland in the 1st century A.D. generally favored the purer sources of sand, such as those flanking the outflow of the river Volturnum on the northern side of the Bay of Naples, particularly when colorless glassware became fashionable in Nero's times.[4]

Natural coloration of glass will move from green to amber, the higher the concentration of iron-sulfur compounds that are formed during the melting of the ingredients. To encourage the formation of these compounds, the furnace has to be kept starved of oxygen—i.e., in a *reducing* state—by filling it with the smoke from the burning of freshly cut, "green" wood. The eventual shade of amber obtained—anything from pale honey to near-black (Plate A.4)—is strongly influenced by those furnace conditions.

FIGURE A.1

This recipe for Roman glassmaking in the eastern Mediterranean is based upon analyses of fragments of glass debris from Jalame near modern Haifa, in Israel, where there was a major glass factory during the third quarter of the 4th century A.D. There seems little doubt that Jalame glassmakers used sand from the river Belus region, since it was just 20 km north of them. This sand's lime content derives from the marine shell debris—crushed crustaceans and mollusks—finely scattered through it. Chemists have shown that most seashore plants are a readily harvested source of soda. This fact has stimulated a lively scholarly debate around the translation of mercatores nitri ("soda merchants") in Pliny's description of how glass was invented (see Endnote 1). Were the merchants bringing a cargo of natron to the local Judaean glassmakers; or did they make their living by burning the soda-rich plants and shipping the ash away from the region?

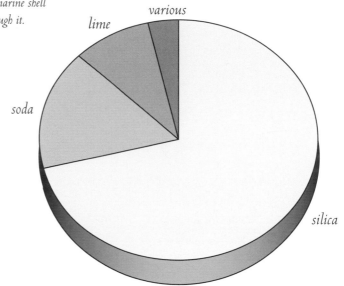

increasing sulfur ⟶

PLATE A.2

Natural aqua-to-pale green

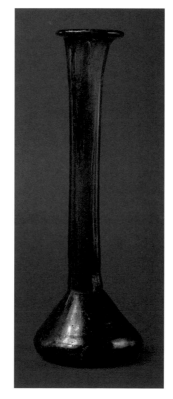

PLATE A.3

Unguentarium
Dark green
Ht., 14.8 cm
Late 1st–2nd century A.D.
Possibly from Luxor, in Egypt
Gift of Lydia T. Morris (1916)
MS 5518

TABLE A.I

The composition of minerals that may have been used for the coloration of Roman glass.

pyrolusite	MnO_2
azurite	$Cu_3(OH)_2(CO_3)_2$
cobaltite	$(Co,Fe)AsS$
chrysocolla	$CuSiO_3.2H_2O$
chalcopyrite	$CuFeS_2$
asbolite	earthy aggregate including CoO and MnO
skutterite	$(Co,Ni,Fe)As_3$
trianite	$2Co_2O.CuO.6H_2O$
stibnite	Sb_2S_3
bindheimite	$Pb_2(Sb,Bi)_2O_6$
cupric oxide	CuO (for a turquoise blue)
Egyptian blue*	$CaCuSi_4O_{10}$
cuprous oxide (cuprite)	Cu_2O (for an opaque red)
calcium antimonate	$Ca_2Sb_2O_7$ (for an opaque white)
lead pyroantimonate	$Pb_2Sb_2O_7$ (for an opaque yellow)

* *An artificial pigment (see Text and Plate A.16).*

increasing sulfur ⟶

PLATE A.4

Amber

oxidized ⟶ *reduced*

PLATE A.5

Purple-to-colorless

increasing copper →

To produce other colors in glass requires the addition of a mineral, usually in the form of a crushed ore (Table A.I). Two comments by Pliny (*Natural History* XXXVI.193) give us a crucial insight into this aspect of Roman glassmaking: "Glass, like copper, is smelted in a series of furnaces, and dull black lumps are formed. . . ." and "After being reduced to lumps, the glass is again fused in the workshop and is tinted. . . ." Thus the production of a stock of glass was a two-step process, the addition of the coloring mineral—presumably as a ground-up powder—occurring in the second stage.

PURPLE (Plate A.5, left)

Addition of a manganese-rich mineral such as pyrolusite will produce purple coloration if there is an *oxidizing* atmosphere in the melting furnace. The usual manganese content of Roman purple glass is about 3%.

COLORLESS (Plate A.5, right)

Alternatively, addition of a manganese-rich mineral such as pyrolusite will produce colorless glass if there is a *reducing* atmosphere in the melting furnace. From our point of view, this decolorization process is a subtle optical effect in which the light aquablue of iron and the light pink of manganese cancel one another out. If there is a slight imbalance in this chemistry, there will be an interaction with sulfur that will give the glass a slight yellowish tinge. Poor mixing and/or fusion of the glassmaking ingredients during the furnace melt, and non-uniformity in the atmosphere across the volume of the furnace, could cause some streakiness in the final product (Plate A.6).

increasing cobalt ⟶

PLATE A.9

Dark blue

The depth of blue coloration derives from the presence of a high level of cobalt (0.44%) and other impurities (manganese, 1.4%; copper, 0.75%; iron, 1.7%).
29-128-1201

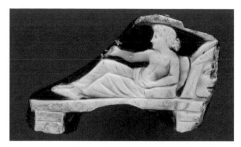

PLATE A.10

Cameo fragment depicting a woman reclining on a couch
Blue ground, white overlay
L., 4.7 cm
Mid—1st century A.D.
Provenance unknown
Maxwell Sommerville Collection

increasing iron impurity ⟶

PLATE A.11

Opaque red

PLATE A.12

A microscopic view of crystals of cuprous oxide (cuprite) scattered through an opaque red glass.
magnification, 320x
Courtesy of the Dept. of Scientific Research of the British Museum

As a glassmaking chemistry, decolorization dates back at least to the 7th century B.C. in the Near East, though the preferred additive was then an antimony-rich mineral such as stibnite. The Roman preference for manganese dates to their first glassmaking endeavors on the Italian mainland, during the Augustan era (see Section E.4).

BLUE AND GREEN (Plates A.7, A.8 and A.9)

The addition of specific coloring agents allows the hue of blue glass to be altered a great deal. For example, the intensity of natural aquablue is increased by the addition of copper in some form. There are many copper-rich minerals that would be suitable for this purpose, e.g., azurite, chrysocolla, and chalcopyrite. But the frequent occurrence of an elevated levels of tin—sometimes also of lead—suggests that the Romans preferred instead to use the oxide scale that they could prepare simply by baking nodules of scrap bronze. Translucent blue gives way to a darker and denser green, as the copper content moves upward over the range of about 2% to 13%. The presence of lead darkens that green even more.

Another turquoise shade, something closer to a powder blue, was obtained by adding to the melt

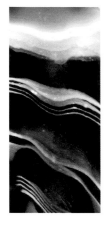

Variations in the opacity of the white bands in sardonyx-like patterns for two early 1st century A.D. ribbed bowls.

b. antimony, circa 10%
MS 3371w

Cup with outsplayed lip
Opaque white, with some soil staining
D., 6.5 cm. (at rim)
First half of the 1st century A.D.
Provenance unknown
Gift of George and Henry J. Vaux (1986)
86-35-16

a. antimony, circa 1%
MS 5387EE

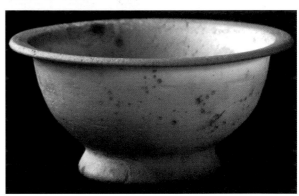

the pigment, Egyptian blue. This is an artificial substance with a history of usage that goes back at least to the 4th Dynasty of Egypt (circa 2600 B.C.). Egyptian blue's spread into the Roman world is well-documented through finds of ingot-like cakes of it among the cargoes of certain shipwrecks. In raw form, it was a popular blue for Roman wall-paintings and mosaics (see Plate A.16): its granular texture seems somehow to translate through into any glass it is used to color.

A darker blue, ranging in hue from royal to navy, is obtained by the addition of a cobalt-rich mineral such as asbolite. The presence of as little as 0.1% cobalt in glass causes intense coloration. Other common impurities in cobalt ores—asbolite is rich in manganese, skutterite in iron and nickel, trianite in copper, etc.—darkens the blue almost to the point of opacity (Plate A.10).

OPAQUE RED (Plate A.11)

We have already seen, with iron and manganese, how much the coloration they produce in glass is influenced by the atmosphere in the furnace—whether it is an oxidizing one or a reducing one. The same is true for copper, with oxidation

yielding blue (see above) and reduction yielding various shades of opaque red.

The mechanism by which this red coloration occurs is intriguing. If the glass melt is very strongly reduced, much of the copper additive precipitates out as minute, needle-like crystals of cuprous oxide (Plate A.12). These crystals scattered through a colorless matrix make it appear a bright blood-red when the copper content is 10% or more. If, however, the matrix would otherwise be a light aquablue because of a natural iron impurity, the cuprous coloration modifies to a brick red or a muddy brown. The same muddy coloration occurs if there is still some copper fully dissolved in the glass.

It takes little to upset this chemistry in a high temperature environment—just a brief whiff of air during the initial infusion of the copper-rich mineral would turn everything blue or green. Even tiny bubbles in an incompletely fused glass could provide enough oxygen to turn green the glass closest to them, so creating a blotchy surface. Yet the successful production of opaque red glass dates back to at least the 14th century B.C. in both Mesopotamia and Egypt. And, by the 9th century B.C., Near Eastern glassmakers were routinely adding some

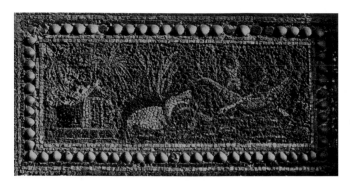

This panel forms part of an elaborate fountain in the courtyard of the Casa del Granduca at Pompeii. The surround comprises Murex and oyster shells set in a matrix of crushed volcanic pumice. The background to the scene itself—a hunt on the Nile—is made up from pellets of the copper-based pigment, Egyptian blue. The animals and plants of the scene are mostly broken-up glass sherds of opaque yellow, emerald, green and turquoise blue. For a history of the use of glass in Roman mosaics, see Sear (1977).
Courtesy of Frank Sear, University of Melbourne

PLATE A.15

Opaque yellow glass was used in both the spiral-woven and solid-colored canes of an early 1st century A.D. cup with a striped mosaic pattern. (See also Figure E.9 for the technique of manufacture of this pattern type.)
MS 3369s

lead to the melt, clearly aware that its presence encouraged the process of cuprous oxide precipitation. (About 1% of lead in the glass is sufficient to ensure the brilliance of the color, though ancient opaque red glasses often contain far more lead than that, even as much as 22%.)

WHITE (Plates A.13 and A.14) AND YELLOW (Plates A.15 and A.16)

Addition of an antimony-rich mineral such as stibnite will produce a white coloration, if there is an *oxidizing* atmosphere in the melting furnace. Reaction between the antimony and the lime constituent of the glass yields a precipitate of minute needles of calcium antimonate in a colorless matrix. Antimony contents ranging from about 1% to 10% yields a white with an opacity that spans from almost eggshell-fine to creamy rich.

If the mineral added to the glass melt contains both antimony *and* lead (e.g., bindheimite), it will usually produce a brilliant yellow coloration. As with white, the process of coloration involves the chemistry of precipitation, but now with the formation of particles of lead pyroantimonate. The Romans rarely used this yellow on its own, but they did create some stunning effects with it in polychrome mosaic wares and complex architectural friezes.

Such was the basic "palette" for Roman glassmaking—everything from almost colorless to intense yellow. Control of coloration must have been something of a technological nightmare, with furnace conditions able to shift the hue of any color so dramatically and with minor mineral contaminants being capable of causing unexpected darkening or color change. Nonetheless, a great deal of product uniformity was achieved, probably by some careful earmarking of reliable sources for every ingredient—sand from that beach cove, stibnite from that outcrop, and so on.

I have dwelt upon the breadth of the Roman palette in the deliberate coloration of glass. So much of the aesthetic appeal of Roman glass for us today lies with the intriguingly varied ways that palette was employed. This is particularly true among mosaic wares during the first half of the first century A.D. (see Plates E.15 and E.16). Yet the overwhelming bulk of the output of the Roman industry was green-tinged glass that was destined to be used only for domestic or commercial purposes.

Can we judge the scale of that output? Of the million or so people in Rome during the Augustan era, just when glass was emerging in the marketplace as a strong alternative to pottery, only a tiny fraction of the city's citizens were the patricians and nouveau-riche businessmen who would spurn the use of glass in their everyday life. The middle class of merchants and craftsmen, the welfare poor, and the slaves who maintained the tempo of every Roman apartment and workshop, all used glass for many different purposes. We could place just a dozen unguent bottles and jars in each woman's dressing-room, a dozen preserving and pickling bottles in each kitchen, and as many water jugs throughout the home. A few of each of these vessels will have been broken and replaced every few years. So it is likely that the production level required to satisfy Rome's needs alone every year was close to two million vessels, possibly even two or three times that.

At that time, there may have been upward of 40 million people spread through the forts, cities, towns, and villages across the Empire. For all of them, glass tableware and containers were commonplace. So the total output of the Roman glassworking industry over the centuries, from the late 1st century B.C. to the early 7th century A.D. must have run into the billions.

Only a tiny fraction of that output has survived till today, so where did all this glassware go? Like modern crockery, once broken, it most likely would finish up on some urban trash heap, there to be trampled crushed and churned over into the local soil during the construction of new buildings and streets. A vessel's bits soon would be degraded to environmental anonymity by the natural acids in our ground water. But a lot of the discarded Roman glassware was recycled: maybe as much as 20% of it; who can say?

In Rome, we know it was common enough for marketplace peddlers to offer the sulfur-tipped pieces of wood which the Romans used to kindle fires in exchange for broken glass (see Martial, *Epigrams* I.41). These peddlers then would sell this glass—today we would call it *cullet*—to workshops in the Trastevere district which lay at the western edge of the city, just beyond the Tiber. (Other writings of that time identify Trastevere as where Rome's odorous tanneries and fire-hazardous workshops usually were located.) There, a glassblower might snap off just the end of discarded jug handle, re-heat it and turn it into a thin-walled wine beaker.[5] Meanwhile, a glasscaster might take broken pieces of mosaic ware vessel and blend them directly into the pattern of a new polychrome bowl or cup, alongside freshly cut canes and strips. The low cost of glassware throughout the Roman world from Augustan times onwards ensured that the owner of a glass workshop was not going to make a fortune in this industry. But the use of cullet as his glass stock certainly will have helped him increase his profit margin.[6]

Much of the Roman glass found in modern excavations owes its survival to the simple fact of being a grave good that was given shelter against the elements (along with the deceased) in a stone sarcophagus or some kind of tomb structure—at minimum, a pottery wine amphora, a lead canister or a massive glass jar. But none of those shelters could ever have been sealed well enough to stop some inflow of moisture from the surrounding ground; persistent inflow that, year-in-and-year-out, gradually took its toll on the very fabric of the glass, weathering its surface in a host of different ways.[7] Some beautiful aesthetic effects are created by these weathering processes—a spectrum of colors that shimmer like those on a peacock's tail feathers, and encrustations that, at first glance, appear to be a layer of gold foil.

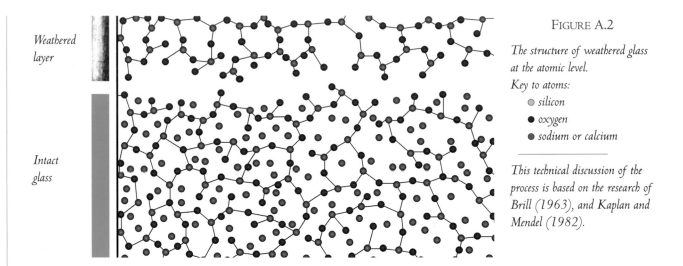

Weathered layer

Intact glass

FIGURE A.2

The structure of weathered glass at the atomic level.
Key to atoms:
○ *silicon*
● *oxygen*
● *sodium or calcium*

This technical discussion of the process is based on the research of Brill (1963), and Kaplan and Mendel (1982).

To understand the chemistry of weathering is to understand something of the nature of glass at the atomic level. Its main ingredient, the quartz of a beach sand, has a well-ordered structure that has its constituent silicon and oxygen atoms bound together in a symmetrical way. If quartz is heated to about 1500°C, these groups of atoms collapse into a molten, liquid state; if this liquid cools quite rapidly, the silicon-oxygen bonds are retained but their layout is distorted in a random manner that, in essence, defines what we would call an ultra-pure silica glass.

Now if we add into that molten chemistry of silica glass the other usual glassmaking ingredients—soda, lime, and potash—the atomic structure becomes far more distorted, even though the fusion of these ingredients occurs at much lower temperatures of around 750°C. The atoms of these ingredients—sodium, calcium, potassium—are now encased in the silica network and stretch it in a million different ways, so that many of the silicon-oxygen bonds are ruptured. In a burial, soil and silt gradually covers it along with all the other grave furnishings; ground water percolates through that soil and the vessel's surface gets wet (Plate A.17). This wetness will leach out atoms of sodium and potassium particularly quickly, but most other elements eventually follow. Thus the surface of the glass is turned into something akin to a silica gel that is water-rich and soda-poor (Figure A.2).

If the ground now dries out for a season, the water evaporates and this gel turns into a free-floating layer of silica, little more than a film, about a thousandth of a millimeter thick, loosely wrapped over the vessel's outline. If that cycle of wetting and drying is repeated, a crust builds up that is the sum of tens, sometimes hundreds of these ultra-thin films.

When we look at this crust today, what we see depends to a large extent upon the chemistry of the soil that surrounded the glass over the centuries. The higher the acidity of the burial environment, the more rapidly the weathering process will proceed. In the case of the most common green-tinged glass, the outer part of the crust often blends together and turns into an enamel-like shell over the entire vessel (Plate A.18). But that weathering shell is quite brittle. If it breaks away, it exposes the flimsier individual films beneath, disrupting many of these so that the thickness with which they coat the vessel is quite variable (Plate A.19). To our eyes, the surfaces of each of these films scatter light in such a way as to produce a brilliant iridescence, such as we see in a layer of oil on water (Plate A.20).

PLATE A.17

Unguentarium
Green, coated with chalky soil
encrustation
Ht., 18.5 cm
1st century A.D.
Provenance unknown
Gift of Mrs. James Mapes Dodge.

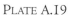

Loss of some parts of the adhering
soil since the vessel's excavation has
led to the loss of some of the
weathering layers.
49-6-7

PLATE A.18

Juglet
Light green, covered with
enamel-like weathering products
Ht., 8.4 cm
Late 4th—5th century A.D.
Provenance unknown
Gift of George and Henry J.
Vaux (1986)
86-35-123

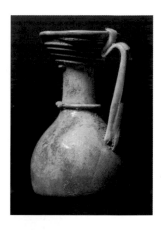

PLATE A.19

Unguentarium
Light green, somewhat weathered
Ht., 9.2 cm
Late 1st—2nd century A.D.
From Beth Shean in Israel: Northern
Cemetery, tomb 18
Excavated by Gerald Fitzgerald (1926)
29-105-659

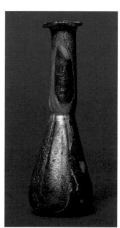

PLATE A.20

Close-up of the lower part of a two-handled
cosmetic flask.
From Beth Shean in Israel
Light green, heavily weathered
Magnification 4x
86-35-56

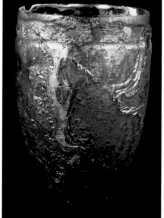

PLATE A.21

Beaker
Colorless, much weathered and so heavily pitted
Ht., 10.8 cm
Late 1st century A.D.
From Beth Shean in Israel: Northern Cemetery,
tomb 54
Excavated by Gerald Fitzgerald (1926)
29-105-732

Far less attractive, however, is what ancient glass looks like once the weathering has penetrated very deeply as the ground water acids find their way into any micro-fractures or air bubbles in the glass. Disfiguring pits soon form amid the weathering films, these pits eventually carrying right through the vessel's body (Plate A.21). The next step, if we could document it, would be complete disintegration of the glass.

In certain deliberately colored glasses, the movement towards disintegration may well occur quite rapidly. For example, the cuprous oxide needles that give the rich color to opaque red glass are easily converted to an ugly green crust of copper chloride (Plate A.22); the creamy opaque white swirls in "onyx" wares become pitted valleys amid the more resistant amber glass around it (Plate A.23). All these destructive chemical processes are natural—as far as I am aware, the Romans never deliberately treated glass surfaces to create the iridescence that we now find so appealing. They are also irreversible, making our inheritance of so much superb Roman glassware far more fragile than we would ever prefer.

PLATE A.22

*Close-up of weathered surface of a body
sherd from a 1st century A.D. cast cup
Opaque red, heavily weathered
Magnification, 4x
MS 5385s*

PLATE A.23

*Close up of a body sherd of an "onyx"
ware bowl
Amber and white, heavily weathered
Magnification, 4x
MS 5387yy*

APPENDIX ENDNOTES

1 Pliny (*Natural History* XXXVI.192) repeats the folklore of his day, that glass was invented when soda merchants (*mercatores nitri*) drew up their ships on the shore at the mouth of the river Belus near Ptolemais (today, the river Na'amath near modern Acre). Lacking stones, the sailors used some of their cargo to hold up their cooking pots—the ensuing fiery fusion of sand and natron produced transparent streams of glass. Although the imagery of this primitive chemistry is surely spurious—to work, it would require far greater heat than that of a cooking fire—we do know that the sands of the river Belus area were heavily exploited for glass-making in Roman times; so much so that, around A.D. 75, a Jewish historian wrote of how ". . . numbers of ships are continually coming to take cargoes of this sand, but it never grows less." (Flavius Josephus, *The Jewish War* II.10).

2 Natron is a complex admixture of sodium carbonate and sodium bicarbonate. Its composition is typically: soda, 94.5%; silica, 1.2%; lime, 1.5%; potash, 0.6%; magnesia, 0.6%; alumina, 0.6%; iron oxide, 0.7%.

In antiquity it was scraped from the Egyptian salt lake deposits at the Wadi el Natrun and at El Kab, the former of these providing the substance with its modern name. Besides being used as a flux in glassworking as described here, it also was a primary ingredient of soap and as the embalming agent for mummification (Wedepohl et al. 1995; Fleming et al. 1981).

3 This observation and most of the technical data on colorants summarized in the next section of this Appendix draw heavily on the work of Brill (1988), Brill and Schreurs (1984), Brill and Cahill (1988), and Henderson (1985).

4 Pliny (*Natural History* XXXVI.194) also comments: "Wherever it [the white sand] is softest, it is taken and ground in a mortar or mill." This implies a deliberate selection of sand batches rich in marine debris, since silica is far harder than shell.

5 Provincial glassmakers were in the market for cullet because it saved them from having to buy expensive fresh ingredients from elsewhere. They also may have been aware that finely-crushed cullet, when mixed into a batch of raw materials, would act as kernels for its fusion, and so encourage a uniform consistency in the final glass stock.

Cullet from colored monochrome wares also was sold directly to mosaic makers, for use in the decoration of the meeting rooms and spas of villas outside Rome (see Plate A.16; also Sear [1977: entries 16 and 26]).

6 The shipment of cullet to those regions at the fringes of the Empire that generally lacked the usual glass ingredients and/or a capability and experience in making it does seem to have been a quite viable commercial concern. In the 2nd century A.D. manuscript, *Periplus Maris Erythraei*, cargoes that include loads of raw glass (Casson 1984) among expensive goods, such as Italian wine and tin, are documented as being exchanged at markets in several Indian Ocean ports for valuable perfume ingredients such as costus and nard, Chinese silk, and onyx (Casson 1979; Stern 1991: see also Appendix B here).

Cullet could be packed tightly and with little concern about further breakage, so it probably was used quite often as a a shipping ballast. The only load of this kind actually recovered is post-Roman, however—one weighing some three metric tons in the hold of an 11th century A.D. shipwreck, where the main cargo was wine amphorae (Bass 1979).

7 It is clear that these weathering processes were not recognized in the 5th century A.D., since one historian observed incorrectly:

"Certainly, if we look at the four elements themselves when they are outside us, we see that neither water nor air nor earth demands anything to feed or on to consume, or in a way harms objects placed near or in contact with it; only fire desires to be continually fed and destroys whatever it meets."

(Macrobius, *The Saturnalia Conversations* XIII.13)

At the turn of the the present century, Louis Tiffany turned iridescent handmade glass into an art form, calling it *favrile*.

REFERENCES

M. Almagro, 1955: *Las Necropolis de Ampurias* II, pp. 57–60 (Seix y Barral, Barcelona).

R.H. Brill, 1963: "Ancient Glass," *Scientific American* 209, 120–131.

R.H. Brill, 1988: in *Excavations at Jalame*, pp. 257–294 and Table 9–6 (ed., G.D. Weinberg: University of Missouri Press, Columbia).

R.H. Brill and N.D. Cahill, 1988: "A Red Opaque Glass from Sardis and Some Thoughts on Red Opaques in General," *Journal of Glass Studies* 30, 16–27.

R.H. Brill and J.W.H. Schreurs, 1984: "Iron and Sulfur Related Colors in Ancient Glass," *Archaeometry* 26, 199–209.

J. Carcopino, 1962: *Daily Life in Ancient Rome*, 20–32 (Viking Penguin, New York).

J. Henderson, 1985: "The Raw Materials of Early Glass Production," *Oxford Journal of Archaeology* 4, 267–291.

M.F. Kaplan and J.E. Mendel, 1982: "Ancient Glass and the Safe Disposal of Nuclear Waste," *Archaeology* 35.4, 22–29.

R.G. Newton and S. Davison, 1989: *Conservation of Glass*, pp. 19–32 and pp. 54–60 (Butterworths: London).

F.B. Sear, 1997: *Roman Wall and Vault Mosaics*, pp. 37–43 (F.H. Kerle, Heidelberg).

D. Whitehouse, 1981: in *Archaeology and Italian Society*, pp. 191–195 (eds., G. Barker and R. Hodges: BAR, Oxford).

D. Whitehouse (ed.), 1990: "The Portland Vase," *Journal of Glass Studies* 32, 14–188.

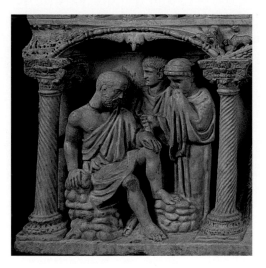

But where shall wisdom be found? . . . gold and glass cannot equal it, nor can it be exchanged for jewels of fine gold. No mention shall be made of coral or of crystal; the price of wisdom is above pearls.

(*Book of Job* XXVIII.17)

FRONTISPIECE F.24 see page 159

APPENDIX B
SOME ANCIENT QUOTATIONS ABOUT GLASS

I HAVE INCLUDED DOZENS OF GREEK AND ROMAN QUOTATIONS THROUGHOUT THE main text, plate captions, and the endnotes of this book, many of them being scene-setting expressions of current social attitudes and beliefs and only a few of them referring directly to glassworking in some way. Below I supplement the latter with other quotations that have caught my eye and my imagination.

Many of these translations should be read with caution. As several scholars have noted (see Stern 1996), a few Roman writers freely interchanged the Greek and the Latin words for glass (*hyalos* and *vitrum*) and rock crystal (*krystallos* and *crystallina*). Thus, both κρύσταλλος [crystal] and ὕελος [glass] was used in a fragmented poem on a 3rd century A.D. Egyptian papyrus in a context that obviously is describing the visually exciting aspects of glassblowing (Stern 1997): "And the crystal, as it tasted the heat of the fire, was softened by the strokes of Hephaistos like . . . He [the glassblower] blew in from his mouth a quick breath . . . like a man essaying the most delightful art of the flute . . . The glass received the force of his breath and became swollen out around itself like a sphere before it. It would receive another onslaught of the divine breath, for often swinging like an ox herd his crook he would breath into. . . ."

(*Papyrus Oxyrhynchus* 3536: from Bowman [1983])

Some recent translators have allowed themselves a similar degree of poetic license. For example, MacLeod favored "Sidonian crystal" as an interpretation for Σιδωνίας ὕελον in a poem by Lucian; and Bennett favored "crystal sea" as an interpretation of *vitreo ponto* in an ode by Horace (see below).

In each instance, of course, the crossover of words picks up on common physical properties of the two materials—their transparency and/or clarity, and their brightness in reflection—and are not implying any confusion about their relative material value in the Roman world (see Endnote 25).

At the same time, amid these ancient texts, there nestles a subtle reflection of how, over time—to be specific, from the late 6th century B.C. to the mid 8th century A.D.,—inquiring minds came to grips with these and other technical properties of glass. The philosophical insight of Aristotle gives way to the puzzlement of Lucretius; the empirical perception of Pliny gives way to the scientific certainty of Agricola. About halfway along that path to such certainty, the Romans created an industry out of a craft.

ὑαλίνων ἐκπωμάτων καὶ χρυσίδων [cups of glass and gold]
"And when we were entertained, we were compelled to drink unmixed wine from cups of glass and gold. . . ."
(Aristophanes' *Acharnians* 75: from Rogers [1960])

τὴν ὕαλον [burning glass]
". . . Say, how would it serve if, when the suit is being listed by the clerk, I should take the burning glass, and stand aloof—just so—with the sun behind me, [if I] were to melt the letters on the summons?"
(Aristophanes, *The Clouds*, 770: from Starkie [1966])

ὕαλον [each piece of glass]
"Yet some of our problems are referred to want of perception; for in some cases if we saw we should not seek—not on the grounds that we knew by seeing, but that we grasped the universal by the seeing. For example, if we saw the glass to be perforated and the light coming through it, it would be clear why it does, even if seeing occurs separately for each piece of glass while comprehending grasps from one time that it is thus in every case."
(Aristotle, *Posterior Analytics* I.31: from Barnes [1984] and Ross [1964])

ὑάλινα διάχρυσα [gilded glass vessels]
"Next in the procession were four large three-legged tables of gold, and a golden jewel-encrusted chest for gold objects . . . two cup stands, two gilded glass vessels, two golden stands for vessels which were six feet high"
(Athenaeus of Naucratis, *Banquet of the Philosophers* V.199.F; excerpted from Kallixeinos of Rhodes' *About Alexandria*: from Rice [1983])

ὕαλον [glass]
"Athenaeus further says that the men of Alexandria make glass, working it into many varied shapes of cups, and copying the shape of every kind of pottery that is imported among them from everywhere."
(Athenaeus of Naucratis, *Banquet of the Philosophers* XI.784; from Gulick [1980])

in primis vitrum [particularly through glass]
"And this [image], when it meets things, passes through, particularly through glass."
(Lucretius, *On the Nature of Things* IV.146: from Rouse [1992])

in primis speculum [particularly a mirror] . . . *vitrum* [glass]
"But when the opposed object is bright and compact, as particularly a mirror, nothing happens of the sort; for the image cannot pass through as through glass, nor again can they be broken; so much safety the smoothness never forgets to afford."
(Lucretius, *On the Nature of Things* IV.150: from Rouse [1992])

foras . . . vitroque meare [way out through . . . glass]
"Besides, one thing is seen to ooze through stone, another through wood, another to pass through gold, another finds its way through silver or glass; for through glass, as we see, images flow; through silver, warmth; and one thing is seen to pass through more quickly than another by the same way."
(Lucretius, *On the Nature of Things* VI.990: from Rouse [1992])

perlucidior vitro [transparent more than glass]
"Repress the wild cymbal along with the Berecyntian horn, orgies followed by blind self-love, by vainglory that lifts its empty head too high aloft, and by a faith that betrays its trust, transparent more than glass."
(Horace, *Odes* I.18: after Bennett [1968])

vitreo . . . ponto [crystal sea]
"Whoever strives, Iulus, to rival Pindar, relies on wings fastened with wax by Daedalean craft, and is doomed to give his name to some crystal sea."
(Horace, *Odes* IV.2: from Bennett [1968])

ὑαλούργῶν [glassworkers]
"I heard at Alexandria, from the glassworkers, that there was in Aegypt a kind of vitreous earth without which many-colored and costly designs could not be executed, just as elsewhere different countries require different mixtures. . . ."
Strabo, *Geography* XVI.2.25: from Jones [1954]

vitrum candidum [white glass]*
"The edible bark of the radish, sun-dried, pulverized and sifted, works well for whitening and hardening the teeth; likewise white glass, which is like crystal, pounded carefully and with the top of spikenard mixed in with it. . . ."
(Scribonius Largus, *Compositions* LX: from Sconocchia [1983])**
* Pliny (*Natural History* XXXVI.194) uses *candidum* in a context which describes glass in a way that can only be translated as colorless. In the same context

he describes glass as *purum* [="pure"], obviously as a synonym for "clear."
** Scribonius was physician to the Emperor Claudius

vitro reponitur [stored in glass]
". . . When dried, these [ingredients] are ground and sifted carefully; then Cretan raisin wine is mixed in until it attains the thickness of honey, and then it's stored in a glass."
(Scribonius Largus, *Compositions* LXIII: from Sconocchia [1983])*
* This is part of a recipe for a medicine to treat tumors. The same phrase—"stored in glass"—occurs in similar herbal recipes for medicines that could be used to treat stomach aches, kidney stones, and a poultice for wounds (chapters CX, CXLV, and CLXXV, respectively).

διαφανέσι λίθοις [transparent stones] . . . ὑάλῳ λευκῇ [white glass]
". . . he cut short our earlier points before we could bring in the stronger ones, and dashed at high speed into the large room of the house, and walked around it and ordered the windows all around to be restored with transparent stones, which in the same way as white glass do not obstruct the light but keep off the wind and the scorching sun."
(Philon Judaeus, *The Embassy to Gaius* XLV.364: from Colson [1971])

vitro [glass]
Fruits seem more beautiful then they actually are if they are floating in a glass bowl.
(Seneca, *Investigations in Natural Science* I.6: from Corcoran [1971])

nisi vitro absconditur camera [not buried in glass]
"But who in these days could bear to bathe in such a fashion? We think ourselves mean if our walls are not resplendent with large and costly mirrors; . . . if our vaulted ceilings are not buried in glass; if our swimming pools are not lined with Thasian marble. . . ."
(Seneca, *Moral Letters to Lucilium* LXXXVI.6: from Gummare [1962])

vitrearium [glassblower] . . . *vitrum* . . . *format* [molds the glass]

Suppose, for example, that a wise man is exceedingly fleet of foot; he will outstrip all the runners in the race by virtue of being fleet, not by virtue of his wisdom. I should like to show Posidonius some glassblower who, by his breath, molds the glass into many shapes which scarcely could be fashioned by the most skilful hand. No, these discoveries have been made since we men have ceased to discover wisdom."

(Seneca, *Moral Letters to Lucilium* XC.31: from Gummare [1962])

vitrea et aena [glass and copper]

"In return for their wares [the traders] bring back items of glass and copper, clothing, and buckles, bracelets and necklaces; consequently that traffic [with southern Arabia] depends principally on having the confidence of women."

(Pliny, *Natural History* XII.88: from Rackham [1986])

vitreae pilae [glass globes]

". . . and yet glass globes containing water become so hot when they face the sun that they can set clothes on fire. Pieces of broken glass can, when heated to a moderate temperature, be stuck together, but that is all. They can never again be completely melted except into globules separated from each other . . ."

(Pliny, *Natural History* XXXVI.199: from Eichholz [1989])

vitro [from glass] . . . *murra* [from murrhine]*

"We drink out of a glass, you from a murrhine, Ponticus. Why? Lest a transparent goblet reveal the two kinds of wine. . . ."

(Martial, *Epigrams* IV.85 from Shackleton Bailey [1993a])

* A vessel carved from Parthian fluorspar (see Lowenthal and Harden [1949]; also Endnotes 24 and 25 here).

toreumata vitri [boldly decorated glass]

"We are plebeian cups of bold glass, and our ware is not cracked by hot water."

(Martial, *Epigrams* XIV.94: from Shackleton Bailey [1993b])

Calices vitrei [glass cups]

"Glass cups . . . You see the ingenuity of the Nile. Desiring to add more to them, ah, how often has the artist spoiled his work!"

(Martial, *Epigrams* XIV.115: from Shackleton Bailey [1993b])

phialam vitream [glass cup]

"But there was once a workman who made a glass cup that was unbreakable . . . when Caesar asked him, 'Does anyone know else how to blow glass like this?' . . . he said not, so Caesar had him beheaded." *

(Petronius, *Satyricon*, 51: from Warmington [1969])

* This story has been repeated many times over by later writers including Isidore of Seville (see below). Comments on its technological aspects can be found in Eggert (1991).

θάλασσα ὑαλίνη ὁμοία κρυστάλλῳ [of glass like crystal]

"From the throne issue flashes of lightning, and voices and peals of thunder, and before the throne born seven torches of fire, which are the seven spirits of God; and before the throne there is a sea of glass, like crystal."

(*The Revelation of John* IV.6: from May and Metzger [1973] and Aland et al. [1994])

θάλασσαν ὑαλίνην [sea of glass]

"And I saw what appeared to be a sea of glass mingled with fire, and those who had conquered the beast and its image and the number of its name, standing beside the sea of glass with harps of God in their hands."

(*The Revelation of John* XV.2: from May and Metzger [1973] and Aland et al. [1994])

χρυσίον καθαρὸν . . . ὑάλῳ καθαρῷ [like pure glass]
"The wall was made of jasper, while the city was pure gold, like pure glass."
(*The Revelation of John* XXI.18: from May and Metzger [1973] and Aland et al. [1994])

ὕαλος διαυγής [transparent as glass]
"And the twelve gates were twelve pearls, . . . and the street of the city was [paved with] pure gold, transparent as glass."
(*The Revelation of John* XXI.21: from May and Metzger [1973] and Aland et al. [1994])

fictilia vel vitrea [earthenware or glass]
"Vessels should be either earthenware or glass and should be numerous rather than large, and some of them should be properly treated with pitch, but some in their natural state as the condition of the material preserved demands."
(Columella, *On Agriculture* XII.4: from Forster and Heffner [1993])

specularibus [windows]
"The house is large enough for my needs but not expensive to keep up. It opens into a hall—unpretentious but not without dignity—and then there are two colonnades, rounded like the letter D, which enclose a small but pleasant courtyard. This makes a splendid retreat in bad weather, being protected by windows and still more by the overhanging roof."
(Pliny the Younger, *Letters* II.17: from Radice [1969])

οἴκοι μεγάλοι ὑάλινοι [houses of glass]
"Around the city runs a river of the finest myrrh, a hundred royal cubits wide, and five deep, so that one can swim in it comfortably. For baths they have large house of glass, warmed by burning cinnamon; instead of water there is hot dew in the tubs."
(Lucian, *A True Story* II.11: from Harmon [1921])

Σιδωνίας ὕελον [Sidonian crystal]
"But the rest of her person has not a hair growing on it and shines more pellucidly than amber, to quote the proverb, or Sidonian crystal."
(Lucian, *Affairs of the Heart* XXVI: from MacLeod [1979])

ὑαλᾶ σχεύη [glassware]
"In this port of trade [Barbarikon] there is a market for: clothing, with no adornment in good quality, of printed fabric in limited quantity; multicolored textiles; peridot (?); coral; storax; frankincense; glassware; silverware; money; wine, limited quantity. As return cargo it offers: costus; bdellium; *lykion*; nard; turquoise; lapis lazuli; Chinese pelts; cloth, and yarn; indigo"
(From the *Periplus Maris Erythraei* XXXIX: from Casson [1979])

λιθίας ὑαλῆς πλείονα γένη χαὶ ἄλλης μορρίνης [glass stones] . . . [millefiori glass]*
"In this area [Barbaria] . . . numerous types of glass stones and also of millefiori glass of the kind produced in Diospolis [in Egypt]"
(From the *Periplus Maris Erythraei* VI: from Casson [1979])
* Use of the term "millefiori" [=mosaic] here is probably incorrect, since the production of such glassware had ceased almost a century before this manuscript was produced (see Section E.4).

λιθίας ὑαλῆς πλείονα γένη [numerous types of glass stones]*
"The principle imports into these ports of trade [on the coast of Azania] are: spears from Muza of local workmanship; axes; knives; small awls; numerous types of glass stones."
(From the *Periplus Maris Erythraei* XVII: from Casson [1979])
* These may be glass trinkets that imitated carved hardstones (Trowbridge 1928).

vitreis quadraturis [square panes of glass]
"Concerning the wealth of this last named Firmus, much is related. For example, it is said that he fitted his house with square panes of glass set in with pitch and other substances and that he owned so many books that he often used to say that he could support the army on the paper and glue."

(Flavius Vopiscus of Syracuse, *Augustan Histories*: Firmus III.2: from Magie [1991])

χαμινίου τοῦ ὑελοψοῦ [furnace of a glassblower]
And again, once he was sitting with his brothers, warming himself next to the furnace of a glassblower, who was a Jew. And jokingly he said to the beggars: "You want me to make you laugh? See, I am making a [sign of the] Cross in the cup which this craftsman makes, and it breaks . . . When he returned, he screamed at the glassblower, "Fool, until you make the sign of the Cross on your forehead, everything is shattered. And again, breaking another ten cups, they were shattered into pieces, and he makes the Cross on his [the glassblower's] forehead and no longer did any break."

(Bishop Leontios of Naples, *The Life of St. Simeon* 1737: from Festugière [1974])

vitrea . . . urna [an urn of glass]
"It is in the basilica built to Paul and John that a representation of the saint was depicted on a wall; this fresco, one can embrace it from the outset for its delicate colors. At the feet of the righteous one, a niche artfully cut into the wall contained a lamp, the flame of which floated inside an urn of glass. I approached in haste, tormented by a profound grief, because the light had left the window of my eyes. As soon as I touched my eyelids with the sacred oil, immediately the keen burning vanished from my sick brow and by virtue of this assuaging balm the healer relieved me and drove out the malady."

(Venantius Fortunatus, *The Life of Saint Martin* IV.693: from Quesnel [1996])

vario fastigia vitro [mosaics of pictured life]
The doorways yield not in splendor, the ceilings are radiant, the gables glitter with mosaics of pictured life."

(Statius, *Silvae* I.44: from Mozley [1967])

candido vitro [transparent glass] . . . *crystalli* [rock crystal]
". . . There is no material more appropriate for mirrors or more suited for painting than this. However, its greatest renown is as transparent glass which very closely resembles rock crystal."

(Isidore of Seville, *Origins* XVI.16: from Reta and Casquero [1983] and Lindsay [1911])

Fit enim ex vitro [It is made of glass]
"The lantern has this denomination because it has the light enclosed in its interior. It is made of glass, the light being imprisoned so that a gust of wind cannot extinguish it, and so that the light is easily spread in all directions."

(Isidore of Seville, *Origins* XX.10: from Reta and Casquero [1983] and Lindsay [1911])

Ablatis igitur dissipatisque vitreis [breaking the glass windows]
"A bold thief came to this church [at Yzeures] and entered it by night. When he realized that everything was watched by the custodians and did not notice any holy vessels that he might steal, he said to himself, 'If I cannot find something, I will steal these glass windows that I see. After melting the metal, I will acquire some gold for myself.' Then, after stealing and breaking the glass windows, he took the metal and came to a village in the territory of Bourges. He put the glass in a furnace and heated it for three days, but he accomplished nothing. Although he was overwhelmed by his crime and although he realized that a divine judgement had been passed upon him, he was not upset and

persisted in his evil deeds. He took from the furnace glass that had been changed into some sort of small strands and sold it to merchants who had arrived. Just like a new Grehazi, once he received the money he came down with incurable leprosy."
(Gregory of Tours, *Glory of the Martyrs*
LVIII: from Van Dam [1988a] and Krusch
[1969])

nate vitriam absidae [before the glass in the apse]
"The day of his festival had come. A paralyzed man who was lame in all his limbs was carried on a wagon and sat before the glass [windows] in the apse where the holy limbs were buried. He fell asleep and saw a man who came to him and said to him: 'How long do you sleep? Do you not wish to be cured?'"
Gregory of Tours, *Glory of the Confessors*
XCIV.94: from Van Dam 1988b] and
Krusch [1969])

περιεργος ἐφῷ ὑέλῳ κενοδοξία [carving on glass]
"To help oneself to cups of silver and gold, or encrusted with stones, is in bad taste: this is nothing but an illusion for the sight. Because if one puts a hot liquid inside them, these objects, all burning hot, are dangerous to pick up, and if on the contrary one puts something cold inside them, the material of the cup spoils and alters the nature of the liquid: there is great peril in drinking with this

luxury . . . And in truth, this refinement of delicate carving on glass—glass which art renders even more fragile—this petty vanity which compels one to tremble while one drinks, it necessitates also the abolishment of the conduct which we should have."
(Clement of Alexandria, *The Pedagogue*
XXXV.1-3: from Mondésert [1965])

uas vitrum [glass cup]
"After a plan was agreed upon, they mixed some poison in his wine. When the glass cup which contained the fatal drink was offered to the Father who was reclining at table, to be blessed according to monastic ceremony, Benedict extended his hand to trace the sign of the Cross. The fatal cup, which he was holding at some distance, broke as if he had hurled a stone against it instead of [making the sign of] a Cross."
(St. Gregory, *Dialogues II: Life and Miracles of
Benedict*: adapted from Antin [1979])

vitri factores [glassmakers]
"When the work was nearing completion, he [Abbot of St. Peters in Canterbury] sent messengers to France who would bring back glassmakers—artisans unknown among the Britons up to this point—so that they could glaze the windows of the church, its collonades, and it upper stories."
(The Venerable Bede, *History of the Abbots* X:
from Plummer [1975])

FRONTISPIECES

FRONTISPIECE F.1

Back at the beginning of the 1st millennium B.C., Rome was nothing more than a scatter of crude huts atop the Palatine Hill. But it was there, so legend claims, that Romulus—one of the two babies suckled by a wolf—created the settlement that would be the foundation of the Imperial city centuries later. The Roman love of tradition ensured that sculptural reliefs like this one from Aventicum (modern Avenches) in Switzerland (Bögli 1989), would appear throughout the Empire as a symbol of the Roman State's authority.
Courtesy of the Musée Romain Avenches
See page 1.

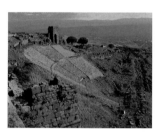

FRONTISPIECE F.2

As they expanded eastward, the Romans received an unexpected territorial windfall, when Attallus III of Pergamum (died A.D. 197) bequeathed his kingdom to them. Peaceful relations with the Romans allowed Attalus' successor, Eumenes II, to undertake a major development of Pergamon itself, including the building of a fine amphitheater on one of the nearby hillsides overlooking the city.
Courtesy of the Deutsches Archäologisches Institut, Istanbul
See page 5.

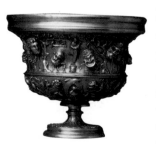

FRONTISPIECE F.3

The eastward thrust of the Romans during the mid-1st century B.C. greatly expanded their territories, while war booty filled the State's treasury to overflowing. But this late 1st century A.D. silver cup (Ht., 12.5 cm) which, in all its decorative motifs, strongly echo artistic traditions in fashion in the Hellenistic World decades earlier, illustrates well enough the susceptibility of the Romans to the beliefs and values of the eastern cultures of the day (Oliver 1977).
Courtesy of the Staatliche Museen, Berlin
See page 13.

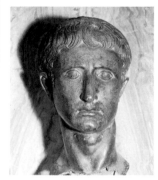

FRONTISPIECE F.4

Augustus (reigned, 27 B.C.–A.D. 14) was the most revered of the emperors among ancient writers such as the historians Suetonius, Tacitus and Dio Cassius, and only lightly chided for his excesses by the usually ruthless satirists, Martial and Juvenal. He demonstrated how tact and discretion could be the basis for imperial government that was far sounder that anything forged by naked power alone (cf. Sulla before him and Nero some decades later). He certainly fulfilled his dying boast, that he found Rome as brick and left it as marble (Suetonius, *Lives of the Caesars*: The Deified Augustus, 28).
Courtesy of the Vatican Museum
See page 17.

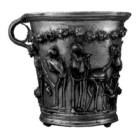

FRONTISPIECE F.5

Roman banquets were lavish affairs with course upon course of rich foods, plenty of wine, and numerous distractions, such a music and poetry recitals and juggling acts. Often, however, the entertainment would pause while the *larva convialis*—a small articulated skeleton made of wood or ivory—was brought to the table. This reminded everyone that the joys of life, including fine dining, were worldly and fleeting. The same notion underlay the depiction of skeletons as banqueteers in this silver goblet, dating to the 1st century A.D., from the ruins of a Roman villa unearthed at Boscoreale, near Pompeii.
Courtesy of the Louvre, Paris
See page 25.

FRONTISPIECE F.6

Roman military movements of the early 1st century A.D. resulted in a significant amount of household goods, glassware included, being carted beyond the Alps, to the new *colonia* of the Northwestern provinces. This striped mosaic bowl (D., 14.5 cm), though certainly of Italian origin, eventually became part of the furnishings of a Roman's grave at Hellingen in Luxembourg (Krier and Reinert 1993).
Courtesy of the Musée National d'Histoire et d'Art, Luxembourg
See page 31.

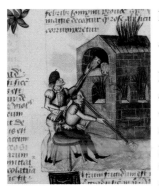

FRONTISPIECE F.7

As this vignette from a 15th century A.D. version of Dioscorides' *Materia Medica* shows, the mass production of mold-blown glassware is a relative straightforward process, particularly if two craftsmen work in tandem and have access to a permanent brick-walled furnace. In Roman times, however, we suspect that many glassblowers were itinerants and so worked on a smaller scale. They carried with them several molds, a blow-pipe and other tools, and they built a makeshift furnace close to wherever they could usefully ply their wares.
Courtesy of the Biblioteca Estense Universitaria, Modene
See page 37.

FRONTISPIECE F.8

This mold-cast, colorless bowl (D., 33.8 cm) was found in the famous *Cave of the Letters* in Israel (Yadin 1963). Its faceted design is exceptionally well-executed and detailed; most bowls of this kind ar either undeco-rated or have just simple lathe-cut grooves, depressions and rounded ridges on both sides of the ledge-like rim (Grose 1991).
Courtesy of The Israel Museum, Jerusalem
See page 43.

FRONTISPIECE F.9

Change the clothes, and change the vessels in the baskets from typical Medieval types to Roman ones, and the hawker of glassware we have here in a mid-16th century A.D. French manuscript would transform into the kind of itinerant glassworker who roamed the roadways of Rome's northwestern provinces in the 2nd and 3rd centuries A.D. We might also expect that one of the baskets contained broken glass fragments (*cullet*) that the glass-worker would at some point in his travels recycle into new domestic tablewares and storage flasks.
Courtesy of the Bibliotèque Nationale, Paris
See page 49.

FRONTISPIECE F.10

The influence of Eastern cults was felt in the highest levels of Roman society. For example, Augustus' son-in-law, Marcus Agrippa, who lived in Egypt for a while, became a follower of the cult of the crocodile god, Sobek. The soldiers under his command were expected to wear a suit made of croc-odile skin like this one dur-ing their formal parades (Knauer 1996).
Courtesy of the Trustees of the British Museum
See page 55.

FRONTISPIECE F.11

The Roman World's trading activities revolved about the movement of grain, oil and wine. Here we see the river boat *Isis Giminiana* taking aboard a shipment of grain at Ostia, and making ready for the upstream journey to Rome. Small loads of glassware might well have been included in the secondary cargo below deck.
Courtesy of the Soprintendenza Archeologica di Napoli e Caserta
See page 59.

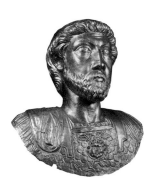

FRONTISPIECE F.12

Emperor Marcus Aurelius (reigned, A.D. 161–180) This emperor's golden bust (Ht., 33 cm; wt., 1.6 kg.) from the Cigognier Sanctuary at Aventicum (modern Avenches) in Switzerland is symbolic of the strength and stability of the Roman World in his time (Bögli 1989). Wars abroad there were, but the frontiers in the North and the East were well maintained. And even amid such strife, Marcus Aurelius had time to express appreciable humanism in his own writings, thus: "Men have come into the world for the sake of one another. Either instruct them then or bear with them. An arrow's path and the mind's path are very different. . . ." (*Meditations* VIII.59/60)
Courtesy of the Musée Romain Avenches
See page 67.

FRONTISPIECE F.13

Emperor Commodus (reigned, A.D. 180–192) gold *aureus* (D., 2.1 cm) For some later historians, the debauched lifestyle of this emperor and the bloodthirsty megalomania that characterized the last year of his reign was an omen in the decline of Rome's

power and fortune during the 3rd century A.D. Certainly Commodus' love of public gladiatorial combat and his assumption of a divine persona as Hercules were in sharp contrast to his father Marcus Aurelius' mild manner and scholarly bent.
Courtesy of the Trustees of the British Museum
See page 73.

FRONTISPIECE F.14

Emperor Septimius Severus (reigned, A.D. 193–211) gold *aureus* (D., 2.1 cm) Late historians had an emotional softspot for Severus who, it is said ". . . was a man of few words, though of many ideas. To friends [he was] not forgetful, to enemies most oppressive: he was careful of everything he wanted to accomplish, but careless of what was said of him." (Cassius Dio, *Roman History* LXXVII.16) Perhaps it was his relentless energy that others found so impressive. Even in the last two years of his life, though crippled by gout, he waged war in Britain, determined to settle the frontier problems there once and for all.
Courtesy of the Trustees of the British Museum
See page 81.

FRONTISPIECE F.15

Though the geography is highly distorted from reality, this portion of the *Peutinger Map*—a 13th century A.D. manuscript based on a late Roman original—shows the lands of the Eastern Mediterranean over which Constantinople (far left, with the enthroned emperor) held sway. As identified here, Bithinia, Galatia, Phrygia, and Asi[a], along with several other provinces, comprised early Byzantine Asia Minor. At the lower right is the tangle of river tributaries which define the triangle of the Nile Delta.
Courtesy of the Österreichische National Bibliothek, Vienna
See page 89.

FRONTISPIECE F.16

All over the landscape near the modern town of Beth Shean in Israel there are reminders of it distant pass. The high-terraced theater and the western public bathhouse (in the foreground) of the Roman city of Scythopolis dominate this aerial view (Mazor and Bar-Nathan 1998). Close by, however, are several ancient cemeteries of much lower profile that encompass a time span from at least the Early Bronze Age (circa 18th century B.C.) through to the later Roman era. A full sixth of the University of Pennsylvania Museum's collection of Roman glass come from tombs at this site.
Photograph by Gabi Laron, courtesy of Yoram Tsafrir, Institute of Archaeology, Hebrew University of Jerusalem
See page 97.

FRONTISPIECE F.17

What was regarded as fashionable for a Roman lady's hairstyle shifted in many different directions over the centuries, but one of the distinctive practices among early Roman empresses was to place a Hellenistic-style triangular hairpiece atop their elaborate coiffure (Stout 1994). Flaccilla, wife of the Emperor Theodosius I, as depicted here on a gold *solidus* dating A.D. 383, broke with that tradition when she began to wear a diadem that, like her husband's, was large and jeweled. Most of her successors followed suit.
Courtesy of the Trustees of the British Museum
See page 103.

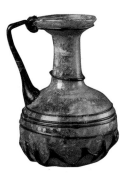

FRONTISPIECE F.18

The meander motif on the body of this early 5th century A.D. juglet (Ht., .9.9 cm) captures the essence of the glassworker's skills. Though not rigidly patterned as its equivalent in cast metalwork would be, this decoration has a spontaneity that allows us to identify with a craftsman thinking "on his feet" how to manipulate a hot thread of glass which has a treacle-like consistency for just a few moments before it cools and solidifies.
University of Pennsylvania Museum
See page 113.

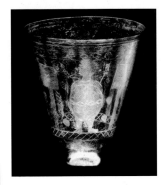

FRONTISPIECE F.19

It is appropriate that, as Rome tried so desperately to stem the tide of barbarian invasions at its Rhineland frontier during the mid-4th century A.D., at least one item of glassware should reflect the military crisis of the region. The linear-cut and abraded decoration on this beaker (Ht., 14.0 cm) is thought to depict the Imperial elite corps (*protectores*) which had been recruited from Germanic peoples that already had settled in the region around Cologne (Harden 1987: entry 131).
Courtesy of the Römisch-Germanisches Museum, Cologne
See page 117.

FRONTISPIECE F.20

Emperor Julian (reigned, A.D. 360–363) gold *aureus* (D., 2.0 cm) The historical focus on Julian's abortive bid to reinstate traditional paganism in Rome has tended to over-shadow his significant contributions to the Empire's general stability both before and during his reign. He restored the Rhine frontier with his defeat of the Alamanni at Argentoratum (modern Strasbourg) in A.D. 357, and he did much to reverse rampant political corruption in Gaul (see Mamertinus, *Latin Panegyric* XI [3].4), and his administrative reforms went some way towards defusing a growing public anger over their tax burden.
Courtesy of the Trustees of the British Museum
See page 121.

FRONTISPIECE F.21

This 15th century A.D. frontispiece to a copy of the late Roman administrative document, *Notitia urbis Constantinopolitanae,* though flawed in its architectural reconstruction, does capture some key features of the Imperial city. In the forefront, the dome of the *Church of Holy Wisdom* towers high above the *Hippodrome* where the early Byzantine rulers mounted circuses just as exhilarating as those of the early Imperial predecessors in Rome. The fine equestrian statue at the left celebrates the Emperor Justinian I.
Courtesy of the Bodleian Library, Oxford University
See page 125.

FRONTISPIECE F.22

Glass surely played one of its most important roles as a symbolic and practical viewing point of the surrounding world, when it was used by Jan van Eyck in his exquisite *The Arnolfini Wedding* (A.D. 1434), to mirror the gathering of guests before the betrothed couple.
Courtesy of the National Gallery, London
See page 131.

FRONTISPIECE F.23

The political division of the Roman World that at the end of the 4th century A.D. crystallized into what we now call the Eastern and Western Empires led to a similar split in the technologies of ancient glassworking. The kind of elongated, usually rectangular glassworking furnace that was to become the norm for Northwestern Europe by the 15th century A.D. is captured in remarkable detail in this early 15th century A.D. Bohemia manuscript, *Sir John Mandeville's Travels.*
Courtesy of the Trustees of the British Museum
See page 137.

FRONTISPIECE F.24

The earliest known mention of glass cited overleaf is in the apocalyptic writings of the Prophet Job who is shown here in a pensive mood in one of the sculpted niches on a wall of the sarcophagus of the Roman senator, Junius Bassus (circa A.D. 359). That old Hebrew text clearly differentiated glass from rock crystal; something that, much to the confusion of modern scholars, both Hellenistic and Roman literature often failed to do.
Courtesy of the Fabbrica di S. Pietro in Vaticano
See page 151.

FRONTISPIECE F.25

Creating a reasonably coherent picture of the development of Roman glassworking means pulling together all manner of ideas cultural and technical from literature old and new, then weighing up the validity of the observations made. In the text that follows this montage of emperors' heads, the anonymous author of *On Matters of War,* from the third quarter of the 4th century A.D., proceeds to strongly criticize the fiscal policies employed a half century before, stating ". . . It was in the age of Constantine that extravagant grants as gold instead of bronze . . . [were committed] to petty transactions." Though this statement was motivated by a desire to promote the pagan viewpoint, it does highlight a reality—that the injection into the early Byzantine economy of appreciable amounts of new gold coinage did cause an inflationary spiral which almost proved ruinous to the Empire's craftsmen, glassworkers included.
Courtesy of the Bodleian Library, Oxford University
See page 191.

1 Current thinking is that Mesopotamian crafts-men moved westward in the 7th century B.C. and settled on the Island of Rhodes so that it became the primary center for the production of core-form vessels for the next two centuries or so. That Rhodian craft seems, however, to have suffered a sharp decline around the time of the Peloponnesian War that left Athens in ruins in 404 B.C. When the craft re-emerged late in the 4th century, the vessel forms and decorative patterns were quite different from earlier ones and clearly Hellenistic in inspiration. Only the common use of the core-form technique and some remnant stylistic aspects in the finish of handles imply a continuation of tradition. The main production centers for the kind of bottle illustrated in Plate E.3 are thought to have been in southern Italy and Macedonia (Grose 1989).

2 Though the production of Megarian bowls was confined to Athens for most of the second half of the 3rd century B.C., the diffusion of the related technology around the Mediterranean was quite rapid thereafter. Popularity for these wares stimulated new workshops first at Pergamon and Tarsus in Asia Minor then just a couple of decades later at Cosa on the western Italian coast, only 120 kilometers north of Rome (Moevs 1980).

3 For several centuries past, bronzeworkers had used a closed-mold technique for their casting efforts. First, a model of the proposed vessel was prepared in wax, its decoration being carved out in full detail on the surface. Clay was then packed tightly around the model and allowed to sun dry to a leather-hard consistency. A subsequent kiln firing resulted in the wax being melted out, so that the mold's inner cavity became an exact hollow replica of the model. The mold would then be re-heated as molten bronze was poured into it (see Horne 1987).

Hellenistic glassworkers used this "lost wax" technique to create bowls decorated with a shallow fluting that closely mimicked the Eastern metalwork of the day (Stern and Schlick-Nolte [1994: item 66]; Oliver [1977: entry 41]). This was not a new idea, however. From the 5th century B.C. onwards, Persian and eastern Mediterranean glassworkers had been producing a wide range of tablewares decorated with lotus and other long-petalled motifs that also drew their inspiration from metal prototypes (Grose [1989: fig. 48]; Oliver [1977: entries 10–12]).

4 The mosaic decoration of glass vessels by a blending together of rod fragments of various colors dates back to the mid-14th century B.C. in Egypt (Keller 1983) and at least to the 8th century B.C. in the Near East (von Saldern 1970; Marcus 1991). Those mosaic wares drew their inspiration from allied crafts for inlay patterning of furniture and elements of massive architecture. The composite cane technology illustrated here (Plate E.6), with its more complex wrapping and controlled stretching of glass rods, seems to have been a quite independent Hellenistic innovation. Mosaic plates and bowls in the tomb hoards from Canusium (see Map E.1) that have forms which are identical to the monochrome vessels from there, place the origins of this technology in the latter part of the 3rd century B.C. (Grose 1989).

5 The earliest known use of the word *vitrum* is by the poet Lucretius (circa 99–55 B.C.) in his famous six volume work, *On the Nature of Things*. The part of his text that I have cited at the head of Section E.3 is important because it recognizes transparency as a vital property of glass. (For similar observations, see the quotations from Book IV.146, IV.150, and VI.990 in Appendix B here.) Thereafter, however, things get confusing, because *vitrum* appears in a number of contexts where it would be

more appropriately translated as "wall mosaic." Thus, in a theater built in 58 B.C. by Sulla's stepson, Marcus Aemilius Scaurus:

"The lowest storey of the stage was marble, and the middle one of glass/mosaic [*media e vitro*] (an extravagance unparalleled even in later times), while the top storey was made of gilded planks."
(Pliny, *Natural History* XXXVI.114)

The use of glass in such a context is not supported by archaeological evidence until Augustan times. Even then, glass is used only sparingly in mosaics to supplement naturally colored stones and other materials (Sear 1977 and Endnote 8 here: see also Pliny, *Natural History* XXXVI.189, where the phrase *vitreas facturus camaras* would most sensibly be translated as "vaults of mosaic.")

6 Concise summaries of the sea-trading of commodities vital to the late Hellenistic and Roman Worlds can be found in Casson (1984), Parker (1992) and Throckmorton (1987). The large-scale shipping of marble from Greece and Asia Minor, and of granite from Egypt, was driven largely by lavish construction projects—theaters, public baths, palaces, temples and administrative buildings (for Rome, see Maps I.2 and I.3 on page x). From the early 2nd century A.D. onwards, however, there was also extensive trading of these same stones as partially pre-fashioned coffins (Walker 1985).

7 Most scholars believe that the ship that sank at Antikythera was en route to Italy, but we have no way of knowing whether all or any of its contents were destined for Rome itself (Weinberg 1992). There came a time, however, when Hellenistic glassware certainly was reaching Rome. A certain Rabirius, who was put on trial in 54 B.C., owned several ships that were ". . . laden with showy and colorful articles of paper, linen and glass." (Cicero, *Letters to his Brother Quintus* II.9)

This ship, like many before and after it, was probably a casualty of the southerly gales (*siroccos*) that every year lash the south coasts of Sicily, Italy, and Greece every fall (Throckmorton and Kapitan 1968).

8 Here I have in mind the broader issue of glass becoming a significant part of Roman domestic life in the way that it would become by the Augustan era. This was the time, however, when the Romans first picked up on the already well-established Hellenistic use of small glass tiles (*tesserae*)—mostly blue and green—for decorative elements of floor mosaics, mixing them in with variously colored tiles of stone and faience (Nenna 1992; Sear 1977). This idea subsequently was adopted by the Romans in the construction of wall and vault mosaics for artificial grottoes (*nymphaea*) and fountain houses (see Plates E.35 and A.16).

9 As my colleague, John Scarborough recently pointed out to me, one of the reasons for Julius Caesar's public popularity was his facility to speak many languages at the venacular level. These he learnt while growing up with the mix of people at the large apartment complex which his mother owned at the edge of Rome's slum area, the Subura (see Map I.1 on page ix).

10 The find of a small, bulbous unguentarium in a burial at Morgantina (modern Aidone) in Sicily, that dates to sometime just after 45 B.C., does provide evidence for an ongoing interest in free-blowing in the glassworking craft (see Grose [1977: fig. 8]). The site also yielded other free-blown vessels—small globular bottles and bowls decorated with pinched ribbing —that date to the Augustan era. But by far the majority of the glassware recovered from contemporary contexts at Morgantina was mold-cast.

11 Aquileia was established as a Roman colony in 181 B.C. During the Imperial era it owed much of its prosperity to the minerals and metal ores of the three provinces—Noricum, Pannonia and Dalmatia—that lay in its hinterland. As a port, it linked a sea route from the East to the roads that carried goods (including glassware) northward to tributaries of the Danube and the Rhine, those rivers

being primary arteries to the Black Sea coast and to the Gallic provinces, respectively (DeMaine 1983; Sorokina 1967).

12 The prestige of sardonyx in Roman times stemmed in part from its connection to earlier Classical myths, one such legendary stone being displayed in the Temple of Concord, set in a golden horn (Pliny, *Natural History* XXXVII.4). Sardonyx was so much an expression of affluence that the satirist Juvenal (*The Satires* XII.144) noted how the lawyer Paulus rented a jewel with one in it whenever he pleaded in court, and so commanded a higher fee than certain of his contemporaries—thus the Roman proverb: "Eloquence rarely appears in rags."

13 These matters are partially captured in this, one of the many moral criticisms voiced by Roman writers shortly after Nero's death:

"Nero's wife Poppaea used to drag five hundred she asses with foals about with her everywhere and actually soak her whole body in a bath of ass's milk, believing it also smoothed out wrinkles."
(Pliny, *Natural History* XI.238)

Nero's avowed love of Poppaea rings somewhat hollow when we recall that he caused her death by kicking her while she was pregnant and ill after she scolded him for returning late from a chariot race (Suetonius, *Lives of the Caesars*: Nero, 35). He also removed Poppaea's son, Rufinus Crispinus, from his list of potential critics by having him drowned by his own slaves.

14 Though ancient texts by Seneca (*On Anger* III.35) and Juvenal (*The Satires* III.194) provide us with a good sense of the risks of apartment dwelling in ancient Rome, I think the following modern description of such matters captures them rather better:

"The building seemed to shimmer for a second, though not with the light. . . . The street was busy; no one else noticed anything at first. The entire frontage of my apartment block crumpled, quite quickly, like a human face dissolving in tears. . . . Then the noise overwhelmed the street. Immediately afterwards we were swamped by a great cloud of masonry dust which enveloped everyone in its stinging, suffocating filth."
(Lindsey Davis, *Venus in Copper*, 234)

15 The region around Capua was Rome's fruit orchard, much of its produce being preserved in honey and traded throughout the Italian mainland. Campania was also famous for the perfume made from the sweetly scented wild roses which grew there each spring when the millet and wheat fields were allowed to stand fallow.

16 Many say that Nero instigated the Great Fire of A.D. 64 simply to clear the space he needed to build his Golden House (*Domus Aurea*). Whatever the truth of that matter, what resulted was a country park in the heart of the city that even Nero's strongest critics grudgingly admitted was an architectural masterpiece (see Tacitus, *Annals* XV.42). Its vestibule was large enough to take a 31 meter high statue of the emperor—this, the first version of the Colossus. Scattered through the rest of the house, were dining rooms with fretted ivory ceilings with panels that could revolve and so shower down flowers on the banquetters below (Suetonius, *Lives of the Caesars*: Nero, 31).

Within two decades, however, the palace's real estate had been urbanized to include the Colosseum and a complex of public baths dedicated to the Emperor Titus. By A.D. 109, the Domus Aurea itself was buried in the foundations of the public baths dedicated to the Emperor Trajan.

17 Surely the most famous cameo vessel is the *Portland Vase* in the British Museum, with its remarkable history of discovery late in the 16th century A.D. and its subsequent restoration and detailed technical analysis (Whitehouse 1990; Painter and Whitehouse 1991). Its depiction of the Greek hero Achilles and related characters is thought by some scholars to be an allegory for the Emperor Augustus and his family. There are several other fine glass cameos, however, that deserve mention

here (Harden [1987: entries 31–36]), most obviously those from Pompeii: (i) the twin panels from the "House of Fabius Rufus" that depict Dionysus and Ariadne; and (ii) the amphora, sometimes called the *Blue Vase*, from a tomb belonging to the "House of the Mosaic Columns" that depicts a Bacchic festival.

18 As we might expect, window glass was used quite extensively in the cooler regions around the Empire, such as Britain, and in a variety of domestic settings (Baxter and Cool 1991). The earlier panes were rough cast into a wooden frame, onto either a smoothed layer of sand, or a slab of stone or wood (Boon 1966). From the late 3rd century A.D. onwards, however, window glass increasingly was made by the *muff process*, wherein a sheet is created from a blown cylinder that has been slit open and warmed until it flattened out. The glass windows of the 6th century A.D. version of the Church of Holy Wisdom in Constantinople surely were made this way (Forbes 1966; see also Harden 1939).

19 Saffron also was included in several Roman medicinal recipes, despite its expense (Scarborough 1996), and it was a popular culinary herb. Saffron spice was prepared from the dried stigmata of *crocus sativa* and, along with pepper, ginger, and cardamon, was much used in Roman cookery—for example, in a broth of sea scorpion and turnips that the gourmet Apicius described in his 1st century A.D. recipe book, *De Re Coquinaria* (see Giacosa 1992). According to Petronius (*Satyricon*, 68), it was also used to color the sawdust strewn about the floor at a banquet.

Direct literary evidence for the tending of vines by shielding them with glass comes solely from the quotation:

"Lest envious winter bite the purple clusters, and chill frost devor the gifts of Bacchus, the vintage lives enclosed in transparent glass and the blooming grape is covered, yet not hidden." (Martial, *Epigrams* VIII.68)

It seems reasonable, however, to accept the following translation which refers to the recommended care of cucumber plants:

"In any case, the vessels ought to be covered with panes of glass, so that even in the cold weather, when the days are clear, they may be safely be brought out into the sun. By this method Tiberius Caesar was supplied with cucumbers during almost the while year." (Columella, *On Agriculture* XI.3)

even though the word *specularibus*, not *vitrum* is used here (see also Appendix B).

20 Space limitations in this Section of the book make it impractical for me to illustrate the diversity of the color schemes used for these two-handled jars. For some typical examples, I would direct the reader to Harden (1987: entries 42 and 45), and Goethert-Polaschek (1977: form 133). The kind of pinched-rib handle that I am referring to here also occurs on the jug shown in Figures E.15b and E.28.

21 Molds of fine gypsum plaster also were used in pottery lamp production (Bailey 1976), and perhaps by the glassworking industry as well. Since the relatively rough and friable surfaces of stone and fired clay molds could cause some pock-marking and bubbling on the glass's surface, metal molds would have been preferred for creating finer designs in low relief (Price 1991).

The limited amount of physical evidence we have for this aspect of Roman glassworking has been gathered together by Foy and Sennequier (1989) and Cool and Price (1995) and can be summarized as follows: (i) stone blocks from various places in the Western provinces, each with negative impressions of concentric circles that most likely were pattern molds for the bases of square bottles during the late-1st-mid-2nd century A.D. (cf. those in Plate E.70); (ii) a mold of similar purpose and date but of fired clay, from the Hahnentor section of Cologne, for a pattern of four concentric circles and right-angled corner pieces; (iii) a fired clay half-mold for a grape flask from Mascquenoise in Belgium, that would date to the late 2nd–3rd century A.D. (cf. Plate E.83); (iv) a one-piece limestone mold from Autun in central France, for a 5th–6th century A.D. bowl form; and

(v) a hexagonal bronze mold from Samaria in Israel, for a floral design used in the late 6th century A.D. (see Section E.21).

22 The kind of copyright laws that are in place for industrial products today were unheard of in the Roman World during the late 1st century A.D. Though, for example, one of the most successful manufacturers of pottery lamps applied the trademark FORTIS on the underside his wares, he was unable to prevent the circulation of dozens of imitations that were similar marked. The original lamp was perfect for use as a master die in the creation of a two-piece mold which, of course, would faithfully reproduce whatever lettering variation or design element the FORTIS factory applied (Harris 1980).

23 The fact that these cups occur in high concentrations at particular sites far from one another—for example, at Vindonissa (modern Windrisch) on the upper Rhine and at Eboracum (modern York) in northern Britain —while they are absent completely at other sites in between, would argue against their long-range trade. Consequently, some scholars believe that they were made by traveling glassblowers who carried with them the clay molds they would need to produce the glassware right at the point of sale (Cool and Price 1995). For their glass stock, these itinerant craftsmen recycled fragments of vessels that could be found in abundance in the trash pits surrounding the camp (see also Endnote 32).

24 For those who, like myself, know little about what distinguishes these various hardstones, I include here a brief description of their mineralogy (see Deer et al. 1966):

Onyx (or banded agate) is a compact variety of silica composed of minute crystals of quartz (SiO_2) and submicroscopic pores, with coloration that is arranged in bands or concentric circles.

Amethyst is quartz (SiO_2), but is distinct from rock crystal in that it has a violet coloration because it contains a trace impurity of iron (typically about 0.022%).

Fluorspar is a natural form of calcium fluoride (CaF_2), its visual appeal stemming from the diffuse bands of blue and purple that run through its otherwise near-colorless structure. The banding is due to an uneven distribution of impurities such as manganese that provide the mineral with coloration because they have been exposed to appreciable amounts of natural radiation over the geological time-scale.

The Roman fascination with these three minerals is described in Pliny (*Natural History* XXXVII.90, .121, and .21), respectively. That same author's brief remark, that: ". . . In general, all gems are rendered more colorful, particularly if it is Corsican honey, which is unsuitable for any other purpose owing to its acidity." (*Natural History* XXXVII.195) has been confirmed as a valid way of artificially coloring banded agate to look like sardonyx (see Nassau [1984: fig. 3]).

25 Mineralogically, rock crystal is quartz that is quite free of impurities and defects and so has a good transparency. Given the esteem in which it was held in Roman society, discussion of its sources and properties by Pliny is surprisingly brief. He does note, however, that a piece of it weighing 150 Roman pounds was dedicated in the Capitol by Augustus' wife Livia and that an earlier writer had seen a vessel carved from it that could hold more than six gallons of wine. More anecdotal is his claim that an enraged Emperor Nero, when overthrown, broke two rock crystal cups as "the vengeance of one who wished to punish his whole generation. . . ." (Pliny, *Natural History* XXXVII.29)

Since I have emphasized so much the nature of the Roman material hierarchy in this essay, I provide here in full Pliny's view of such matters:

"However, to return to products pure and simple, the most costly product of the sea is the pearl; of the earth's surface, rock crystal; of the earth's interior, diamonds, emeralds, engraved gemstones, and vessels of fluorspar; of the earth's increase, the scarlet kermes-insect and silphium, with spikenard and silks

from leaves, citrus wood from trees, cinnamon, cassia, and amomum from shrubs, amber, balsam, myrrh and frankincense, which exude from trees and shrubs, and costus from roots. As for those animals which are equipped to breathe, the most costly product found on land is the elephant's tusk, and on sea the turtle's shell. Of the hides and coats of animals, the most costly are the pelts dyed in China and the Arabian she-goat's tufted beard which we call *ladanum*. Of creatures that belong to both land and sea, the most costly products are scarlet and purple dyes made from shellfish. Birds are credited with no outstanding contribution except warriors' plumes and the grease of the Commagene goose. We must not forget to mention that gold, for which all mankind has so mad a passion, comes scarcely tenth in the list of valuables, while silver, with which we purchase gold, is almost as low as twentieth." (Pliny, *Natural History* XXXVII.204)

26 In the same passage, Cicero went on to say: "And the most shameful occupations are those which cater to our sensual pleasures, '. . . fish sellers, butchers, cooks, poultry raisers, and fishermen . . .' as Terence says [in his 2nd century B.C. comedy, *The Eunuch*]. Add to these, if you like, perfume-makers, dancers, and all of vaudeville." He also made the telling observation that carried through into the late 1st century A.D. as one of the most widely accepted of Roman social attitudes: "Also vulgar . . . are the occupations of all hired workmen whom we pay for their labor, not for their artistic skills; for with these men, their pay is itself a recompense for slavery." Only the occupations of medicine, architecture and the teaching of liberal arts were spared his distaste.

Being a craftsman was not in itself, however, the real barrier to social advancement. Implicit in this matter is the fact that only those who lived off the income of their ancestral estates or their own financial investments could afford to take up unpaid "public service" positions such as magistracies. All the folk that Cicero devalued rarely could aspire

to such a government post, itself the stepping stone for further acquisition of wealth.

27 The exceptional skills of 1st century A.D. Roman bronzemakers are apparent not only in the fountain-head illustrated here, but also in a whole range of massive statuary and bronze vessels, particularly oil lamps, that have been found at various buildings at Pompeii (for examples, see Franchi dell'Orto and Varone [1993: entries 104, 122, 125, and 193–195]).

28 Pliny (*Natural History* XIV.9–148) provides a comprehensive description of Roman winemaking down to the detail of preferred methods of vine-grafting and the prevalent views on the quality of both Italian and provincial wines. The decline of the famed Italian vineyards that he attributed to a mistreatment of the land seems to have continued over the subsequent centuries. Even at the beginning of the 4th century A.D. however, wine from the Falernum district (near Capua)—the *grand cru* region in Republican times—was still producing wine at about 30 denarii per *sextarius* (1.14 U.S. pints), which was four times the price of what ever was then popular as *vin ordinaire* (see Fleming 1997a: pls. 63–67]: Shelton [1988: entry 152]).

The overall decline of the Italian vineyards from the Augustan era onwards had significant trade implications. During the 1st century B.C., some 40 million amphorae of Italian wine used to be traded to Gaul alone and, while the Roman army must have consumed a great deal of this, so too did the Gallic nobility. The historian, Diodorus Siculus (*History of the World* V.2) noted that, in return for one amphora of wine, the merchant might expect to receive one slave—a highly advantageous deal, considering that in Italy a slave then cost at least sixty times as much (Potter 1990).

29 The way in which the Romans developed urbanism in Gaul was quite subtle. To a large extent, the purpose of establishing *colonia* was to provide the opportunity for war veterans to establish personal wealth at the cost of those

that Rome had conquered. With the organization of *civitates*, it was a matter of erstwhile tribal leaders continuing to exert fiscal and moral control over their own (Bekker-Nielsen 1989). Ensuring that the *civitates* were well separated from one another placed enough economic strain on local officials that individually they could not challenge Roman authority. To some extent, this arrangement also put them in a competitive setting in terms of trade. The Emperor Augustus artfully ensured the allegiance of the northern part of Gaul—*Gallia Comata*—by dividing it into three provinces—Aquitania, Lugdunensis, and Belgica—that were shaped deliberately to cut across ethnological divisions (Hammond and Scullard [1970: 458])

30 Over the four years, A.D. 66–70, the province of Judaea was awash with troops from all over the Eastern Empire—from Antioch in southeastern Asia Minor to Zeugma on the river Euphrates and various legionary camps in Egypt (Josephus, *The Jewish War* V.I). Specifically, in the early part of A.D. 67, the Emperor-to-be Vespasian's forces were centered on three whole legions: "One, the *XV Appollinaris*, which had earlier in the 60s been engaged in the Armenian campaign, had since been moved to Alexandria and was now marched from there to Ptolemais by Vespasian's son Titus. The others were the *V Macedonica*, also earlier in Armenia, but where it had been since then is unknown; and the *X Fretensis*, also engaged earlier in Armenia, but from the established garrison of Syria." (Millar, *The Roman Near East*, 72). Two years later, Vespasian sent portions of these legions back to Italy, there to link up with legions from the Danubian provinces that descended on Italy from the north, thereafter to oust the Emperor Vitellius from Rome.

Restless though these times certainly were, the kinds of troop displacement described here often was repeated on a smaller scale throughout the first two centuries A.D. (see Cornell and Matthews [1982: p.79]; Keppie [1984: Appendix 2]) and that they also were a significant stimulus to long range movement of commodities throughout the Roman World (Middleton 1983).

32 The recycling of glass has been identified at only a few archaeological sites of the early Imperial era, among them York in northern England where the Tanner Row excavations yielded partially melted scrap fragments (*cullet*); at Nijmegen on the Rhine where large trash pits of broken glass also contained various kinds of glassworking debris including failed, distorted vessels that we now call *wasters* (Cool and Price 1995; Isings 1980). Our best indirect evidence for recycling comes from the fact that many trash deposits of glass comprise only small fragments, reflecting how the cullet "stock" had been picked over and the larger fragments carted away (Price 1987). I suspect that itinerant glassworkers were quick to scavenge the huge amounts of glassware, complete or smashed, that were discarded as a legion moved away from a settlement, unless it was dumped somewhere inaccessible, such as a water well or a latrine pit (Caruana 1992; Price 1985; Price 1993).

I discuss some of the technical aspects of the recycling of broken glass and the long distance trading of cullet in Appendix A.

33 What we know about the location and substance of Roman glassmaking and glassworking sites is summarized by Isings (1980), Foy and Sennequier (1989), Cool and Price (1995), and Morel et al. (1992) for the Western provinces; and by Brill (1967), Brill, (1988), Fischer (1993), and Gorin-Rosen (1993) for the Eastern provinces.

34 The clearest picture we have of how a craft-based industry developed in the Western Empire comes from potterymaking. An expansion of the already massive kiln complexes around Arretium (modern Arezzo) had established that city as the primary center for production in Italy in Augustan times (Greene 1977). Even as it flourished, however, new workshops were set up in and around the fast-expanding provincial cities such as

Lugdunum (modern Lyon) in Gaul. The productivity of these workshops was raised by shifting to them some of the skilled craftsmen and hardware of their owner's Italian facilities. A decade or so later, pottery workshops in southern Gaul became prominent, particularly those around Massilia (modern Marseilles). As far as I am aware, however, the potterymaking industry did not have the itinerant craftsmen that are thought to have played such a significant role in the everyday practice of glassworking.

35 Many of the shapes and decorative elements of glass vessels were copied from, or shared by, pottery vessels in vogue at the same time. Thus, in the mid-to-late 1st century A.D. the sets of grooved bands that were then being mold-cast and incised on pottery vessels were simulated by lathe-cutting on glass ones (Ettlinger 1951; Greene 1977): ditto, for the outsplayed or folded rims of plates, bowls, and cups of the early 1st century A.D. that are almost signature products of the pottery then coming out of the massive kiln complexes at Arretium (Hayes 1997). In the case of the dimpling and faceting, which was so fashionable for glass vessels late in the 1st century A.D. however, it may well be that it was the potters who were the mimics (Martin 1977).

In Figure E.16 here, I have illustrated how glassblowers manipulated their material to mimic the rim shapes on cups and plates that potters achieved using mold-casting.

36 The modern "Hollywood" image of Nero fiddling while Rome burnt is based loosely upon comments about that emperor's life made more than half a century after his death: "Viewing the conflagration from the Tower of Maecenas and exulting, as he said, in 'the beauty of the flames,' he sang the whole of [his own composition] *The Fall of Ilium*, in his regular stage costume." (Suetonius, *Lives of the Caesars*: Nero, 38) There is other evidence, however, that suggests Nero was away from Rome the night of the fire and that he rushed back to organize housing for those who had lost their homes (Nichols and McLeish 1976).

A factor underlying the populace's acceptance of Nero's persecution of Christians was the cult's overt claims that the imminent end of the earth (thus, the destruction of the Roman World) would be a fiery apocalypse.

37 Our knowledge of these matters comes from Tacitus (*Annals* XV.44). One of the reasons that the Christian acceptance of martyrdom surprised the Roman authorities so much was their experience that cult followers usually were quite fickle. For many, being part of a cult was a fad open to disenchantment and dismissal, and "conversion" as we think of it was not considered binding. It was common enough for someone who moved to another city to transfer his/her allegiance to whatever religious standpoint prevailed most strongly there.

Some years later Juvenal referred to one of the horrors of these times as "the shirt of discomfort" (*The Satires* VIII.235), a garment soaked in pitch that the Christians wore as they were bound at a stake and burnt alive. These human torches served as the illumination for Nero's circus games as the daylight faded (Wilken 1984).

38 We know that Augustus was particularly tolerant of Judaism to the extent that if the distribution of monthly grain dole fell upon a Sabbath, he instructed his officials to set aside an appropriate amount for the Jewish needy until the next day (see Philo, *The Embassy to Gaius*, 155). The truth is, the Romans simply were uncomfortable with any organizations that had an established treasury which might be used to stir up popular unrest (Shelton 1988). When Pliny the Younger became governor of the provinces of Bithynia and Pontus (in northern Asia Minor) in A.D. 110, he demanded that Christians recant their faith more on the grounds that their grouping together posed a threat of civil strife than because of any fault he could find with their religious views and practices (Wilken 1984).

39 Mithras, the ancient Iranian god of light and truth, gained Empire-wide popularity in the 3rd century A.D. The role of Mithras as a creator god was symbolized by the slaying of a bull, its flowing blood being the source of Life.

Mithraic shrines have been found at many military settlements along the Rhine frontier, the fort at Nida (near modern Frankfurt) had at least four of them together with many Mithraic sculptures (King 1990). There are also three inscribed altars at Brocolitia (modern Carrawbaugh) on Hadrian's Wall that honor this cult (Keppie 1991). Recent excavations of a Mithraeum at Aquincum (modern Budapest) in Hungary yielded a fine glass bowl that is appropriately decorated with an engraving of a bull (Kocsis 1991).

40 It has to be said that the urban juxtaposition of cultic attitudes was not always harmonious. For example, in A.D. 177, a conflict between the powerful followers of Cybele in Lugdunum (modern Lyon) and a group of local Christians led to many of the latter being fed to the wild beasts of the amphitheater (King 1990).

41 Trajan's rise to imperial power was along the tried-and-true path of bygone days. His father commanded the Legion X *Fretensis* during the Jewish War in A.D. 68 (see Endnote [30]) and at various times was the governor of the provinces of Baetica, Syria, and Asia (then meaning just the southwestern part of modern Asia Minor). Trajan served with his father in Syria in the 70s and within a decade was commander of the Legion *VII Gemina* in northern Spain. He was extremely popular with his troops during the Dacian campaign, when he showed every willingness to share their hardships and risks.

Despite the high regard with which he was held by the Roman populace and the State's politicians, Trajan did have some significant moral weaknesses, namely a devotion to boys and wine, and a blood-thirstiness for animal slaughter during amphitheater spectacles that sometimes outstripped even Nero's excesses.

42 Glass inkwells of the 1st century A.D. usually had three looped handles and a squat cylindrical body—though hexagonal ones are known as well—and an inward-folded rim that extended sufficiently far as to leave just a small mouth to the vessel (see Cool [1996: fig. 12b]). (If I recall correctly, inkwells from the era of quilled pens tended to have this last feature as well.) For the most part, they seem to have a product of the Northwestern provinces (Cool and Price 1995). Though glass inkwells were never as popular as pottery ones, the fact that this kind of vessel entirely vanished from the glassworkers repertoire early in the 2nd century A.D. has always surprised me. I am tempted, therefore, to believe that some of the globular vessels which appear at that date—specifically those with a narrow neck and a somewhat flattened underside (see Fleming [1996: fig. 22]; Sennequier [1985: fig. 212])—are now misidentified as "oil flasks."

The belief that glass may have been used to make a shower-like device for sprinkling wine is based on a quotation: "The [rain] shower that comes from Jove will pour water in plenty to mix in your cups. This *nimbus* will give you wine." (Martial, *Epigrams* XIV.112)

43 Provincial Romans certainly appreciated their luxuries, even when they were on the move. Thus Pliny (*Natural History* XXXIII.143) says of an earlier governor of Germania: "But, good heavens, Pompeius Paulinus, the son of a Knight of Rome at Arles and descended on his father's side from a tribe that went clad in skins, to our knowledge has 12,000 pounds of silver plate with him when on service with an army confronted by tribes of the greatest ferocity."

44 I imagine that the Roman preoccupation with daily public bathing has some parallel with the modern Christian notion that "cleanliness is next to Godliness." In an intriguing sideline to this subject, however, physical anthropologists have recently shown that the urban male population of an island near Ostia suffered a far higher incidence of auditory problems

than their less hygiene-obsessed counterparts in the neighboring countryside (Manzi et al. 1991). Though, given the incessant gossip and the clamor of food vendors that went on at public bath-houses every afternoon, perhaps a little deafness was something to be thankful for (Fleming 1997a).

45 Evidence for this point is particularly clear in the kinds of vessels that were distributed along the various rivers that linked the trading centers of the Danubian provinces—Noricum, Pannonia, and Dalmatia—to the Black Sea coast (see DeMaine 1983).

46 The sale of domestic glassware within the Empire was never going to have a significant profit margin: because of the sharp divisions of wealth with in Roman society, the mass of the population lacked the means to buy too many manufactured goods (Casson 1986; Duncan Jones 1980). Roman glassware was, however, quite highly prized in many of the lands beyond the Empire's frontiers, and it could be exchanged at a very favorable rate for items that, however briefly, were regarded as exotic by Rome's nouveau riche. The trade in glass vessels at a number of coastal market-places in the lands bordering the Indian Ocean is documented directly in a 2nd century A.D. manuscript known as the *Periplus Maris Erythraei* (Casson 1989: see also Appendix B here). But finds in Korea and southern China indicate that Roman glassware was traded by sea much further than that (In-Sook Lee 1997; Takashi Taniichi 1983). Similarly, finds at various trading outposts along the famous Silk Route indicate that Roman glassware also was carried overland from frontier cities in Syria, across Iran and into northern China (Curtis 1979; Whitehouse 1989). Meanwhile, in the West, the peoples of Scandanavia had a centuries long tradition of importation of Roman glassware, most of it originating in the Rhineland as we might expect, though a few items of Syrian origin seem to have reached that far north as well (Ekholm 1963; Hansen 1995).

47 When glass bottles were used to move something over long distances, they were probably packed a dozen or so at a time in wooden crates that were then wedged in amongst similarly small loads of pottery plates, clothing, and farm tools, all heaped onto a horse-drawn cart or a river barge (see Fleming [1997a: pl. 10]). For this kind of small-scale shipping, the fragility that we now instinctively associate with glass seems to have been a relatively minor limitation in Roman times. Certainly the thick-walled square bottles of the kind illustrated in Plates E.66, E.68, and E.70,a could stand up to a lot of jiggling and bumping around; presumably, thinner-walls vessels were heavily wrapped in some packing material such as straw or cloth. The discovery of glass vessels at remote cities in Iran (Whitehouse 1989; Curtis 1979), and at Roman outposts along the Persian Gulf (During Caspers 1980; Haerinck 1992) indicates clearly enough that, if the will and the wealth were there, some items of glass could be moved across continents (see also Endnote 46).

48 Because of its potential for corruption, the idea of a monopoly in an industry raised the same kind of fears among Roman business-men that it does among Western governments today: ". . . nothing having been the subject of more frequent legislation by the senate, and every emperor without exception having been approached by complaints from the province." (Pliny, *Natural History* VIII.135). To Pliny's dismay, even the market for the hedge-hog skins which were used in dressing cloth for garments was controlled in this way!

49 Here "white earth" alludes to a polishing powder used by silversmiths—probably what we call diatomaceous earth today—an inferior grade of which was used to trace the finishing lines for circus races and to mark imported slaves when they were put on sale (see Pliny, *Natural History* XXXV.26).

50 Some signs of the greater respect now afforded slaves include the fact that one of the rules of Nero's Senate—that all the slaves of a murdered official would be put to death,

even if none of them were responsible—was no longer considered appropriate. Hadrian sought ways of protecting slaves by introducing laws that required any capital charges against them to be handled through official courts. He also banned the sale of slaves to a pimp or a gladiator trainer without due cause (see Aelius Spartianus, *Augustan Histories: Hadrian* XVIII.7). But there were still many instances of the flogging of slaves for truly minor failings and of needless brutality (see Martial, *Epigrams* III.94; and Juvenal, *The Satires* VI.475, among others), not to mention instances of ugly sadism:

"He [Vedius Pollio] used to toss slaves sentenced to death into ponds of lampreys, not because wild animals on land were not capable of killing a slave, but because with any other type of animal he was not able to enjoy the sight of a man being torn to pieces, completely, in one moment."
(Pliny, *Natural History* IX.39)

51 A more cynical explanation of the better lot of slaves in the 2nd century A.D. was that the owner was protecting his investment. There were still major slave markets in Alexandria and on the Aegean island of Delos, but the asking prices were now quite high. Slaves usually were valued at 2000 *sestertii* for legal purposes, but skilled ones fetched much higher sums, not least the language teacher Lutatius Daphnis, at 700,000 *sestertii* (Duncan-Jones 1982).

52 Reality was that the city-owned slaves who worked on public projects such as road or aqueduct construction, and those who labored in the mines or on farms (where they were usually thought of as the kin of farm animals: see Varro, *On Agriculture* I.17) had such short lifespans that few of them would have survived to be part of Roman society, let alone rise to prominence in it (Shelton 1988; Duncan-Jones 1990). A slave who worked in a private household—for example, as a tutor, gardener, or barber—did, however, have a chance of establishing some personal contact with his owner and therefore of being treated somewhat more humanely. He might receive occasional small gifts of money (*peculium*) that, if saved, might add up to the price of his freedom.

To put in context some of the achievements of the freedmen who became politically successful figures in their own lifetime, we should note that towards the end of the 1st century A.D. the cost of gaining release from slavery could be as much as 4,000 *sestertii* (Duncan-Jones 1982). A craftsman's income at that time was only about 1,000 *sestertii* a year, so anyone with higher aspirations had to either gamble in trade or have some unusually appealing skills. A position on the council of an Italian town required evidence for ownership of property valued in excess of 100,000 *sestertii*. To maintain the lifestyle deemed appropriate to a senator you needed a fortune of about 8 million *sestertii* !

53 The way that educated slaves could take advantage of their privileged position in a wealthy man's household is described entertainingly by a mid-1st century A.D. novelist thus: "Then, as the Gods willed, I became the real master of the house, and simply had his brains in my pocket." (Petronius, *Satyricon*, 76).

The two great "success stories" for slaves in the Roman World were surely the Emperor Pertinax (reigned, A.D. 193), who was the son of a freedman who had prospered in the wool trade (Scarre 1995), and a eunuch freedman of the Emperor Claudius named Poseides, who is said to have built a house in Rome that was so large that it dwarfed the Temple of Jupiter on the Capitoline Hill (see Suetonius, *Lives of the Caesars*: Claudius, 28; also Juvenal, *The Satires* XIV.91).

54 Even earlier than Pliny's time, a Greek literary critic who taught in Rome around 20 B.C. commented how many ways there were by which slaves could gain their freedom. He urged that magistrates be appointed to vet the reasons why that freedom was granted, and having identified the unworthy individuals, that ". . .they should expel from the city the foul and polluted herd." (Dionysius of Halicarnassus, *Roman Antiquities* IV.24)

56 Juvenal was right: the more affluent Greek businessmen *did* aspire to own property on the two most prestigious hills at the heart of Rome, the Esquiline and Viminal (see Map I.I on page ix). Let it be said, though, that he had a distrust and dislike of foreigners in general, claiming that perjury was one of their most common failings (*The Satires* VI.16). He belittled the dietary laws of the Jews, the astrological beliefs of the Parthians, and the honesty of the faith of the followers of the Egyptian goddess Isis (*The Satires* VI.159, VI.557 and VI.534, respectively). He was contemptuous of the new class of freedmen who had shaken off the fetters of slavehood and had grown as wealthy as some of the merchant Greeks in the city (*The Satires* VII.16).

57 The strength of the fashion for beards from the 2nd century A.D. onwards can be well-illustrated by contrasting the clean-shaven appearance of the men in Augustus' *Ara Pacis* monument in Rome with the scene on a triumphal arch now located in Rome's Capitoline Museum that depicts Marcus Aurelius and several colleagues—all of them heavily bearded—as they carry out a traditional sacrifice (see Stone [1994: figs. 1.6–1.16]). This fashion attracted its dose of satirical criticism like every other:

"O lovely whiskers, o inspirational mop! But if growing a beard, my friend, means acquiring wisdom, any old goat can be Plato."
(Lucian of Samosata, *Meditation on Bearers* XI.430)

58 I have followed the approach of Charleston (1964) who differentiates the two ways of decorating a glass surface as follows: (i) *lathe cutting*, where the vessel is rotated while the cutting tool is applied to it; and (ii) *engraving*, where the head of the cutting or abrading tool is rotated while the vessel is brought to it and held steady. The phrase ". . . aliud torno teritur, aliud argenti modo caelatur. . . ." (Pliny, *Natural History* XXXVI.193) would suggest that the Romans made a similar differentiation, if we accept a translation ". . .

some machined on a lathe, and some chased like silver [= engraved]."

59 A commonality in vessel shapes suggests that, during the late 1st century A.D., factory-cast blanks were rough-cut and tooled before they were sent on to glassworkers who specialized in faceting also were provided to those who specialized in painting or enameling glassware (Oliver 1984). Certainly we know that, in the 3rd century A.D., vessels of identical shape were provided glassworkers for either wheel-cut decoration or painting (see Figure E.43).

There is also some possibility that much of the final faceting of glassware was carried out in the marketplace, perhaps to customer taste. Thus, in the context of Jewish codes of purity, as laid out in the *Mishnah*, the "bed" at the stall of a glasscutter (*zaganim*) was regarded as unclean, whereas that of the harness-makers were cleanest of all (Neusner 1974, for *Kelim* XXIV.8: see also Endnote 110).

Glasscutters (*diatretarii*) and glassworkers (*vitrari*) also are differentiated in *The Theodosian Code*, in the section that describes the Emperor Constantine's decision to exempt certain craftsmen from compulsory public service (see Endnote 91)

60 The overall economic healthiness of the Empire did allow several local officials to make quite substantial private donations to the regions in their care. For example, the building of the amphitheater at Carnuntum (modern Vienna) was funded by an immigrant from Syrian Antioch, C. Domitius Zmaragdus, who had become an official of that city. Similarly, Pliny the Younger donated 1.3 million *sestertii* towards the building of a library and an extension of one of the public baths in the town Comum (modern Como) in Italy, where he had been raised (Duncan-Jones 1982, entries 441 and 469a).

61 Among other things, Hadrian simply forbade circumcision on penalty of castration of the perpetrator. In principle, such a ban affected many peoples in the Levant and Africa. For

them, however, this ban was a nuisance; for the Jews it was a sacrilege. Hadrian's successor, Antoninus Pius, recognized the differing impact of this edict and so revoked it for the Jews alone.

In researching the religious climate of the early-to-mid-2nd century A.D. I was impressed by the following observations:

". . . by the days of Hadrian, the outlook for the Christians, although they still had trials to undergo, was much brighter than it was for the Jews. Jesus had turned the direction of life, its moral goal, from the nation, that is his own Jewish nation, to the individual soul, which had no nationality. From Paul to Pasternak, men of Jewish race have besought their brother Jews to heed the message. In Hadrian's day, as in later ages, their tragic inability to do so was to bring upon them unspeakable calamity."
(Stewart Perowne, *Hadrian*, 145)

Meanwhile, Bowerstock (1995) notes that the Christians participated vigorously in the civic and intellectual life of the Empire's cities, so that there was often a sympathetic leaning towards them amongst the general populace. In contrast, the Jews conspicuously separated the conduct of their life from everyone else.

62 I have followed academic convention here, in labeling this particular epidemic as the plague. In reality, however, it may have comprised several different infections, including something akin to modern smallpox (Jackson 1988). The most respected physician of the day, Galen of Pergamum, though he noted the occurrence of a fever and pustules, played down their significance in favor of carefully recording the skin rash and the spitting of blood. Thereafter, he diagnosed the disease as due to an abscess on the lungs (McNeill 1977).

In a way which echoes the rituals that European monks of the 14th century A.D. invoked to halt the plague's progress (see Braudel 1979; Carmichael 1986; also several Medieval mystery novels, such as Gregory 1996), so the Romans tried to combat it with a centuries-

old purification ceremony in which statues of the gods were placed on banqueting couches in public places and served with an offering. Such emotional defenses were hopelessly inadequate, so that ". . . the dead were removed [wholesale] in carts and wagons." (Julius Capitolinus, *Augustan Histories*: Marcus Antoninus XIII.2) This same source does go on to say, however, that strict laws for burial practices were introduced at this time, including one that forbade anyone from building a tomb for a plague victim at his country estate. I suspect the lives of many rural folk were saved by this constraint.

Duncan-Jones (1996) provides an excellent review of the Antonine Plague episode, both in terms of the literary descriptions of it and of the impact it had on some specific sectors of the Roman economy, including brickmaking and the quarrying of marble. Each of the latter activities show a dramatic decline during the plague years, assuredly because of the death or flight of workers.

63 The renewed prosperity of Gaul early in the 3rd century A.D. was marked by the expansion and elaborate decoration of many of its villas, the revival of the *garum* industry along the western coastline, and a strong commercial linkage to the cities of Romano-Britain (Galliou 1981).

64 The history of the Rio Tinto mines, including their decline during the mid-2nd century A.D., is summarized in Jones (1980). To give a sense of the scale of agricultural activity and industry being effected by Severus' actions, I would note that in their heyday the olive orchards of the Guadalquivir river valley of Baetica province alone may have comprised more than 12 million trees. Aside from the massive labor force required to care for and harvest these trees, there had to have been a matching mass production of about 0.7 million pottery amphorae to provide for the transport overseas of both the olives and their oil (Mattingly 1988).

65 Unguentaria recovered from cemeteries associated with the Roman mining complex in the

Rio Tinto valley (northeast of modern Huelva) provides us with insight into both the organization of the perfume industry in Spain and its decline at the end of the 2nd century A.D. (Price 1977). One group has a marking on the base that reads PRO.MANC.B.C.AR., the parts of which translate:

- PRO[CURATORIS] = *procurator*, a State official
- MANC[IPIORUM} = *mancipium*, a term that refers to the formal disposal or transferral of property
- B[ONIS] C[ADUCIS] = *bona caduca*, a legal phrase for possessions that did not fall to the heir mentioned in a will because he was childless. (In default of a family transfer of the inheritance, the latter would default to the Imperial treasury: see Millar 1963.)
- AR[VAE]. = Arva, one of the main cities of the province of Baetica—perhaps where the procurator held office.

In sum, this translation suggests an Imperial confiscation of what once had been a privately owned unguent factory; a confiscation that we can be reasonably sure occurred sometime before A.D. 180, since the Rio Tinto mines were all but worked out by that time (Jones 1980). What kind of unguent from Spain would be valued sufficiently to justify such action remains obscure.

AR., if not representing Arva, could translate as AR[UCCI]. = Aroche, which is quite close to Rio Tinto; or it could denote some other local town. Either way, it is logical to assume that the glass workshop that produced the bottles themselves will have been located quite near by.

66 For once, the purpose of this taxation was not war-driven, but rather the raising of funds to maintain public baths (see Aelius Lampridius, *Augustan Histories:* Severus Alexander XXIV.5). Who actually suffered from this imposition is uncertain, since there is a contradictory notion expressed in a passage a little earlier in the same source: "He assigned public revenues to individual communities for the advancement of their own special handicrafts."

67 The fate of the succession of the emperors during the first half of the 3rd century A.D. can be summarized as follows (after Scarre 1995):

Caracalla A.D. 211–217	murdered at Carrhae by a bodyguard
Macrinus A.D. 217–218	executed at Archelais by a centurion
Elagabalus A.D. 218–222	murdered in Rome at the Praetorian camp
Alexander Severus A.D. 222–235	murdered near Mainz by centurions
Maximinus Thrax A.D. 235–238	murdered at Aquileia by troops in camp
Gordion I A.D. 238	committed suicide at Carthage
Gordion II A.D. 238	killed while defending Carthage
Balbinus A.D. 238	murdered in Rome by the Praetorian guard
Gordion III A.D. 238–244	murdered near Circesium by his troops
Philip the Arab A.D. 244–249	killed in battle at Beroea
Decius A.D. 249–251	killed in battle at Abrittus.

Thus, eleven emperors died in the space of just four decades, all of them violently.

The emperors of the second half of this century fared no better. From the time when Gallienus came to power in A.D. 253 until the murder of Carinus in A.D. 298, there were ten of them: seven were murdered, one of them (Claudius II) died of the plague, one of them (Quintillus) committed suicide, and one of them (Carus) was struck down by lighting.

To these accepted emperors, we can add the usurpers of the breakaway Gallic Empire:

Postumus A.D. 260–269	murdered in Mainz by his own troops
Marius A.D. 269	strangled in a private quarrel

Victorinus A.D. 269–271 — killed by an angry husband

Tetricus A.D. 271–274 — surrendered to Aurelian: died of old age.

68 The quality of Roman silver coinage is measured relative to silver content of 3.65 grams in the Augustan *denarius*. The rapid debasement of silver coinage during the mid-3rd century A.D. attracted a lot of counterfeiting in the Northwestern provinces (Boon 1988). Silver-rich coins would be hoarded for their intrinsic precious metal content, but only after a series of clay molds had been made from them. These molds were then stacked and used to mass-produce bronze disks which, of course, bore the same surface images as their silver models. A silver wash over the surface made these coins look real enough to any naive merchants in the provincial marketplace.

69 The whole issue of the way in which the Roman World moved away from coinage and depended increasingly on "in-kind" arrangements for taxation (particularly for agricultural produce) is an extremely complicated one. In the single paragraph of my text, I have tried to summarize the ideas of Bowman (1980) and Whittaker (1980) on such matters as they are understood for the Roman economy of the 4th century A.D. while with due caution interpolating those ideas back half a century or so. The declining importance of coinage at that time is aptly illustrated by the historical observation that:

"Aurelian set aside for the city of Rome the revenues from Egypt, consisting of glass, paper, linen, and hemp, in fact, the products on which a perpetual tax was paid in kind."
(Flavius Vopiscus, *Augustan Histories:* The Deified Aurelian XLV.1)

It was the subsequent disruption of such revenues that forced Aurelian to move swiftly against Firmus of Alexandria, when the latter attempted to usurp imperial power in A.D. 272 (Johnson 1951: also Flavius Vopiscus, *Augustan Histories:* Firmus III.1).

70 Many scholars—among them, Garnsey (1988); Rickman (1980); and Casson (1984)—believe that you cannot overstress the role played by grain shipments in the stability of Roman society overall and of the trade for all manner of commodities. Even the speed of movement of information itself was controlled, to some extent, by the time it took a grain ship to travel from Alexandria to Ostia (Duncan-Jones 1990).

Though Rome was certainly hostage to any grain embargo, using it as a strategic device could backfire. In A.D. 189 Cleander, a freedman of the Emperor Commodus, incurred the people's wrath by buying up and controlling massive stocks of grain. His downfall was engineered by a Prefect of Grain Supply who deliberately aggravated the grain shortage for a while (Bowman 1986).

71 Pagan leaders blamed Christians for all the problems afflicting the Roman World during the 3rd century A.D. just as assertively as they had in previous centuries (Alföldy 1974). Thus, one pagan scholar complained:

"Now people are surprised at the plague which has seized the city for so many years, meanwhile [the god of healing] Asclepius and other gods do not appear. Nobody has seen a god being helpful to the State since Jesus was worshipped."
(Porphyry of Tyre, *Against the Christians*, fragment 80)

Meanwhile Christian leaders blamed the pagans for lack of appreciation of God's growing wrath over both the wickedness of their persecutions and the lack of proper management of the affairs of State (Anonymous 1839). Thus there is the apocalyptic view of these matters:

". . . know that herein prediction has been given; that in the last days mischiefs were to be multiplied and changes of adversity to advance, and that as the day of judgment approached, the censure of an offended God, was to be more and more enkindled to the plaguing of the race of man."
(St. Cyprian, *Treatises* VIII.3)

and the practical, economic one:

"You complain of dearth and famine, as if drought made worse famine than corruption, as if by buying up the annual products and multiplying their cost, distress was not kindled to a severer force."
(St. Cyprian, *Treatises* VIII.5)

72 For example, the western, Atlantic-bound regions of the Gallic provinces became prey to pirate raids which steadily eroded the economic structure of the region; so much so, in fact, that the main buildings on estates were simply abandoned as homes in favor of nearby bath-houses that were converted into rough-and-ready dwellings (Galliou 1981). As the network for agricultural trade fell apart, an idled peasantry became disgruntled, finally lashing out in a series of slave uprisings during the 280s that weakened the Gallic economy even more.

For a similar discussion of the fluctuating fortunes of the cities at the frontiers on the Rhine and the Danube, see King (1990). For a discussion of the impact of the various events, political and natural, that so influenced the economy of the Roman World during the 3rd and 4th centuries A.D., see MacMullen (1988).

73 This dimple-and-boss motif also occurs among wheel-cut glass vessels of the Eastern Empire (Harden 1987; O'Connor 1997). The patterning with shallow ovals and bosses most likely was inspired by similar decoration on Roman vessels carved from rock crystal (Vickers 1996).

74 Thus, for example, records for the prices of wine and wheat indicate that, over the first half of the 3rd century A.D. Egypt was relatively immune from the economic crises that were then afflicting the Western provinces (Rathbone 1991). In fact, in the wake of the Antonine Plague years, as exotic goods from the East once more flowed through Alexandria and as Roman officials patronized Egyptian cities with public buildings and popular spectacles, life along the Nile was reasonably com-

fortable (Johnson 1951). All that changed in A.D. 250, however, as the plague again broke out in Alexandria, just at the time when the city was in turmoil because of internal civil strife and widespread famine. The city's bishop, Dionysus, bemoaned the declining population and observed:

"And the river that flows past the city at one time appeared drier than the waterless desert. . . . At another time it overflowed to such an extent that it submerged the whole neighborhood, both the roads and the fields. . . . And always its course is defiled with blood and murders and drownings."
(Eusebius of Caesarea, *Ecclesiastical History* VII.21)

It is difficult to imagine that local industries such as glassworking fared too well in such a depressing environment.

75 To be specific, this flute came from Tomb W T8 in the Meroitic cemetery at Sedeinga and is now in the Khartoum Museum (inv. no. Kh. 20418). With it were found an almost identical, but larger flute, and two others finished with painted and gilded scenes of offerings being made to the Egyptian deity, Osiris. There is some suggestion that they were smashed deliberately during the rituals performed at the time of closure of the tomb though the purpose of that action is now obscure (Leclant 1973). The composition of the glass of these vessels conforms to the standard soda-lime recipe of Roman glassmaking though other glassware from the site has a potash-rich composition that is usually associated with glassmaking in Mesopotamia (see Brill 1991).

Though most of the parallels for these flutes have been found in Roman Egypt, four similar examples have been found in Roman graves in the Western Empire: one in Trier, one in Bonn, and two in Cologne (see Goethert-Polaschek [1977: entry 337], Follmann-Schulz [1988: taf. 36], and Friedhoff [1989: abb. I], respectively.) Whether we argue that these vessels were traded across the Mediterranean and along the riverways of the Rhineland, or that

Eastern glassworkers took their ideas and their skills along that route, these vessels would seem to be a good material reflection of the renewed stability of the Western frontiers after the Emperor Aurelian's military successes in A.D. 274.

76 Underpinning this idea is a letter sent by a soldier stationed in Alexandria to his father living in the farming village of Karanis in the Fayoum oasis:

"Know father that I have received the things that you sent me. . . . I have sent you . . . sets of glassware, two bowls of *quinarius* size, a dozen goblets . . ."
(*Papyrus Michigan* 5390)

Glassware recovered from excavations at Karanis does display a wide range of quality and the finer items are assumed to have been imports of this sort (Harden 1936: Gazda 1983).

77 Christian leaders pointed to Constantine's conversion as an act of God that brought stability back to Roman society in the wake of the harrowing famine and plague that had beset Italy during the reign of his predecessor, the pagan Maximinus Daia (reigned, A.D. 310–313) (see Eusebius of Caesarea, *Ecclesiastical History* IX.8). But one of Constantine's critics states that the conversion was something of a matter of personal guilt for putting to death his own son Crispus (allegedly for being intimate with his stepmother Fausta) and then murdering Fausta herself in a scoldingly hot bath—thus:

"Feeling guilty about these crimes as well as about his scorned oaths, he approached the priests asking for lustration. They replied that no method of purification had been handed down capable of cleansing such abominations. But a certain Spaniard named Aegyptius . . . maintained confidently that 'the doctrine of the Christians could wash away any crime and held out this promise, namely, that the unrighteous who accepted it would immediately stand free and clear of all sin'."
(Zosimus, *New Histories* II.29)

78 The Edict on Maximum Prices that Diocletian issued in A.D. 301 to combat inflation is perhaps the best known administrative measure of his reign. It is a quite different edict, however, for which religious scholars will remember this emperor; in fact a string of them starting with one in A.D. 297 that was designed to force Christians out of the army, and culminating seven years later in an ultimatum that all Christians, clergy and laity alike, were to offer sacrifice to the traditional pagan gods on pain of death. These measures had little effect in the the Western provinces, since these were under the control of Maximian and Constantinus.

79 The wall paintings of the Via Latina tombs are fully illustrated in Ferrua (1991). The relief on the Rondanini sarcophagus is illustrated in Toynbee (1971: plate 74).

80 The examples of confusion of pagan and Christian imagery cited here are taken from Cornell and Matthews (1982: 147 [Athen's carving]), Roberts 1977: 11 [papyrus poems]), and Harden (1987: entries 122 and 128 [glass engravings]). Another of interest is the use of misunderstood Egyptian-like figures in a frieze in the tomb chapel of Junius Bassus, a Roman senator who converted to Christianity just before his death in A.D. 359 (see Plate E.89). This frieze, unlike the rest of the wall decorations in the chapel that were constructed from various colored stones, was created out of fragments of blue, orange and yellow glass (Auth 1990).

The Cologne glassware referred to here is engraved free-hand. It has to be said, however, that the use of engraving in this way was far more commonly used to create secular images —mostly hunting scenes—than they were religious ones, Christian or pagan (Harden 1960).

A rustic villa at Lullingstone in southeastern England provides us with one of the earliest indications of Christianity's provincial progress in the post-Constantine years (Scullard 1995: 119–122). The villa itself had fallen into neglect during the 3rd century

A.D. possibly because its owner had supported Clodius Albinus in his abortive bid to become emperor, with the consequence that the estate had been confiscated by the State (see Section E.14). When rebuilt, in their high quality this villa's mosaics reflect well the renewed agricultural prosperity of the area, while their themes—"Pegasus and the Chimera," "Europa and the Bull," and so on—along with two lines of text alluding to Virgil's *Aeneid*, define the cultured occupants' pagan beliefs. Around A.D. 350, however, a corner of the home was set aside as a Christian chapel, which was decorated with paintings of the Chi-Rho monogram and of worshippers with outstretched arms.

81 For comprehensive discussion of the Mildenhall Treasure and the Sevso Treasure, and of other major hoards of Roman 4th century A.D. silverware, see Stefanelli (1991), and Mango and Bennett (1994).

82 A clear testimony to the persistence of the Bacchic cult is a remarkable purple glass bucket that is now housed in the Treasury of San Marco in Venice. This stands 20.3 cm high and is covered with a wheel-cut and engraved scene of Dionysian revelry (Harden 1987: entry 122).

83 Other pagan practices to which the Church turned something of a blind eye included the rituals of graveside banquetry, such as the sharing of wine with the deceased by pouring it into a metal pipe that connected to the burial chamber a couple of meters below where relatives dined in his/her honor. The offering of perfumes at the tomb of Christian martyrs also was a quite common practice, leading inevitably to some "miraculous" events. Thus:

"This table set over the tomb has twin holes, allowing perfume to be poured into the recesses below. From the holy ashes stored there comes a healing breath and a hidden fragrance, conferring sacramental quality on the pouring vessels. For after they had poured in the liquid perfume, and at once scooped it from the tomb lying beneath the earth, and those who had bestowed the nard on the tomb prepared to draw it up and apply it to themselves, they found the vessels miraculously filled not with nard but with a heap of dust which burst out from below. . . ." (Paulinus of Nola, *Poems* XXI.590)

Other Church leaders, among them the saint-to-be Augustinus of Thagaste, protested vehemently against this compromising of Christian principles. There was even intense debate about the use of candles in the honor of the relics of matyrs, critics denouncing such action as a rite of idolatry. For an excellent review of all these matters, see MacMullen (1997).

84 At a secondary level, monasticism was on the increase. Although this meant that the Christian was seeking separation from the world, most monks carried with them the Gospel instruction to love one's neighbor. Around A.D. 320, in the Nile valley, Pachomius encouraged the notion that would-be hermits form communities akin to rural cooperatives with a monastery wall defining their sacred precinct (Rousseau 1985). Similar communities were founded in Egypt's Wadi Natrun, in the Judaean Desert, in Asia Minor, and in North Africa by Augustine who had come across groups of like-minded monks in Milan and Rome.

85 The prevailing attitude on the purpose of pilgrimage is captured by the message: "It may help you, loving sisters, the better to picture what happened in these places when you read the holy books of Moses." This was sent around A.D. 383 by the lady Egreria to her friends in Gaul during her journey towards Jerusalem (see Chadwick and Evans [1989: 25]). The cultural backdrop to this and other pilgrimages of this kind is discussed in Hunt (1982) and Drinkwater and Elton (1992).

The 5th century A.D. priest, Cyril of Scythopolis, provides glowing accounts of the houses set up by monks in the Judaean desert where any pilgrim could rest and eat (see Price 1991).

86 In much the same way as, in the early 13th century A.D., St. Francis of Assisi rejected the

opulence of the Roman Catholic Church, so in the mid-4th century A.D. there sprang up a strong ascetic movement that, among other things, was highly critical of the luxury attendant upon the ritual ceremonies carried out in the new Christian churches. The advocates for the movement—among them, the wandering St. Jerome and St. Martin of Tours—urged self-depravation, at times even physical self-abuse, as means of chastening the body in its worldly existence. Thus, for a while, glass found a place at the altar in a highly symbolic way:

"Saint Exuperius, Bishop of Toulouse, while his mouth is pale from fasting, he is tormented by another's hunger, and he consigned all his possessions to [those who are the] flesh of Christ. Yet nothing was richer than that man, who carried the body of the Lord [the Host] in a wicker basket, and the blood in a glass; who expelled greed from the temple . . . so that the house of the Lord might be called a house of prayer and not a den of thieves."
(St. Jerome, *Letters* CXXV.20)

87 The somewhat formal character of the early Italian cemeteries is discussed in detail by Toynbee (1971: 73–91). That author cites several tomb inscriptions which indicate the Roman concern over the spatial limits of a tomb plot was rooted as much in fear of disturbing the soul of the deceased as it was the legalities of land ownership. Thus, a certain Gaius Tullitus Hesper adds to his altar's memorial a dire warning that ". . . If anyone disturbs them [his bones] or removes them from here I pray that he may, while alive endure prolonged pains of body and that, when he dies, the gods of the lower world will reject him." (Dessau, *Selected Latin Inscriptions* 8184)

88 The Yarhai tomb complex is illustrated and discussed in detail in Toynbee (1971: 231–234), along with a number of other massive tombs in the cemeteries of Palmyra and those excavated around the Eastern frontier city of Dura Europus on the Euphrates river.

89 Other than among two unusual ware types—the gold-glass medallions and the hexagonal flasks that are discussed in Sections E.15 and E.21 , respectively—the direct representation of Christian imagery and ideas in the decoration of glass vessels is very rare during the early Byzantine era. Examples of which I am aware include: {i} one of a pair of "blue-blob" beakers, from a women's grave just outside the West Gate of Aventicum (modern Avenches) in Switzerland, that is roughly inscribed in the Greek for "Live in God" (Bögli 1989); {ii} a square-sided bottle, from a late 4th century A.D. grave in tomb 295 at Beth Shean in Israel, with a Chi-Rho style Cross cast into its base (see Fleming 1997b); {iii} a 6th century A.D. chalice-like cup that is engraved with two different crosses, one of them in a curtained niche, the other free-standing (see Ross 1962; for a similar vessel from Gerasa in Jordan, see Baur 1938); and {iv} a series of mold-blown bowls, dating variously from the 5th-to-early 6th century A.D., with a Chi-Rho style Cross at the center of the decoration on each of their bases (see Foy and Sennequier [1989: entry 32]; and Périn [1972: fig. 7]).

90 Sometime after the mid-5th century A.D., mold-blowing *was* used to create a fascinating series of six-sided glass jugs and bottles with panel reliefs that included saintly looking characters who most likely represented St. Simeon Stylites (Matheson 1980). St. Simeon was expelled from his monastery for excessive austerity and spent the last thirty years before his death in A.D. 459 in chains atop a pillar (*stylos*, in Greek) in Qallat Seman, in Syria. The glass vessels bearing this imagery presumably were souvenirs for pilgrims to this place.

91 In that it encompassed a whole range of craftsfolk, from architects and stone-masons to veterinarians and physicians to dyers, the granting of this exemption was probably a political rather than an economic gesture. Constantine took a similar line with the families of "those youths in the African provinces

who are about eighteen years old and have had a taste of the liberal studies . . ." (*The Theodosian Code* 13.4.1) so that they could be trained as architects (Pharr 1952). Therein lay the foundations for a building boom in the African provinces during the latter half of the 4th century A.D. (Whittaker 1980).

92 There are many texts that mock the complexity and excesses of Roman women's cosmetic preparations, and not just a few that tease Roman men for their over-indulgence in perfumery (see Carcopino 1962: also Fleming 1997b), but I particularly like the following two:

"A single ringlet out of the whole circle of hair had gone amiss, fixed insecurely with an unsteady pin. Lalage punished this misdeed with the mirror in which she had seen it, and [her maid] Plecusa fell smitten, victim of the cruel tresses."
(Martial, *Epigrams* II.66)

"Then, turning the conversation to the subject of age, he asked her whether she would prefer eventually to be gray or bald. She replied that for her part she would rather be gray. 'Why, then,' said her father, thus rebuking her deceit, 'are these women of yours in such a hurry to make you bald?'"
(Macrobius, *The Saturnalia Conversations* II.5)

Though this second quotation refers back in time, to an exchange between the Emperor Augustus and his wanton daughter Julia, it no doubt reflects the social attitudes of the early 5th century A.D. when it was actually written.

The early 3rd century A.D. views of the early Christian Father, Tertullian, that I quoted at the head of Section E.17, provide a novel ecclesiastical twist to this topic.

93 I find it intriguing that, in Book XXXIII of his *Natural History*, Pliny makes no mention of galena—natural lead sulfide—being used as an eye make-up, even though he discusses in remarkable detail the origins and properties of all the common minerals known to the Roman World. Instead, he refers to the use of artificially prepared compounds of lead for medici-

nal purposes (XXXIII.110 and XXXIV.169), the sulfide being used as an eye-*wash* and to remove ugly scars and spots from women's skin. In contrast, we find antimony being discussed thus:

"Antimony has astringent and cooling properties, but it is chiefly used for the eyes, since this is why even a majority of people have given it the Greek name *platyophthalmon* ['wide-eye'], because in beauty-washes for women's eye-brows it has the property of magnifying the eyes."
(Pliny, *Natural History* XXXIII.102)

Like galena, metallic antimony has an attractive silvery-luster (Paszthory 1990), so it too could have been used for Theodora's make-up in Plate E.108. This raises the possibility that the twin-chambered glass flasks featured here were actually used to store galena for a *medicinal* purpose rather than a cosmetic one.

94 Constantine himself had starved the Goths into submission on the Danube frontier in A.D. 334; Julian (reigned A.D. 360–363) had campaigned very successfully at the Rhine frontier in the years before he took over became emperor; and Valentinian I (reigned A.D. 364–375) also managed to keep the Germanic threat in check, falling to his enemies only when the delegation they sent to seek amnesty made him so angry that he suffered a fatal stroke.

95 Whether decoration with just a loosely wound spiral should be added to this list is debatable. It was certainly a quite popular motif on glassware during the latter half of the 4th century A.D. (see Plate E.104). It can hardly be regarded as distinctive for the period, however, since it has antecedents at least as far back as the 1st century A.D. no doubt because of the simplicity with which it could be applied. Loosely bound spiral threads also occasionally were used to decorate 4th century A.D. glassware in the Rhineland, in one instance being wound over the top of an optic-blown spiral pattern of the kind illustrated in Figure E.51a

(Goethert-Polaschek 1977: various entries, especially 1345). Again because of the simplicity with which this motif can be created, however, this usage is unlikely to constitute evidence of East-West transfer of technology.

96 The various ways in which the early Christian leaders approached the issue of slavery is summarized in Bradley (1994), noting particularly that they styled themselves and their followers as "slaves of Christ (or the Lord)." The negative impact of Christian beliefs upon the slave's existence is elegantly captured in the comment:

"Whatever the theologian may think of Christianity's claim to set free the soul of the slave . . . the historian cannot deny that it helped to rivet the shackles rather more firmly on his feet."
(Ste Croix 1981: 420)

97 The Empire's craftsmen and farmers probably shared the view of early 1st century B.C. politician, Marcus Porcius Cato—best known as the author of *On Agriculture*—that moneylenders were kin to murderers (see Cicero, *An Essay on Duties* II.25), but a simple lack of capital forced so many people to borrow against future income. Part of the fiscal problems that craftsmen and farmers experienced arose from the economic inflation that occurred when Constantine suddenly released large amounts of new coinage that had been minted from gold gathered from the confiscation of ornamental materials in pagan temples (see Thompson [1952], citing an anonymous treatise, *On Matters of War* II.1).

98 The long arm of governmental opinion eventually would extend into such matters as to who was responsible if things were thrown out of the upper storey windows of a building, or what should be done about a farmer who organized the furrows on his land to divert rainwater to another field to the disadvantage of his neighbor (Ulpian, *The Digest of Justinian* IX.3 and XXXIX.3, respectively). It even reached into the afterworld, mixing together the parts of a modern adage death

and taxes—thus: "Anyone who spends something on a funeral is held to contract with the deceased, not with the heir." (Ulpian, *The Digest of Justinian* XI.7) (see Watson 1985).

99 I doubt the glassworking community around Constantinople in the latter part of the 6th century A.D. were ever too happy with their craft being caught up in the following piece of anti-Jewish propaganda:

"It is an old custom in the imperial city that, when there remains a considerable quantity of the holy fragments of the immaculate body of Christ our God, boys of tender age should be fetched from among those who attend the schools, to eat them. On one occasion of this kind, there was included among them the son of a glassworker, a Jew by faith; who, in reply to the inquiries of his parents as to the cause of his delay, told them what had taken place, and what he had eaten in company with the other boys. The father, in his indignation and fury, places the boy in the furnace where he used to mold the glass."
(Evagrius, *History of the Church* IV.36)

100 The economic condition of the Eastern provinces before Constantine's time is difficult to assess with any accuracy (MacMullen 1990: footnote 110). Evidence for agricultural decline in the mid-3rd century A.D. can be contrasted with an upsurge of synagogue construction and a richness of grave furnishings in some regions. Even in the 4th century A.D. economic improvements seem to have been spotty in character, some towns flourishing, some stagnating. As tends to have been true in the Roman World overall over the centuries, renewed prosperity often was tied directly to Imperial military presence.

For the first half of the 5th century A.D. the Eastern Empire was ruled in turn by two politically lazy emperors, Arcadius and Theodosius II (died A.D. 408 and A.D. 450, respectively), who it is said were dominated by eunuchs, women, and ministers of varying competence and honesty (Foss and Magalino 1977). Yet the administration functioned, the taxes came in on time, and the armies for the

most part remained loyal. The Vandals briefly threatened the Imperial calm by attacks eastward along the North African coastline, but they were to find it easier to cross the seas and sack Rome in A.D. 455. The Balkan provinces were devastated by the continual raids of Attila the Hun, who took huge sums of gold by way of tribute before turning his attention to the West. Still, the fertile lands of Syria and Egypt continued to produce the revenue essential to the running of the State.

Late in the century the Empire suffered the ignominy of being ruled by an Isaurian bandit chief named Tarasicodissa, who gained imperial power under the name of Zeno. His reign (A.D. 474–491) was marked by civil war, and by the building of lavish churches in his mountainous homeland of southern Asia Minor. His successor, Anastatius, drove out the Iraurians and established a government that was both effective in its fiscal policies and surprisingly free of corruption. This emperor managed to reduce taxes *and* leave behind a surplus of 300,000 pounds of gold when he died in A.D. 518.

101 For quite a while, these displaced glassworkers would have recycled whatever cullet they could lay theirs hands on. Gradually, however, they came up with their own recipe for glassmaking. They substituted either soda-rich plantstuffs such as marsh samphire (*Salicornia europaea*) or the potash-rich ashes of the fuel—usually, the wood of beech or oak, though waste grain, ferns, or heather would work as well—that fired their furnaces (Henderson 1985) for the natron ingredient that the Roman industry used (see Appendix A). *Forest glass*, as it predictably came to be known, had about two-thirds of the soda and lime contents of its Roman counterparts.

102 An intriguing aspect of this separation of Britain from the rest of the Northwestern provinces was the steady decline in the use of glass for unguentaria during the first half of the 4th century A.D. (Cool 1995). Whether the potterymaking industry picked up this market slack for such vessels, or whether the British fervor for perfumed oils was far less than elsewhere in the Empire, is unclear.

103 The increasing separation between the Western and Eastern glassworking traditions from the mid 4th century A.D. onwards is echoed by the way that the furnace technology of glassworking developed thereafter in the two regions (Charleston 1978). The eastern style of furnace had three essential features—a single stoke-hole at the bottom, a middle chamber with several "glory holes" that allowed access to pots of molten glass stock, and an upper chamber where finished vessels would gradually cool down. (This last step—*annealing*—gave the glass its robustness against fracture during subsequent use.) This furnace form is well illustrated in several ancient manuscripts (see Plates E.56 and F.7 here) and was the one eventually adopted in most of the lands around the Mediterranean Basin. The distinctive feature of the western style of furnace was that the primary and annealing furnaces were placed at the same level (see Plate F.23). Either the main furnace shared its heat laterally or both furnace chambers drew their heat from a common fire-trench running the length of the entire structure. This was the furnace type that dominated throughout northern Europe, and the one described and illustrated in so much detail by writers such as Antonio Neri's *Art de la Verrerie* (1752) and Johann Kunckel's *Ars Vitraria Experimentalis* (1679). Several of these western furnaces also had a fritting chamber included in them, and some 18th century A.D. illustrations of English furnaces indicate that yet another chamber would be available for heating cullet.

104 For the quarter of a century after the assassination of Valentinian III in A.D. 451, the rate of rise and fall of emperors recalls the events of the chaotic years that followed the murder of Caracalla in A.D. 217 (see Endnote 67):

Pretonius Maximus A.D. 455	killed during flight from the Vandals
Avitus A.D. 455–456	deposed; murdered by Ricimer*

Majorian A.D. 457–461	beheaded by Ricimer*
Severus III A.D. 461–465	died of natural causes?
Anthemius A.D. 467–472	executed by Ricimer*
Olybrius A.D. 472	died of natural causes?
Glycerius A.D. 473–474	fled Rome before Nepo's attack
Julius Nepos A.D. 474–475	overthrown by his army leaders
Romulus Augustulus A.D. 75–476	abdicated power and retired

* Ricimer was commander of the Suevi, a Germanic people who eventually settled in Spain (Scarre 1995). His power is apparent from the way he was able to remove three different emperors before he died himself in A.D. 472. The short gaps in the reign periods among the emperors listed above match the times when Ricimer was trying to persuade the Eastern Emperor Leo I to accept his choices of Western leaders as legitimate rulers.

105 The Diocletion Prices Edict actually makes a distinction between a mosaicist who worked on a church's floor (*tessellarius*) and the one that worked aloft in its high vaults (*musearius*). Difference in their pay reflects the relative risk associated with their efforts—50 *denarii* per day for the former, 60 denarii per day for the latter (Graser 1940: as discussed by Sear 1977).

106 The most published depictions of glass lamps atop a menorah are both of mosaic pavements, one in the 4th century A.D. synagogue at Hammat Tiberias (Dothan 1983), the other in a 6th century A.D. synagogue at Beth Shean (Ben-Dov and Rappel 1987). Chain-hung lamps of these times seem to have a quite different shape—cylindrical, rather than conical (see Avigad [1976: fig. 100]).

107 Unlike the plague episodes that broke out during the Antonine era (see Endnote 62), there is no question that the Justinian plague was of the true bubonic variety, *Pasteurella pestis*—the one spread by the black rat. Its characteristic symptoms of lymph node swelling, pustule growth and patient delirium were described in graphic detail by the contemporary historian, Procopius of Caesarea. At the peak of virulence during its four month ravaging of Constantinople, the disease was claiming as many as ten thousand victims a day, so that then

". . . those who were making these [burial] trenches, no longer could keep with the number dying, mounted the towers of the fortifications of Sycae (modern Galata) and, tearing off the roofs, threw the bodies in there in complete disorder. . . . As a result of this, an evil stench pervaded the city and distressed the inhabitants even more."
(Procopius, *History of the Wars* II.10)

The Emperor Justinian himself also fell ill but recovered, apparently suffering a swelling in the groin but no spread of the disease.

As was to be true in Medieval times, the indirect impact of this plague episode was as much emotional as physical. Everyone was confused, and no doubt appreciably alarmed, that the disease struck down saints and sinners alike—Christians fared no better than Jews, masters no better than their household slaves (Jackson 1988).

108 In and around Jerusalem, there were all manner of places to stay. Those who came from the emperor's court most likely would head for the house established on the Mount of Olives by Melania the Elder and Rufinus of Aquileia sometime after A.D. 380—a somewhat too comfortable place for true pilgrims, in the opinion of Jerome of Stridon who founded a similar place of rest close to the Church of the Nativity in Bethlehem (Hunt 1982). For her part, the humble Paula preferred one of the monastic cells that flanked the Holy Sepulcher itself, when she reached Jerusalem in A.D. 385, at the end of her pilgrimage from Rome (see Chadwick and Evans [1987: 25]).

Aside from the hardship it entailed, pilgrimage to Jerusalem from the West was a major personal commitment in terms of time, by land or sea. The Bordeaux pilgrim (circa A.D. 333) travelled for almost 11 months; the Lady Egeria quoted in Endnote 85 spent about 13 months on the road, out of the more than four years she was away from home. Antoninus of Piacenza, in northwestern Italy (circa A.D. 570) took about about eight months; while the English Bishop Willibard (circa A.D. 724) took more than three times that just on his journey from Rome to Jerusalem (Wilkinson [1977: 19]).

109 There still exists a group of metal ampules inscribed in Greek with phrases such as "Oil of the Tree of Life from the Holy Places of Christ" that clearly indicate they once contained sacred oil from one of Jerusalem's shrines. These vessels are said to have been presented to the Church of St. John the Baptist in Monza by the Longobard queen Theodolinda shortly before her death in A.D. 625 (Barag 1970).

110 According to one interpretation of the Jewish Talmudic text, *Midrash raba Numeri*—known now only from late 1st millennium A.D. versions, but certainly based on much earlier sources—glassworkers were regarded as quite ordinary folk, versus goldsmiths who were much admired and potterymakers who for some reason were looked down upon (Schüler 1966). So it is not surprising that the Jewish contribution to the glassworking industry is difficult both to pin down.

Glassworkers also are mentioned in the context of Jewish codes of purity, as laid out in the *Mishnah* (Neusner 1974):

"An earth oven which has a place for setting [the pot] is unclean. And [an oven] of those who make glass (*'osé zekhukhit*), if there is on it a place for setting the pot, is unclean. A kiln of limeburners, and of glassblowers (*zegagin*), and of potters, is clean. . . ."
(*Kelim* VIII.9)

But this text includes every other kind of craftsman as well at some point or other, so it would seem wrong to think that the Jewish contribution to the glassworking industry *per se* is being singled out as something exceptional.

Continuity of Jewish involvement in glassworking *after* the Roman era is clear, however, particularly in Jerusalem. For example, we know that the Kalif 'Abd al-Malik (A.D. 685–705) sought to employ Jewish craftsmen to make lamps for the Dome of the Rock, only to have the plan blocked by the Omar ibn Abd al-Aziz (Anon. J. 1971). There is also ample archaeological evidence for the production of many kinds of Islamic glassware in Jerusalem through till at least the mid-13th century A.D. (Hasson 1983).

111 Our current knowledge of the craft of rock crystal carving in the Islamic world from the 9th to the 11th century A.D. is summarized by Whitehouse (1993), with special reference to a parallel that can be drawn between a rock crystal ewer in the Victoria & Albert Museum and a cameo-cut glass ewer in the Corning Museum of Glass.

The use of glass for imitation of rock crystal continued to be common enough in more recent times as well. In the 12th century A.D. in Book III of Eraclius' *Coloribus et Artibus Romanorum* there are indications that glass and rock crystal were regarded as all but interchangeable, in terms of how either material should be ground or polished. Additionally, it is clear that in the early 17th century A.D. several Bohemian hardstone engravers—most notably, Casper Lehman of Prague—adapted their skills very effectively to the production of finely engraved glassware (Drahotová 1981).

112 For an introduction to the story of Venetian glassworking, see Liefkes (1997), Jacoby (1993), and Hollister (1983). For a discussion of the growth of the Bohemian industry and examples of its characteristic products, see Hejdová (1975).

113 For some specific examples of the ongoing use of various Roman glassworking techniques, see Ricke (1989: entry 107 ["snake-thread"]); Bertelli (1970: figs. 10–15 [gold-glass medallions]); and Theuerkauff-Liederwald (1968: various entries [applied blobs or *prunts*]).

114 For other illustrations of glassware included in scenes of *The Last Supper*, see Foy and Sennequier (1989: entries 165, 192 and 298). For early illustrations of monastic lamps and secular scenes of wining and dining, see Hejdová (1975: figs. 1–13); also Foy and Sennequier (1989: entry 232) for a depiction of a set of conical lamps in the famous 14th century A.D. *Tapestry of the Apocalypse* in the cathedral of Angers. For early illustrations of other glassware in monastic settings, see Gasparetto (1975): also Foy and Sennequier (1989: entry 387) for the 16th century A.D. manuscript, *Speculum humanae Salvationis*, which includes a bulbous flask, a convex mirror and a pair of eye-glasses.

115 For several specific examples of wine glass depicted in Dutch paintings, see Sutton (1984). There was, of course, a parallel "still-life" painting tradition in 17th century A.D. Spain that similarly included glassware amongst its conventional artistic props. Some notable examples include Juan van der Hamen y León's *Still Life with Sweets and Glassware*, and Antonio de Perada's *Kitchen Scene* (see Jordan and Cherry [1995: plates 12 and 31]).

116 Informative scenes which represent the glass-making industry of more recent times include: (i) the miniature in the Bohemian manuscript, *Sir John Mandeville's Travels*, of about A.D. 1420 that illustrates both the gathering of raw materials and the use of a furnace for glass-blowing (Charleston 1978: fig. 16: also Plate F.23 here); (ii) the painting on a cylindrical beaker (*humpen*) that depicts the glasshouse of Christian Preussler at Zeilberg, in Bohemia, as

it was in A.D. 1680 (Charleston 1978: fig. 25); (iii) the plate of the *Service des Arts industriels* that was painted by Jean-Charles Develly for the Manufacture Royal at Sèvres, and purchased by King Louis Philippe of France in A.D. 1836, that shows workers rolling sheets of molten glass (Ennès 1990: also Christie's sales catalogue, *Continental and British Ceramics*, June 1993: item 37); and (iv) the scene on a wine goblet which was made in A.D. 1774 for the Norwegian freemason, Andreas Schmidt, that shows all the parts of an glass engraver's wheel (Polak 1960: plate Id).

117 The *Mappae Clavicula* was primarily a compilation of recipes for the production of artists' pigments (including many involving the gold that was used in the most elaborate illumination), but it did contain some translations on Arabic alloys, and on things as disparate as ancient Greek pneumatic toys, sugar candy and explosives that were not included in its predecessor, the *Compositiones Variae* (Johnson 1939; Smith and Hawthorne 1974). Though the range of substances discussed in both these manuscripts is very broad, the techniques and associated equipment that are described are quite rudimentary: the most complex device recommended was the glassmaker's furnace.

For well-respected translations of Biringuccio's *De la Pirotechhnia* and Agricola's *De Re Metallica*, see Smith and Gnudi (1942) and Hoover and Hoover (1950), respectively.

118 Quotations from several translations of some of the early texts on glassmaking are provided in Charleston (1978a), including one from the Swedish priest, Peder Mansson, who compiled an eye-witness account of the glass industry in Rome during his stay in that city that spanned A.D. 1508–1524 (see also Charleston [1978b]).

COMMODAE AVCTORITATIS VARIAE PRISCORᵤ MONETAE
A E R E I.
L V T E I.
D E C O R I O.
DE INHIBENDA LARGITATE.

FRONTISPIECE F.25 see page 159

If anyone wishes to paint vases with glass . . . let him choose for himself two stones of red marble, between which let him grind the Roman glass, and when it is pulverized as fine as the dust of the earth, let him make it liquid with the clear fatness of gum.

(Eraclius, *Coloribus et Artibus Romanorum* I.3)

REFERENCES

SOURCES FOR QUOTATIONS

Anonymous (transl.), 1839: *Treatises of S. Caecilius Cyprian* (London: J.G. and F. Rivington).

P.V. Davies (transl.), 1969: *Macrobius: The Saturnalia* (New York: Columbia University Press).

H.B. Dewing (transl.), 1961: *Procopius: History of the Wars, Books I and II* (Cambridge: Harvard University Press).

M. Dods (transl.), 1948: *The City of God by Saint Augustine* (New York: Hafner).

H.A. Drake, 1976: *In Praise of Constantine: A Historical Study and New Translation of Eusebius' "Tricennial Orations"* (Berkeley: University of California Press).

H.R. Fairclough (transl.), 1991: *Horace: Satires, Epistles and Ars Poetica* (Cambridge: Harvard University Press).

A.S.L. Farquharson (transl.) and R.B. Rutherford (edit.), 1989: *The Meditations of Marcus Aurelius* (New York: Oxford University Press).

B.F. Grenfell and A.S. Hunt, 1922: *The Oxyrhynchus Papyri XV* (London: Egypt Exploration Society).

G.P. Goold (transl.), 1990: *Propertius: Elegies* (Cambridge: Harvard University Press).

W. Hamilton (transl.), 1986: *Ammianus Marcellinus: The Later Roman Empire* (London: Penguin).

J. Jackson (transl.), 1986: *Tacitus: Annals IV–VI, XI–XII* (Cambridge: Harvard University Press).

J. Jackson (transl.), 1991: *Tacitus: Annals XIII–XVI* (Cambridge: Harvard University Press).

H.L. Jones (transl.), 1954: *The Geography of Strabo VII* (Cambridge: Harvard University Press).

F.G. Kenyon, 1937: *The Chester Beatty Biblical Papyri: Descriptions and Texts of Twelve Manuscripts on Papyrus of the Greek Bible*, fascicle III: Pauline Epistles (London: Emery Walker).

D. Magie (transl.), 1982: *Scriptores Historiae Augustae III* (Cambridge: Harvard University Press).

D. Magie (transl.), 1993: *Scriptores Historiae Augustae II* (Cambridge: Harvard University Press).

T. Mommsen (transl.), 1985: *The Digest of Justinian I* (Philadelphia: University of Pennsylvania Press).

M.M. Morgan (transl.), 1989: *The Emperor Julian: Panegyric and Polemic* (Liverpool: Liverpool University Press).

H.A. Musurillo, 1979: *The Acts of the Pagan Martyrs* (New York: Arno).

J. Neusner (transl.), 1988: *The Mishnah, Kelim* (New Haven: Yale University Press).

J.H. Oliver (transl.), 1953: "The Ruling Power," *Transactions of the American Philosophical Society* 43.4.

W.R. Paton (transl.), 1979: *Polybius: The Histories* (Cambridge: Harvard University Press).

G.G. Ramsey (transl.), 1996: *Juvenal and Persius* (Cambridge: Harvard University Press).

E.E. Rice (transl.), 1983: *The Grand Procession of Ptolemy Philadelphus* (New York: Oxford University Press).

J.C. Rolfe (transl.), 1989: *Suetonius I*, Books I–IV (Cambridge: Harvard University Press).

J.C. Rolfe (transl.), 1992: *Suetonius II*, Books V–VIII (Cambridge: Harvard University Press).

D.R. Shackleton Bailey (transl.), 1993a: *Martial: Epigrams I*, On the Spectacles and Books I–V (Cambridge: Harvard University Press).

D.R. Shackleton Bailey (transl.), 1993b: *Martial: Epigrams II*, Books VI–X (Cambridge: Harvard University Press).

D.R. Shackleton Bailey (transl.), 1993c: *Martial: Epigrams III*, Books XI–XIV (Cambridge: Harvard University Press).

J.A. Shelton, 1988: *As the Romans Did* (New York: Oxford University Press).

H. Schenkl (transl.), 1965: *Themistii Orationes Quae Supersunt I* (Berlin: B.G. Teubner).

H. Schenkl (transl.), 1971: *Themistii Orationes Quae Supersunt II* (Berlin: B.G. Teubner).

J.F. O'Sullivan (transl.), 1947: *The Writings of Salvian, the Presbyter* (New York: Cima).

W. Watts (transl.), 1996a: *Augustine' Confessions: Books I–VIII* (Cambridge: Harvard University Press).

W. Watts (transl.), 1996b: *Augustine' Confessions: Books IX–XIII* (Cambridge: Harvard University Press).

C.R. Whittaker (transl.), 1969: *Herodian: History of the Empire, Books I–IV* (Cambridge: Harvard University Press).

G.A. Williamson (transl.), 1988: *Josephus' The Jewish War* (London: Penguin).

J. Wilkinson, 1977: *Jerusalem Pilgrims* (Warminster: Aris & Phillips).

GENERAL REFERENCES

J. Alarcao, 1970: "Abraded and Engraved Late Roman Glass from Portugal," *Journal of Glass Studies* 12, 28–34.

J. Alenus-Lecerf, 1995: "Contribution a l'etufes des verres provenant des tombs Merovingiennes de Belgique," in *Le Verre de l'Antiquite Tardive et du Haut Moyen Age*, 57–92, ed., D. Foy (Cergy-Pontoise: Musee Archeologique Departmental du Val D'Oise).

G. Alföldy, 1974: "The Crisis of the Third Century as seen by Contemporaries," *Greek, Roman, and Byzantine Studies* 15, 89–111.

M. Almagro, 1955: *Las Necropolis de Ampurias II* (Barcelona: Seix y Barral).

Anon. A.R., 1994: reprint from the August 1994 issue of the trade journal *Glass* that was kindly provided me by Theresa Green of the British Glass Industries Research Association in Sheffield.

Anon. J., 1971: "Glass," in *Encyclopaedia Judaica*: part 7, 603–611 (Jerusalem: MacMillan).

Anonymous, 1839: *The Treatises of S. Caecilius Cyprian*, 200–229 (London: Rivington).

R. Atwater, 1966: *Procopius' Secret History* (Ann Arbor: University of Michigan Press).

S.H. Auth, 1990: "Intarsia Glass Pictures in Coptic Egypt," *Annales du 11e Congrès de l'Association Internationale pour l'Histoire du Verre*, 237–246 (Amsterdam: A.I.H.V.).

N. Avigad, 1976: *Beth Shearim: Reports on the Excavations during 1953–1958: III*, catacombs 12–23 and fig. 100 (New Brunswick: Rutgers University Press).

G. Avni, and Z. Greenhut, 1996: *The Akeldama Tombs*, 95–103 (Jerusalem: Israel Antiquities Authority).

D. Bailey, 1976: "Potter Lamps," in *Roman Crafts*, 93–104, eds., D. Strong and D. Brown, (London: Duckworth).

D.M. Bailey, 1992: "A Grave Group from Cyzicus," *Journal of Glass Studies* 34, 27–34.

D. Barag, 1970: "Glass Vessels of the Roman and Byzantine Periods in Palestine," Doctoral Dissertation for the Hebrew University: Jerusalem.

D. Barag, 1970: "Glass Pilgrim Vessels from Jerusalem-Part I," *Journal of Glass Studies* 12, 35–63.

D. Barag, 1971: "Glass Pilgrim Vessels from Jerusalem-Parts II and III," *Journal of Glass Studies* 13, 45–63.

R.D. Barnett and C. Mendelson (edits.), 1987: *Tharros*, appendix A (London: British Museum).

T. Barton, 1994: "The *Inventio* of Nero: Suetonius," in *Reflections on Nero*, 48–63, eds., J. Elsner and J. Masters (Chapel Hill: University of North Carolina Press).

G.F. Bass, 1984: "The Nature of the Serce Limani Wreck," *Journal of Glass Studies* 26, 64–69.

G.F. Bass, 1886: "A Bronze Age Shipwreck at Ulu Burun (Kas): 1984 Campaign," *American Journal of Archeology*, 90, 281–282.

G.F. Bass, 1978: "Glass Treasure from the Aegean," *National Geographic* 153, 768–793.

P.V.C. Baur, 1938: in *Gerasa*, 505–546, ed., C.H. Kraeling, (New Haven: Yale University Press).

M.J. Baxter and H.E.M. Cool, 1991: "An Approach to Quantifying Window Glass," in *Computer Applications and Quantitative Methods in Archaeology*, 127–131, eds., K. Lockyear and S. Rahtz (Oxford: BAR Intern. Series 565).

T. Bekker-Nielsen, 1989: *The Geography of Power* (Oxford: BAR International Series 477).

H.I. Bell, 1924: *Jews and Christians in Egypt*, 72–88 (London: The British Museum).

M. Ben-Dov and Y. Rappel, 1987: *Mosaics of the Holy Land*, 38–100 (New York: Adama).

C. Bertelli, 1970: "Vetri italiani a fondo d'oro del secolo XIII," *Journal of Glass Studies 12*, 70–78.

D.G. Bird, 1984: "Pliny and the Gold Mines of the North-west Iberian Peninsula," in *Papers in Iberian Archaeology*, 341–368, eds., T.E.C. Blagg et al. (Oxford: BAR International Series 193).

A.E.R. Boak, *Manpower Shortage and the Fall of the Roman Empire in the West*, 109–129 (Westport, CT: Greenwood).

H. Bögli, 1989: *Aventicum: The Roman City and the Museum*, cover, fig. 52 and fig. 78 (Avenches: Association Pro Aventico).

D. von Boeselager, 1989: "Zur Datierung der Gläser aus zwei Gräbern an der Luxemburger Strasse in Köln," *Kölner Jahrbuch für Vor- und Frühgeschichte 22*, 25–35.

G.C. Boon, 1966: "Roman Window glass from Wales," *Journal of Glass Studies* 8, 41–45.

G.C. Boon, 1988: "Counterfeit Coins in Roman Britain," in *Coins and the Archaeologist*, 102–188, eds., J. Casey and R. Reece (London: Seaby).

G.W. Bowerstock, 1995: *Martyrdom and Rome* (New York: Cambridge University Press).

A.K. Bowman, 1980: "The Economy of Egypt in the Earlier Fourth Century," in *Imperial Revenue, Expenditure and Monetary Policy in the Fourth Century* A.D., 23–40, ed., C.E. King (Oxford: BAR International Series 76).

A.K. Bowman, 1986: *Egypt after the Pharaohs*, 38–50 (Berkeley: University of California Press).

K. Branigan and D. Miles (eds.), 1989: *Villa Economies: Economic Aspects of Romano-British Villas* (Sheffield: University of Sheffield).

F. Braudel, 1979: *The Structures of Everyday Life I*, 78–90 (New York: Harper and Row).

R.H. Brill, 1963: "Ancient Glass," *Scientific American* 209.5, 120–131.

R.H. Brill, 1965: "The Chemistry of the Lycurgus Cup," *Proceedings of the VIIth Internatiuonal Congress on Glass*, paper 223 (Brussels: I.C.G.).

R.H. Brill, 1967: "A Great Glass Slab from Ancient Galilee," *Archaeology* 20.2, 88–95.

R.H. Brill, 1988: in *Excavations at Jalame*, 257–294, ed., G.D. Weinberg (Columbia: University of Missouri Press).

R.H. Brill, 1991: "Scientific Investigations of Some Glasses from Sedeinga," *Journal of Glass Studies* 33, 11–28.

R.H. Brill and N.D. Cahill, 1988: "A Red Opaque Glass from Sardis and Some Thoughts on Red Opaques in General," *Journal of Glass Studies* 30, 16–27.

R.H. Brill and J.W.H. Schreurs, 1984: "Iron and Sulfur Related Colors in Ancient Glass," *Archaeometry* 26, 199–209.

R.H. Brill and D. Whitehouse, 1988: "The Thomas Panel," *Journal of Glass Studies* 30, 34–50.

J.J. Buchanan and H.T. Davis, 1967: *Zosimus: New Histories*, 53–79 (San Antonio: Trinity University Press).

G. Bustacchini, 1973: "Gold in Mosaic Art and Technique," *Gold Bulletin* 6.2, 52–56.

M.H. Callendar, 1965: *Roman Amphorae*, xix–41 (New York: Oxford University Press).

A. Cameron, 1996: "Orfitus and Constantius: A Note on Roman Gold-glasses," *Journal of Roman Archaeology* 9, 295–301.

J. Carcopino, 1962: *Daily Life in Ancient Rome*, 277–286 (London: Penguin).

A.G. Carmichael, 1986: *Plague and the Poor in Renaissance Florence*, 90–107 (London: Cambridge University Press).

L. Casson, 1984: *Ancient Trade and Society*, 70–85 and 96–116 (Detroit: Wayne State University Press).

H. Chadwick and G.R. Evans, 1989: *Atlas of the Christian Church*, 14–39 (New York: Facts on File).

P. Charanis, 1967: "Observations on the Demography of the Byzantine Empire," in *Proceedings of the XIIIth International Congress of Byzantine Studies*, 445–463, eds., J.M. Hussey et al. (London: Oxford University Press).

R.J. Charleston, 1964: "Wheel-engraving and -cutting: Some Early Equipment," *Journal of Glass Studies* 6, 83–100.

R.J. Charleston, 1978a: "Glass Furnaces through the Ages," *Journal of Glass Studies* 20, 9–33.

R.J. Charleston, 1978b: "A Gold and Enamel Box in the Form of a Glass Furnace," *Journal of Glass Studies* 20, 35–44.

D. Charlesworth, 1966: "Roman Square Bottles," *Journal of Glass Studies* 8, 26–40.

H. Chew, 1988: "Lsa tombe Gallo-Romaine de Saintes. Nouvel examen du matériel," *Antiquités Nationales* 20, 35–61.

R.G. Collingwood and R.P. Wright, 1965: *Roman Inscriptions in Britain I* (Oxford: Clarendon Press).

H.E.M. Cool, 1995: "Glass Vessels of the Fourth and Early Fifth Century in Roman Britain," in *Le Verre de l'Antiquite Tardive et du Haut Moyen Age*, 11–23, ed., D. Foy (Val d'Oise: Cergy-Pontoise Musee Archéologique Departemental).

H.E.M. Cool, 1996: "The Boudican Uprising and the Glass Vessels from Colchester," *Expedition* 38.2, 52–62.

H.E.M. Cool and J. Price, 1995: *Colchester Archaeological Report* 8, 179–206 (Colchester: Colchester Archaelogical Trust).

T. Cornell and J. Matthews, 1982: *Atlas of the Roman World*, 168–223 (New York: Facts on File).

J.W. Crowfoot, G.M. Crowfoot, and K.M. Kenyon, 1957: *Samaria-Sebaste III: The Objects from Samaria*, 402–422 (London: Palestine Exploration Fund).

G.M. Crowfoot, and D.B. Harden, 1931: "Early Byzantine and Later Glass Lamps," *Journal of Egyptian Archaeology* 17, 196–208.

L.C. Cowie, 1972: *The Black Death and Peasants' Revolt*, 59–69 (London: Wayland).

L.A. Curchin, 1991: *Roman Spain: Conquest and Assimilation*, 134–153 (Routledge: New York).

J.E. Curtis, 1979: "Loftus' Parthian Cemetery at Warka," *Archäologische Mitteilungen aus Iran* 6, 309–317.

R. van Dam, 1985: *Leadership and Community in Late Antique Gaul*, 1–24 (Berkeley: University of California Press).

P.V. Davies, 1969: *Macrobius' The Saturnalia*, various entries (New York: Columbia University Press).

L. Davis, 1991: *Venus in Copper*, 234–236 (New York: Crown).

M.R. DeMaine, 1983: "Ancient Glass Distribution in Illyricum," *Journal of Glass Studies* 25, 79–86.

W.A. Deer, R.A. Howie and J. Zussman, 1966: *An Introduction to Rock Forming Minerals*, 351 and 511 (London: Longman).

B. Doe, 1971: *Southern Arabia*, 134–137 (New York: Thames & Hudson).

G. Donato, and M. Seefried, 1989: *The Fragrant Past*, 51–60 (Atlanta: Emory University Museum).

M. Dothan, 1983: *Hammath Tiberias: Early Synagogues at the Hellenistic and Roman Remains*, 37–38 (Jerusalem: Israel Exploration Society).

O. Drahotová, 1981: "Comments on Caspar Lehmann, Central European Glass and Hardstone Carving," *Journal of Glass Studies* 23, 34–45 and 46–55.

R.P. Duncan-Jones, 1982: *The Economy of the Roman Empire*, 366–369 (New York: Cambridge University Press).

R.P. Duncan-Jones, 1990: *Structure and Scale in the Roman Empire*, 7–29 (New York: Cambridge University Press).

R.P. Duncan-Jones, 1996: "The Impact of the Antonine Plague," *Journal of Roman Archaeology* 9, 108–136.

E.C.L. During Caspers, 1980: *The Bahrain Tumuli*, pl. xxv (Leiden: E.J. Brill).

E.B. Dusenbery, 1967: "Ancient Glass from the Cemeteries of Samothrace," *Journal of Glass Studies* 9, 34–49.

J. Edmondson, 1987: *Two Industries in Roman Lusitania: Mining and Garum Production* (Oxford: BAR International Series 362).

G. Ekholm, 1963: "Scandinavian Glass Vessels of Oriental Origin from the First to the Sixth Century," *Journal of Glass Studies* 5, 29–38 and fig. I.

M. Eckoldt, 1984: "Navigation on Small Rivers in Central Europe in Roman and Medieval Times," *International Journal of Nautical Archaeology and Underwater Exploration* 13.1, 3–10.

G. von Eggert, 1991: "'vitrum flexile' als Rheinischer Bodenfund?," *Kölner Jahrbuch für Frühgeschichte* 24, 287–296.

V.H. Elburn, 1962: "Ein christliches Kultgefäss aus Glas in der Dumbarton Oaks Collection," *Jahrbuch der Berliner Museen* IV, 17–41.

P. Ennès, 1990: "Four Plates from the Sèvres Service des Arts industriels (1820–1835)," *Journal of the Museum of Fine Arts Boston* 2, 89–106.

E. Ettlinger, 1951: "Legionary Pottery from Vindonissa," *Journal of Roman Studies* XLI, 105–111.

V.I. Evison, 1972: "Glass Cone Beakers of the 'Kempston' Type," *Journal of Glass Studies* 14, 48–66.

V.I. Evison, 1983: "Some Distinctive Glass Vessels of the Post-Roman Period," *Journal of Glass Studies* 25, 87–93.

A. Ferrua, 1990: *The Unknown Catacomb*, 59–165 and fig. 129 (New Lanark, Scotland: Geddes and Grosset).

A.J. Festugière and L. Rydén, 1974: *Vie de Syméon le Fou et Vie de Jean de Chypre*, 162 (Paris: Paul Geuthner).

A. Fischer, 1993: "The Early and Late Byzantine Glass of Sepphoris, Israel," in *John C. Young Scholars Journal*, I–36 (Danville, KY: Centre College).

G.M. Fitzgerald, 1931: *Beth-Shan Excavations III: The Arab and Byzantine Levels* (Philadelphia: University Museum Publications).

S.J. Fleming, 1975: *Authenticity in Art*, 117–124 (London: Institute of Physics).

S.J. Fleming, 1996: "Early Imperial Roman Glass at the University of Pennsylvania Museum," *Expedition* 38.2, 13–37.

S.J. Fleming, 1997a: *Roman Glass: Reflections of Everyday Life*, various plates (Philadelphia: University of Pennsylvania Museum).

S.J. Fleming, 1997b: "Late Roman Glass at the University of Pennsylvania Museum," *Expedition* 39.2, 25–41.

S.J. Fleming, B. Fishman, D. O'Connor, and D. Silverman, 1980: *The Egyptian Mummy: Secrets and Science*, plates 29–36 (Philadelphia: The University Museum).

A.-B. Follman-Schulz, 1988: *Die römischen Gläser aus Bonn*, tafel 10 (Cologne: Rheinland Verlag).

B. Follman-Schulz, 1989: "Ein Römischer Grabfund des 4. Jahrhunders n. Chr. aus Zülpich-Enzen, Rheinland," *Kölner Jahrbuch für Vor- und Frühgeschichte* 22, 49–68.

R.J. Forbes, 1966: *Studies in Ancient Technology: V*, 185–187 (Leiden: E.J. Brill).

D. Foy and G. Sennequier, 1989: *À travers le verre du Moyen Age à la Renaissance*, 45–62 and III–117 (Rouen: Musées departementaux de la Seine-Maritime).

L. Franchi dell'Orto and A. Varone, 1993: *Rediscovering Pompeii*, various entries (Rome: L'Erma di Bretschneider).

F. von Fremersdorf, 1966: "Die Anfänge der Römischen Glashütten Kölns," *Kölner Jahrbuch* 8, 24–43 and fig. 5.2.

U. Friedhoff, 1989: "Beigaben aus Glas in Körpergräbern des Späten 3. und des 4. Jahrhunderts: Ein Indiz für den Sozialen Status des Bestatteten," *Kölner Jahrbuch für Vor- und Frühgeschichte* 22, 37–48.

A. Frova, 1971: "Vetri romani con marchi," *Journal of Glass Studies* 13, 38–44.

S. Fünfschilling, 1986: "Römische Gläser aus Baden-Aquae Helveticae (aus den Grabunger 1892–1911)," *Jahrebericht der Gesellschaft P.O. Vindonissa 1985*, 81–160.

Galliou, P., 1981: "Western Gaul in the Third Century," in *The Roman West in the Third Century, Part II*, 259–286, eds., A. King and M. Henig (Oxford: BAR International Series 109).

A. Gasparetto, 1967: "A proposito dell'Officina vertaria Torcellana: Forni e sistemi di fusione antichi," *Journal of Glass Studies* 9, 50–75.

A. Gasparetto, 1975: "Note Sulla Vetraria E Sull'Iconografia Vertaria Bizantina," *Journal of Glass Studies* 17, 101–113.

P. Garnsey, 1983: "Famine in Rome," in *Trade and Famine in Classical Antiquity*, 56–65 (Cambridge: Cambridge Philosophical Society).

P. Garnsey, 1988: *Famine and Food Supply in the Graeco-Roman World*, 218–243 (New York: Cambridge University Press).

G. Gatteschi, 1924: *Restauri della Roma Imperiale*, pl. 19 (Rome: Comitato di azione partiotticca fra il personale postale-telegrafico-telefonico).

E.K. Gazda (edit.), 1983: *Karanis: An Egyptian Town in Roman Times*, 8–31 (Ann Arbor: University of Michigan).

I. Giacosa, 1992: *A Taste of Ancient Rome*, various entries (Chicago: University of Chicago Press).

K. Goethert-Polaschek, 1988: *Katalog der Römischen Gläser de sRheinischen Landesmuseums Trier* (Mainz: Philipp von Zabern).

S.M. Goldstein, 1989: "Old Glass, New Glass, Gold Glass: Some Thoughts on Ancient Casting Technology," *Kölner Jahrbuch für Vor- und Frühgeschichte* 22, 115–120.

E.R. Goodenough, 1953: *Jewish Symbols in the Greco-Roman Period: III*, fig. 784 (New York, Bollingen Series).

Y. Gorin-Rosen, 1993: "Hadera, Bet Eli'ezer," *Excavations and Surveys in Israel* 13, 42–43.

R.S. Gottfried, 1983: *The Black Death*, 54–103 (New York: Free Press).

E.R. Graser, 1940: in *An Economic Survey of Ancient Rome*, V, 305–421 (London: Oxford University Press)

K. Greene, 1977: "Legionary Pottery, and the Significance of Holt," in *Roman Pottery Studies in Britain and Beyond*, 113–132, eds., J. Dore and K. Greene (Oxford: BAR 30).

K. Greene, 1986: *The Archaeology of the Roman Economy*, 156–168 (Berkeley: University of California Press).

S. Gregory, 1996: *A Plague on Both Your Houses*, 124–192 (London: Warner).

M. Grieve, 1971: *A Modern Herbal*, 293–297 (New York: Dover).

D.F. Grose, 1977: "Early Blown Glass," *Journal of Glass Studies* 19, 9–29.

D.F. Grose, 1989: *Early Ancient Glass*, various sections (New York: Hudson Hills).

D.F. Grose, 1991: "Early Imperial Roman Cast Glass: The Translucent Coloured and Colourless Fine Wares," in *Roman Glass: Two Centuries of Art and Invention*, 1–18, eds., M. Newby and K. Painter (London: The Society of Antiquaries of London).

E. Haerinck, 1992: "Excavations at ed-Dur (Umm al-Qaiwain)-Preliminary Report in the Fourth Belgian Season (1990)," *Arabian Archaeology and Epigraphy* 3, 190–208.

T.E. Haervernick, 1967a: "Die Millefioririppenschale des Hl. Servatius in Maastricht," *Journal of Glass Studies* 17, 71–73.

T.E. Haervernick, 1967b: "Die Verbreitung der Zaren Rippenschalen," in *Jarrbuch der Römisch–Germanische Zentralmuseums Mainz* 14, 153–166.

W. Hamilton (trnasl.), 1986: *Ammianus Marcellinus' The Later Roman Empire (A.D. 354–378)* (London: Penguin Books).

U.L. Hansen (edit.), 1995: *Himlingøje-Seeland-Europa*, 141–189 (Copenhagen: Det Kogelige Nordiske Oldskriftselskab).

D.B. Harden, 1936: *Roman Glass from Karanis found by the University of Michigan Archaeological Expedition in Egypt 1924–29*, 155–165 (Ann Arbor: University of Michigan Studies, HS 41).

D.B. Harden, 1939: "Roman Window–Panes from Jerash, and Later Parallels," *Iraq* VI, 91.

D.B. Harden, 1968: "The Canosa Group of Hellenistic Glasses in the British Museum," *Journal of Glass Studies* 10, 21–47.

D.B. Harden, 1987: *Glass of the Caesars*, various entries (Milan: Olivetti).

R. Hasson, 1983: "Islamic Glass from Excavations in Jerusalem," *Journal of Glass Studies* 25, 109–113.

J.W. Hayes, 1975: *Roman and Pre-Roman Glass in the Royal Ontario Museum*, various entries (Toronto: Royal Ontario Museum).

J.W. Hayes, 1997: *Handbook of Mediterranean Roman Pottery*, figs. 14–25 (London: British Museum Press).

D. Hejdová, 1975: "Types of Medieval Glass Vessels in Bohemia," *Journal of Glass Studies* 17, 142–150.

D. Hejdová, 1981: "The Glasshouse at Rejdice in Northeastern Bohemia: Late Sixteenth-Early Seventeenth Centuries," *Journal of Glass Studies* 23, 18–33.

J. Henderson, 1985: "The Raw Materials of Early Glass Production," *Oxford Journal of Archaeology* 4, 267–291.

E.I. Higachi, 1990: *Conical Glass Vessels from Karanis: Function and Meaning in a Pagan/Christian Context in Rural Egypt*, 365–381 (Ann Arbor: University of Michigan).

P. Hollister, 1983: "Muranese Millefiori Revival of the Nineteenth Century," *Journal of Glass Studies* 25, 201–206.

H.C. Hoover and L.H. Hoover (transl.), 1950: *De re metallica* (New York: Dover).

L. Horne, 1987: "The Brasscasters of Dariapur, West Bengal," *Expedition* 29.3, 39–46.

C. Howgego, 1995: *Ancient History in Coins*, 115–140 (New York: Routledge).

E.D. Hunt, 1992: in *Fifth-Century Gaul: A Crisis of Identity?*, 264–287, eds., J. Drinkwater and H. Elton (New York: Cambridge University Press).

E.D. Hunt, 1982: *Holy Land Pilgrimage in the Later Roman Empire A.D. 312–460* (Oxford: Clarendon).

S.A.S. Husseini, 1938: "A Rock-cut Tomb Chamber at 'Ain Yabrud," *The Quarterly of the Department of Antiquities in Palestine* 6, 54–55 and plates V–VIII.

C. Isings, 1957: *Roman Glass*, various entries (Groningen: J.B. Wolters).

C. Isings, 1969: "Snake Thread Glass with Applied Shells from Stein (Dutch Limburg)," *Journal of Glass Studies* 11, 27–30.

C. Isings, 1980: "Glass from the *Canabae Legionis* at Nijmegen," in *Ber Rijksdienst Oudheidkund Bodenmerz* 30, 281–346.

Y. Israeli, 1983: "Ennion in Jerusalem," *Journal of Glass Studies* 25, 65–69.

Y. Israeli, 1991: "The Invention of Blowing," in *Roman Glass: Two Centuries of Art and Invention*, 46–55, eds., M. Newby and K. Painter (London: The Society of Antiquaries of London).

R. Jackson, 1988: *Doctors and Diseases in the Roman Empire*, 56–85 (Norman: University of Oklahoma Press).

G.L. Jacobson, 1992: "Greek Names on Prismatic Jugs," *Journal of Glass Studies* 34, 35–43.

D. Jacoby, 1993; "Raw Materials for the Glass Industries of Venice and The Terrafirma, about 1370–about 1460," *Journal of Glass Studies* 35, 65–90.

A.C. Johnson, 1951: *Egypt and the Roman Empire*, 23 and endnotes (Ann Arbor: University of Michigan Press).

R.P. Johnson, 1939: *Compositiones Variae*, 9–21 (Urbana: University of Illinois Press).

S. Johnson, 1976: *The Roman Forts of the Saxon Shore* (London: Elek).

A.H.M. Jones, 1994: *The Later Roman Empire 284–602: I*, 77–97 (Norman: University of Oklahoma Press).

G.B.D. Jones, 1980: "The Roman Mines of Rio Tinto," *Journal of Roman Studies* 70, 146–165.

M.F. Kaplan and J.E. Mendel, 1982: "Ancient Glass and the Safe Disposal of Nuclear Waste," *Archaeology* 35.4, 22–29.

C.A. Keller, 1983: "Problems in Dating Glass Industries of the New Kingdom: Examples from Malkata and Lisht," *Journal of Glass Studies* 25, 19–28.

L. Keppie 1984: *The Making of the Roman Army*, appendices 2 and 3 (London: Batsford).

L. Keppie, 1991: *Understanding Roman Inscriptions*, 94–97 (Baltimore: Johns Hopkins University Press).

A. King, 1990: *Roman Gaul and Germany*, 89–109 and 189–201 (Berkeley: University of California Press).

E.R. Knaur, 1993: "Roman Wall Paintings from Boscotrecase: Three Studies in the Relationship Between Writing and Painting," *Metropolitan Museum Journal* 28, 13–46.

L. Kocsis, 1991: "A Glass Bowl with Engraved Ornament from the Mithraeum in the Legionary Fort at Aquincum (Budapest)," *Journal of Glass Studies* 33, 29–31.

C. Kondoleon, 1979: "An Openwork Gold Cup," *Journal of Glass Studies* 21, 39–50.

A. Koster and D. Whitehouse, 1989: "Early Roman Cage Cups," *Journal of Glass Studies* 31, 25–33.

J. Krier and F. Reinert, 1993: *Das Reitergrab von Hellingen*, 17–27 (Luxembourg, Musée National d'Histoire et d'Art).

E. Künzl, 1983: *Medizinische Instrumentale aus Sepulkralfunden der römischen Kaiserzeit*, 40–128 (Bonn: Rheinisches Landesmuseum).

J. Leclant, 1973: "Glass from the Meroitic Necropolis of Sedeinga (Sudanese Nubia)," *Journal of Glass Studies* 15, 52–68.

In-Sook Lee, 1993: *Ancient Glass in Korea*, various plates (Seoul: Chang-Moon).

K. Lehmann-Hartleben and E.C. Olsen, 1942: *Dionysiac Sarcophagi in Baltimore*, 20–33 (Baltimore: Walters Art Gallery).

A. Lezine, 1969: *Les Thermes d'Antonin à Carthage* (Tunis: Societe tunisiènne de diffusion).

S.N.C. Lieu (edit.), 1986: *The Emperor Julian Panegyric and Polemic*, Claudius Marmentius (Liverpool: Liverpool University Press).

C.S. Lightfoot, 1987: "A Group of Early Roman Mold-blown Flasks from the West," *Journal of Glass Studies* 29, 11–21.

C.S. Lightfoot and M. Arslan, 1992: *Ancient Glass in Asia Minor: The Yüksel Erimtan Collection* (Ankara: E.M.T.A.S.).

B. Liou and P. Pomey, 1985: "Direction des recherches archéologiques sous-marines," *Gallia* 43, 547–576.

P. LLewellyn, 1993: *Rome in the Dark Ages*, 1–51 (New York: Dorset).

A.I. Lowenthal and D.B. Harden, 1949: "Vasa Murrhina," *Journal of Roman Studies* 39, 31–36.

G. Mackworth Young, 1949: *Excavations at Siphnos IV: The Roman Graves of the First Century A.D.*, 80–92 (Athens: Annual of the British School at Athens 44).

R. MacMullen, 1987: "Tax-Pressure in the Roman Empire," *Latomus* XLVI.4, 737–754.

R. MacMullen, 1990: *Corruption and the Decline of Rome*, 21–35 (New Haven: Yale University Press).

C. McEvedy, 1988: "The Bubonic Plague," *Scientific American* 258.2, 118–123.

R. McMullen, 1987: "Late Roman Slavery," *Historia* XXXVI.3, 379–382.

J. Magness, 1998: "Illuminating Byzantine Jerusalem," *Biblical Archaeology Review* 24.2, 41–47 and 70–71.

N. Makhouly, 1939: "Rock-cut Tombs at El-Jish," *The Quarterly of the Department of Antiquities in Palestine* 8, 45–50.

M.M. Mango and A. Bennett, 1994: "The Sevso Treasure," *Journal of Roman Archaeology* 12.1, 55–480.

G. Manzi, A. Sperduti and P. Passarello, 1991: "Behavior-induced Auditory Exostoses in Imperial Roman Society: Evidence from Coeval Urban and Rural Communities near Rome," *American Journal of Physical Anthropology* 85.3, 253–260.

M.I. Marcus, 1991: "The Mosaic Glass Vessels from Hasanlu, Iran: A Study in Large Scale Stylistic Trait Distribution," *Art Bulletin* 73, 536–560.

T. Martin, 1977: "Vases sigillés de montans imitant des formes en verre?" *Gallia* 35, 249–257.

S. B. Matheson, 1980: *Ancient Glass in the Yale University Art Gallery*, 132–135 (New Haven: Yale University Press).

D.J. Mattingly, 1988: "Oil for Export?: A Comparison of Libyan, Spanish and Tunisian Olive Oil Production in the Roman Empire," *Journal of Roman Archaeology* 1, 33–56.

G. Mazor and R. Bar-Nathan, 1998: "The Bet She'an Excavation Project-1992–1994," *Excavations and Surveys in Israel* 17, 7–38.

F. Meijer and O. van Nijf, 1992: *Trade, Transport and Society in the Ancient World*, 60–102 (New York: Routledge).

C. Meyer, 1992: *Glass from Queir al-Qadim and the Indian Ocean Trade*, 15–74 (Chicago: The Oriental Institute).

E.M. Meyers and L.M. White, 1989: "Jews and Christians in a Roman World," *Archaeology* 42.2, 26–33.

P. Middleton, 1983: "The Roman Army and Long Distance Trade," in *Trade and Famine in Classical Antiquity*, 75–83 (Cambridge: Cambridge Philosophical Society).

F. Millar, 1993: *The Roman Near East 31 B.C.–A.D. 337*, 70–79 (Cambridge: Harvard University Press).

P. Mirti, A. Casoli and L. Appolonia, 1993: "Scientific Analysis of Roman Glass from Augusta Praetoria," *Archaeometry* 35.2, 225–240.

M.T.M. Moevs, 1973: "The Roman Thin Walled Pottery from Cosa," in *Memoirs of the American Academy in Rome* XXXIII, 49–58.

M.T.M. Moevs, 1980: "Italo-Megarian Wares at Cosa," in *Memoirs of the American Academy in Rome* XXXIV, 169–229 and pls. 17–22.

J. Morel, H. Amrein, M.-F. Meylan and C. Chealley, 1992: "Un atelier de verrier du milieu du le siècle apr. J.-C. à Avenches," *Archéologie suisse* 15.1, 2–17.

C. Moretti and S. Hreglich, 1984: "Opacification and Coloring of Glass by the Use of 'Anime'," *Glass Technology* 25.6, 277–282.

H.A. Musurillo, 1979: *The Acts of the Martyrs* (New York: Arno).

K. Nassau, 1984: "The Early History of Gemstone Treatments," *Gems & Gemology* 1984, 22–33.

F. Naumann-Steckner, 1991: "Depictions of Glass in Roman Wall Paintings," in *Roman Glass: Two Centuries of Art and Invention*, 86–98, eds., M. Newby and K. Painter (London: The Society of Antiquaries of London).

M.D. Nenna, 1992: "L'emploi du verre, de la faïence et de la peinture dans les mosaïques de Délos," *Bulletin de Correspondance Hellénique* CXVI, 607–631.

J. Neusner, 1988: *The Mishnah*, 893–949 (New Haven: Yale University Press).

R. Newton and S. Davison, 1989: *Conservation of Glass* (Boston: Butterworth's).

R. Nichols and K. McLeish, 1976: *Through Roman Eyes*, 42–46 (New York: Cambridge University Press).

D. O'Connor, 1993: *Ancient Nubia: Egypt's Rival in Africa*, 70–107 (Philadelphia: The University Museum).

W.A. Oldfather, 1926: "Kerameus of a Worker in Glass," *Journal of the American Ceramic Society* 9, 633–649.

A. Oliver, Jr., 1977: *Silver for the Gods*, 113–115 (Toledo: The Toledo Museum of Art).

A. Oliver, Jr., 1984: "Early Roman Faceted Glass," *Journal of Glass Studies* 26, 35–58.

P. Oliver, 1961: "Islamic Relief Cut Glass: A Suggested Chronology," *Journal of Glass Studies* 3, 9–30.

B. Päffgen, 1989: "Glasbeigaben in Römischen Gräben bei St. Severin in Köln," *Kölner Jahrbuch für Vor- und Frühgeschichte* 22, 17–23.

K. Painter and D.B. Whitehouse, 1991: "The Portland Vase," in *Roman Glass: Two Centuries of Art and Invention*, 33–41, eds., M. Newby and K. Painter (London: The Society of Antiquaries of London).

A.J. Parker, 1992: "Cargoes, Containers and Stowage: The Ancient Mediterranean," *International Journal of Nautical Archaeology* 21, 89–100.

K. Parlasca, 1966: *Mummein Porträts*, tafels 52.1–4 and H (Weisbaden: Steriner).

E. Paszthory, 1990: "Salben, Schminken und Parfüme im Altertum," *Antike Welt* 21, 2–64.

D.P.S. Peacock, 1977: "Pompeian Red Ware," in *Pottery and Early Commerce: Characterization and Trade in Roman and Later Ceramics*, 147–162, ed., D.P.S. Peacock (New York: Academic Press).

P. Pensabene, 1978: "A Cargo of Marble Shipwrecked at Punta Scifo near Crotone (Italy)," *International Journal of Nautical Archaeology and Underwater Exploration* 7.2, 105–118.

P. Périn, 1972: "Deux verreries exceptionnelles provenant de la nécropole mérovingienne de Mézières," *Journal of Glass Studies* 14, 67–76.

S. Perowne, 1960: *Hadrian*, 136–150 (New York: Croom Helm).

P.W. Pestman, 1971: "Loans Bearing No Interest?," *Journal of Juristic Papyrology* XVI/XVII, 7–29.

W. von Pfeffer and T.E. Haevernick, 1958: "Zarte Rippenschalen," *Saalburg Jahrbuch* 17, 75–88.

C. Pharr (transl.), 1952: *The Theodosian Code* (Princeton: Princeton University Press).

S. Picozzi, 1988: "La nava romana di Grado," *Subacqueo* 16.181, 46–50.

R.H. Pinder-Wilson and G.T. Scanlon, 1987: "Glass Finds from Fustat: 1972–1980," *Journal of Glass Studies* 29, 60–71.

P. Plass, 1995: *The Game of Death in Ancient Rome*, 15–134 (Madison: University of Wisconsin Press).

J. du Plat Taylor and H. Cleere (eds.), 1978: *Roman Shipping and Trade: Britain and the Rhine Provinces*, various entries (London: C.B.A).

A. Polak, 1960: "Two Nöstetangen Goblets Recently Discovered in England," *The Connoisseur* [February issue], 18–21.

T.W. Potter, 1990: *Roman Italy* (Berkeley: University of California Press).

D.J. de S. Price, 1977: "Gears from the Greeks," in *Transactions of the American Philosophical Society* 64.2, 1–70.

J. Price, 1977: "Roman Unguent Bottles from Rio Tinto (Hulelva) in Spain," *Journal of Glass Studies* 19, 30–49.

J. Price, 1978: "Trade in Glass," in *Roman Shipping and Trade: Britain and the Rhine Provinces*, 70–78, eds., J. du Plat Taylor and H. Cleere (London: C.B.A.).

J. Price, 1985: "The Roman Glass," in *Inchtuthil the Roman Legionary Fortress Excavations 1952–65*, 303–312, eds., L.F. Pitts and J.K. St. Joseph (London: Britannia Monograph Series 6).

J. Price, 1987a: "Glass Vessel Production in Southern Iberia in the First and Second Centuries A.D.: A Survey of the Archaeological Evidence," *Journal of Glass Studies* 29, 30–39.

J. Price, 1987b: "Glass from Felmongers, Harlow in Essex: A Dated Deposit of Vessel Glass found in an Antonine Pit," *Annales du 10e Congrès de l'Association Internationale our l'Histoire du Verre*, 61–80 (Amsterdam: A.H.I.V.).

J. Price, 1991: "Decorated Mould-blown Tablewares in the First Century A.D.," in *Roman Glass: Two Centuries of Art and Invention*, 56–75, eds., M. Newby and K. Painter (London: The Society of Antiquaries of London).

J. Price, 1993: "Vessel Glass from the Neronian Legionary Fortress at Usk in South Wales," *Annales du 12e Congrès de l'Association Internationale pour l'Histoire du Verre*, 67–77 and fig. 3 (Amsterdam: A.I.H.V.).

P. Puppo, 1995: *Le Coppe Megaresi in Italia*, 17–53 (Rome: "L'Erma" di Bretschneider).

D. Rathbone, 1991: *Economic Rationalism and Rural Society in Third-Century A.D. Egypt*, 464–471 (New York: Cambridge University Press).

S. Raven, 1993: *Rome in Africa*, 79–99 and 132–143 (New York: Routledge).

Th. Rehren, 1997: "Ramesside Glass-colouring Crucibles," *Archaeometry* 39.2, 355–368.

D.W. Reynolds, 1997: "The Lost Architecture of Ancient Rome," *Expedition* 39.2, 15–24.

E.E. Rice, 1983: *The Grand Procession of Ptolemy Philadelphus*, 15 and 77 (New York: Oxford University Press).

H. Ricke, 1995: *Glaskunst*, entries 33 and 102 (New York: Prestel).

G. Rickman, 1971: *Roman Granaries and Store Buildings*, 163–193 (New York: Cambridge University Press).

G. Rickman, 1980: *The Corn Supply of Ancient Rome*, 120–197 (Oxford: Clarendon Press).

G.E. Rickman, 1988: "The Archaeology and History of Roman Ports," *International Journal of Archaeology and Underwater Exploration* 17.3: 257–267.

C.H. Roberts, 1977: *Manuscript, Society and Belief in Early Christian Egypt*, 11 and footnotes (London: Oxford University Press).

M.C. Ross, 1962: *Catalogue of the Byzantine and Early Mediaeval Antiquities in the Dumbarton Oaks Collection* I, entry 97 (Washington DC: Dumbarton Oaks).

S. Rotroff, 1982: "Silver, Glass, and Clay," *Hesperia* 51, 329–337.

P. Rousseau, 1985: Pachomius: *The Making of a Community in Fourth Century Egypt* (Berkeley: University of California Press).

A. von Saldern, 1970: "Other Mesopotamian Glass," in *Glass and Glassmaking in Ancient Mesopotamia*, 203–228, eds., A. Leo Oppenheim, R.H. Brill, D.P. Barag, and A. von Saldern (Corning, NY: Corning Museum of Glass).

A. von Saldern, 1980: *Ancient and Byzantine Glass from Sardis*, 35–97 (Cambridge: Harvard University Press).

N. Saliby 1981: "Verres provenant de la cote phenicienne," *Annales de 8e Congrès International d'Etude Historique de Verre*, 133–144 (Amsterdam: A.I.H.V.).

J. Scarborough, 1996: "Drugs and Medicine in the Roman World," *Expedition* 38.2, 38–51.

C. Scarre, 1995: *Chronicle of the Roman Emperors*, various entries (New York: Thames and Huson).

L.A. Scatozza Höricht, 1991: "Syrian Elements among the Glass from Pompeii and Herculaneum," *Roman Glass: Two Centuries of Art and Invention*, 56–85, eds., M. Newby and K. Painter (London: The Society of Antiquaries of London).

I. Schüler, 1966: "A Note on Jewish Gold Glasses," *Journal of Glass Studies* 8, 48–61.

G.D. Scott, 1991: "Producing Cage Cup Replicas," *Journal of Glass Studies* 33, 93–95.

G.D. Scott, 1993: "Reconstructing and Reproducing the Hohensülzen Cage Cup," *Journal of Glass Studies* 35, 106–118.

G.D. Scott, 1995: "A Study of the Lycurgus Cup," *Journal of Glass Studies* 37, 51–64.

F.B. Sear, 1997: *Roman Wall and Vault Mosaics*, 37–43 (Heidelberg: F.H. Kerle).

S. Stone, 1994: "The Toga: From National to Ceremonial Costume," *The World of Roman Costume*, 13–45, eds., J.L. Sebasta and L. Bonfante (Madison: University of Wisconsin Press).

J. Seligman, J. Zias and H. Stark, 1996: "Late Hellenistic and Byzantine Burial Caves at Giv'at Sharet, Ber Shemesh," *'Atiqot* XXIX, 44–54 and fig. 17.

G. Sennequier, 1985: *Verrerie d'Époque Romaine*, 123–127 and 169–182 (Rouen: Musées départementaux de la Seine-Maritime).

G. Sennequier, 1986: "Un certain Amarantus (ou Amaranthus?), verrier installé en Bourgogne au Ier siècle de notre ère," *Journal of Glass Studies* 28, 11–18.

J.-A. Shelton, 1988: *As the Romans Did*, various entries (New York: Oxford University Press).

K.J. Shelton, 1981: *The Esquiline Treasure*, 72–75 (London: British Museum).

S.E. Sidebottom, 1986: *Roman Economic Policy in the Erythra Thalassa, 30 B.C.–A.D. 217*, 1–181 (Leiden: E.J. Brill).

C.S. Smith and M.T. Gnudi (trans.), 1942: *The Pirotechnia of Vannoccio Biringuccio* (New York: American Institute of Mining and Metallurgical Engineers).

C.S. Smith and J.G. Hawthorne, 1974: "Mappae Clavicula: A Little Key to the World of Medieval Techniques," *Transactions of the American Philosophical Society* 64.4, 3–33.

N.A.F. Smith, 1978: "Roman Hydraulic Technology," *Scientific American* 238.5, 154–161.

N.P. Sorokina, 1967: "Das Antike Glas der Nordschwarzmeerküste," *Annales du 4é Congres des Journées Internationales du Verre*, 67–79 (Amsterdam: A.H.I.V.).

N.P. Sorokina, 1987: "Glass Aryballoi (First–Third centuries A.D.) from the Northern Black Sea Region," *Journal of Glass Studies* 29, 40–46.

G.E.M. de Ste Croix, 1981: *The Class Struggle in the Ancient Greek World from the Archaic Age to the Arab Conquests*, 420 (Ithaca: Cornell University Press).

L.P.B. Stefanelli, 1991: *L'Argento dei Romani*, 87–94 (Rome: "L'Erma" di Bretschneider).

E.M. Stern, 1989: "The Production of Glass Vessels in Roman Cilicia," *Kölner Jahrbuch für Vor- und Frühgeschichte* 22, 121–128.

E.M. Stern, 1991: "Early Exports beyond the Empire," in *Roman Glass: Two Centuries of Art and Invention*, 141–154, eds., M. Newby and K. Painter (London: The Society of Antiquaries of London).

E.M. Stern, 1995: *Roman Mold-Blown Glass*, fig. 17 and 69–73 (Rome: "L'Erma" di Bretscneider).

E.M. Stern, 1997: "Glass and Rock Crystal: A Multifaceted Relationship," *Journal of Roman Archaeology* 10, 192–206.

E.M. Stern and B. Schlick-Nolte, 1994: *Early Glass of the Ancient World*, 72–79, (Ostfildern: Verlag Gerd Hatje).

D.E. Strong, 1966: *Greek and Roman Gold and Silver Plate* (Ithaca, NY: Cornell University Press).

A.M. Stout, 1994: "Jewelry as a Symbol of Status in the Roman Empire," in *The World of Roman Costume*, 77–100, eds., J.L. Sebesta and L. Bonfante (Madison: University of Wisconsin Press).

P.C. Sutton (edit.), 1984: *Masters of Seventeenth Century Dutch Genre Painting* (Philadelphia: Philadelphia Museum of Art), pls. 70, 79, 101, 102 and 106.

V.G. Swan, 1992: "Legio VI and its Men: African Legionaries in Britain," *Journal of Roman Pottery Studies* 5, 1–33.

Takashi Taniichi, 1982: "Snake-thread Glasses in the East and the West," *Bulletin of the Okayama Orient Museum* 2, 21–59.

Takashi Taniichi, 1983: "Pre-Roman and Roman Glass Recently Discovered in China," *Bulletin of the Okayama Orient Museum* 3, 83–105.

A.-E. Theuerkauff-Liederwald, 1968: "Der Römer, Studien zu einer Glasform," *Journal of Glass Studies* 10, 114–155.

P. Throckmorton (edit.), 1987: *The Sea Remembers*, 60–83 (New York: Weidenfeld & Nicolson).

P. Throckmorton and G. Kapitän, 1968: "An Ancient Shipwreck at Pantano Longarini," *Archaeology* 21.3, 182–187.

J.M.C. Toynbee, 1971: *Death and Burial in the Roman World*, 234–244 (Cornell University Press, Ithaca).

J.D. Vehling, 1977: *Apicius: Cookery and Dining in Imperial Rome*, 241 (New York: Dover).

M. Vickers, 1996: "Rock Crystal: The Key to Cut Glass and *Diatreta* in Persia and Rome," *Journal of Roman Archaeology* 9, 48–65.

M. Vickers, 1997: "Glassware and the Changing Arbiters of Taste," *Expedition* 39.2, 4–14.

M. Vickers, O. Impey and J. Allan, 1986: *From Silver to Ceramic* (Oxford: Ashmolean Museum).

S. Walker, 1991: "Bearded Men," *Journal of the History of Collections* 3.2, 265–277.

S. Walker, 1985: *Memorials to the Roman Dead*, 18–36 (London: British Museum).

J. Ward-Perkins and A. Claridge, 1976: *Pompeii A.D. 79*, entries 83, 244 and 312 (Bristol: Imperial Tobacco).

L.W. Watkins, 1970: "Pressed Glass of the New England Glass Company," *Journal of Glass Studies* 12, 149–164.

K.H. Wedepohl, I. Kreuger, and G. Harmann, 1995: "Medieval Lead Glass from Northwestern Europe," *Journal of Glass Studies* 37, 65–82.

G.D. Weinberg, 1965: "The Glass Vessels from the Antikythera Wreck," *Transactions of the American Philosophical Society* 55.3, 30–39.

G.D. Weinberg, 1988: *Excavations at Jalame*, 38–102 (Columbia: University of Missouri Press).

G.D. Weinberg, 1992: *Glass Vessels in Ancient Greece*, various entries (Athens: Archaeological Receipts Fund).

K.D. White, 1984: *Greek and Roman Technology*, 91–112 and 208–216 (Ithaca: Cornell University Press).

D. Whitehouse, 1983: "Medieval Glass in Italy: Some Recent Developments," *Journal of Glass Studies* 25, 46–55.

D.B. Whitehouse, 1989: "Begram Reconsidered," *Kölner Jahrbuch für Vor- und Frühgeschichte* 22, 151–157.

D.B. Whitehouse (edit.), 1990: "The Portland Vase," *Journal of Glass Studies* 32, 14–188.

D.B. Whitehouse, 1991: "Cameo Glass," in *Roman Glass: Two Centuries of Art and Invention*, 19–32, eds., M. Newby and K. Painter (London: The Society of Antiquaries of London).

D. Whitehouse, 1993: "The Corning Ewer: A Masterpiece of Islamic Cameo Glass," *Journal of Glass Studies* 35, 48–56.

D.B. Whitehouse, 1996: "Glass, Gold, and Gold-glasses," *Expedition* 38.2, 4–12.

C.R. Whittaker, 1980: "Inflation and the Economy in the Fourth Century A.D.," in *Imperial Revenue, Expenditure and Monetary Policy in the Fourth Century A.D.*, 1–22, ed., C.E. King (Oxford: BAR International Series 76).

F. Wiblé, 1986: *Forum Claudii Vallensium*, fig. 28 (Martigny: Fondation Pro Octodurum).

R.L. Wilken, 1966: *The Christians as the Romans Saw Them*, 48–67 (New Haven: Yale University Press).

J. Wilkinson, 1977: *Jerusalem Pilgrims Before the Crusades* (Warminster: Aris and Phillips).

S.H. Young, 1993: "A Preview of Seventh-Century Glass from the Kourion Basilica, Cyprus," *Journal of Glass Studies* 35, 39–47.

SOURCES FOR GREEK AND ROMAN TRANSLATIONS

B. Aland, K. ALand, J. Karavidopoulos, C.M. Martini and B.M. Metzger, 1994: *The Greek New Testament* (Münster: Deutsche Bibelgesellschaft).

J. Barnes (edit.), 1984: *The Complete Works of Aristotle* (Princeton: Princeton University Press).

J.W. Basore (transl.), 1928: *Seneca: Moral Essays* (Cambridge: Harvard University Press).

C.E. Bennett, 1968: *Horace: The Odes and Epodes* (Cambridge: Harvard University Press).

E. Carey (transl.), 1994: *Dio Cassius: Roman History*, Books 56–60 (Cambridge: Harvard University Press).

L. Casson, 1979: *The "Periplus Maris Erithraei"* (Princeton: Princeton University Press).

F.H. Coleson, 1971: *Philo X* (Cambridge: Harvard University Press).

T.H. Corcoran (transl.), 1971: *Seneca VII: Naturales Quaestiones I* (Cambridge: Harvard University Press).

A.J. Festugière, 1974: *Vie de Syméon le Fou* (Paris: Librairie Orientaliste Paul Geuthner).

E.S. Forster and E.H. Heffner (transl.), 1993: *Columella: On Agriculture X–XII* (Cambridge: Harvard University Press).

R.M. Gummare (transl.), 1962: *Seneca: ad Lucilium Epistulae Morales II* (Cambridge: Harvard University Press).

A.M. Harmon, 1921: *Lucian* (New York: G.P. Putnam).

I. Hilberg, 1918: *Sancti Esebii Hieronymi Epistulae III*, epistulae CXXI–CLIV (Vienna: F. Tempsky).

F.G. Kenyon, 1934: *The Chester Beatty Biblical Papyri: Descriptions and Texts of Twelve Manuscripts on Papyrus of the Greek Bible*, fascicle III: Pauline Epistles and Revelation (London: Emery Walker).

B. Krusch (edit.), 1969: *Scriptores Rerum Merovingicarum I, part II:* Gregorii Episcopi Turnoensis, Miracula et Opera Minora (Hannover: Hahnianus).

W.M. Lindsay, 1911: *Isidori Hispalensis Episcopi: Etymologiarum sive Originum XX* (Oxford: Clarendon).

D. Magie (transl.), 1991: *Scriptores Historiae Augustae I* (Cambridge: Harvard University Press).

H.G. May and B.M. Metzger (edits.), 1973: *The Holy Bible* (New York: Oxford University Press).

C. Mondésert (transl.), 1965: *Clément d'Alexandrie: Le Pédagogue* II (Paris: Les Editions du Cerf).

A. Mozley, 1967: *Statius: Silvae* (Cambridge: Harvard University Press).

S. Quesnel (transl.), 1996: *Venance Fortunat IV: Vie de Saint Martin* (Paris: Les Belles Lettres).

H. Rackham (transl.), 1986: *Pliny: Natural History IV*, Books XII–XVI (Cambridge: Harvard University Press).

B. Radice (transl.), 1969: *Pliny: Letters*, Books VII–X and Panegyricus (Cambridge: Harvard University Press).

B. Radice (transl.), 1969: *Pliny: Letters and Panegyricus I* (Cambridge: Harvard University Press).

J. Reta and M. Casquero, 1983: *San Isidro de Sevilla, Etimologías II:* Books XI–XX (Madrid: Biblioteca de Autores Cristianos).

E.E. Rice, 1983: *The Grand Procession of Ptolemy Philadelphus* (New York: Oxford University Press).

B.B. Rogers, 1960: *Aristophanes I* (Cambridge: Harvard University Press).

W.D. Ross (transl.), 1964: *Aristotelis: Analytica Priora et Posteriora* (Oxford: Claredon).

W.H.D. Rouse (transl.), 1992: *Lucretius: De Rerum Natura* (Cambridge: Harvard University Press).

D.R. Shackleton Bailey, 1993a: *Martial: Epigrams I*, On the Spectacles and Books I–V (Cambridge: Harvard University Press).

D.R. Shackleton Bailey (transl.), 1993b: *Martial: Epigrams III*, Books XI–XVI (Cambridge: Harvard University Press).

A.H. Sommerstein (transl.), 1998: *The Comedies of Artistophanes* I: Acharians (Warminster: Aris & Phillips).

W.J.M. Starkie, 1966: *The Clouds of Aristophanes* (Amsterdam: A.M. Hakkart).

R. Van Dam, 1988a: *Gregory of Tours: Glory of the Martyrs* (Liverpool: Liverpool University Press).

R. Van Dam, 1988b: *Gregory of Tours: Glory of the Confessors* (Liverpool: Liverpool University Press).

E.H. Warmington (transl.), 1969: *Petronius* (Cambridge: Harvard University Press).

INDEX